*Human
Freedom after
Darwin*

Human Freedom after Darwin

A Critical Rationalist View

JOHN WATKINS

OPEN COURT
Chicago and La Salle, Illinois

To order books from Open Court, call toll-free 1-800-815-2280.

Open Court Publishing Company is a division of Carus Publishing Company.

Printed and bound in the United States of America.

Library of Congress Cataloging-in-Publication Data

Watkins, John W. N.
 Human freedom after Darwin : a critical rationalist view / John Watkins.
 p. cm.
 Includes bibliographical references and index.
 ISBN 0-8126-9406-6 (alk. paper). — ISBN 0-8126-9407-4 (pbk. : alk. paper)
 1. Free will and determinism. 2. Naturalism. I. Title.
BJ1461.W38 1999
123'.5 21—dc21 99-045355

Contents

Preface

This book is not about political freedom; nor is it about free will, though that receives some passing mention. It is about larger issues to do with human freedom of the kind that Spinoza, Kant, and Schopenhauer addressed. These issues seem to have dropped off the agenda of Anglo-American philosophy. This book seeks to revivify them by approaching them from a fresh philosophical standpoint.

A view of human freedom requires a view of what used to be called Man's Place in Nature, in order to assess what autonomy or self-determination, if any, Nature allows to individuals when their minds are at their active best. Unlike a world-view in the seventeenth or eighteenth century, a world-view today must accord with contemporary neo-Darwinism. A world-view that does that will be sketched in Part One, in which Chapter 5, on genes and the mind, and Chapter 3, on science and determinism, have key positions.

The question as to how human minds at their active best should be understood will be answered from a critical rationalist standpoint. Critical rationalism is a theory of knowledge, especially scientific knowledge. The theories of knowledge put forward by Descartes, Spinoza, Hume, and Kant, were very different, but they had one thing in common: they denied that there can be genuine invention in science. Critical rationalism disagrees. Its most distinctive feature, with respect to the above question, is its analysis of major theoretical advances in science. Its finding is that they introduce new content that could not have been derived from material already there; there must be genuine invention in science, otherwise those advances would not have occurred. Critical rationalism was sometimes seen as the idiosyncratic doctrine of a noisy gang who denied such truisms as that science starts from observations. But the central components of its understanding of science are very generally accepted

nowadays.[1] Yet perhaps there has been insufficient appreciation of its main contribution to philosophical anthropology, namely that science testifies to human inventiveness. Of course there is creative thinking in other fields, but it is within science that it is most perspicuous and demonstrable.

I tried to spell out the critical rationalist view of science, whose essentials I had learnt from Karl Popper, with a certain rigour in my *Science and Scepticism* (1984). In the present book that view is presented in an easygoing and informal way. I rather take it for granted that it is the rightful successor to classical empiricist and classical rationalist accounts of human knowledge. On one nontrivial issue I have revised my position. Back in 1934 Popper proudly declared: *There is no need even to mention 'induction'.*[2] I was one of those within his circle who came to accept that his non-inductive solution for the problem of choosing the best theory with respect to the aim of theoretical science does not carry over to the pragmatic problem of induction, namely technology and practical decision-making. In the Epilogue of my *1984* I offered what I considered an ingenious new solution for this latter problem, but it came in for penetrating criticism,[3] and I have conceded defeat.[4] I now accept that practical life calls for some inductive assumption.

A theory of knowledge cannot by itself sponsor a particular world-view, but it can help in the formation of one by sifting the credentials of candidates competing for inclusion. That task will occupy Part One. Nor can a theory of knowledge by itself sponsor a particular view of human freedom, but it can help in revising views on freedom associated with classical empiricism and classical rationalism. That task will occupy Part Two.

In the body of the book the mind-body relation is treated from a Darwinian standpoint, which turns out to be in broad alignment with common-sense views. The metaphysical issues are taken up in the Epilogue.

1. Abner Shimony caught the nub of critical rationalism when he wrote that 'the scientific method combines openness to theoretical innovation with a critical insistence upon experimental test' (1993, ii, p. 325). See also Michael Redhead 1995.

2. This was in a discussion of a paper by Reichenbach at a conference in Prague; see his 1959, p. 315.

3. Especially in Howson 1991.

4. Watkins 1995.

Popper was concerned with issues to do with human freedom, and he often spoke of coming to its philosophical defence.[5] But he never got around to doing so; he left a gap, which I hope the present book will fill. I have tried to make it reader-friendly, avoiding technicalities, for it deals with matters which concern us all.

The bits of evolutionary theory in §§ 4.6, 5.2, 5.4, and 5.6 have all been under critical fire at the Work-in-Progress seminar founded some years ago by Helena Cronin. Among its members I am grateful to Oliver Curry, Colin Tudge, Richard Webb and especially to Andy Wells, our chairman, who also made extensive comments on the Epilogue. To Helena herself I owe an extended debt. Over twenty years ago, appalled by my succumbing to Wynne-Edwards's group selection theory, she thrust *The Selfish Gene* into my hands. In the early 1980s, when I was officially her Ph.D. supervisor, I began watching the development of what was to become *The Ant and the Peacock*. Through her I met Richard Dawkins and John Maynard Smith and, later, Geoffrey Miller, all of whom have strongly influenced Part One. The latter has been helpful in providing me with advance copies of work in progress. I am grateful to Arthur Jensen and Nick Humphrey for encouragement over § 5.6.

Ingemar Lindahl has been something of a "find". He wrote to me out of the blue a few years ago in connection with an idea of Popper's, referred to near the end of the Epilogue. It turned out that our interests overlap rather remarkably. He gave me detailed comments on Chapters 4 and 5, and the Epilogue.

For about the first five years of the writing and re-writing of this book Youssef Aliabadi regularly went over my latest draft, giving me much helpful criticism. Alan Musgrave worked through the entire TS as it was in 1995, splattering it with sharp comments; recently, under great pressure of time, he did the same with the Epilogue. As usual, my old friend's influence has been most beneficial.

ERSKINE HILL, London

On 26 July 1999, eleven weeks after completing this book, John Watkins died of a heart attack while sailing his boat, Xantippe, *on the Salcombe estuary, South Devon, England.*

5. *1982b* (p. xxi); and see 1972, p. 206; *1994a*, p. 200; *1994b*, p. 129.

Notes to the Reader

The kind of freedom envisaged in this book is open to men and women, and I have tried to avoid "sexism". But I dislike conspicuous avoidance, such as replacing "he" by "she". Earlier writers on freedom, from Hobbes and Spinoza to Huxley and Russell, were "sexist" to a man, and when discussing their views it has sometimes been difficult not to get drawn in. So I follow a precedent set by that great champion of women's rights, J. S. Mill, and declare in advance that in such phrases as "Man's Place in Nature", the word "Man" refers to female as well as male human beings.

Not very long ago Keynes and others were writing "*à priori*"; this got simplified to "*a priori*" and then to "a priori"; I carry this to its natural conclusion and write "apriori" (and "aposteriori").

Unless the title is needed for some reason, author's works are usually referred to by a date or other abbreviation. In the case of books this is italicized. It may be dropped in a subsequent run of references to the same work. Full publication details are given under References. Italicized words in quotations were italicized in the original unless otherwise indicated; ellipses are indicated by '. . .'; material inside square brackets has been added by me.

Introduction

Call a view of human freedom *eliminative* if it says that human beings have no freedom, or no more than other physico-chemical systems; *levelling* if it says that they have the same sort of freedom as other animals; and *distinctive* if it says that they may attain a degree of freedom which other animals either cannot attain at all or can attain only to a much lower degree. Classical empiricism has generally sponsored a levelling or eliminative view. Thus Hobbes allowed liberty equally to men and to beasts (*1655*, p. 409) and, indeed, to inanimate things (*Leviathan*, p. 107). Hume claimed that his idea of necessity, far from lowering human actions to the level of the operations of senseless matter, raised the latter to the former's level (*Treatise*, II, iii, 2); but levelling-up is still levelling. By contrast, classical rationalism (a term which in the present context covers Kant's theory of knowledge as well as Descartes's, Spinoza's, and Leibniz's) has generally been associated with distinctive views.

Call a world-view *naturalistic* if it abides unswervingly by the principle that "Man is a part of nature", where 'Man' denotes the whole person, mind and body. Classical empiricists' levelling or eliminative views of freedom generally stayed within the bounds of naturalism. By contrast, classical rationalists' distinctive views generally strayed beyond those bounds. (We shall find this to be true of Spinoza, although "Man is a part of nature" was a main thesis of his.) So the question arises whether critical rationalism, here seen as the mettlesome successor to those once powerful but now moribund classical theories of knowledge, supports a viable view of human freedom that is at once distinctive and naturalistic. This book will offer a positive answer by unfolding such a view.

The plan of the book is as follows. In Part One a naturalistic world-view will be arrived at in the following way. In Chapter 1 the critical rationalist view of human knowledge will be presented with special reference to a recurrent feature of growth of science, a feature that defeats both classical empiricism and classical

1

rationalism and is of decisive importance in several ways. In Chapter 2 guidelines will be laid down to regulate a critical rationalist's science-oriented world-view. Chapter 3 will take up the question of determinism. The above feature will be used as an argument for a kind of indeterminism quite distinct from chance. The above guidelines will call for the inclusion, give-or-take a few revisions, both of classical Darwinism, whose main metaphysical implications will be drawn out in Chapter 4, and of neo-Darwinism, or Darwinism with its modern genetic underpinning, whose implications for 'Man's Place in Nature' will be examined in Chapter 5.

By the end of Part One we will have taken a down-to-earth look, mainly from a Darwinian or neo-Darwinian viewpoint, at most of the grand metaphysical issues—God, soul, materialism, idealism and, more especially, the mind-body relation. Part Two will turn to the possibility of a distinctive view of human freedom within the naturalistic framework set out in Part One. The investigation will open with an examination of some historically significant views about freedom or autonomy, in the hope of locating mistakes to avoid and leads to follow. The thinkers to be looked into, not in chronological order, are Hobbes and Hume, Descartes, Schopenhauer and Kant, and finally Spinoza who will get a chapter to himself. Although there will be large differences, it will be from two diverging tendencies in Spinoza, to be labelled "Conquer Fortune" and "Transcend Fortune", that our Third View of human freedom will draw most. The philosophical legitimacy of the mind-body relation it presupposes will be considered in the Epilogue.

PART ONE

Naturalism

Chapter 1
Critical Rationalism
and Science

Philosophers who have taken human freedom seriously have typically related it to what they consider the best kind of human knowledge. That is pre-eminently true of Spinoza; and his example shows that a mistaken theory of knowledge can have disastrous consequences for a philosophy of freedom. A good theory of knowledge is a basic prerequisite for a worthwhile view of freedom. And a first requirement of a theory of knowledge is to get its understanding of science right. Science is to our ordinary everyday knowledge like a cathedral to working men's cottages. Scientific theories vary in power and scope; but great science is on a par with great music or poetry as a human accomplishment. In view of our eventual goal in Part Two, it will be instructive to see how critical rationalism radically overhauls and revises the mistaken conceptions of science of its two main precursors, classical empiricism and classical rationalism, got it wrong.

According to classical empiricism, all our concepts derive from sense-experience. They provide the bricks with which our knowledge of the external world is built. It is possible to combine the bricks in new ways and in that sense to manufacture new complex ideas. But new simple ideas enter the mind only when obtruded into it by a novel kind of sensory experience. There is no genuine invention of ideas, no thinking up of a concept or proposition that was not implicit in what was there before. Here is Locke's statement of classical empiricism's *no-invention-of-ideas* thesis:

When the understanding is once stored with these simple ideas, it has the power to repeat, compare, and unite them, even to an almost infinite variety, and so can make at pleasure new complex ideas. But it is not in the power of the most exalted wit . . ., by any quickness or variety of thought, to invent or frame one new simple idea. . . . The dominion of man in this little world of his own understanding, being much-what the same as it is in the great world of visible things, wherein his power . . . reaches no further than to compound and divide the materials that are made to his hand, but can do nothing towards the making the least particle of new matter, or destroying one atom of what is already in being. The same inability will every one find in himself, who shall go about to fashion in his understanding any simple idea. (*Essay*, II, ii, 2)

For classical empiricism there are, of course, no factual propositions whose truth could be known independently of experience, no synthetic apriori truths. And new complex ideas formed by wilful association are unlikely to correspond to anything in nature. It is associations formed naturally, by induction after many repetitions, that are likely to correspond to causal connections in nature. Although Hume famously taught that there can be no proof of this, he accepted it as a matter of fact; there is, he wrote, 'a kind of pre-established harmony between the course of nature and the succession of our ideas' (*Enquiries*, # 44). According to classical empiricism, scientific knowledge should grow in a smooth, cumulative way, as observed regularities get encapsulated in low-level law-statements cautiously induced from repeated observations, and as the inductive ascent gradually proceeds to larger generalizations. Although minor adjustments and refinements may sometimes be called for, the process should be essentially incremental, later additions generally fitting in with what was there before.

Classical rationalism held that the mind can be active in the pursuit and attainment of truth, and that some factual propositions can be known apriori. It complemented the idea of passive sensory intuitions with the idea of active intellectual intuitions. Reason can intuit essences and express these intuitions in axioms whose truth is necessary and self-evident. And from a suitable set of such axioms it can derive an array of proven theorems with a non-trivial, synthetic content. Euclid's geometry was seen as a deductive system consisting of synthetic apriori truths about space. And Spinoza claimed (though he didn't use this Kantian

terminology) that his system consists of synthetic apriori truths about God-or-Nature. However, for classical rationalism this active, apriori cognizing was not strictly inventive. Descartes said that human reason has been pre-attuned to Nature by God, who imprinted ideas of its laws in our minds (*Discourse*, p. 106); they are there, waiting to be recalled. When cognizing in this way the mind proceeds along existing pathways, uncovering something that is already there. The human mind at its active best is neither inventive nor critical, but proceeds unerringly, knowing that it does so.

Kant also held that the human mind is pre-attuned to Nature, though not by a Third Party. Nature, the totality of appearances, is structured by categories imposed by the human mind; experience provides the aposteriori content. According to him, this apriori structuring goes very far; the categories supply 'the complete plan of a whole science' (*CPR*, B 109), and the plan turns out to be surprisingly detailed and exact. It begins with repulsive force as a precondition for the very possibility of matter, since the essence of a material body is to repel penetration by other bodies (*Foundations*, p. 499, prop 2). But repulsive force must be complemented by attractive force, otherwise material bodies would explode and the universe fly apart (p. 512, prop 7). As to the strength of this attractive force:

> we find a physical law of reciprocal attraction extending over the whole material nature, the rule of which is that it decreases inversely with the square of the distances of each attracting point, just as the spherical surfaces in which this force diffuses itself increase, which seems to lie necessarily in the nature of things themselves and hence is usually propounded as capable of being known *a priori*. (*Prol*, § 38)

(One might suppose that Kant would have judged his *Metaphysical Foundations of Natural Science* to have carried the apriorization of Newtonian physics far enough; but in his old age his ambition was to write a work, entitled 'Transition from the Metaphysical Foundations of Natural Science to Physics', which would carry it further.[1])

1. See Kant, *OP*, and Eckart Förster's introduction, pp. xxxivf.

What sort of history might classical rationalists expect science to have? That science has *developed* might seem to pose a problem for them. Descartes declared that all the scientific truths in his *Principles* 'have been known from all time and by all men'.[2] Then what was there for Harvey, Galileo, Kepler, and others to do? Why the long, slow history? Part of the answer is that, in addition to fundamental principles known apriori, science needs auxiliary assumptions which cannot be supplied by reason, for instance about the relative masses and distances of the bodies in the solar system. But the main answer harks back to Plato. Truths can be innate in our minds without our being aware of them. They can be overlain, suppressed, "forgotten", needing to be recollected, one after another, perhaps under the prodding of experimental findings.[3] So science will have a history. But classical rationalism is like classical empiricism in carrying the implication that its growth should be smooth and cumulative. Each new "recollection" of an apriori truth will add to what was there before without cancelling any previous "recollection"; earlier apriori truths can't get elbowed aside by later ones. And if the role of experience is, as Kant put it, to fill in the "complete plan" provided apriori by the mind's categories, the growth of science on its empirical side should also be essentially incremental.

Critical rationalism is at one with classical empiricism in denying the possibility of synthetic apriori truths, or non-analytic truths knowable independently of experience. A consistent proposition either holds in all possible worlds, in which case it is knowable apriori but analytic, or it holds in some possible worlds but not in others, in which case it is non-analytic and not knowable apriori. But what about pure mathematics? Was Kant wrong to hold that it consists of synthetic apriori propositions? In his 1978 Imre Lakatos distinguished those extra-scientific systems that are deductively organized into "Euclidean" ones where all the axioms are known to be true, and "quasi-empirical" ones where the axioms are not all known to be true and the axiom-set has to be judged by its consequences, as with scientific theories. His thesis was that all serious mathematics is quasi-empirical. In support of

2. *Works*, i, p. 209; and see *Principles*, IV, 200.
3. Galileo seems to have held such a view; for references see Watkins *1973*, pp. 38–40.

this he pointed out that, despite the endeavours of Frege, Russell, Hilbert, and others to "Euclideanize" mathematics, virtually everyone who had worked in this area—pre-eminently Russell himself, but also Bernays, Church, Curry, Gödel, Kalmar, Mostowski, Quine, Rosser, von Neumann, and Weyl—had come to recognize, with great reluctance in some cases, the quasi-empirical nature of mathematics. That Euclidean geometry itself, with its problematic Parallel Postulate, is not "Euclidean" was shown by the invention of non-Euclidean geometries in the nineteenth century.

What sort of history does critical rationalism expect science to have? The short answer is: a turbulent one. That a theory has been riding high, achieving a wide range of predictive successes, does not mean that it is verified; it is open to daring spirits to construct rivals to it. A rival theory should match or, better, exceed the present theory in explanatory and predictive power; it may proceed from radically different assumptions; if it does, these may lead to predictive implications that diverge, if only slightly, from those of the present theory; these will point the way to crucial experiments from which both old and new theory will be at risk. Karl Popper was famously impressed by the risk of refutation which Einstein ran when he put forward his General Theory of Relativity (henceforth GTR) in competition with Newtonian Mechanics (henceforth NM). The latter had been superbly corroborated by a great variety of experimental observations, and had seemed to Kant, and continued to seem to many others, a grand system of verified truth. But GTR had predictive implications that diverged from those of NM. There were not many such divergences, and they were all small; but in some cases, for instance with regard to the bending of light rays passing close to the sun, they were large enough to be exposed to experimental test.

There had been a rather similar relationship between NM and its predecessors. NM led to small but systematic revisions of the predictive content of Galileo's and Kepler's laws. Galileo's law had freely falling bodies near the earth's surface falling with constant acceleration. NM said that they will fall with a slightly increasing acceleration; for their acceleration varies with the gravitational force, which varies inversely with the square of the distance between the centres of gravity of the earth and the falling body, and hence increases as this distance decreases. Kepler's laws had

the planets orbiting the sun in perfect ellipses, the sun being stationary at one focus. NM said that the planets are pulling the sun and each other about because of the mutual gravitational attractions between them, though the resulting perturbations are mostly very slight. The logical incompatibilities between Newton's and Kepler's theories, which provide a decisive argument against the inductivist view of science, had been stressed by Pierre Duhem in his *1906*, as Popper acknowledged (*1972*, p. 358n).

As well as revising the predictive content of its predecessors NM went beyond them, making predictions in areas where they were silent. Galileo's laws applied to terrestrial bodies and Kepler's to the planets, but NM applied to all bodies whatsoever, bringing tides, comets, double stars, galaxies, . . . as well as cannon-balls and planets, within its scope. When a major new theory T_2 supersedes an earlier theory (or conjunction thereof) T_1 which had in its time been highly successful, what typically happens at the empirical level may be represented, a shade simplistically, as follows:

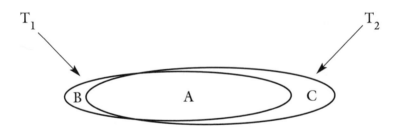

FIGURE 1.1

The predictive content of T_1 consists of area B + A and that of T_2 of area A + C. Area B is the predictive content of T_1 that is revised by T_2, and area C is the predictive content of T_2 that either revises or goes beyond that of T_1.[4] The diagram may give a

4. 'Predictive content' as in the definition for 'CT' in Watkins *1984*, § 5.15. My fuller treatment there, which employs the notion of incongruent counterparts, handles the technical difficulty that if T2 revises T1, then T1 will, as a matter of logic, have some content that goes beyond that of T2 as well as vice versa.

somewhat exaggerated impression of the difference in the theories' predictive contents. Einstein said that despite the profound difference in the fundamental assumptions of the two theories, only three places had been identified where GTR diverged to a testable degree in its predictive implications from NM.[5] It is from tests in area C that the new theory T_2, if successful, will gain the most striking corroborations. Thus the behaviour of Halley's comet tested NM in an area where its predecessors had not ventured, and its return, 72 years later, just as Halley had predicted, provided a 'stunning corroboration'.[6] Also of great interest are propositions in area C that diverge sufficiently from their counterparts in area B for crucial experiments between them to be possible. For instance, when the planets Saturn and Jupiter are in conjunction, the perturbations newly predicted by NM, though small, were large enough for Newton to call on Flamsteed, the Astronomer Royal, to check on them carefully, which he did with results that strikingly vindicated NM.[7]

What typically induces such a revision-cum-expansion of the superseded theory's predictive content? When I tackled this large question on previous occasions I brought in considerable technicality.[8] This time I will keep the answer short and non-technical. This question can be approached in two ways. One can consider the matter historically, holding up for examination a number of paradigm examples of theoretical progress of this kind. Or one can consider the matter apriori and ask what sort of factor *could* bring about that sort of revision-cum-expansion. As to the first way: of course, historians tend to miss factors they are not looking out for. But idea-dominated historiography of science of the kind so admirably exemplified by Meyerson's *1908*, Einstein and Infeld's *1938*, Koyré's *1957*, Cohen's *1960*, Holton's *1973*, and Zahar's *1989*, offers an answer which might be summarized as follows: we should not be deceived by the near-continuity at the observational level into supposing that this results from small changes higher up; there is typically a *radical discontinuity* at the

5. Einstein *1918/54*, p. 124. The three famous differences concerned the motion of the perihelion of Mercury, curvature of light rays passing close to the sun, and displacement of spectral lines towards the red end of the spectrum.
6. Lakatos *1978*, i, pp. 5, 184.
7. The story is told in Watkins *1984*, pp. 331–33.
8. In Watkins 1974, 1975a, and *1984*, especially pp. 182f.

theoretical level; the superseding theory typically comprehends the phenomena from a quite different angle, replacing the ontology of the old theory by one whose theoretical assumptions involve conceptual as well as propositional novelty.

The apriori answer ties in with that. How this revision-cum-expansion at the empirical level comes about is easy to explain when it is seen as theory-induced; and what other explanations for it are there? Empiricist-minded philosophers of science would presumably say that it is brought about at the behest of empirical and/or methodological considerations. Well, the revision typically extends far beyond areas where the previous theory had been found to be in empirical trouble (if indeed it was in any empirical trouble). Astronomers may have become a shade uneasy about the behaviour of Saturn and Jupiter before Newton,[9] but Mercury and Mars seemed to be impeccably Keplerian planets. But NM implied that *all* planetary orbits are subject to perturbations. Again, a slight movement of Mercury's perihelion had been detected before Einstein, but GTR predicts that the elliptical (or almost elliptical) orbits of *all* the planets are gradually rotating round the sun, even if this is detectable only in the case of the planet nearest the sun. A methodological rule might call for corrections in pursuit of simplicity and elegance. But to an a-theoretical onlooker, the Newtonian revisions of Galileo's and Kepler's laws would appear to be going in the opposite direction. Where Kepler had planets orbiting in perfect ellipses and Galileo had bodies falling with a constant acceleration, Newton has planets orbiting in distorted ellipses and bodies falling with an inconstant acceleration. It might seem like wanton disfigurement. But, of course, these revisions are non-wanton in the light of the fundamental assumption in the theoretical ontology of Newtonian Mechanics.

The following diagram depicts the relation between superseded and superseding theory as critical rationalism sees it. The A, B, C areas are as before. Each apex represents the theory's premises, consisting of both theoretical and auxiliary assumptions. Thus if T_1 and T_2 were respectively NM and GTR, the former's ontology, with its hard massy corpuscles, action-at-a-distance, and

9. The story is complicated; see Watkins *1984*, pp. 332–33.

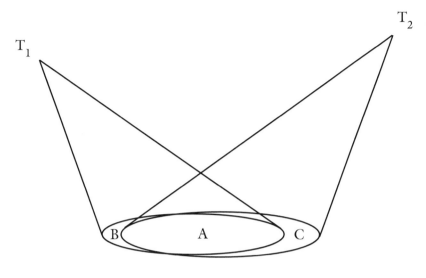

FIGURE 1.2

absolute space and time, is right outside the latter's ontology, as the diagram suggests.

Let us now consider the no-invention-of-ideas thesis in relation to major theoretical advances in science. Hume declared that the 'creative power of the mind amounts to no more than the faculty of compounding, transposing, augmenting, or diminishing the materials afforded us by the senses and experience' (*Enquiries*, # 13); in other words, creativity consists in manipulating existing materials. But before taking that up, let us first consider Kant. Unlike Hume, Kant was not an out-and-out defender of the no-invention-of-ideas thesis; he allowed that there are novel ideas for the creation of which there can be no recipe: 'where an author owes a product to his genius, he does not himself know how the *ideas* for it have entered into his head, nor does he have it in his power to invent the like at pleasure, or methodically, and communicate the same to others in such precepts as would put them in a position to produce similar products' (*CJ*, § 46). It is a production 'for which no definite rule can be given' (ibid). However, he accepted the no-invention thesis with respect to science. Not even the best scientific minds are truly creative; when a great scientist 'weaves his own thoughts' and brings fresh gains to science,

what is accomplished in this way is something that *could* have been learned. Hence it all lies in the natural path of investigation and reflection according to rules, and so is not specifically distinguishable from what may be acquired as the result of industry backed up by imitation. So all that *Newton* has set forth in his immortal work on the Principles of Natural Philosophy may well be learned, however great a mind it took to find it all out, but we cannot learn to write in a true poetic vein. (*CJ*, § 47)

It will be claimed against Kant that there is true inventiveness in science as there is in poetry and music, and that it is easier to show this with regard to science.

Kant's no-invention thesis is reminiscent of Bacon's idea of a "compass-and-ruler" method for advancing science, as Joseph Agassi calls it, a method which 'renders talent superfluous' (*1981*, p. 194). Before going further into Kant's views it may be mentioned that Herbert Simon and his co-workers have attempted to vindicate Bacon's idea by developing a computer program (called BACON) to make scientific discoveries.[10] Actually, the aim they gave it was not yet to make fresh discoveries, but to remake past discoveries using only data available to the original discoverers. And it seemed to succeed. Some of Simon's students were able to come up with Kepler's Third Law within an hour or two[11] (it took poor, unprogrammed Kepler many years). But when one looks into it one finds that hindsight was providing significant help.[12] Where Kepler had been like an examination candidate who first thinks up a good question and then thinks up a good answer to it, BACON was like a candidate thinking up a good answer to a question set by an examiner. If the question is: "Find integer values of m and n that will satisfy the formula $T^m = kR^n$, where T is the time it takes a planet to complete one orbit of the sun, R is the mean radius of its orbit, and k is a constant", the answer, given adequate data, may not be too difficult to compute. The difficult part is discovering the right question, which in Kepler's case included the daring assumption that k is the same for all planets. Moreover, BACON was supplemented by some 'domain-specific heuristics' in the computing of answers to preset questions. Kepler had to do it all for himself.

10. Langley *et al. 1987.*
11. Simon 1992.
12. See Gillies 1992; Watkins 1992.

Reverting to Kant, we may say that it is as if, while praising Newton for his amazing ability to draw circles freehand, he had pointed out that they could have been drawn by compass. We have already encountered the view of Kant's that dictated this line: the main work had already been done by innate categories of the human mind. So Newton needed only to fill in the aposteriori content. But in "explaining" how Newton could make his discovery, Kant's pre-attunement theory explains too much; for it creates the problem of 'how everybody else could have failed to make it' (Popper *1963*, p. 95). It also predicts too much; for it implies that Newton's achievement is unassailable. It may conceivably come to be subsumed under a wider theory with a richer theoretical ontology, but it will never be displaced by a theory with a conflicting theoretical ontology. But just that is what happened to NM with the advent of GTR.

Back now to Hume; is Newton's fundamental idea amenable to the classical empiricist view of the formation of complex ideas? What operations did Hume and other empiricists consider admissible in the forming of complex ideas from materials provided by the senses? Locke had allowed four. The first three were copying, dividing, and compounding; these carry the mind from specific primary images to secondary images which are again specific, though typically paler and vaguer. The fourth operation allowed by Locke was that of abstracting. Locke supposed that this carries the mind from specific primary images to something non-specific and general which can be imagined only with some difficulty; thus from singular images of an oblique triangle and a tight-angled triangle and an equilateral triangle and an isosceles triangle and a scalenon triangle we can abstract a general image of a triangle, one that is 'neither oblique nor rectangle, neither equilateral, equicrural, nor scalenon; but all and none of these at once' (*Essay*, IV, vii, 9). Berkeley's scornful dismissal of such "abstraction" (*Principles*, pp. 32f) was endorsed by Hume (*Treatise*, I, 1, vii).

No classical empiricist countenanced *negation* as an admissible operation here, and it is easy to see why. A young lady informs David Hume that she has a clear and distinct idea of a perfect, immaterial being. He begs her to point out the impressions (sensory experiences) from which she derived it, adding: 'if you cannot point out *any such impression*, you may be certain you are mistaken, when you imagine you have *any such idea*' (*Treatise*, I,

ii, 5). She says that from an impression of a cracked teacup she derived the idea of a thing that is imperfect and the idea of a thing that is material; by negating the first she proceeded to the idea of a thing that is perfect, and by negating the second to the idea of a thing that is immaterial; she then conjoined these into the idea of a thing that is perfect and immaterial. Hume would have said that negation is not an admissible operation here; you do not arrive at a new colour-idea by proceeding from blue to not-blue; told that something is not-blue, you can form an idea of what its colour is not, but not of what its colour is. A consequence of the foregoing is that for classical empiricism, purged of Lockean abstraction, a term denotes an idea only if it denotes something *imaginable*; otherwise it is vacuous and without meaning.

A recipe for *x* tells you what materials to use and what operations to perform on them in order to produce *x*. Classical empiricism clearly implies that for any "novel" idea that Newton or anyone else may seem to have invented de novo, there was a recipe for producing it (though the recipe need not have been thought up beforehand); a "novel" idea *x* will be a new combination of pre-existing ideas, say *a*, *b*, and *c*. Thus the recipe would be of the form, 'Take *a*, *b*, and *c* and perform on them the following operations: . . .', the operations being restricted to copying, dividing, and compounding. Before turning to the question of the creativity exhibited by NM, let us look briefly into a question of artistic creativity . Does Coleridge's *The Ancient Mariner* exhibit creativity? This question has been discussed by Margaret Boden (*1990*, pp. 112f) who was relying on what she calls 'a masterly literary detective story', namely an investigation by John Livingston Lowes (*1927*). Coleridge wrote of water-snakes which 'moved in tracks of shining white'; which had a rich attire: 'glossy green, and velvet black'; and whose 'every track was a flash of golden fire'. Where did he get these images from? It seems that he had ransacked a wide variety of sources, including Captain Cook's diaries and other seafaring memoirs, treatises on optics, and various volumes of the *Philosophical Transactions of the Royal Society*. Thus Priestley's *Opticks* records fishes which left a luminous track, Cook mentioned sea-snakes and sea animals with a white, shining appearance who, in candlelight, looked green tinged with 'a burnished gloss' and in the dark were like 'glowing

fire.' The mean-minded claim that Coleridge's poem was just a concoction of plagiarized images is surely wrong, but how would one set out to refute it?

In connection with the identification of novelty, science has the important advantage that there are logical relations between the new material and what was there before. (This difference also makes it possible for there to be criteria of progress in science.) That the NM idea of gravitational attraction-at-a-distance had propositional novelty relative to the state of scientific knowledge as it was in Kepler and Galileo's day is attested by its greater generality and by its systematically disturbing effect on what was there before. That also seems to exclude the possibility of any sort of inductive progression to this new idea from what was there before. However, possessing propositional novelty is no guarantee that the idea was not formed in a Humean way. The proposition that in the mountains of Thessaly there dwells a race of creatures, part horse and part man, must once have possessed propositional novelty, but it would be trivially easy to give a Humean analysis of its key idea. Could an analogous analysis be performed on Newton's key idea? As we saw, a complex idea formed in a Humean way must be imaginable, as the idea of a centaur is; a term was said to be vacuous if it fails to stand for an imaginable idea. Is this idea of Newton's imaginable?

Well, Newton himself was very aware that talk of an attractive force between two bodies, separated by a vacuum, would be regarded by contemporaries as unintelligible. As a good Cartesian he had for a long time found it unintelligible himself; he had pictured gravity, or heaviness, as produced by a kind of cosmic dust swirling in all directions, with large bodies having a shadowing effect and creating round themselves areas of lesser density into which bodies in their vicinity would tend to move (see *Opticks*, Qu. 20, 21). And unimaginable this new concept surely is. Suppose that God first created body A in what had been empty space, and afterwards body B at a distance from A. According to Newton's idea of gravitational attraction, at the moment when B popped into existence body A became subject to a gravitational pull. Now if A and B had been in some sort of physical medium, an ether say, one could imagine waves of disturbance spreading outwards very rapidly from B to A. But can one imagine something *immaterial* spreading with *infinite* velocity from B and

instantaneously exerting a *pull* on A? I can't. But being unimaginable does not entail being unintelligible. Consider the equation $y = \frac{1}{x}$; it is perfectly intelligible. Now let x go from -1 to 1; it is easy to *say* that as x passes through 0 the value of y flips from minus infinity to plus infinity, but can anyone *imagine* this? I can't. Anyway Newton, his disclaimers notwithstanding, seems to have come to regard the intelligible but unimaginable idea behind his inverse square law as corresponding to something "out there", real and irreducible (see Westfall *1980*, pp. 462–65). So at least some major theoretical advances in science refute the no-invention-of-ideas thesis common to classical empiricism and classical rationalism. For critical rationalism, such advances involve big swings in a theoretical superstructure that transcends and yet conforms (or almost conforms) itself to its empirical basis.

Popper declared that the question how new ideas occur 'may be of great interest to empirical psychology; but it is irrelevant to the logical analysis of scientific knowledge' (Popper *1959*, p. 31). But it is relevant to a philosophy concerned with the human mind at its active best. So let us look briefly and a little diffidently into intellectual creativity. The phenomenon of a seemingly novel idea obtruding itself, unbidden and virtually complete, into a human mind has often been seen as calling for a divine-inspiration hypothesis, as in Plato's *Ion*. The reason is clear. Human manufacturing processes take time; creating things at a stroke is a divine prerogative. And it has been widely supposed that a novel idea typically pops into existence all at once: at one moment it wasn't there at all, and then, before you can say *Eureka*, it's there, virtually complete though perhaps needing a little polishing. Thomas Kuhn came close to championing what we may call the *all-at-once* hypothesis when he wrote: 'the new paradigm, or a sufficient hint to permit later articulation, emerges all at once, sometimes in the middle of the night, in the mind of a man deeply immersed in crisis' (*1962*, p. 89). Elsewhere Kuhn said that scientific theories are 'invented in one piece' (1970, p. 12). Many mathematicians, poets, musicians, and scientists have endorsed the all-at-once hypothesis, testifying that in their case the new idea (tune, equation, or whatever) arrived fully formed. Many have also testified to a feeling of being under outside guidance when this happened. After quoting Housman saying that sometimes, when inspiration dried up in the middle of a poem, he would have to start *writing*

it himself, Friedrich Waismann reported other poets expressing the feeling that they are 'not so much the originator of the poem as its receiver'; for instance, Thackeray said that it seemed as if an occult Power were moving the pen (*1968*, p. 204). And Jacques Hadamard in his *1945* cited many affirmations, from Gauss, Helmholtz, and others, of the all-at-once and outside-guidance hypotheses in combination.

It is widely accepted among those who have studied inventive processes that such experiences of suddenness and otherness are deceptive, the product of processes that are internal but largely subconscious. Thus after saying that these 'sudden enlightenments' cannot be produced by sheer chance, Hadamard went on: 'there can be no doubt of the necessary intervention of some previous mental process unknown to the inventor, . . . an unconscious one' (*1945*, p. 21). He relied very much on evidence provided by Poincaré's famous account of mathematical discovery. With one notable exception, Poincaré's first-hand experiences of mathematical discovery seemed to fit the all-at-once hypothesis. The typical pattern was as follows. After wrestling unavailingly with a problem, he would put it aside with no glimmer of a solution in sight, and turn to other matters; and then, after a lapse of time and apparently without further effort on his part, the solution would come to him, as he stepped into a carriage or was walking on a cliff, with the 'characteristics of conciseness, suddenness, and immediate certainty' (*1908*, p. 54). (However on one famous occasion his experience was different: he became to some degree privy to mental processes of a kind of which he was normally unaware. One night, when he was fatigued but unable to sleep, a 'host of ideas kept surging in my head; I could almost feel them jostling one another, until two of them coalesced, so to speak, to form a stable combination' (pp. 52–53). He likened the process to a number of Epicurean atoms colliding and rebounding until two got hooked together (p. 61). On this occasion, he remarked, he was assisting at intellectual work which is normally unconscious but which became partly perceptible to his overexcited consciousness without thereby changing its nature (p. 63). It is plausible to suppose that his other, seemingly all-at-once discoveries were likewise the fruit of furious mental activity that went on in a compartment of his mind to which his waking self was not normally privy. Roger Penrose reported once 'having an

odd feeling of elation that I could not account for' (*1989*, p. 544); he had to do some detective work to retrieve a new thought (relating to black holes) which was already lurking somewhere in his mind.

The demise of the all-at-once hypothesis deprives the divine-inspiration hypothesis of its main prop. Discovery and invention no longer carry a mark of divinity if they are really, contrary to introspective experience, the outcome of a drawn-out process, involving much trial-and-error, at an unconscious level. The short answer to a poet, musician, or mathematician who disowns the credit for an invention is: 'Well, no one else did it'. But the thesis that creativity is largely an unconscious process only pushes the problem back. If Poincaré was unable to solve a deep mathematical problem when consciously wrestling with it, why should he have done any better when wrestling with it unconsciously? If an attack made in broad daylight is going to fail, why should one made in the dark succeed? Poincaré called that part of the mind that engages in the processes of discovery, and to which the conscious ego is not normally privy, the *subliminal ego*. Concerning it he gave, as a 'first hypothesis', the following account: 'The subliminal ego is in no way inferior to the conscious ego; it is not purely automatic; it is capable of discernment; it has tact and lightness of touch; it can select, and it can divine. More than that, it can divine better than the conscious ego, since it succeeds where the latter fails' (*1908*, p. 57). Paul Valéry split this "subliminal ego" into two parts, one of which he considered much superior to the other: 'It takes two to invent anything. The one makes up combinations; the other one chooses. . . . What we call genius is much less the work of the first one than the readiness of the second one to grasp the value of what has been laid before him and to choose it'.[13]

Valéry was no doubt right to highlight "the second one" with its uncanny capacity for evaluation and selection and its ability to turn the spotlight of consciousness on the chosen item, leaving the rest in darkness. But perhaps Valéry underestimated "the first one". His remark suggests that it merely throws existing elements into new combinations. Poincaré seems also to have held this

13. Quoted in Hadamard, p. 30.

view. A passage of his opens with the remark that mathematical discovery 'does not consist in making new combinations with mathematical entities that are already known' (*1908*, p. 50); one might have expected the passage to go on to say that it involves the introduction of hitherto unknown mathematical entities. But no, it goes on to say that making new combinations

> can be done by anyone, and the combinations that could be so formed would be infinite in number, and the greater part of them would be absolutely devoid of interest. Discovery consists precisely in not constructing useless combinations, but in constructing those that are useful, which are an infinitely small minority. Discovery is discernment, selection.

This seems to suggest that the subliminal ego is supplied with a fixed stock of mathematical "atoms" to which it does not add, being content to cast them into interesting new combinations. But to sustain that would require a version of Descartes's innate-ideas hypothesis. Without that we can only assume that if intellectual developments in the evolutionary prehistory of our species had been watched over by a Recording Angel, there would have been early stages when the stock of mathematical "atoms" was far smaller than the mature Poincaré's stock, perhaps consisting of *one*, *two*, and *many*. In mathematics, as in science, there has to have been invention of new units as well as of new combinations of existing units.

So there is a large difference between critical rationalism and both its classical predecessors. Classical empiricism saw the growth of scientific knowledge as a plodding process, ideational novelty being injected into it only by novel sensory impressions. Classical rationalism saw it as the filling out by experience of a comprehensive and fixed innate ideational structure. Critical rationalism sees it as adventuring with ideas, often freshly minted ones (in Chapter 3 it will be argued that novel ideas inject the most disturbing kind of indeterminacy into our human world), with rigorous testing preventing the process getting out of hand. This latter point marks another big difference between critical rationalism and its predecessors, this time over the role of criticism. Classical rationalism supposed that human reason can attain infallible, apriori knowledge of fundamental scientific principles and *know* that it has done so. If the epistemic appraisals made by Kant

of Newton's inverse square law or by Descartes of his laws of iner-
tia and the conservation of motion (*Principles*, III, 36, 37) had
been right, trying to bring criticism to bear on them would be
like trying to fault 2 + 2 = 4. With classical empiricism the matter
stands a little differently. It allowed that error can get in, for
instance by making inductions from biased samples, and this
opens up a modest corrective role for experience. Sometimes trav-
ellers' tales could provide the correction: swans in Australia are
not white and there are latitudes where the sun does not rise and
set every twenty four hours. And where classical rationalism oper-
ated with the Euclidean ideal of deductions from infallible
premises, classical empiricism operated with non-deductive infer-
ences in the opposite direction. This of course exposed it to the
Pyrrhonian sceptic's criticism that the whole structure is logically
invalid. But as inductivism sees it, to uphold this line of criticism
would bring epistemic endeavours to a halt and lead to intellec-
tual nihilism. As Hume put it, when a Pyrrhonian 'awakes from
his dream, he will be the first to join in the laugh against himself,
and to confess, that all his objections are mere amusement'
(*Enquiries*, # 128); there is no answer to them, but they have to
be ignored; carelessness and inattention are the only remedy. As
Ayer put it, there is a kind of logical gap that we do not attempt
to close or bridge; 'we are simply to take it in our stride' (*1956*, p.
80; Ayer did not say when a logical gap is *too* wide for us to take it
in our stride).[14]

One thing that critical rationalism shares with classical ratio-
nalism is the principle that only deductive inferences are valid; it
has no use for non-deductive inferences. But where classical ratio-
nalism saw deduction being used to proceed à la Euclid from
axioms to proven theorems, critical rationalism sees it being used
critically, in a testing process. Its critical prong is the essential
complement of its inventive prong. In § 5.6 below a solution will
be offered for a seeming paradox for the theory of evolution,
namely that human beings are endowed with a very non-uniform
capacity for invention. Here, the relevant point about it is that
the products of a strong inventiveness need to be disciplined by

14. The anti-sceptical strategies of Ayer, Strawson, and other non-deductivists are
examined in Watkins *1984*, pp. 32f.

criticism. A basic tenet of Popper's was always that the role of experiment in science is to provide not verification but searching criticism. Of course, devising a new and probing experimental test may itself involve inventiveness.[15]

Among philosophers other than critical rationalists the word "knowledge" is usually used as a success-word: where there is knowledge there is *truth*, and truth that is *certified* in some way. But both the O.E.D. and Webster's Dictionary allow it to mean a branch of learning, which is how critical rationalism uses it: there is no inconsistency in saying that medical knowledge in the eighteenth century contained much that was erroneous. As we saw, even the best corroborated scientific theories, such as Newton's, remain conjectures which may one day be superseded by a theory with essentially different premises. This gives critical rationalism the following important advantage over philosophies of science that prefer to see scientific theories approximating to a verified status. Scientific theories were spoken of above as having a rich theoretical ontology; and so they usually do when interpreted realistically, as meaning what they say about the structure and content of reality. But for would-be verificationists this rich theoretical content is an embarrassment; it makes them terribly top-heavy. So there has been a strong desire to cut them down to a confirmable size. From Ernst Mach to the Vienna Circle, empiricists have insisted that science must remain at the empirical surface.[16] Critical rationalism, by contrast, has no fear of depths; it combines its conjecturalism with a cheerfully realist view of science. (It also favours realism in the popular sense of intellectual honesty in the face of a harsh reality.)

Let us now consider what principles should guide a critical rationalist in the formation of a world-view.

15. See for example Hacking *1983*, pp. 149f.
16. For references see Watkins *1984*, § 4.3 ('The Revulsion against Depth').

Chapter 2
How to Build a
World-View

A world-view is seen here as an attempt to answer questions that bear on what Huxley and others called "Man's Place in Nature". A proposition that offers a possible answer to such a question may be considered a candidate for inclusion in a world-view. However, there is no fixed agenda or pre-set list of questions with which a world-view is required to deal. Different people have different concerns in this area. An issue which exercises you may be one on which I 'wish to keep an empty mind', to borrow David Miller's phrase (*1994*, p. 145). Thus questions of cosmogony, or how it all began, have greatly exercised some people and inspired much ancient myth, while other people are more concerned with the world in which we now are. My hope is that we will be dealing with issues of concern to most reflective people by concentrating on ones relevant to the question of human freedom.

Just because a world-view touches on human wants and fears and anxieties there is the danger that it is driven by wish-fulfilment. This danger is aggravated by the fact that a world-view typically consists of metaphysical propositions. How can there be non-arbitrary acceptance and rejection in this area? Before Kant, classical rationalists had handled metaphysical propositions with assurance, confident that pure reason can construct an experience-transcending, necessarily true, substantive theory of the world. Kant killed that idea; but as we saw, he still supposed that it is possible to delineate certain structural features within experience that have a synthetic apriori character. This belief rested ultimately on the assumption that Euclidean geometry is apriori and consists

of synthetic truths about space, and on Kant's apriorization of the foundations of the natural science of his day. The former idea was killed by the invention of non-Euclidean geometries, and the latter by the overthrow of classical physics. With the demise of classical rationalism and of the Kantian synthetic apriori, all hope has gone that pure reason could construct a metaphysical world-view; and metaphysics eludes empirical control almost by definition.

So it looks as though Kant was right when he said, 'It is possible to blunder around in metaphysics in many ways, without fear of being detected in falsehood' (*Prol*, § 52b). At this stage one may have a sneaking sympathy with logical positivism's attempt to commit metaphysical propositions, and world-views constituted by them, to the flames by declaring them pseudo-propositions without truth-values. But it is not difficult to show that logical positivism infringed the principle that if p is a proposition with a decidable truth-value, for instance a refutable scientific hypothesis, and q stands in a definite logical relation to p, then q is also a proposition with a truth-value even if this is undecidable.[1]

If metaphysical propositions are not open to direct control, perhaps they can be brought under some kind of indirect control by relating them to propositions that are under good control? For critical rationalists, this would mean, first and foremost, propositions of science. But what should the relation be? In the past some of us have suggested that metaphysical ideas may be appraised in terms of their fruitfulness for science.[2] William Whewell wrote:

> Physical discoverers have differed from barren speculators, not by having *no* metaphysics in their heads, but by having *good* metaphysics while their adversaries had bad: and by binding their metaphysics to their physics, instead of keeping the two asunder. (*1847*, i, p. x)

I once proposed modifying that to:

> Physical discoverers have differed from normal scientists [in Kuhn's sense], not by having *no* metaphysics in their heads, but by having *new* metaphysical ideas while their adversaries clung to old ones endorsed by existing science;

1. Watkins 1958.
2. See e.g. Agassi *1975*, chap. 9, and Albert 1985, pp. 61f.

and by binding their metaphysics to revolutionary physical theories, instead of keeping the two asunder. (Watkins, 1975, p. 119)

That approach may be in order when the hope is that a daring metaphysical speculation will seed a theoretical advance in science, in the manner touched on in Chapter 1. In such cases there will be no requirement on the metaphysical idea to conform with current science; for the audacious and perhaps foolhardy intention is to supersede some currently prevailing scientific theory by developing a revolutionary new one that approaches the phenomena from a new angle.

But when the intention is to build a world-view as soberly and realistically as possible, innovative metaphysical speculations which might seed new scientific developments are not at all what is wanted. Whatever surprises the future may have in store, current science is the best factual knowledge we currently have. Our problem would be solved if, presented with rival candidates for inclusion in a world-view, current science always tells in favour of one and against the rest. To what extent is that possible? Well, it would be impossible if science had to be understood instrumentally or in some other de-ontologizing way. As was said at the end of Chapter 1, the motive for such impoverishing interpretations has usually been the hope of cutting back scientific theories to a confirmable size. Critical rationalism relinquishes that as a vain hope. Having no epistemological motive to cut back scientific theories, critical rationalism has no reason to understand science in a minimalist way that would deprive us of our best guide in matters metaphysical. It values science so highly largely because it sees science as cosmology, as seeking to discover the underlying substance and structure of the world. It interprets scientific theories realistically, taking their theoretical ontology, or what they say about the invisible infrastructure of the world, at face value. Some philosophers of science, most notably Duhem, have interpreted science instrumentally in order to hush up potential conflicts between science and religion. In § 6.3 below we will find Kant seeking a protected status for what he supposed to be factual presuppositions of morality. But critical rationalism is against giving a protected status to factual propositions in any area. If unfettered critical examination is the rule within science, why should factual propositions outside science be treated more leniently?

Should we also allow common sense a role in the building of a world-view? Suppose that there are areas where current science can proffer no guidance; may we there fall back on common sense? Well, some philosophers have famously made common sense the supreme arbiter. In his 'A Defence of Common Sense' (1925) G. E. Moore presented certain propositions of common sense as propositions which he knew, with certainty, to be true. They were therefore suited to serve as touchstones for speculative metaphysics; any philosophical propositions in conflict with them could be dismissed. He had in mind two kinds of proposition: (1) autobiographical propositions about himself, and (2) generalizations of the propositions under (1) to other people. The propositions under (1) were of two main kinds, (a) bodily and (b) mental. Under (a) he included the proposition that there is a body, namely Moore's, which has had a continuous existence since it was born, and has been in various spatial relations with other material objects including other human bodies; this body has always been on, or not far from, the surface of the earth, which already existed before this body was born. Under (b) he included the proposition that he, Moore, has had many experiences of various kinds, such as perceptions, memories, expectations, dreams, and feelings. Under (2) he put the 'truism' that propositions similar to those in (1) hold for very many (he would not say all) other human beings.

How might a critical rationalist respond to that? Concerning their certainty his actual words were: 'propositions, every one of which (in my own opinion) I *know*, with certainty, to be true' (p. 32). This is an uneasy compromise between 'propositions which I believe, with a feeling of certainty, to be true', and 'propositions which I know, infallibly, to be true'. Let us try to keep psychological and epistemological factors separate here. What we have, psychologically speaking, are deep-seated convictions of common sense. Peter Strawson has spoken rather similarly of certain beliefs to which our commitment is 'pre-rational, natural, and quite inescapable' (*1985*, p. 51; 1958). As to their epistemological status: while some of Moore's autopsychological examples under (1b) may have had a *cogito*-like character and have been known, infallibly, by him to be true, those under (1a), far from rightfully silencing idealists, solipsists, and defenders of other outlandish philosophical positions, are more likely to provoke counter-

argumentation to the effect, say, that the world may have been created five minutes ago full of "memories" and "records" of its "past", or whatever.

But the main threat to common-sense convictions has come, not from philosophy, but from science. If Moore had been writing in the sixteenth century, he might well have extended the bit about his body having a continuous existence on or close to the surface of the earth, by adding that the earth provided him (at least when he was on dry land and there were no seismic tremors) with a *stationary platform* from which, on a clear morning, he could watch the sun appear above the horizon and begin its diurnal ascent; he would surely have dismissed as absurd the suggestion that this platform is whizzing round in space. Or consider the proposition that for any two events *a* and *b*, either *a* and *b* begin simultaneously, or *a* begins before *b*, or *b* begins before *a*. Common sense takes this absolutist view of time, and it was endorsed by Kant (*CPR*, B 46f). But it was undermined by Relativity theory. Instead of imputing infallibility to common sense, let us rather agree with Popper that common sense is not always right and that 'things get really interesting just when it is wrong' (*1976*, p. 125).

Freed from a restriction to ones that are infallibly true, we can expand Moore's stock of common-sense propositions. He included propositions about his body and propositions about his experiences, but none about the relationship between these two sides of himself. Yet untutored common sense undoubtedly makes assumptions about this relationship. When one is engaged in some activity one's attention is usually too preoccupied to be watching oneself at the same time. However, this is sometimes possible. I am doing so now, as I type these words; and I find myself automatically assuming that the movements of my fingers are under my mental control. The control is imperfect of course; I make typos. But my fingers are surely not pressing the keys of their own accord. I make this agency-assumption, as we may call it, about myself quite involuntarily. Like Moore, I would generalize it to other people. I assume that for all of us it is integral to our internal view of ourselves. Jaegwon Kim called it a central principle of common-sense psychology (*1998*, p. 110). It is not like the common-sense conviction that fear makes the heart beat faster; we could absorb the shock of learning that it is really the

other way round, with fear having a chilling effect that slows the pulse-rate. But the shock of learning that our agency-assumption is wrong would precipitate an identity-crisis.

Then what role, if any, should common-sense convictions play in the formation of our world-view? Let *p* be a proposition endorsed by common-sense convictions; its being fallible means that *p* does not have the automatic right to inclusion it would have had if it could be known infallibly to be true. Does it have a presumptive right? Should *p* be included unless there are positive reasons for excluding it? Critical rationalists will of course agree that any such presumptive right is quashed when scientific considerations tell against *p*, as they did against geocentricism. But suppose that *p* is a component of common sense and is not under any such direct challenge from science; may it then contribute to our world-view?

Well, there are two doctrines, both of which have had distinguished adherents, which deny common sense an independent role in the formation of a world-view. We may call them respectively the doctrine of the Omnicompetence of Physics and the doctrine of the Radical Overthrow of Common Sense by Science; or for short the Omnicompetence doctrine and the Overthrow doctrine. Although related, these differ. The first declares common sense redundant, the second repudiates it as systematically erroneous. Imagine that physics has terminated with a final "theory of everything", or Ultimate Physical Theory (henceforth UPT). Ignore the various difficulties which this idea involves (see Redhead *1995*, pp. 63f), and assume that UPT's propositions, which are universal, are all true and that any candidate for addition to them is either already logically implied by them or false. The Omnicompetence doctrine claims that all meaningful factual questions could be answered by UPT, either on its own or in conjunction with appropriate singular statements of initial and boundary conditions. But this leaves open a possibility rejected by the Overthrow doctrine, namely that some common-sense beliefs will get ratified by UPT. The Overthrow doctrine claims that common sense will be discredited by UPT not just *en detail* but *en gros*. But this leaves open a possibility rejected by the Omnicompetence doctrine, namely that there are genuine questions (perhaps to do with times close to the Big Bang) that not even UPT could answer.

The Omnicompetence doctrine appeals to a recurring pattern in the history of science which goes like this. In the infancy of what later became a mature science there had been two or more independent theories, each having its distinctive ontology and the phenomena in its domain seeming to be of an essentially different kind from phenomena in the others' domains. There then occurred, either in a series of steps or at one fell swoop, theoretical developments culminating in these separate theories being absorbed into (reduced to) one unified theory.[3] Phenomena in the different domains of the previous theory are now (assuming the new theory to be true) shown to be diverse manifestations of the one underlying stuff postulated by the new theory. A heterogeneity of natural kinds at the phenomenal level gets subordinated to homogeneity at the theoretical level. Here is a simplified, schoolboy example. Gilbert's field theory for *magnetic* phenomena, Franklin's "fluid" theory for *electric* phenomena, and Young's wave theory for *optical* phenomena were independent of one another, and the phenomena in their respective domains seemed to belong in different categories. Then Faraday brought magnetic and electrical phenomena together under a unified field theory; and with the advent of Maxwell's equations, light was incorporated into the new, all-encompassing electro-magnetic field.

To this historical pattern the Omnicompetence doctrine gives the following twist: if all goes ideally well, such developments will terminate with UPT which will be able to answer any genuine question about any matter of fact, physical or otherwise, either on its own or in conjunction with appropriate with singular statements; "questions" it could not answer would be pseudo-questions. Leibniz and others have given reasons for supposing that UPT can never be attained;[4] but let us suppose for argument's sake that it might be, and ask whether, if it were, it could be omnicompetent.

Here is one factual question which seems likely to remain beyond the competence of our imagined UPT. At each moment during our waking lives we are having experiences which almost

3. Unified as opposed to a mere ragbag collection; how to draw this distinction is discussed in Watkins 1984, § 5.3.

4. Leibniz 1710, pp. 974, 1124, 1717. For additional references, see Watkins 1984, pp. 130f.

immediately slip into the past. Could physics ever explain what gives them their fleeting *nowness*? In his Intellectual Auto-biography Carnap reported some conversations with Einstein, in one of which

> Einstein said that the problem of the Now worried him seriously. He explained that the experience of the Now means something special for man, something essentially different from the past and the future, but that this important difference does not and cannot occur within physics. That this experience cannot be grasped by science seemed to him a matter of painful but inevitable resignation. . . . 'there is something essential about the Now which is just outside the realm of science'. (Carnap 1963, p. 38)

Although he had not pressed the point against Einstein at the time, Carnap disagreed: 'Since science in principle can say all that can be said, there is no unanswerable question left.' But that is merely to re-assert the Omnicompetence doctrine against this counter-example to it. Surely Einstein was right. Science can locate events, to employ McTaggart's distinction, only on the B-series, with its *earlier-later* relation. It might be claimed that this is a case where science over-rides common sense and rightly eliminates the *now*; indeed, it has been claimed that the space-time structure of Einstein's special relativity theory eliminates all transiency from nature. Abner Shimony (*1993*, ii, pp. 271–287) has argued cogently against this claim, using in historical support Einstein's view as reported by Carnap. Such eliminativism would be a glaring example of what Bas van Fraassen calls 'the imperialism of physics' (*1980*, p. 83). At any moment in anyone's waking life the *now* is very real. (We could redirect Descartes's *Cogito* at it: I may be deceived in now believing that I have had experiences in the past; perhaps I came into existence a moment ago with a stock of "memories". But I cannot be deceived in believing that I am now having experiences.) The conclusion seems to be that physics can neither capture nor eliminate the *now*.

Then there would be questions about itself which UPT could not answer. I will mention two of these here (others will come up in the next chapter). (1) The philosopher-scientist Percy Bridgman gave a reason for rejecting the Omnicompetence doctrine which could be put like this. Suppose that UPT exists. Then its existence poses an explanandum: why does it exist? If UPT could answer all questions it could answer this one. But if it did,

then an explanandum would reappear in an explanans of itself. An infinite regress opens up (*1936*, p. 118). (2) Gödel's second theorem leads us to another question that UPT could not answer. Suppose that, when our imagined UPT is first put forward, the scientific community takes it for granted that it, like all its predecessors, will eventually be superseded. But as it goes on performing faultlessly the question begins to be asked with increasing insistence, Is this the *ultimate*, true theory? And this perfectly genuine question UPT cannot answer. For suppose it answered *yes*. Then it would declare itself true, and hence consistent; and we know from Gödel's theorem that the consistency of a consistent system is not provable within the system; were it to assert its consistency, it would render itself inconsistent.

So the Omnicompetence doctrine is false; there are pockets of truth that the most imperialistic physics could never subdue. What about the Overthrow doctrine? In the seventeenth century a serious split developed in the realist camp. It seemed obvious to many leading thinkers on both sides of the divide that there was an irreconcilable conflict between the new science and common sense, with the former repudiating the latter en bloc. Nearly all those in the vanguard of the scientific revolution, such as Galileo and Boyle, together with their philosophical allies, such as Descartes and Locke, believed that the real world as revealed by the new science is systematically different from the world as it appears to common sense; if it consists just of hard, massy, corpuscles obeying the laws of mechanics, then colours, smells, and sounds must be subjective qualities projected by sentient beings onto a colourless, odourless, silent world. On the other side, Berkeley regarded himself as a spokesman of religion and common sense against the new, free-thinking, materialist science. (An entry in his Notebook runs: 'Mem: to be eternally banishing Metaphisics &c & recalling Men to Common Sense', *Works*, i, p. 91.) These scientific thinkers would 'lead us to think all the visible beauty of the creation a false imaginary glare' (*1713*, p. 211). He sought to turn the tables on them by arguing that it is *science* that is not what it appears to be; it appears to give us information about realities behind the phenomena; but there is nothing behind the phenomena, and science really only gives us rules for correlating and predicting phenomena (*1721*).

But common sense involves a kind of realism that conflicts with Berkeleyan idealism; it accepts the materiality and "out-thereness" of familiar things. Against naive realism, which says that things are as we perceive them to be, common-sense realism allows that there may be more to them than meets the eye. Our perceptions of rainbows and mirages and images of defunct stars are not divinely co-ordinated hallucinations, which is what Berkeleyan idealism turns all intersubjectively shared perceptual experiences into, but nor are they faithful representations of an external reality. Common-sense realism is under no internal compulsion to deny that things have an infrastructure. Conversely, scientific realism is under no internal compulsion to deny the reality of the familiar macro-objects of common sense, its oranges and elephants. But it did not seem like that to natural philosophers in the seventeenth century. What generated this supposed conflict between science and common sense was an assumption shared by both sides, namely that what is real is all at one level, things that apparently or allegedly exist at other levels being illusory or fictitious. For scientific realists reality was all at the bottommost level: atoms are real, but oranges qua juicy, coloured, medium-sized objects are illusory; there are really only congeries of atoms. For Berkeley it was the other way round: reality is all at the phenomenal surface beneath which there is no physical reality; an orange's taste and colour are real, but there is no medium-sized material object there and nor, of course, are there any colourless atoms. If we replace the assumption that reality is all at one level with the assumption that reality is multi-levelled, the conflict dissolves.[5]

Grover Maxwell argued from scientific realism to the repudiation of common-sense realism as follows. You, let us say, are examining an orange; Maxwell invites you to make an inventory, in the light of the best available scientific knowledge, of the kinds of entity involved in the causal processes that issue in your orange-like perceptions. Such an inventory will include such things as atoms, photons, neurons—but no orange: 'the stimulation of the retina is accomplished solely by photons emitted from the atoms comprising the surface of the material object in question. The material object just is this collection of submicroscopic

5. See Popper 1963, pp. 115–16. Schlagel 1986, pp. 274f, adopts a rather similar position, with acknowledgements to Popper.

particles and the relations that subsist among them' (1968, p. 151); in seeing an "orange" you are seeing something that isn't really there, an illusion generated by micro-entities which you don't see and are really there.

This argument presupposes that only entities at the bottom-most level are real. From a logical point of view it is pre-Darwinian; it fails to take into account that animals' brains are realistically decoding the subliminal signals reaching their sense-organs, extracting from them messages to do with food, danger, and other macro-level phenomena. An inventory of the impulses reaching my television aerial, and of the processes within the set, would include photons, electrons, and so on, but *no people*. Does that mean that the images of people it presents are illusory, with nothing real corresponding to them? No; a television set decodes signals encoded at the transmitting end, and its images usually correspond rather well (apart of course from their two-dimensionality) with something real at the other end. Now consider a dog sniffing a piece of meat. The meat is giving off signals; not deliberately encoded signals, to be sure, but signals that the dog's brain is able, as a result of natural selection, to decode. The dog turns away—the meat smells bad. And this corresponds rather well with a reality at the other end; the meat *is* bad.

The thesis that only entities at the bottom-most level are real had a certain plausibility in the days of classical atomism, when atoms were seen as ultimate, indivisible units, everything else being made up of them. When atoms turned out to be composite, it was at first supposed that the protons, neutrons . . . of which they were composed were the fundamental, indivisible units. But Einstein's equation $E = mc^2$ implied the inter-convertibility of energy and matter; when a swarm of particles was released upon the disintegration of a neutron inside one of the new atom-smashers developed after WW2, the particles were not ex-constituents of the neutron; they were born out of the lost energy and had brief lives. As Patrick Suppes put it, 'we cannot have a reduction of subject matter to the ultimate physical entities because we do not know what those entities are' (*1984*, p. 123). It is not just that we do not at present know what they are; the assumption that science will ever reach a bottom-most level, or even that there is such a level which it may fail to reach, is in question. As John A. Wheeler put it: 'One therefore suspects that it is wrong

to think that as one penetrates deeper and deeper into the structure of physics he will find it terminating at some nth level' (1977, pp. 4–5).

Thus to restrict the title 'real' to things existing at a supposed ultimate level would imply that it is all too likely that no entity so far recognized by science is real. But why should not being at the ultimate level imply not being real? An atom as conceived by Democritus was an absolutely stable, homogeneous unit; in Bohr's original model a hydrogen atom, with its electron circling a positively charged nucleus, was still stable but no longer homogeneous. The shift from homogeneity to heterogeneity does not bring in its train a shift from reality to non-reality. And if atoms are real despite their complex structure, so surely are molecules. And so we can go on working up towards the macro-level. Why should we not regard diamonds as real? They are a lot more stable than radon atoms.

You may say that we must surely admit that colours are subjective qualities projected onto physical objects by visually sentient beings. Must we? You are told the following: 'There is something, call it w, which when passed though a certain instrument, call it P_1, gets decomposed into a, b, c, . . .; and when the process is reversed with a, b, c, . . . being passed though instrument P_2, w is reconstituted; and all this proceeds independently of perceivers.' Wouldn't you conclude that a, b, c, . . . and w are not mind-dependent but objective? But what you have been given is an account of a famous experiment of Newton's where w is sunlight, P_1 and P_2 are suitably positioned prisms, and a, b, c, . . . are the colours of the spectrum.

It is sometimes supposed that properties which are scientifically explained in terms of properties and relations of things at a deeper level are thereby *explained away*. This is a dangerous mistake. Bohr's model of the hydrogen atom explained something that Rutherford's model had not explained, namely the stability of the atom. There was no tendency for the atom or its stability to be thereby explained *away*, though it is of course true that in penetrating to a deeper level science may revise its previous account of things higher up: Bohr's model did suggest that an atom is not, after all, *absolutely* stable but might conceivably be split. The account that nuclear physics gives about what happens at the micro-level when an atom bomb explodes has no tendency to

deprive that macro-event of its reality. Likewise, an explanation in economics of inflation, say, as the unintended outcome of the actions of various individuals has no tendency to deprive this social phenomenon of its awesome reality.

Let us now consider, in the light of the thesis that reality is multi-levelled, Eddington's "two tables" (*1928*), or desks as I prefer to make them. Desk A, the desk of common sense, is mostly made of solid wood; on Eddington's account, desk B, the desk as understood by physics, is mostly made of empty spaces pervaded by fields of force with electric charges moving at great speeds. A scientific realist who subscribes to the Overthrow doctrine will declare desk B real and desk A illusory. A Berkeleyan idealist will have it the other way round, declaring desk B a fictional construct, useful for correlating and predicting perceptual experiences. A neo-Kantian might say that both desks are real but belong to different worlds, the exact world of mathematical physics and the inexact world of common sense (see for instance Körner *1966*). Schopenhauer would say (rightly according to Bryan Magee *1997*, pp. 389f) that we have here one thing with a dual aspect, a phenomenal outside and a noumenal inside. If we translate his "inside-outside" language into our "top-bottom" language, he was saying that the one reality exists at two levels, top and bottom. The multi-level realism endorsed here revises this to say that there are many more than two levels and there may be no bottom level. (It might point out that desk A is already multi-levelled, with its visual sheen, walnut veneer, hidden glue . . .)

Let desk B now be the desk as described by physics at the deepest level physics has so far attained. Here is an argument against the Overthrow doctrine. *If* reality were all at that level there could be no loss of information in discarding a true common-sense description of desk A in favour of a true and complete scientific description of desk B (perhaps reinforced by a neuroscientific account of the effects of photons . . . impinging on perceivers' sense-organs). But this replacement might very well involve losses as well as gains. Where the common-sense description of desk A says, for example, that it has a secret drawer containing a locket of hair and a cache of old love letters, the scientific description of desk B would speak unrevealingly of, say, a field of force with fast-moving electric charges in it. This is not a case where science is revising common sense; science is not saying

it's not really a cache of old love letters, as it does say that the earth is not really a stationary platform with the sun rising in the east and setting in the west. The scientific description misses out on the love letters, catching only their atomic constitution.

Let us now formulate guidelines to regulate a critical rationalist's handling of candidates for inclusion in a provisional worldview. Critical rationalism has the advantage over justificationist theories of knowledge that it is not obliged to take into account all logically possible alternatives to a given hypothesis, but may attend just to ones that are seriously proposed.[6] To simplify the exposition it will be assumed that for any seriously proposed candidate p for inclusion in a world-view there is just one seriously proposed rival candidate q, p and q being mutually incompatible. 'Science endorses p' will be taken to mean that contemporary science provides a strong case for p. This is a bit vague, but it would be too much to require entailment. Classical physics is generally supposed to have provided a strong case for determinism (we will be examining it in the next chapter) without actually entailing it.

The upshot of the above discussion is that while we should be guided primarily by science in the formation of a world-view, we may also be guided by common sense where it is not under challenge from science. This suggests these two rules for inclusion, where p is a seriously proposed candidate and the incompatible q is its only seriously proposed rival:

(1) Include p if p but not q is endorsed by contemporary science.

(2) Include p if p but not q is endorsed by common sense which is not here under challenge from contemporary science.

The q in rule (2) might have a theological endorsement.

Now to rules for exclusion. There is an asymmetry between inclusion and exclusion: including p automatically excludes not-p, whereas excluding q does not automatically include not-q; q may

6. See the discussion in Watkins 1984, § 8.4 of Abner Shimony's "tempered personalism" in what is now Chapter 9 in Shimony 1993, i.

be excluded in either a univocal or an agnostic way. This distinction is particularly relevant with respect to pure existential statements, which assert the existence of things of a certain kind within an unrestricted spatio-temporal domain. Such statements often play an important role in metaphysical doctrines. There will be a good case against an existential statement if it conflicts with science, and a good case for it if it is endorsed by contemporary science, or by common sense, or is directly supported by independent evidence. (It might be supported by independent evidence without being endorsed either by contemporary science or by common sense. For instance, there is strong clinical evidence, some of which will be touched on in § 4.5 below, for the claim that some human bodies have been inhabited by two or more separate personalities; phenomena of this kind have not, so far as I know, been brought under any neuropsychological theory, and they are alien to common-sense ideas about personhood.) But it may well be that the most that can be said against an existential statement is that there is *no* case *for* it. At one place Berkeley declared: 'It is for me a sufficient reason not to believe the existence of any thing, if I see no reason for believing it' (*1713*, p. 218). That is equivocal between seeing-no-reason-to-believe-*q* being: (i) a sufficient reason for him not to believe *q*, and (ii) a sufficient reason for him to believe not-*q*. Since (i) is tautological, he presumably intended (ii). But (ii) is too strong; to affirm it is to deny that there are more things in heaven and earth than are dreamt of in your philosophy. We can pick a middle way between (i) and (ii) by allowing that *q* may be excluded from one's world-view in an agnostic spirit, without including not-*q*.

We may sum up the foregoing in the following two rules for exclusion:

(3) Exclude *q* and include not-*q* if a good case against *q* is provided by contemporary science, or by common sense (if common sense is not here under challenge from science), or by independent evidence.

(4) Exclude *q* but without including not-*q* if the exclusion of *q* is not required by Rule 3 but no case for *q* is provided by contemporary science, or by common sense, or by independent evidence.

Although these guidelines are a bit vague they will prove sufficiently precise for our purposes. (For quite a few purposes the following implication of them is enough: exclude q if your case for accepting it amounts to no more than that you would like it to be true.) Philosophical discussion of the more philosophically tendentious propositions that will be included, under their guidance, will be postponed to the Epilogue.

Chapter 3
Betwixt Chance and Necessity

Now to the formation of a world-view. Determinism is obviously one possible candidate for inclusion. (We will later find it playing a dominant role in the philosophies of Spinoza, Kant, and Schopenhauer.) What rival candidates should we consider? According to Hume, the sole alternative to causal necessity is chance; there is no middle possibility; if an event occurs, then either (i) it was causally necessitated or else (ii) it was not causally necessitated and happened by chance. In his own words, ''tis impossible to admit of any medium betwixt chance and an absolute necessity' (*Treatise*, I, iii, 14). This thesis, which we may call *Hume's fork*, was the major premise in his argument for causal determinism. His minor premise was that there is no chance. He did not of course deny that there is something that the vulgar call chance; but "chance"-events are events whose causal determination is 'secret and conceal'd' (I, iii, 12). Laplace handled them in the following way. Consider the statement, 'The probability of event e, given conditions c, is one half', where c stands for conditions, say the spinning of a coin, obtaining at or before time t_0 and e for an event, say the coin landing heads up, occurring after t_0. For Laplace, such a statement may well be true: the probability of e relative just to c may indeed be one half. However, in reality there will always be, in addition to c, further conditions x obtaining before t_0 and such that the probability of e on c-and-x is either one or zero; probabilities reflect a mixture of knowledge and ignorance (*1812*, p. 6); in this case, knowledge of c and ignorance

of x. It is as if Laplace had said that there are always hidden parameters in chance-like processes.

This determinist thesis, the denial of ontological chance, has been overtaken by developments in modern physics since 1926. It is generally accepted that the micro-indeterminacies of twentieth-century physics are irreducible and that the currently reigning quantum theory involves a 'pure tychism' (Sklar *1993*, p. 123); that is to say, there are no hidden parameters whose values, if only they could be ascertained, would send all the probabilities to either zero or one. The process of radioactive decay provides paradigm cases of irreducible micro-indeterminacy. If c stands for being an intact radon atom at t_0 and e for disintegrating during the next 3.82 days, then to the statement that the probability of e given c is one half current theory adds that there are *no* conditions x obtaining before t_0 such that the probability of e on c-and-x is either one or zero. It used to be supposed that their probability is absolutely invariant. James Jeans said that 'an atom had always the same chance of disintegrating, whatever its past history or present state might be' (*1947*, p. 312), and Max Born said that it is 'quite impossible to affect the disintegration by any means whatever, whether by high or low temperatures, electric or magnetic fields, or any other influences' (*1951*, p. 237). It has since turned out that it isn't quite like that: exceptionally high pressures do very slightly affect the rate of disintegration.[1] But we can say that for all conditions x obtaining before t_0 other than extremely high pressure, the probability of e on c-and-x is always one half. God does play dice with the world! Rule 3 in the previous chapter clearly implies that we must exclude a strict physical determinism.

Let us put on hold for the moment the question of a middle possibility between chance and necessity, and ask how big a difference would be made by the introduction just of this kind of tychism into what had been a thoroughly deterministic world-view. Hume would have found it most unwelcome, especially if it infiltrated our decision-making apparatus (*Treatise*, II, iii, 2). But it was welcomed by some who sought to exploit the new micro-indeterminacies in favour of freewill. Quite soon after the advent

1. Holton and Roller 1958, p. 670n.

of Heisenberg's Uncertainty Principle, Arthur Compton (of "Compton Effect" fame) was declaring that the new physics leaves room for non-physical factors to play a determining role (*1935*, passim). He envisaged an apparatus in which a photon passes through a shutter with an equal chance of reaching photoelectric cell A or photoelectric cell B, these cells being connected to amplifiers. If it reaches cell A a stick of dynamite will be exploded, but not if it reaches cell B. Compton claimed that since it is not physically determined, the way the photon will go 'may be determined by nonphysical means without violating the laws of the physical world' (p. 60). But can such a non-physical determinant make a physical difference without altering the probabilities? Compton tried to avoid this awkward question by asserting that probabilities do not apply to individual events. Many would dispute that.[2] And in any case we can raise a similar question with respect to propensities and frequencies. And it confronts Compton with a dilemma. A non-physical "determinant" that made no statistical difference would hardly be a determinant, but if it made a statistical difference it would, as Compton saw it, violate the laws of physics.

We might present the difficulty Compton was facing here in a more general way. Suppose that you face a choice between behaving in one of two ways, call them b and not-b. Let c denote certain physical conditions that obtained before you were born, and let m be a variable that ranges over your current beliefs and preferences. We can conceive three very different situations. (1) First, a starkly deterministic situation: c determines b irrespective of whatever your current state of mind may be. We could express this by saying that, for any m, the probability of b on c & m is the same as the probability of b on c alone, namely 1. In that case your beliefs and preferences will have no influence on this impending behaviour of yours. (2) We now introduce an element of chance: c no longer determines b; the probability of b on c alone is, let us say, $\frac{1}{2}$. Suppose, furthermore, that there is a value of m, call it m_{yes}, such that the probability of b on c & m_{yes} is 1, and another value of m, call it m_{no}, such that the probability of b on c & m_{no} is 0; then the introduction of this new factor has been

2. E.g. Popper 1957; Lewis 1986, p. 84.

accompanied by your gaining full control over this impending behaviour of yours. (3) But now imagine a situation that is like (2) in making the probability of b on c alone $\frac{1}{2}$, but like (1) in making the probability of b on c & m the same as the probability of b on c alone. You would not have gained any control over this impending behaviour of yours. If, in the Compton scenario, non-physical "determinants" cannot alter the probabilities, since doing so would violate the laws of physics, then it would resemble situation (3).

The fact is that the introduction of micro-indeterminacies has made less difference to our macro-level view of the world than might have been expected. Nowadays it is generally accepted that indeterminism at the quantum mechanical level is compatible with something virtually equivalent to determinism at the macro-level.[3] There may be the occasional seepage into the living-room from the micro-indeterminacies in the basement;[4] for instance, they may be used to generate random numbers in lotteries. And a set-up might conceivably be so arranged that if a certain chance-event occurred there would be a large disturbance at the macro-level. But when micro-indeterminacies are involved in macro-level phenomena, it typically happens that the numbers are so astronomical that in the statistical aggregate all indeterminacy is effectively ironed out; the familiar bell-shape of curves for probability-distributions becomes virtually indistinguishable from a vertical line with horizontal tails. The measured size of a sample of radon will go on halving at fixed intervals with a determinacy equal to that with which the measured velocity of a ball rolling down an inclined plane goes on doubling.

Let us now revert to the main question, which is not whether there is chance but whether there is a middle possibility between chance and necessity. It will be argued that there is. Actually, the existence of one kind of middle possibility follows trivially from the existence of micro-probabilities, at least when they are amenable to human adjustment. Suppose that the probability of an electron hitting a certain region of a photographic plate can be controlled by altering the size of the slit of a diffraction apparatus.

3. E.g. Grünbaum 1972, pp. 621f; Shimony 1993, i, p. 30
4. Honderich has denied this; see his 1988, p. 330 and Watkins 1990.

Electrons are to be fired neither just a few times nor billions of times, but a thousand times. On setting 1 the probability of a hit is 0.1 while on setting 2 it is 0.2. Then setting 2 will not causally necessitate twice as many hits as setting 1; there is not an "iron" control over the statistical aggregate. But nor, on the other hand, is there no control. There is a plastic control.[5] Hume's mistake with regard to his exclusive cause/chance dichotomy was not to notice that a doctrine of universal determinism calls for two universal quantifiers. It should say that *all* events are determined in *all* details, or completely determined. The negation of determinism is not that some events are completely undetermined, as Hume took it to be, but only that some events are not completely determined.

However, a more interesting kind of middle possibility than this will be argued for, and the argument will take no advantage of micro-indeterminacies. It relies on these two facts about scientific theories: they are humanly invented and they may be technologically influential. It goes through irrespective of whether the theories are deterministic or indeterministic. Indeed, it will make the exposition easier if we pretend to be back in the days of classical physics and ask whether we would then be obliged by our Rule 1 to include determinism in our world-view; did classical physics endorse cosmic determinism? But before we proceed to that we need a sharp characterization of determinism.

First, two classic formulations. Democritus is reported to have said: 'From infinite time back are foreordained by necessity all things that were and are and are to come.'[6] And Laplace, after saying that the present state of the universe is the effect of its anterior state and the cause of the one to follow, famously declared that for an Intelligence ("Demon") that understood all the laws of nature and knew exactly the relative position and momentum, at a given instant, of every particle in the universe, 'nothing would be uncertain and the future, as the past, would be present to its eyes' (*1812*, p. 4). Use will also be made in what follows of an idea put forward by Richard Montague (1962/74), and taken up by John Earman (1971, *1986*), Peter Clark (1989,

5. This term was introduced in Popper 1966.
6. See Bailey 1928, p. 120.

1996) and others. Here, one proceeds to a notion of cosmic determinism from a characterization of a deterministic *theory*. Let T be a scientific theory, let M_i be a randomly chosen model of T, and let $S(M_i, t_0)$ be a state-description, in terms of T's state-variables, of M_i, at time t_0. If T is deterministic, then $S(M_i, t_0)$ fixes state-descriptions of M_i for all later times, and also for all earlier times since with deterministic theories there is invariance under time-reversal (see Earman *1986*, pp. 128f). Let M_j also be a randomly chosen model of T. One of Montague's main points was that, with a deterministic T, if any state in the history of M_i coincides with a state in the history of M_j, then all their states coincide and $M_i = M_j$. Imagine such a history to be represented by a "world-line", each point of which corresponds to a state of the model at a certain time. (I put the word in scare-quotes because it relates only to our models.) A deterministic T will not allow this "world-line" to branch:

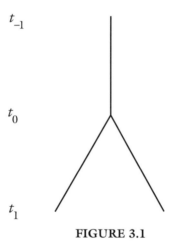

t_{-1}

t_0

t_1

FIGURE 3.1

—that would introduce an indeterminacy at t_0. And because of invariance under time-reversal, it will not allow the mirror image of this, namely "world-lines" merging:

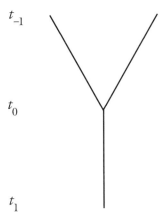

t_{-1}

t_0

t_1

FIGURE 3.2

This means that two "world-lines" cannot cross, which would involve merging and branching. If they are separate anywhere they are separate everywhere.

A feature of all the above formulations is the symmetry they assert between past and future. For Democritus, events that are to come are no less fixed than events that have been. To Laplace's Intelligence, future states are no less present than past states. On the Montague-Earman formulation, fixing any point on a possible world-line fixes the entire line. For determinism, the past/future distinction is no more basic than an up/down or a left/right distinction. To the uncontroversial assumption that past events, though no longer with us, are *there*, fixed and unalterable, determinism adds the controversial assumption that future events, though not yet with us, are likewise *there*, fixed and unalterable. Einstein with his four-dimensional block universe came to succeed Laplace as the scientific apostle of cosmic determinism. Popper reported that in conversation Einstein agreed 'with the motion picture analogy: in the eyes of God, the film was just there, and the future was there as much as the past'.[7]

That determinism conflicts with common sense becomes clear when one transfers the film analogy to one's own life, at least if

7. Popper 1982b, p. 90; and see Popper 1976, pp. 128f.

one assumes one still has a few years to go. It seems quite unacceptable that frames representing one's future states differ only positionally from frames representing one's past states. It is a deep-seated conviction of common sense that one's future is unlike the past in not being wholly fixed and unalterable. The agency-assumption mentioned in the previous chapter is tied up with a belief in the openness of the future at least of our near-environment to our impending decisions. If you are planning a summer holiday you will implicitly assume, as you go about it, that the world allows you a modest degree of spielraum and that the decision you reach will subsequently make a difference. If contemporary science endorsed determinism, this would be an area where a common-sense contribution to one's world-view would, by Rule 3 above, have to be vetoed by scientific considerations. Let us now consider whether scientific considerations should have exercised such a veto in the heyday of classical physics; did classical physics endorse a cosmic determinism?

It might seem so. Areas where natural phenomena had appeared to exhibit a certain waywardness or indeterminacy had been conquered, one after another, and the reign of exact scientific law established over an ever-widening domain. To Greek astronomers, the planets appeared to wander about the sky. But with Kepler their "wanderings" were brought under three elegant and exact laws of planetary motion. In his day, however, comets were still sky-wanderers. But Newton's theory showed that they too are law-abiding, moving either along hyperbolas and not returning, or else along elongated ellipses and returning, as Halley's comet duly did. Newton's theory did not deal with magnetism and electricity, but they would be dealt with comprehensively by the theories of Ampère, Faraday, and Maxwell. Physics had been going from strength to strength with an unbroken sequence of deterministic theories. Would it not have been reasonable to conclude from the triumphs of classical physics that causal determinism prevails in the world?

This conclusion did not go entirely unchallenged. One thinker who challenged it was C. S. Peirce in his 'The Doctrine of Necessity Examined' (1892); but he rather confounded ontological questions about spontaneity or chance in nature with epistemological questions about the inexactness of our measurements of continuous quantities. That classical physics implies cosmic

determinism was also challenged by Popper in his 1950. The core of his argument for indeterminism in classical physics went like this. Let W, L, and P be, respectively, a classical mechanical "world", the laws that W obeys, and a predictor. The latter has the measuring capacity to ascertain an exact state-description of W at any time t and the logico-mathematical capacity to derive from this, in conjunction with L, state-descriptions of W at all other times. P may be regarded as a physical embodiment of Laplace's Intelligence; instead of intuiting the state of W at t, P ascertains it by very delicate physical measurements, and instead of mentally cognizing future states, P prints out its predictions. Popper pointed out that a necessary condition for P to be able to predict future states of W is that all causal interaction between W and P is one-way, from W to P and never from P to W: neither P's data-gathering nor P's prediction-making must disturb W. So W is not after all the whole "world" as here envisaged; there is something physical outside W which W is strongly influencing, namely P itself. Let W* denote the physical "world" W + P. Popper showed that P could not predict future states of W*, since this would involve predicting its own future states.

It is not necessary to rehash Popper's argument for this sort of scientific unpredictability here. Assume that it is correct, as I think it is. Then we have here a breakdown of what he called scientific determinism, or the thesis that there is in principle no limit to the scientific predictability of the world. But does it tell against metaphysical determinism, or the thesis that everything is causally determined in every detail? He insisted that this whole imaginary set-up is entirely in line with classical physics; and showing that scientific unpredictability arises within such a framework does not show the framework to be causally indeterministic. John Earman rightly criticised Popper for confounding the ontological question of causal determinism with the epistemological question of scientific predictability (*1986*, pp. 8–10, 65). Yet Earman seems to have done something similar himself. He too challenged the conventional wisdom that it was only with quantum mechanics that physics introduced an essentially non-determinist theory. He claimed that Newtonian mechanics is in some ways 'quite hostile to determinism' (*1986*, p. 2); but his case for Newtonian indeterminism seems to be exposed to the sort of objection that he raised against Popper. It rests on the theoretical possibility of a

"space invader"; this is the temporal mirror image of an object accelerating away from the solar system towards infinity, namely an object approaching the solar system from infinity (p. 34). This raises the possibility that a seemingly closed Newtonian system will be disturbed from without. Yes, but how does this bear on the ontological issue? Let W now denote a Newtonian world which we believe to be closed, but erroneously because a space invader, call it O, is approaching it. Let W* denote the physical world consisting of W + O. Then W*'s future states are not fully predictable by us, but this is no reason to suppose that they are not causally determined.

Now to the main argument for a kind of indeterminism not involving chance. It calls for a bit of deterministic physics which has been technologically influential and the discovery of which involved the sort of inventiveness discussed in Chapter 1. For ease of exposition I will concentrate just on Faraday's revolutionary discoveries in electro-magnetism. (In 1831 he was visited in his laboratory by Sir Robert Peel; the Prime Minister pointed to an odd-looking device and asked what use it was; Faraday is supposed to have replied that he didn't know, though he expected it would be taxed. It was in fact the first dynamo; L. P. Williams *1965*, p. 196.) Let E denote the far-reaching physical changes— the construction of power stations and hydro-electric dams, the supply of electric power, the lighting and machinery—to our human environment that have occurred in consequence of the invention of the dynamo, and let L denote the totality of the laws of nature. We will now suppose, for argument's sake, that the history of science is destined to terminate with an ultimate physical theory (henceforth UPT) no less deterministic than classical physics. So the laws in L are now supposed to be perfectly deterministic.

Consider the state of the world in the year 1066, to pick at random a far-off time: is it reasonable to suppose that everything was then in place to lead inexorably and precisely to the changes denoted by E above? The common-sense answer is that something essential was missing then, namely Faraday's discoveries. Determinists might try to meet this objection by answering that while ideas relevant to E did not yet exist in 1066, physical factors did then exist that would lead in a causally determined way to

physical states correlated with those ideas. The physical processes were proceeding along their predetermined courses with ideas dancing intermittently in attendance.

Two objections will now be raised to this. The first, which may be abbreviated to 'Whence the pre-established harmony?', goes through whenever one person responds appropriately to a question asked by someone else. Trifling questions will do. After take-off you ask a fellow passenger what the time is in New York. The present objection would not apply if you got a reply like: 'I wish they'd bring the drinks trolley'. It needs to be an appropriate reply, like 'Well, they're five hours behind us, so it'll be 7 am over there'. Let m_1 denote your mental processes as you asked your question and let p_1 denote whatever physical processes in you accompanied those mental processes. And let m_2 and p_2 similarly denote your companion's mental processes and the accompanying physical processes as she answered your question. We now push t_0 back to a time when there was matter but no mind. (The assumption that there was such a time will be explicitly introduced in § 4.3 below.) According to determinism, the then state of the universe included conditions, call them c_1, sufficient to predetermine, given the laws L, the occurrence of the physical events p_1, and likewise conditions c_2 sufficient for p_2 (c_1 and c_2 may overlap or even coincide). From the grand cosmic processes that have been occurring between then and now we focus on the two extended causal chains, $c_1 \rightarrow p_1$ and $c_2 \rightarrow p_2$. The first of these raises no particular difficulty; it ended with a physical effect which was accompanied, not by a dream-experience, stabbing sensation, or whatever, but by m_1 which included your wondering what the time is in New York. But the second chain raises the following question: why should it have provided, just when and where it was needed, a physical effect, namely p_2, which was accompanied, not by a dream-experience, stabbing sensation, or whatever, but by m_2 which included your companion's thought about what time it is in New York? Why should mindless matter at t_0 have been predisposed to generate, via changes on the thing-side, changes m_1 and m_2 on the thought-side that would fit in so nicely with one another? Of course, the problem disappears for a determinist who calls upon a divine Mind to supervise the process. But how can a secular determinism meet the difficulty?

It can hardly appeal to coincidence; this sort of thing is happening all the time.[8]

The second objection, which may be abbreviated to 'How did Spinoza's fingers do it?', reflects the fact that neither in Spinoza's parallelism (to be discussed in § 7.3 below), nor in the determinism-cum-epiphenomenalism envisaged here, is there any causal input from the mental to the physical. Unlike the first objection, this one is most telling where the bodily behaviour is the outward expression of high-powered thinking. Thus p_1 might now denote physical changes occurring as Spinoza penned the thought that the order and connection of ideas is the same as the order and connection of things (E, IIP7). We again put t_0 back to a time before there was mind. According to determinism, the then state of the world contained conditions c_1 sufficient, given laws L, to predetermine the physical event p_1. This implies that while Spinoza's thinking did indeed accompany this physical event, it made no contribution to his penning that sentence. This implication has been hailed by some determinists. Thus Ted Honderich has reaffirmed that determinism, which he accepts, rules out the idea that we ever originate anything (*1988*, pp. 385–391). It also implies that, if the laws as they relate to physical processes had remained unchanged, but consciousness had never come into existence, then Spinoza's finger movements would have been exactly the same. This implication has also been hailed by some determinists. Thus Dean Wooldridge declared that 'every detail of the past and future history of mankind would be the same if consciousness were completely nonexistent, just so long as the physical laws of nature were kept unchanged' (*1968*, p. 134). C. D. Broad had earlier pointed out that 'anyone who denies the action of mind on body must admit that books, bridges and other such objects *could* have been produced even though there had been no minds', an implication which, as he truly remarked, 'seems manifestly absurd to common sense' (*1925*, p. 115). The suggestion that the ink-marks made by Spinoza, or by Faraday, or by Shakespeare, or for that matter by Wooldridge when he was writing about consciousness, might still have been made if their heads

8. For the pre-history of the present argument, and its debts to Alfred Landé, Karl Popper, and J. L. Mackie, see Watkins 1985.

had been physically the same but had never had a thought in them does bring to mind Descartes's remark: 'there is nothing imaginable so strange or so little credible that it has not been maintained by one philosopher or other' (*Discourse*, p. 90). Again, of course, the problem disappears if a divine Mind is called in to supervise the process.

But however little credible it may be that those ink marks could have been the same if their makers had been mindless, are we entitled to reject it, given the present supposition, introduced for argument's sake, that physics will terminate with the deterministic UPT? Wouldn't this bring cosmic determinism in its train? Let us say that a physical theory T *comprehends* a physical change at time t_1 if T makes possible the deduction of a prediction/explanation of its occurrence at t_1 from a true report of physical conditions obtaining at any earlier time t_0. In the previous chapter it was argued that UPT could not be omniscient because there are questions about itself that it could not answer. But could it be *physically complete* in the sense that it could comprehend all physical changes? As a way of entry into this question let us consider Newton's reasons for holding that his theory of universal gravitational attraction was not complete. One was that physical forces of kinds other than the gravitational forces recognized by his mechanics are at work in the cosmos; he specifically mentioned magnetic and electric attractions (*Opticks*, Queries 22, 31). Our UPT will not have any incompleteness of that kind. His other reason was encapsulated in a dubious piece of theology which, however, has the merit of showing that a seemingly complete theory may, as it were, shoot itself in the foot with respect to completeness, by opening up new technological possibilities consequential exploitations of which it is unable to comprehend.

Newton calculated that mutual interactions among planets and comets generate irregularities which would lead to collisions if God did not intervene and bring about a "reformation" of the solar system (*Opticks*, Query 31). Leibniz famously derided this idea: 'Nay, the machine of God's making is so imperfect according to [Sir Isaac Newton and his followers] that He is obliged to clean it now and then by an extraordinary concourse, and even mend it as a clockmaker mends his work' (1717, p. 1096). And when Laplace re-worked Newton's calculations he concluded that he had no need of that hypothesis (*Oeuvres*, vi, pp. 479f). But

however theologically or otherwise unsatisfactory it may be, all that matters here is that Newton's idea is not self-contradictory, and no one accuses it of that.

For present purposes we may re-state his idea anthropomorphically. We suppose that God ascertains the exact physical state of the world at t_0 and records it in state-description $S(W, t_0)$. For a deterministic theory, it will be remembered, one such state-description is supposed to specify an entire world-line. God now conjoins $S(W, t_0)$ with UPT and starts deriving state-descriptions for times $t_1, t_2, t_3 \ldots$. These show planets moving with increasing irregularity and eventually colliding. We might call this a 'planets-in-collision' world-line. God now decides to intervene in order to prevent these collisions. Let $S'(W, t_1)$ be a state-description that differs slightly from $S(W, t_1)$, and is such that, when it is conjoined with UPT, it specifies a sequence of world-states in which the planets do not collide. The difference between $S(W, t_1)$ and $S'(W, t_1)$ is analogous to that between two states of a railway system that are the same except for one or two switched points. God now intervenes at some time between t_0 and t_1 and switches the world to the collision-free sequence $S'(W, t_1)$, $S'(W, t_2)$, $S'(W, t_3) \ldots$

But wait! We started out with two true premises, $S(W, t_0)$ and UPT, and we supposed that their conjunction had the 'planets-in-collision' world-line as a logical consequence. But if that were so, no augmentation of those premises could overrule that conclusion.[9] Yet it has been overruled as a result of additional information about divine tampering with initial conditions. So it could not have been deducible from those premises. What has gone wrong? The answer is that to secure deducibility we need an additional proposition, call it C. Just what C says will be spelt out shortly, but for the moment take it to be a *ceteris paribus* clause which implies that God does not intervene. C could restore deducibility by being used either to strengthen the premises or to weaken the conclusion. If used in the first way, the false 'planets-in-collision' conclusion would be logically implied by the augmented premise $S(W, t_0)$ & UPT & C which is false just because its conjunct C falsely states that God does not intervene.

9. If p entails q, then for any r, p & r entails q.

Alternatively, we may export C to the conclusion, turning the latter into an 'if-then' statement with C as its antecedent clause and the 'planets-in-collision' world-line as its consequent clause.[10] The thus revised conclusion says in effect that if God does not intervene, then the planets will collide. Since its antecedent clause is false, this 'if-then' statement is true.[11] We now have true premises entailing a true conclusion, but the latter is neutral as to whether the planets will or will not collide.

What exactly might C say? It may help if I simplify the notation. Let e now stand for the premise from which God originally derived the 'planets-in-collision' conclusion, namely the conjunction of supposed ultimate theory and the state-description of the world at t_0, and let h stand for that conclusion. Let x be a variable which ranges over events occurring at any time after t_0. Then our proposition C might say: 'For any x, the probability of h on e & x equals its probability on e alone.[12] And C is false because in our scenario there is an x which sends the probability of h right down to zero, namely the above divine intervention.

So our deterministic UPT would not after all bring cosmic determinism in its train. It would remain incomplete; there would be facts that it could not comprehend. One of these was highlighted in the previous chapter: UPT could not comprehend the fact of its own existence. To which we can now add that it could not comprehend the disturbing uses that might be made of the new technological possibilities that it would open up. But let us now disengage ourselves from Newton's dubious theology and from eschatological assumptions about the finalization of physics, and consider exploitations of new technological possibilities opened up by actual physical theories. Consider for example the physical changes that occurred at or near the earth's surface in the vicinity of Los Alamos shortly after 5.30 a.m. on 16 July 1945. Let T now be an amalgamation of all the general scientific propositions (due to Rutherford, Bohr, Hahn, Lise Meitner, Chadwick, Szilard, the Joliot-Curies, Pauli, Fermi, Teller, and others) relied on in the construction of the device that was exploded then. And imagine that a complete record was kept of every change to initial

10. If p & r entails q , then p entails r Æ q (if r then q).
11. The formula p Æ q is equivalent to q or not-p and is true whenever p is false.
12. In notation: "x[p(h | ex) = p(h | e)].

conditions, right down to the final triggering, that went into the construction and firing of that device. Call this record E. Finally, let A predict an atomic explosion. Assume that T logically implies: $E \rightarrow A$. But while T could predict that *if* the technological manipulations recorded in E are carried out, then the explosion will follow, it could not predict that they will be carried out. It would not comprehend E. That they were carried out was in large part because of the knowledge of T in the minds of Robert Oppenheimer and his team (there were also politico-military reasons, of course); and T has no comprehension of knowledge of itself in human minds. Any wider theory into which T may subsequently be incorporated will have an analogous lacuna.

Hume was doubly wrong. Quantum mechanics teaches us that there is chance. But in the present chapter, the importance with respect to determinism of QM's break with classical physics is not so much its introduction of irreducible indeterminacy at the micro-level. That it was a revolutionary intellectual development with highly disturbing technological implications helps to establish that there is a middle possibility between causal necessity and chance, generated by the peculiarly human collaboration between, so to say, inventive minds and deft fingers. QM strikingly exemplifies Popper's conception of scientific growth. And I will conclude with a comment on my old teacher. Although two of the main planks of his philosophy were his indeterminism and his conjecturalist philosophy of science, he never deployed the latter in support of the former. He had in his hands this powerful argument for indeterminism and strangely enough he didn't use it. He sometimes seemed to be about to do so. Consider, for instance, the refutation of historicism he presented in the preface that he added to *The Poverty of Historicism* when it was published as a book, in 1957. Its first step was that the course of human history is strongly influenced by the growth of human knowledge. Then comes what he called the 'decisive step'. One might have expected this to be that the ontological claim that the growth of human knowledge is intrinsically indeterministic. Instead, his 'decisive step' was the epistemological claim that we cannot *predict* the future growth of our scientific knowledge. At around this time he was writing *The Open Universe*, published only in 1982 and sub-titled 'An Argument for Indeterminism'. Chapter III, entitled 'The Case for Indeterminism', has a section on the

growth of theoretical knowledge; and there too he presented the same merely epistemological argument. But irrespective of how science advances it is trivially true that we cannot scientifically predict at time t_0 a scientific discovery that is going to occur at time t_1; if we got it right the discovery would have been made at t_0. In the present chapter the claim has been, not that electrification or atomic explosions were in principle unpredictable back in 1066, say, but that they were not then causally determined.

Chapter 4
Darwinism: Some Metaphysical Implications

Another major component must now be added to the indeterminism introduced in the last chapter. Our rules for the building of a world-view obviously require a central place to be given to the Darwinian theory of evolution. Moritz Schlick rightly instanced this theory when he spoke of great transformations of world-view resulting from far-reaching natural discoveries (1934, p. 144). Some contemporary philosophers proceed as if one can pick out of the air those propositions that make up Naturalism, perhaps equating it with materialism or physicalism. But to do it apriori is at once lazy and presumptuous. There is a long-standing tradition, which will be followed here and goes back at least to the Greek atomists, that equates it with the thesis that "Man is a part of nature", and leaves it to natural philosophy to tell us what that means; which is what Darwin and his followers have been doing very successfully.

Before Darwin, however, "Man is a part of nature" remained little more than a metaphysical slogan. Moreover, it was a slogan with a large question mark against it. One thinker who proclaimed it was Spinoza (*E*, IV Ap7). Now it is a manifest fact that men, birds, and other living creatures display an appearance of design. How did Spinoza handle this problem? Instead of tackling it, he attacked those who saw a problem here. In the famous Appendix to Part I of the *Ethics* he declared that when credulous people 'see the structure of the human body, they are struck by a foolish wonder, and because they do not know the causes of so

great an art, they infer that it is constructed, not by mechanical, but by a supernatural or divine art'. But why was their wonder foolish? Instead of the eye or the brain, let us take a humbler organ, the epiglottis. Here is William Paley celebrating it:

> In a city-feast, for example, what deglutition, what enhalation! yet does this little cartilage, the epiglottis, so effectually interpose its office, so securely guard the entrance of the wind-pipe, that whilst morsel after morsel, draught after draught, are coursing one another over it, an accident of a crumb or a drop slipping into this passage (which nevertheless must be opened for the breath every second of time), excites in the whole company, not only alarm by its danger, but surprise by its novelty. (*1802*, pp. 156–57)[1]

How would Spinoza have answered Paley? Would he have said that the parts of a watch could have been separately created and thrown into place just by the unregulated interplay of natural forces? According to Sherrington, the number of cells that make up a child at birth, each of which 'has assumed its required form and size in the right place', is about 26×10^{12} (*1940*, p. 101). If watches cannot be thrown together, how can babies be?

Ernst Haeckel's estimate of this lacuna of Spinoza's is interesting. Haeckel was a tough-minded naturalist. (In the present book *naturalist* means someone who adheres to a naturalistic outlook rather than a student of plant or animal life, though quite a few of the naturalists who figure in it, including Haeckel, were also naturalists in the other sense.) He did for Darwinism in Germany very much what Huxley did for it in England. (Kant had said that a Newton of the organic world will never arise; Haeckel said that he had arisen in the person of Charles Darwin.[2]) His other main

1. Philip Woodfield drew my attention to this passage. Here is a modern version: 'Muscles in the diaphragm and the tongue must perform a synchronized operation. At the critical moment, the soft palate must move back to protect the nose cavity, the cartilages of the larynx must displace themselves to close the windpipe, and the epiglottis must duck out of the way before the mouthful of food passes by' (Wooldridge *1968*, pp. 58–59).

2. Popper declared that 'Haeckel can hardly be taken seriously' (*1945/66*, ii, p. 314); but Darwin took him seriously (see, for instance, *Descent*, p. 4; Desmond and Moore *1991*, pp. 538–540), and so did Huxley (see, for instance, L. Huxley 1903, i, pp. 384–85.) Among other things, Haeckel developed the hypothesis that ontogeny recapitulates phylogeny, speculated about a "Missing Link" (it would have an incipient capacity for language), and coined the term 'ecology' in relation to an animal's living-cum-non-living environment.

hero was Spinoza, whom he valued chiefly for his 'pure, unequivocal monism' (*1899*, p. 8). This says that there is no division into Creator and Creation or into Mind and Matter; the world is one substance. (For Haeckel, the one substance was energy, whose different forms are interconvertible; the conservation of energy was the supreme law.) Did Haeckel criticise Spinoza for pooh-poohing what was really a fundamental problem? No at all; he congratulated him for pressing on in advance of any scientific support (p. 103)! Richard Dawkins has expressed the conviction 'that our own existence once presented the greatest of all mysteries, but that it is a mystery no longer because it is solved. Darwin and Wallace solved it' (*1986*, p. ix). Haeckel may have felt that Spinoza was right not to let himself be driven off course by a difficulty which, however serious it may have been then, had now been cleared up.

Since Darwin's day Darwinism has of course been underpinned by a genetic basis. The resulting synthesis is usually known as neo-Darwinism. This has filled out classical Darwinism's solution of the problem pooh-poohed by Spinoza. In the words of Jacques Monod, who received a Nobel prize for his work on genetic coding and protein synthesis: 'The organism is a self-constructing machine. Its macroscopic structure is not imposed upon it by outside forces. It shapes itself autonomously' (*1970*, p. 52). He should perhaps have said 'quasi-autonomously', since there has to be an ongoing collaboration between the organism's genome and its environment if a normal phenotype is to develop. The present chapter will be concerned with Darwin's Darwinism. After considering a feature of it which will prove important later, namely its anti-saltationism, we will go on to consider the bearing of Darwinism on grand metaphysical issues to do with materialism, idealism, God, the soul, and the mind-body relation. Neo-Darwinism will be taken up in the following chapter.

§ 4.1 Anti-Saltationism

Darwin adhered tenaciously to the thesis that only *very slight* variations can be favourable.[3] His deep conviction here is attested by

3. See *Origin*, pp. 413–14, and also Darwin (ed.) *1888*, ii, pp. 333–34 and iii, p. 33.

his reluctant retention of it when he was casting round for ways to rescue his theory after William Thomson (later Lord Kelvin) had authoritatively (but, it turned out later, mistakenly) estimated that the earth had cooled too recently for the animal kingdom to have evolved à la Darwin.[4]

His anti-saltationism was vigorously contested by some of his young supporters. Thus T. H. Huxley regarded it as an unnecessary encumbrance, and he cited counter-examples to it. One was a six-fingered and six-toed man whose deformity was inherited. Another was what Richard Goldschmidt (*1940*) might have called a 'hopeful monster', namely an Ancon ram with an unusually long body and short bandy legs from which a pure Ancon breed was bred.[5] Again, A. R. Wallace's *Darwinism* (1889) has a chapter entitled 'Difficulties and Objections' whose first sub-heading is, 'Difficulty as to smallness of variations'. He there suggested that Darwin had exposed himself to the objection 'that such small and slight variations could be of no real use' (p. 127).

The alternative thesis, that large variations may be advantageous, is of course open to the objection that a large variation in one organ is likely to leave it maladjusted in relation to other organs; thus a considerable lengthening of a wing might overtax the wing muscle, while a considerable strengthening of wing muscle might overtax the heart. How did Wallace meet this objection? At one stage he appealed to something which nowadays is called *coadaptation* and is universally disallowed. This involves the occurrence of two or more variations which are jointly advantageous but none of which would be advantageous without the others. If some or all of them would have actually been *dis*advantageous on their own we might speak of *strong* coadaptation, which is what would be involved here. Wallace wrote: 'This objection seemed a very strong one so long as it was supposed that variations occurred singly and at considerable intervals; but it ceases to have any weight now we know [*sic*] that they occur simultaneously. . . . [A]nd it may also be considered probable that

4. Darwin wrote to a correspondent: 'Thomson's views of the recent age of the world have been for some time one of my sorest troubles' (Darwin [ed.] *1888*, iii, p. 115). Thomson later reduced his estimate of the period since the earth had been a molten mass from 200 million years to a mere 20 to 40 million years (Dampier *1948*, p. 299).

5. See Huxley (ed.) *1903*, i, p. 254 and Huxley 1860, pp. 39, 77.

when the two characters *act* together, there will be such a correlation between them that they will frequently *vary* together' (p. 127). Here he meets an objection to serial coadaptation by bringing in simultaneous coadaptation.

However he then went off on another tack, saying that such 'coincident variations' are not essential and appealing instead to the idea that animals possess "surplus powers" that enable them to absorb large variations:

> All animals in a state of nature are kept, by the constant struggle for existence and the survival of the fittest, in such a state of perfect health and usually superabundant vigour, that in all ordinary circumstances they possess a surplus power in every important organ—a surplus only drawn upon in cases of the direst necessity when their very existence is at stake. It follows, therefore, that *any* additional power given to one of the component parts of an organ must be useful—an increase, for example, either in the wing muscles or in the . . . length of the wing might give *some* increased powers of flight; and thus alternate variations—in one generation in the muscles, in another generation in the wing itself—might be as effective in permanently improving the powers of flight as coincident variations at longer intervals. (pp. 127–28)

That is like saying that a dreadnought which in "ordinary circumstances", in peacetime, cruises at about half her maximum speed and carries about half her full load of ammunition, could have been given either more gun-power and still cruise at that speed, or more engine-power and still carry that amount of ammunition. But what matters is the effect of these enhancements on her performance during a period of "direst necessity", in wartime. A one-sided increase say in gun-power would have to be paid for, say by reduced speed or smaller magazines. If naval architects got the actual balance about right, the cost would have outweighed the gain. And the utility of large variations in an animal should likewise be judged by their bearing on its performance in times of "direst necessity", when survival is at stake. At such times, Wallace would have agreed, it will exploit the powers it uses to the utmost; the concept of *surplus* power ceases to apply here. And if natural selection had got the previous balance about right, the cost of a large enhancement of a single organ would outweigh the gain.

Darwin dealt with saltationist claims in the sixth edition of the *Origin*. He was unimpressed by six-fingered men and Ancon sheep (*Origin*, 6th ed, p. 201). As to the suggestion, put forward by St George Mivart (*1871*), that the wing of a bird was developed by 'a comparatively sudden modification of a marked and important kind', Darwin pointed out that, for a new species to arise from such a modification, not only would large anatomical adjustments within the creature be needed, but it would need a suitable mate. As Ernst Mayr put it, a number of *matching* "hopeful monsters" would need to appear simultaneously (*1976*, p. 93; Darwin's words had been: 'several wonderfully changed individuals [would need to have] appeared simultaneously within the same district', *Origin*, 6th ed, p. 202).

R. A. Fisher (*1930*, p. 40) had a simple and seemingly decisive argument against the viability of large mutations. Assume that wing-length in a certain species of bird is not yet optimal, and let r be the difference between its present length and the ideal length for this bird in the absence of changes elsewhere. We may assume that r is not large, otherwise the species would be unlikely to have survived. Call changes of wing length "small" if less than and "large" if more than $2r$; then "large" changes are always disadvantageous, but "small" ones have a half chance of being advantageous. Dawkins (who drew attention to this argument of Fisher's) pointed out that some seemingly large variations are really duplications, as when a snake gets an additional vertebra as a result of a 'more-of-the-same-here' mutational genetic instruction (*1986*, p. 235). He called them 'Stretched DC8 macromutations'. Huxley's six-fingered man was presumably a case of that kind.

§ 4.2 Materialism

As a way of opening up the question of the relation between Darwinism and materialism, let us look into the claim that Darwin himself was a materialist. This claim was advanced by Howard Gruber, in Gruber & Barrett *1974*, in connection with the young Darwin's notebooks, compiled during 1838–39. They were edited, together with some other early Darwiniana, by Paul Barrett. Stephen J. Gould claimed that materialism was a persisting tendency in Darwin's thinking (*1978*, pp. 21f), and Mario Bunge has taken a similar line (*1981*, pp. x, 91–92).

What kind of materialism was being imputed to Darwin? Let M and C stand for matter and consciousness. Eliminative materialism says that C no more exists than do ghosts or witches. The identity theory says that C exists but adds that it is M. Epiphenomenalism says that C exists and is not M but adds that nothing is done by C; mental happenings are never causes but always only effects of physical changes. No one is claiming that Darwin embraced eliminative materialism; we will find him taking for granted the reality of dreams, fears, pains, memories, and other mental occurrences. Gruber's view seems to be that the young Darwin was a materialist in the sense of the identity theory (though Gruber didn't use this term). Darwin, he says, 'considers a mental act to be a brain event' (1980, p. 48); for Darwin, 'the brain *is* the mind' (p. 57). Gould's view seems to be that Darwin was an epiphenomenalist (though Gould didn't use this term) who held that thoughts are by-products of brain processes and do not affect bodily behaviour. Thus Gould, after declaring that 'Darwin applied a consistent philosophy of materialism to his interpretation of nature' (*1978*, p. 13), added that this is 'the postulate that matter is the stuff of all existence and that all mental and spiritual phenomena are its by-products' (p. 24). Now the Notebooks do indeed contain entries that suggest materialism. One opens with the words: 'To avoid stating how far I believe in Materialism, say only . . .';[6] at another place he exclaims to himself 'oh you materialist!';[7] elsewhere he added: 'This materialism does not tend to atheism'.[8] However, I will argue that already in the Notebooks Darwin rejected both the identity theory and epiphenomenalism, and that as he used it, 'materialism' meant a kind of naturalism which regards animal mentality as naturally evolved *and as having efficacy for that very reason*.

Gould claimed that Darwin kept his materialism to himself, still side-stepping the issue in *Origin* and letting the cat out of the bag (not his expression) only in *Descent* and *Expression*. Darwin, he said, delayed publishing his theory, partly from a need for

6. Barrett *1980*, p. 16, § 57; the sentence continues: '. . . that emotions, instincts degrees of talent, which are hereditary are so because brain of child resembles parent stock'.

7. Ibid, p. 190, C166.

8. Ibid, p. 134, OUN 37n.

supporting data, but mainly from his fear of avowing a heresy; not
the heresy of evolution (evolution 'was widely and openly dis-
cussed during the first half of the nineteenth century', p. 23) but
the deeper and more dangerous heresy of materialism. Now it is
true that evolutionary ideas were already in the air. Here is a
revealing glimpse: in April 1856 Charles Lyell, the geologist who
had such an influence on Darwin, made the following entry in his
notebook:

> After conversation with Mill, Huxley, Hooker, Carpenter and Busk
> at Philos. Club, concluded that the belief in species as permanent,
> fixed and invariable, and as comprehending individuals descending
> from single pairs or protoplasts is growing fainter—no very clear
> creed to substitute.[9]

Darwin himself added to the second edition of *Origin* a
'Historical Sketch' in which he listed a number of naturalists who
had made some contribution to the idea of the mutability of
species.

But most earlier theories treated evolution as progressive, and
as proceeding under the guidance of a beneficent force. They did
not undermine Paley's argument for the existence of divine
design. A passage which Darwin quoted from the anonymous
Vestiges of Creation (1844; tenth edition 1853) spoke of 'the sev-
eral series of animated beings, from the simplest and oldest up to
the highest and most recent' as 'tending, in the course of genera-
tions, to modify organic structures in accordance with external
circumstances', adding that these are 'the "adaptations" of the
natural theologian' and that it all takes place 'under the provi-
dence of God'. In Darwin's theory, by contrast, there is no super-
vision: the processes of variation and selection are mindless; they
create the appearance of design, but this appearance is deceptive. I
think that Darwin expected, and rightly, that *his* theory of evolu-
tion by natural selection would provoke fierce hostility. This did
not make him afraid to publish it; he always envisaged eventual
publication. But it would need a lot of empirical support.

As we saw, the M and N Notebooks do show Darwin referring

9. Quoted in Ruse *1979*, p. 202; the OED entry for 'protoplast' says: 'the first-made
thing or being of its kind; the original archetype'.

to himself as a materialist. But what did he mean by 'materialism'? At around this time he noted in the margin of a book: 'By materialism, I mean, merely the intimate connection of kind of thought with form of brain.'[10] This is rather tantalizing; the 'intimate connection' could be anything from identity to two-way interaction. There are entries in the Notebooks that appear to support Gould's or Gruber's readings of Darwin's "materialism". One runs: 'The mind is function of the body'.[11] And at one place Darwin toyed with the idea that the relation of thought to brain is analogous to the relation of gravity to matter: 'Why is thought being a secretion of brain, more wonderful than gravity a property of matter?'[12] But elsewhere he turned against this idea:

> if thought, etc bore the same relation to the brain that [gravitational] attraction does to matter, it might with equal propriety be said that the /living/ brain perceived, thought, remembered, etc
>
> Now this would certainly be a startling expression, & so foreign to the use of ordinary language that the onus probandi might fairly be laid with those who would support the propriety of the expression.[13]

And Darwin went on to deny any analogy between the gravity-matter relation and the thought-brain relation:

> There is nothing analogous to this [the relation of gravitational attraction to matter] in the relation of thought, perception, memory etc. either to our bodily frame or the cerebral portion of it
>
> Thoughts, perceptions etc., are modes of subjective action—they are known only by internal consciousness & have no objective aspect. If thought[s] bore the same relation to the brain [that gravitational attraction bears to matter], they could be perceived by the faculty by which the brain is perceived but they are known . . . quite independent[ly] of each other
>
> Thought is only known *subjectively* . . . the brain only objectively.[14]

10. See Gruber *1981*, p. 201.
11. Barrett *1980*, p. 71, § 5.
12. Ibid, p. 191, C 166.
13. Ibid, p. 136, OUN39.
14. Ibid, p. 137, OUN41.

Darwin was here anticipating an objection raised in a famous paper by Thomas Nagel (1974) against all attempts at physicalist reductions of mental phenomena. Nagel rightly insisted that an essential feature of the latter is their subjectivity, their being tied to a unique point of view. By contrast, a physical structure has an objective character not tied to any particular point of view. Hence a purported "reduction" of the mental to the physical would deprive the former of its most essential feature.

The Notebooks are largely concerned with distinctive peculiarities of mental phenomena. As Gruber himself says, 'These notes contain fascinating sketches of possible psychological treatises—on the causes of happiness, on dreams, on unconscious imagery, association, and creative thinking' (in Barrett, *1980*, p. 56). (One persistent theme is a topic that will come up in § 4.4 below, namely split consciousness.) And there are places where Gruber's own commentary seems rather to suggest that Darwin accepted dualist interactionism. For instance he made the following comment on Darwin's theory of blushing: 'In this passage he is writing, as often before, about the relation between mind and body [footnote omitted]. But this time there is a reversal. He is talking about . . . the way in which mental events influence bodily ones' (p. 112). Darwin's view, Gruber continued, 'means that blushing requires a person conscious of himself and conscious of others, conscious of his own past and of others' thought about [his own past]' (p. 113). So blushing is the somatic effect of a rather complex conscious state. That sounds like an 'in-out' process.[15] But the omitted footnote sends Darwin back to physical reductionism: 'By this time we can be confident that for Darwin this [the relation between mind and body] means the relation between the brain and other organs of the body.' Gruber did not discuss the passage quoted earlier where Darwin repudiates the identification of subjective mind with objective brain.

Gruber claimed (p. 52) that Darwin arrived 'at a hypothesis astonishingly like the famous James-Lange theory of emotions', which says that we feel fear because we are running away and not the other way round. But here Gruber seems to have misread the following (admittedly none too perspicuous) entry:

15. I adopt this term from McGinn *1991*, p. 54n.

The sensation of fear is accompanied by /troubled/ beating of heart, sweat, trembling of muscles, are not these effects of violent running away, & must not <this> /running away/ have been usual effects of fear.[16]

I read this as saying that troubled beating of the heart, sweat . . . are effects of violent running, the running away itself being the effect of fear; the causal arrow is again 'in-out', from mental state (fear) to bodily action (running away), the latter having other bodily accompaniments (such as faster heart beat).

There is further evidence in the Notebooks that the young Darwin's "materialism" imputed great causal importance to mind (consciousness, thought) while insisting that it has a secular origin, having evolved along with animals' bodies. When he wrote: 'The soul by the consent of all is superadded, animals not got it',[17] he was not, as some commentators have supposed,[18] expressing his own view; he was entirely persuaded that animals *have* got it. (This entry goes on to speak of animals as 'our fellow brethren in pain'.) And he regarded its first coming into existence in some rudimentary form as a momentous development. Thus he wrote: 'People often talk of the wonderful event of intellectual man appearing', but 'introduction of man nothing compared to the first thinking being'.[19] 'My theory', he confided, 'would lead to the study of instincts, heredity and *mind heredity*'.[20] It seems that Darwin from the outset regarded their mentality as crucially important to the biological organisms on which natural selection operates. The difference between having mentality and not having it is much bigger than the difference between human mentality and mentality in other animals: 'The difference [in] intellect of man & animals not so great as between living thing without thought (plants) & living thing with thoughts (animal).'[21] When some twenty years later and with *Origin* about to be published, he asked what was the lowliest sort of creature his theory needed

16. Barrett *1980*, p. 16, § 57.
17. Ibid, p. 187, B232.
18. e.g. Humphrey *1986*, pp. 62–63.
19. Ibid, p. 186, B207.
20. Ibid, p. 187, B228, my italics.
21. Ibid, p. 186, B207, B214.

to have originally existed for it to account for the subsequent production of all presently existing kinds of vertebrate animal, his answer was not some mindless cellular ensemble but 'a simple Archetypal creature, like the Mud-fish or Lepidosiren, with the five senses and *some vestige of mind*'.[22] The Notebooks, intended for their author's eyes alone, are often hard to decipher; but although the word 'materialism' crops up in them from time to time, they seem to me to point unambiguously to a position akin to dualist interactionism.

So much for his position in the Notebooks; what about his position in his published works? Gould claimed that Darwin's reluctance to avow his materialism largely explains his twenty year delay in publishing *Origin*, adding that he did avow it later, in *Descent* and *Expression*. Well, I found nothing smacking of materialism in *Expression*, unless one counts its quiet inclusion of man within the scope of 'the general theory of evolution, which is now so largely accepted' (p. 336). As to *Descent*: one of its main theses is that virtually every feature of human mentality also appears, though perhaps only in a rudimentary or incipient form, in other animals: there are large variations and gradations within our species, between a Newton or a Shakespeare and, say, a Fuegian savage; and there are again large variations and gradations between a Fuegian savage and an orang-outan; but though large, these are only differences of degree; 'the senses and intuitions, the various emotions and faculties . . . of which man boasts, may be found in an incipient, or even sometimes in a well-developed condition, in the lower animals' (p. 193); many human varieties of consciousness, such as pleasure, pain, suspicion, attention, memories, even jealousy and love, are shared to varying degrees by the lower animals (pp. 98f).

Another main thesis was that all this animal consciousness has had a high survival value. Again, he tended to work backwards from the human condition. He took it for a fact that man mainly owes his predominant position in the world to his intellectual faculties; but since these faculties were inherited from primeval men and their ape-like progenitors, they were always being advanced by natural selection (p. 196). He imputed great biological utility

22. Letter to Lyell, F. Darwin *1888*, ii, p. 174, my italics.

to animals' intelligence. For instance: 'In North America, where the fur-bearing animals have long been pursued, they exhibit, according to the unanimous testimony of all observers, an almost incredible amount of sagacity, caution and cunning' (pp. 121–22). He supported the claim 'that animals possess some power of reasoning' with the assertion that they 'may constantly be seen to pause, deliberate, and resolve' (p. 114). Perhaps *constantly* is too strong; but many animals surely do make preliminary investigations.[23] (Our cat, up a tree and wanting to jump onto a rather slender branch, will first test it with her paw.) It surely never was Darwin's view that an animal's consciousness enables it to be no more than the powerless spectator of its body's struggles to survive.

Apart from Darwin's personal opinions, there is a straightforward Darwinian argument for the efficacy of consciousness. It goes like this:

Major premise: If in the course of evolution a phenotypic character has spread widely among a large variety of species and has become more pronounced during phylogenetic development, then it was being selected for its survival value.

Minor premise: Consciousness has spread widely among a large variety of species and has become more pronounced during phylogenetic development.

Lemma: Something can have survival value only if it affects bodily performance.

Conclusion: Consciousness affects bodily performance.
It will be useful to give this argument a name for easy reference; I will call it the *survival-value argument* for the efficacy of consciousness. (A way of trying to avoid this argument will be examined and found wanting in § 4.5 below.)

In the 1920s Darwinism was waved aside by influential philosophers. Thus Wittgenstein declared: 'The Darwinian theory

23. Tinbergen (*1953/65*, p. 45) gave a nice example, due to Lorenz, of a small creature being observed to pause, deliberate, and resolve.

has no more to do with philosophy than has any other hypothesis of natural science' (*1922*, 4.1122). The case of C. D. Broad in *The Mind and its Place in Nature* (1925) is more remarkable. He had hold of the survival-value argument—and then threw it away. Whatever his eventual position was with respect to the fifty seven—sorry, seventeen—varieties of theory he enumerated about the relation of mind to matter, he was at one stage favouring what he called Two-sided Interaction, declaring the arguments against it 'worthless', and 'seeing no good reason to deny that mind acts on body' (p. 118). So one might have expected him to invoke the survival-value argument, which he did. He presented it fairly enough as follows:

> It is a fact . . . that minds increase in complexity and power with the growth in complexity of the brain and nervous system. Now, if the mind makes no difference to the actions of the body, this development on the mental side is quite unintelligible from the point of view of natural selection. Let us imagine two animals whose brains and nervous systems were of the same degree of complexity; and suppose, if possible, that one had a mind and the other had none. If the mind makes no difference to the behaviour of the body the chance of survival and of leaving descendants will clearly be the same for the two animals. Therefore natural selection will have no tendency to favour the evolution of mind which has actually taken place. (*1925*, p. 119)

And yet he threw it out as 'quite obviously invalid' (p. 119). Why? He wrote: (i) 'Natural selection is a purely negative process; it simply tends to eliminate individuals and species which have variations unfavourable to survival' (*1925*, p. 119), adding: (ii) 'The plain fact is that natural selection does not account for the origin or for the growth in complexity of anything whatever; and therefore it is no objection to any particular theory of the relations of mind and body that, if it were true, natural selection would not explain the origin and development of mind' (p. 120).

Broad had a reputation for being scientifically with it, but sentence (i) was a dreadful clanger. Applied to giraffes, it implies that their necks always were long; what natural selection did was to stop them getting shorter! The fact is, of course, that with genetic recombination and mutation throwing up variations in all directions, selection against unfavourable variations and selection for

favourable variations are all tied up. If a certain variable, say the length of the giraffe's neck, was eventually brought to an optimum value, then natural selection will henceforth exercise a 'purely negative' pressure against variations in any direction from this norm, since they will all be disadvantageous. But before that, it was exercising a directional pressure to bring it, over a long period of time, to that optimum value. (Another kind of natural selection pressure will be discussed in § 5.6 below.)

There is a grain of truth in sentence (ii) above. The theory of natural selection may be unable to account for the *origin* of something for whose growth in complexity it can account. One great example is life itself; as Darwin wrote in 1863: 'It is mere rubbish, thinking at present of the origin of life; one might as well think of the origin of matter' (in F. Darwin *1888*, iii, p. 18). And the same holds for consciousness. As we saw, Darwin esteemed the emergence of consciousness a momentous happening; but why it happened 'is as hopeless an enquiry as how life itself first originated' (*Descent*, p. 100). Robin Fox overshot the mark when he wrote: 'Darwin did not banish mind from the universe as [Samuel] Butler feared; indeed, he gave us a basis for explaining how mind got into the universe in the first place' (1971, p. 295). He should have said: '. . . explaining how mind, having somehow got into the universe, spread and grew in complexity'.

Broad's dismissal of the survival-value argument seems to have gone unchallenged until recently.[24] There is no mention of this or other matters relating to Darwinism in the volume devoted to Broad in The Library of Living Philosophers (Schilpp *1959*), published over thirty years later, and his uncorrected mistake is still repeated; for instance, Richard Swinburne wrote: 'The crucial thing to notice about Darwinism is that natural selection is not a method of evolution at all; it is a method of eliminating the less satisfactory variants among those which have evolved' (*1986*, p. 185).

Some forty years after Broad's pronouncement the biologist W. H. Thorpe rightly complained that philosophers of mind have been 'neglectful of evolution theory which is of profound significance for their subject' (*1962*, p. 82). Actually, when Thorpe

24. See now Lindahl 1997.

wrote that, the frontier between evolutionary theory and philosophy was already being crossed in both directions by such men as Dobzhansky and Popper, who were reviving an earlier tradition of frontier-crossing inaugurated rather discreetly by Darwin himself, and carried on by such thinkers as Baldwin, Haeckel, Huxley, James, and Wallace, to mention only people who figure in the present book.

§ 4.3 Idealism and Panpsychism

It is clear from Darwin's occasional remarks about the origins of life and consciousness that he assumed that there was matter before there was life and life before there was mind. And this *Matter before life, life before mind* assumption seems an obvious candidate to be a component of our world-view. *Matter before life* is clearly endorsed by contemporary science. There could not have been life on earth until its surface had cooled sufficiently, and this life seems to have originated locally. Cosmic radiation constitutes a powerful objection to the hypothesis that it could have travelled here unaided and unprotected from somewhere else (see for instance Delbrück *1986*, p. 31). Francis Crick (*1981*, passim) toyed with the idea, how seriously is not clear, that micro-organisms reached earth from outer space in an unmanned spacecraft; and I suppose that they could have come in some fossilized form. But in any case life must have started well after the Big Bang, as Crick agrees (p. 142). As to *Life before mind,* given that it took a long time before brains were evolved, this is implied by a somewhat stronger assumption whose adoption into our world-view will be argued for below, namely that there is no mundane mentality apart from living brains.

One might suppose that no Darwinian would dispute the *Matter before life, life before mind* assumption, which rules out both idealism and panpsychism. Yet some thinkers sympathetic to Darwinism have tended to espouse, often in a rather oscillating way, some kind of idealism, and a few have plumped for panpsychism. It will be instructive to look into some striking examples of these tergiversations. We may begin with Schopenhauer. He lived too early (1788–1860) to have been literally a Darwinian, but one likes to think that he responded with sympathetic interest

when, near the end of his life he, as a regular reader of the London *Times*, read its review of *Origin*;[25] for he was intensely interested in matters to do with heredity (as we will see in § 6.2 below), and was impressed by the high degree of adaptedness of plants and animals to their environments.[26] A dramatic oscillation between materialism and idealism occurs early in his *1819/44*.[27] On the one hand, certain fundamental principles

> lead us necessarily to the certain assumption that each more highly organized state of matter succeeded in time a cruder state. Thus animals existed before men, fishes before animals, plants before fishes, and the inorganic before that which is organic; consequently the original mass had to go through a long series of changes before the first eye could be opened.

On the other hand

> the existence of this whole world remains forever dependent on that first eye that opened. . . . Thus we see, on the one hand, the existence of the whole world necessarily dependent on the first knowing being, however imperfect it be; on the other hand, this first knowing animal just as necessarily wholly dependent on a long chain of causes and effects which has preceded it, and in which it itself appears as a small link. These two contradictory views, to each of which we are led with equal necessity, might certainly be called an *antinomy* . . . (*1819/44*, i, p. 30)

The aim of natural science is to derive all possible states of matter 'from one another, and ultimately from a single state'. Its philosophy is materialism. But materialism 'carries death in its heart'; it is defeated by the principle *No object without subject*. He added later that the antinomy is overcome in the 'truth' that 'intellect and matter are correlatives, in other words, the one exists only for the other; both stand or fall together They are

25. As Bryan Magee reports, *1983/97*, pp. 3, 98. The review, which appeared on December 26, 1859, was written (except for the opening sentences) by Huxley; see L. Huxley *1903*, i, pp. 255f.

26. 'The eye is well adapted to light and its refrangibility, the lungs and the blood to air, the air-bladder of fishes to water, the eye of the seal to change of its medium . . . ' (*1819/44*, i, p. 159). And see the section on Comparative Anatomy in his *1836*.

27. *1819/44*, i, pp. 29f. Elie Zahar drew my attention to this passage.

in fact really one and the same thing, considered from two oppo-
site points of view' (*1819/44*, ii, pp. 15–16). You have a cake; you
eat it; and still you have it! It is of course not true that 'intellect
and matter are correlatives'; vast amounts of matter in the uni-
verse have no relation to intellect, at least as we know it. The
source of the antinomy is the fallacious principle *No object without
subject*. It is of course true that an object cannot be conceived,
located, or described without a subject to do the conceiving . . .
But an object can exist without being conceived.

Mach embraced Darwinism: 'I have been a witness of the
powerful impetus which Darwin's work gave in my time not
merely to biology, but to all scientific enquiry, and it is not likely
that I should underestimate the value of the theory of evolution'
(*1906*, p. 79); and Darwinism, according to Mach, gives a thor-
oughgoing causal priority to the physical: Darwin's 'theory is
inseparable from the hypothesis that each and every psychical
entity is physically founded and determined' (p. 50). Yet Mach's
sensationalism or "neutral" monism was really a kind of idealism.
In his youth he had briefly accepted the idea that nature is the
totality of the appearances generated by the interplay between
egos and something external and alien to them, namely Kantian
things-in-themselves; and then, as he recorded in a famous foot-
note, it occurred to him, to his delight, that things-in-themselves
are redundant and can be discarded: 'On a bright summer day in
the open air, the world with my ego suddenly appeared to me as
one coherent mass of sensations' (*1886/1906*, p. 30).

Earlier we saw Schlick testifying to the significance of Darwin's
theory of evolution; and there is an oscillation reminiscent of
Schopenhauer's in what appears to have been his last work, a lec-
ture on 'The Universe and the Human Mind' (1936). This starts
with a thoroughly naturalistic review of the human situation
within the cosmos; the conclusion is that man sinks 'into utter
insignificance in the universe' (p. 502). 'But now', Schlick contin-
ued, 'the philosopher appears, and wonders if this account of the
matter can finally satisfy him' (p. 505); "the philosopher" turns
out to be an idealist, and in no time at all he effects a complete
bouleversement: 'the mind of man is again located at the centre of
the world'; idealism 'assures us that the ultimate building-blocks
of the universe are mental in character, and that the whole physi-

cal world, with its atoms and stars, represents merely an external appearance or conceptual construction' (p. 508). Naturalism as envisaged by Schlick reminds one of Housman's lines: 'I, a stranger and afraid/ In a world I never made'; idealism, as he envisaged it, would allow one to change them to: 'I, at home and unafraid/In a world that I have made'. One side says 'that the building-blocks of the universe are electrons and so on, while the other maintains that these building-blocks are sensations' (p. 509); then which is correct? Schlick answered that *both* are: 'we can see in what sense it is perfectly correct to say, with naturalism, that man is only a vanishingly small dust-grain in a universe of inexpressible size and sublimity; and in what other sense it is also perfectly correct to speak, with idealism, of the world as man sees it, as if it were his own world, in which he may feel himself the master' (p. 512). I prefer Berkeley's straightforward kind of idealism to this 'now-you-see-it, now-you-don't' kind.

As a last example I will mention Erwin Schrödinger. He was a Darwinian and made a contribution to neo-Darwinism that will be touched on in § 5.2 below. But his *My View of the World* (1964) has a chapter on reasons for abandoning the dualism of mind and matter in favour of idealism (pp. 61–67).

Some Darwinians have repudiated *Matter before life, life before mind* on the ground that it breaches the principle of continuity. For it implies that at some point in the phylogenetic process, consciousness occurred for the very first time. One common-sense response to this is to point out that this also happens in the developmental process from fertilized ovum to young child. Some thinkers have reacted to this with the thought that the newly fertilized ovum already possesses mentality. Thus the distinguished evolutionist Sewall Wright declared that the emergence of mind from no mind at all would be 'sheer magic' (1964, p. 278). To which Dobzhansky crisply replied: 'If this is "sheer magic", it is a kind of magic the world is full of' (*1967*, p. 31).[28] Let us go into the bearing of the principle of continuity on the *Matter before life, life before mind* assumption.

28. For an interesting account of Dobzhansky's intellectual relationship to Wright, see Ruse *1995*, pp. 43f.

A strong principle of continuity had been upheld in antiquity by Anaxagoras; how, he asked, can hair come from what is not hair, or flesh from what is not flesh[29]—or, we might add, mind from what is not mind? Haeckel was cited earlier as a tough-minded admirer of Darwin. But his adherence to a principle of continuity rendered him tender-minded (I nearly said soft-minded). His *1899* has a chapter on the 'embryology of the soul'; in this he announced that when a sperm and an ovum come together at conception, each brings with it its own "cell-soul", and these two cell-souls coalesce into one soul. But if soulfulness does not emerge ex nihilo, where do these gametes get their souls from? Haeckel answered that unicellular protozoa, the earliest and most rudimentary form of life, have a simple cell-soul (p. 53). But he had not yet gone far enough to placate his principle of continuity: these protozoa need in their turn to have acquired their soulfulness from a still earlier source if soulfulness was not to have emerged ex nihilo with them. Once again Haeckel obliged: 'even the *atom* is not without a rudimentary form of sensation and will' (p. 80).

William James had gone straight to the conclusion to which one is driven if one admits that consciousness exists but denies that it could have emerged in the course of evolution: 'If evolution is to work smoothly, consciousness in some shape must have been present at the very origin of things' (*1890*, i, p. 152, italicized in the original). James himself repudiated panpsychism (p. 164), and he pointed to the havoc a principle of continuity can cause here, enabling you to level up or to level down (p. 138).[30] Let p say that humans possess consciousness and q say that amoebas lack consciousness. Many people would agree that we have here two plain truths. But a principle of continuity as here understood empowers us to proceed equally from p to not-q or from q to not-p; to proceed, in other words, either from the first truth to the denial of the second, or from the second to the denial of the first. As James put it, such arguments 'eat each other up'. There has to be something wrong with a principle that gives its blessing to that sort of thing. Wherein lies the mistake?

29. Burnet *1930*, p. 259; fragment 10 in *Diels*.
30. And see Keith Campbell *1984*, p. 49.

Anaxagoras, Haeckel, and Wright all seem to have assumed that if, for some variable x which now has a positive value, there had ever been a time when $x = 0$, then there would have been a break in continuity when x first acquired a positive value. But that is not so. Let x always have been increasing with time; in § 4.4 below we will find Leibniz pointing out that if x were traced backwards in time it might be found to approach zero asymptotically *or tangentially*. To the famous diagram in Newton's 'System of the World' (*1934*, p. 551) showing the trajectories of missiles hurled, with successively greater force, by a giant hand from the top of a high mountain we could add one showing that of a missile hurled with such tremendous force that it flies away forever along a semi-hyperbola. Its distance s from the mountain top would be a continuous and increasing function of time; however, traced backwards, s would approach zero tangentially and attain zero in a finite time. We should not be driven by continuity considerations to the doctrine that mind is co-temporal with matter.

§ 4.4 God and the Soul

Darwinism would seem to endorse a straightforward rejection of the proposition that human affairs are under divine supervision. However, the publication of Darwin's *Origin* in 1859 generated an intense theological discussion, and we ought to take a quick look at this. I will take advantage of James Moore's excellent *1981*, which provides a comprehensive survey of it (his bibliography runs to 69 pages). Afterwards we can proceed to a quick look at the question of human immortality.

God and Darwinism Five main strategies were open to Christian believers confronted by classical Darwinism: (I) reject it outright; (II) accept it but claim a separate lineage for Man; (III) accept it for the human body but exclude souls from its scope; (IV) accept it, but exploit to theological advantage the gaps in the theory (a main gap being its silence about the origin of consciousness); (V) accept it and subordinate it en bloc to an all-embracing theology that will bring everything under divine supervision.

These strategies were tried out in roughly that order. Strategy I was soon abandoned; head-on opposition died away quite quickly. Michael Ruse writes:

a very high proportion of active scientists, particularly biologists, had followed [Darwin] over to evolution. . . . From friends like Hooker and Huxley to foes like Owen and Mivart, British biologists were evolutionists. Moreover, people became evolutionists at a remarkable speed. In 1859 hardly anyone was an evolutionist . . . By 1865 most British biologists were evolutionists, and one can make a case for setting the date as early as 1862. . . . [T]he holdouts tended to be the older men who were dropping away from active science. (*1979*, pp. 228–29)

Bishop Wilberforce's 1860 review of Darwin's *Origin* was reprinted in 1874; otherwise he seems not to have fired another shot after his intervention at the British Association meeting in Oxford in 1860. And by 1866 his mentor, Richard Owen, was claiming priority over Darwin, according to Moore (*1981*, p. 88), with respect to the theory of natural selection!

As to strategy II: the most intellectually eminent man to take it up, though only briefly, was Wallace. Consideration of his argument for it, which was an interesting one, will be postponed till § 5.4 below. Another thinker who adopted strategy II was the Duke of Argyll, whom Darwin judged 'extremely clever'.[31] He claimed that we humans are degenerate descendants of a primal pair (Moore *1981*, p. 232). What adherents of strategy II badly needed is for our species to be marked out by some physical characteristic, preferably relating to the brain, that had no analogue at all in any other species; for that would suggest a separate lineage, going back perhaps to Adam and Eve. To form an idea of what would have suited them very well we may hark back for a moment to Descartes. Suppose that it had been discovered that humans possess a pineal gland while other animals do not. That would have been a triumph for strategy II, given his claim that souls regulate the nervous system via the pineal gland. But the gland was plainly visible in the brains of sheep and calves which Descartes got from the butcher to dissect. As to the human brain: Descartes reported that the gland had not been visible to him on the sole occasion when he had attended a human autopsy, adding that the 'old professor who was performing the autopsy, named Valcher,

31. F. Darwin *1888* , iii, p. 32. For his part, the Duke called Darwin 'this most advanced disciple of pure naturalism' (1862, p. 392; quoted in Cronin *1991*, p. 26).

admitted to me that he had never been able to see it in any human body' (*Letters*, p. 72). Descartes reported this negative finding in a way that turned it to his advantage; instead of saying that we do not observe the gland in man he said that we do 'observe that the gland is smaller in man than it is in animals' (p. 70). He might have added that it needs to be vanishingly small for the soul to be able to move it.

Adherents of strategy II were long frustrated in their search for the unique human feature. And then Owen claimed to have found it: the human brain is unique in its possession of the hippocampus minor. He was challenged by T. H. Huxley, and the debate aroused intense interest; 'for a month, in April, 1861, all England watched as her two greatest anatomists waged war over a little bump in the brain' (Gould *1978*, p. 49). It turned out that Owen was wrong; apes and other animals also have a hippocampus minor (Huxley *1863*, pp. 133–34). After that the search for a separate physical lineage for Man was abandoned.

Strategy III, which concedes that the human body has been evolved by natural selection but insists that the soul was divinely superadded only when the body was ready to receive it, is still quite widely adopted. (It was re-affirmed by Pope John Paul in a letter to Vatican scientists, 24 October, 1996.) It faces considerable difficulties. We saw that Darwin was persuaded of the survival value to our ape-like progenitors of their conscious intelligence. But if the soul was divinely superadded only late in the evolutionary process, our forebears must have been doing well enough without it before then. (It might be retorted that the soul's utility is not biological but spiritual, endowing its possessor with freewill and a knowledge of right and wrong.) Another difficulty concerns congenital feeble-mindedness. Darwin was wont to stress that while natural selection has produced wonderfully well adapted mechanisms, its products are by no means perfect and occasional malfunctionings are to be expected. But won't feeble-mindedness have to be blamed on God if minds are a divine gift?

At the risk of digressing I may mention that J. B. Watson was in an unholy alliance with theologians who adopted strategy III. He accepted hereditarianism with respect to bodily characteristics but denied it with respect to psychological capacities: 'there is no such thing as an inheritance of capacity, talent, temperament, mental constitution and characteristics' (*1924/30*, p. 94, italics

omitted). His behaviourism was pitted as much against the hered-itarianism associated with Galton, Pearson, and others as against mentalistic psychology. He regarded psychological capacities as superadded—by cultural conditioning, to which he imputed almost magical powers; if applied early enough, any healthy infant could be conditioned to become an artist, merchant-chief—you name it (p. 104).[32] Watson didn't notice that with this claim he was implicitly letting in the inheritance of a powerful kind of mental capacity. Konrad Lorenz was later to write: 'the innate is not only what is not learned, but what must be in existence before all individual learning in order to make learning possible' (*1965*, p. 44). According to Watson, every normal, healthy infant has the potential to fulfil any one of a great variety of vocations. How this tremendous potential gets actualized in individual cases may be determined by cultural conditioning, but it would have had to be there before conditioning began; infants would need to be innately endowed with it.

We might summarize strategy IV thus: fill the gaps in Darwin's theory with divine agency. Strategy IV incorporated strategy III, since one of the gaps in Darwin's theory was its silence about the origin of consciousness. Another gap was Darwin's lack of a viable theory of variations. Thus Asa Gray wrote: 'at least while the physical cause of variation is utterly unknown and mysterious, we

32. His track record with respect to this claim was not very impressive. The infants on which he and his team practised their conditioning arts were hospital-reared. Although he complained that 'we were not allowed full control of the children' (*1930*, p. 167), he seems to me to have been given a pretty free hand. Consider the case of Little Albert, described by Watson as 'a wonderfully "good" baby. In all the months we worked with him we never saw him cry until after our experiments were made!' (p. 159). One result was achieved with consistent success: a child would be conditioned to become intensely afraid of something of which it had been unafraid. Little Albert had played happily with a white rat—until Watson began to have appearances of it accompanied by something unpleasant, usually a loud bang. The laboratory notes record that when the course of conditioning was completed, 'The instant the rat was shown the baby began to cry. Almost instantly he turned sharply to the left, fell over, raised himself on all fours and began to crawl away so rapidly that he was caught with difficulty before he reached the edge of the mattress' (p. 161). Watson explained: 'We were rather loath at first to conduct experiments in this field, but the need of study was so great that we finally decided to attempt to build up fears in the infant and then later to study practical methods for removing them' (p. 159). But did he ever discover methods for removing them? His biographer declared: 'what can be con-ditioned can be unconditioned' (Cohen *1979*, p. 144); but he offered no evidence that Watson ever removed any of the fears he and his team instilled. Watson's infant-moulding programme seems to have got stuck at the stage of engendering phobias which, for all he knew, might prove life-long.

would advise Mr Darwin to assume . . . that variation has been led along certain beneficial lines' (Moore *1981*, p. 274). But there was much dissatisfaction among theologians with strategy IV. As well as the danger that the sphere left to divine agency would shrink as pockets of inscrutability succumbed to scientific investigation, many thinkers deplored the suggestion that God intervenes only now and then; 'a theory of occasional intervention implies as its correlative a theory of ordinary absence [italics omitted] . . . Either God is everywhere present in nature, or He is nowhere' (Aubrey Moore, in Moore *1981*, pp. 264, 268).

Which brings us to strategy V: make a theological take-over bid for Darwinism; replace the Genesis story of a once-and-for-all creation by the idea of an ongoing creation in which "natural" selection is part of a supernatural design. John Dewey called it 'design on the instalment plan'.[33] It is really an extension to the whole animal kingdom of the old providential theory of history, which sought to explain human evil and suffering in terms of the fulfilment of God's long-term plans. It may not have been much fun getting in the way of Julius Caesar's army when he was conquering large parts of Europe, Egypt, and Judea; but he, without realizing it, was making the world ready for Christ. As Arch-Bishop Bossuet put it, when Caesar's task was done, 'the whole world lived in peace under his power, and Jesus Christ came into the world' (*1681*, p. 156). R. G. Collingwood summarized the providential theory of history as follows: 'Thus the plans which are realized by human action (such plans, I mean, as the conquest of the world by Rome) come about not because men have conceived them, decided on their goodness, and devised means to execute them, but because men, doing from time to time what at the moment they wanted to do, have executed the purposes of God' (*1946*, p. 47).

Strategy V can be seen as one more attempt to solve the problem of evil. Its proponents allowed that evolution exacts 'a very terrible price' and has much that is wasteful or cruel in it; but God is directing it 'to an end worth all the cost' (Iverach, in Moore *1981*, p. 331). God, employing slow and roundabout methods, is ensuring that things are getting better all the time.

33. Dewey *1910*, p. 12, quoted in Cronin *1991*, p. 18.

But this "solution" poses a new difficulty, to which Leibniz had drawn attention. It implies that if we could travel backwards in time we would find the world's goodness tending to zero, though perhaps asymptotically (1715, pp. 1080–81). But if God created a world that had much less goodness in it than it would have later, then either he *could* have made it better then but preferred not to, in which case he lacked benevolence, or he *could not* have made it better then, in which case he lacked power. In either case God is less than perfect.

If evil exists, and on a large scale, and if its existence cannot be justified along meliorist lines, then the claim that human affairs are under divine supervision, understood as the continuous and effective supervision of a caring God, is defeated. Some theologians tacitly concede as much. Thus Martin Buber in his *Eclipse of God* (1952) announced that from time to time God conceals himself from the world, as he did during the Holocaust;[34] would a caring God turn away from a suffering humanity just when some divine intervention is most needed? A critical rationalist will prefer not to pussyfoot around but adopt the plain proposition that human affairs are not under divine supervision, or *No divine supervision* for short.

Immortality Does *No divine supervision* knock out the possibility of immortal souls? Some distinguished thinkers have held that there could still be immortal souls if there were no God. Let us look into this. St. Augustine crisply listed the possibilities as to the origin of souls as follows:

> [1] The soul comes from propagation. [2] The soul is created new in the case of every individual. [3] The soul exists elsewhere and is sent divinely into the body of a man at birth; or lastly [4] of its own will, it slips into bodies. (*De Lib*, iii, 21)

[4] will be understood as saying that souls slip into bodies without divine supervision. We may conflate [2] and [3] into [2-3] which says that God has created a soul for each human body, leaving it open whether souls pre-exist the bodies they occupy.

34. For incisive criticism of Buber's and related theological positions see Edwards 1973, pp. 394f, and Grünbaum 1995, pp. 210f.

Augustine rejected the naturalistic [1]: how could a carnal act generate a soul possessing free will and knowing the difference between right and wrong? But he was undecided between the others. And some distinguished twentieth-century thinkers have looked favourably upon something like [4]. John Eccles (*1970*, pp. 82–83) quoted approvingly a passage from H. S. Jennings's *1930* in which the possibility was entertained of a store of selves ready to come forward when an ovum is fertilized. And before that McTaggart had held out the possibility that there is no God but that souls are immortal, pre-existing as well as surviving their bodies (*1906*, p. 291). So he too regarded [4] as a genuine possibility. I will now argue that [4] is not a viable alternative. The argument will focus on the embodying of souls and goes through irrespective of what happens after death.

Let m and n be respectively the number of new human bodies that will come into existence during a certain period and the number of souls available for embodiment during that period. Under [1] above the supply of souls is naturally adjusted to the demand, and $n = m$; and under [2-3] it is divinely adjusted, and again $n = m$. But under [4] there is no regulation of the supply of souls; what assurance is there that n will be large enough to meet the demand? Proponents of [4] seem not to have noticed this difficulty; I know of no place where Plato, for example, asked what guarantee there is of an adequate supply of souls. True, he envisaged souls being recycled; and that might solve the difficulty for a population of constant size. But the human population seems usually to have been expanding, except during mass epidemics; and an expanding population will need additional souls however often old souls are re-used. If it goes on expanding indefinitely, may not a time come when there are not enough souls? But assume that we will always have $n > m$. This assumption raises difficulties of its own. Why should exactly m of them desire to slip into a body during this period, the others preferring to hang back? And if exactly m souls do come forward, what brings about the one-to-one pairing of them with the m bodies awaiting them? No one is telling the souls which body to slip into. Some bodies may offer better prospects than others; may there not be unseemly scrambles with several souls trying to slip into one well-favoured body and other bodies being passed by? I conclude that [4] is not a viable alternative. McTaggart was wrong;

the idea of souls pre-existing and post-existing the bodies they temporarily inhabit presupposes divine control over their creation and distribution.

Thus the choice is really, as one suspected all along, between the naturalistic [1] and the theological [2–3], with critical rationalists being obliged by *No divine supervision* to adopt [1] and to exclude the doctrine of the survival of the soul after bodily death. But should they exclude it in an agnostic spirit in line with Rule 4, or include its negation in line with Rule 3? It is generally accepted that, as Colin McGinn put it, the integrity and functioning of the brain is necessary to the integrity and functioning of the mind (*1982*, p. 16). And during the last fifty years support has been found for a narrower thesis which says that with undamaged brains there is a rough correlation between measures of brain activity and levels of mental activity. The invention of the electroencephalograph (EEG), the discovery of REM (rapid-eye-movement) sleep, and the development of sleep laboratory techniques[35] have made it possible to detect certain significant changes in the brain as a subject passes from wakefulness to sleep and from dreamless sleep to dreaming. Already by 1957 it had been found that the EEG slow waves which take over during sleep give way periodically to bursts of increased activity during REM sleep, when dreaming is occurring.[36] It seems that heightened mental activity, whether the subject is awake or dreaming, goes with increased activity in associated brain areas. All this strongly supports the thesis that no mentality survives the cessation of all brain activity; which means that a critical rationalist should exclude the above doctrine robustly, in line with Rule 3, adopting the proposition that there is no mundane mentality apart from living brains or *No mind without brain* for short. This implies the falsity of the panpsychist doctrine, touched on earlier, that every bit of physical stuff has some (perhaps merely incipient) mentality, and of the related doctrine of "mind-dust", as William James (*1890*, i, p. 149) called it, without believing in it, which says that minds are congregations of pre-existing particles of mentality. It

35. See e.g. Patricia Churchland *1986*, pp. 204f.
36. Hobson 1988, pp. 290f; he cited Kleitman and others.

also rules out David Chalmers's idea that a thermostat has low-grade experiences (*1996*, pp. 293f).

The evidence that defeats the divine supervision hypothesis does not defeat the hypothesis of an aloof God. What attitude should a critical rationalist adopt to the latter? For my part I appreciate Darwin's own painfully and carefully considered response to his own theory. He had been a believer, and had found Paley very cogent.[37] In his *Beagle* days he was still firmly convinced of the existence of God and the immortality of the soul (*Auto*, p. 91). But he slowly moved away from these certainties. He appreciated Asa Gray's attempt to deflect theological wrath by showing that natural selection is consistent with natural theology, but he did not really agree. He wrote to Gray:

> With respect to the theological view of the question. This is always painful to me. I am bewildered. I had no intention to write atheistically. But I own that I cannot see as plainly as others do, and as I should wish to do, evidence of design and beneficence on all sides of us. There seems to me too much misery in the world. I cannot persuade myself that a beneficent and omnipotent God would have designedly created the Ichneumonidae with the express intention of their feeding within the living bodies of Caterpillars. (F. Darwin *1888*, ii, pp. 311–12)

(Darwin had come across this practice in Brazil in 1832.[38]) He came to see that Paley's argument from design, which had seemed so conclusive, 'fails, now that the law of natural selection has been discovered' (*Auto*, p. 87). The existence of suffering fits in with development 'through variation and natural selection' (p. 90) but tells against the theological position. Yet he hesitated: can 'this immense and wonderful universe' be the result of blind chance? He was content to remain an Agnostic (p. 94). Agnosticism of what stripe? I think that Maurice Mandelbaum probably got it right: 'it was an Agnosticism based on an incapacity to deny what there was no good reason for affirming' (1958, p. 376); in other words, having no good reason to believe q is not by itself a reason

37. To pass his Cambridge examination he had had to get up Paley's *Evidences*, and he claimed afterwards that he could have written out the whole book, adding that its logic 'gave me as much delight as did Euclid' (*Auto*, p. 59).

38. See Desmond and Moore *1991*, p. 123.

to believe not-q. (Incidentally, the term 'agnostic' had recently been coined by Huxley, and as a label for his own position.)[39]

However, much as I sympathize with it I will not press this view of Darwin's. So far as the project of developing a distinctive view of freedom within naturalistic bounds is concerned there is no need, given what has already gone into our critical rationalist world-view, to pronounce on the fraught issue of theism *vs* agnosticism *vs* atheism. Between them, *No divine supervision* and *No mind without brain* imply that if God exists he will not impinge on us in this life, or afterwards.

§ 4.5 Epiphenomenalism

There is a way of avoiding the survival-value argument presented in § 4.2 above for the efficacy of consciousness. Let x be a phenotypic character which is generally agreed to have spread widely and become more pronounced during phylogenetic development. It might be claimed that x was being carried along by something else, call it y, which was being selected for its survival value, and that x as such is without survival value. Substitute consciousness for x and the brain for y and you have epiphenomenalism. Epiphenomenalism may here be taken as a stand-in for all theories, from Spinoza's parallelism to Donald Davidson's "anomalous monism",[40] that agree that there is both mental and bodily activity and deny that there is any causal input from the mental to the physical.

Epiphenomenalism, Automatism, and Divided Consciousness
The most influential epiphenomenalist in Darwin's day was the man whom Darwin called his 'general agent' and who called himself 'Darwin's bull-dog', namely Huxley.[41] In 1882, a few weeks before he died, Darwin concluded a letter to Huxley with the words: 'Once again, accept my cordial thanks, my dear old friend. I wish to God there were more automata in the world like you'

39. Or so he claimed in Huxley 1889, p. 239; both the OED and Webster's corroborate this claim.

40. See Davidson *1980*, pp. 214f.

41. Huxley (ed.) *1903*, i, p. 247, ii, p. 62.

(F. Darwin *1888*, iii, p. 358). This was a chaffing reference to a famous paper of Huxley's entitled 'On the Hypothesis that Animals are Automata, and its History' (1874). One might say that where Darwin took a quasi-Cartesian view of humans as intelligent agents and projected it down to pre-human levels, Huxley took a quasi-Cartesian view of animals as automata and projected it up to the human level. He accepted the survival-value argument's minor premise; continuity considerations and similarities between human and animal brains led him to conclude 'that the brutes, though they may not possess our intensity of consciousness . . ., yet have a consciousness which . . . foreshadows our own' (1874, p. 237). So consciousness has spread widely and has become more intense during its development. So Descartes was wrong to deny them consciousness. But he was right to regard them as automata. They are conscious automata. Conversely, Descartes was wrong to say that we are not automata; we too are conscious automata (pp. 243–44).

Huxley drew support for his thesis from a medical case in which a human body seemed to be performing more or less skilled and complex tasks without conscious assistance; for if that can sometimes happen, may it not be happening all the time? It concerned a French sergeant who had been wounded in the brain during the battle of Bazeilles. His case had been reported in 1874 by the physician in charge of it, a Dr. Mesnet. The sergeant had at first been paralyzed, but recovered and became nearly normal, except that, at intervals from about two to four weeks, he would go into a strange state, for periods of from fifteen to thirty hours. In this state he seemed devoid of consciousness; as Huxley put it: 'He eats, drinks, smokes, walks about, dresses and undresses himself, rises and goes to bed at the accustomed hours. Nevertheless, pins may be run into his body, or strong electric shocks sent through it, without causing the least indication of pain' (1874, p. 228). Yet in this state he still executed some tasks with an uncanny precision. Here is an example reported by Mesnet. The sergeant had set out to write a letter to his general suggesting that he deserved a medal for his courage and good conduct. As usual when in this state, he seemed quite oblivious of the presence of people near him. He had before him a pile of about ten sheets of paper.

He was writing on the first page when it occurred to us to draw it quickly away. His pen continued to write on the second page, as if he had not perceived that we had removed the first; and he finished his sentence without pausing, and with only a slight movement of surprise. He had written ten words on the second sheet when we removed it rapidly as we had done the first, and he finished on the third sheet the line he had commenced on the preceding one, in exact sequence. In the same way we took away the third sheet, then the fourth. When he came to the fifth he signed his name at the foot of the page, although all that he had written had disappeared with the preceding sheets. We then saw him raise his eyes to the top of this blank page, read all that he had written, forming each word with a movement of the lips, then repeatedly trace with his pen on different points of this blank page—there a comma, there an *e,* there a *t,* attentively following the spelling of each word, which he corrected to the best of his ability; and each of these corrections corresponded to an incomplete word that we found in the same position, even to distance, on the sheets that we held in our hands. (1874, p. 54)

As Huxley put it, 'If the five sheets had been transparent . . . they would, when superposed, have formed a properly written and corrected letter' (1874, p. 233).

The sergeant's transitions to an abnormal state were abrupt, according to Mesnet, and his performances became 'quite automatic, the simple result of waking habits continued in sleep': 'the being who is conscious, responsible, in full possession of his senses, is an instant later only a blind instrument, an automaton obedient to the unconscious activity of his brain' (italics omitted). Huxley concurred: 'in the abnormal state, the man is a mere insensible machine' (1874, p. 235).

However, the Mesnet-Huxley interpretation of this case was searchingly challenged by Alfred Binet. Nowadays, Binet usually rates a footnote for his work on intelligence testing. But he and Pierre Janet, both pupils of Charcot, did experimental work in psychology of far-reaching philosophical significance. Concerning Mesnet's view that the sergeant's doings in his abnormal state were purely reflex and automatic Binet wrote:

This explanation, emanating from an authority who had himself observed the facts, is presented with such conviction that several psychologists have had no difficulty in accepting it. . . . [It] has been

adopted by the well-known English naturalist, Huxley, and has been used by him in constructing his theory that consciousness is an epiphenomenon. Of what use is consciousness, it is asked, if it can be so easily dispensed with, if the brain, in its absence, can perform intelligent actions? (*1892*, p. 63)

He went on to declare their hypothesis 'very rash', claiming that the case is open to 'a totally different interpretation . . . if the observations be reread with care. One meets with signs of consciousness at every turn' (p. 64). Indeed, his criticism largely took the form of citing details from Mesnet's own report against the latter's general diagnosis. Mesnet had claimed that the sergeant's doings, in his abnormal state, were 'waking habits continued in sleep'; yet by Mesnet's own account, the sergeant, a man of entire moral integrity in his normal state, exhibited an 'irresistible desire to steal' when in an abnormal state. Here is another observation of Mesnet's that Binet turned against the "insensible automaton" thesis: 'Touch is of all the senses the only one which persists and puts the patient in relation with the external world. The delicacy with which he moves his hands over objects, the use which he makes of touch on a thousand occasions when we were present, attest a refinement and acuteness of this sense above the normal average' (quoted by Binet, *1892*, p. 47).

Let us leave the sergeant for a moment and turn to another case studied by Binet (*1892*, pp. 65–74). Binet had been fascinated by Charcot's work on hypnosis. One of Charcot's patients at the Salpêtrière Hospital was a journalist, referred to as B—, who periodically suffered attacks during which he went into an abnormal state rather similar to the sergeant's. B— had often mentioned an intention of writing a story about the Salpêtrière. During one of his attacks he was provided with pen, ink, and paper, and the word 'Salpêtrière' was shouted at him. (Unlike the sergeant, B— was not totally blind and deaf to people around him during an attack.) He soon began to write, and he completed twelve pages within an hour. When he emerged from his abnormal state he was shown the pages. He was astonished; they were in his handwriting and the sort of thing that he might have written, yet he had no recollection of writing them. In a later abnormal state he carried the story to page 20. When he emerged this time he was not shown these new pages, and nothing more was

said, either to him or by him, about his story. About three weeks later he again went into an abnormal state and was again induced to resume his story. As a practising journalist, B— followed the custom of repeating, at the top of each new page, the last word or two of the preceding page. He numbered the new sheet page 21, and wrote at the top of it the last two words of the old page 20, as if there had been no interruption of his story-writing.

B—'s case seems to exemplify rather clearly Binet's fundamental hypothesis to the effect that the normal unity of consciousness can sometimes be split into two or more consciousnesses, each with its own memory, and even, perhaps, its own moral character (*1892*, p. x). (Recall the sergeant's proclivity to steal when in an abnormal state.) Typically, though we will encounter exceptions to this, neither of the two consciousnesses has any direct awareness of the other. If we think of B— as turning into B_2 during an attack, then periods when B_2 was "out" were blank periods for B— and vice versa. When B_2 was writing that story about the Salpêtrière he would presumably have experienced no significant temporal gap between reaching the bottom of page 20 and beginning page 21. In cases where Huxley and others saw a normally conscious person turning, from time to time, into a mindless automaton going through various behavioural motions, Binet saw the control over a human body temporarily switched from the usual consciousness to an alternative consciousness.[42]

Binet together with Janet discovered that the splitting of a hitherto undivided consciousness into two or more separate consciousnesses can be effected artificially, under hypnosis. What Ernest Hilgard later called the *hidden observer method* (1979, pp. 57f) was acknowledged by him to have been discovered in the 1880's by Binet (Hilgard also made acknowledgements to Janet; *1977*, pp. 4–7). Here is Binet's description of this method: 'while [the subject] is in this [hypnotized] state . . . someone speaks to him in a low voice, and arranges with him that he shall answer

42. The entries on Binet in both *The Encyclopedia of Philosophy* (ed. Paul Edwards) and the *Encyclopaedia Britannica* ignore this work. But Josef Breuer made generous acknowledgements to Binet and Janet; it was they who first 'succeeded in getting into contact with their patients' "subconsciousness", with the portion of psychical activity of which the conscious waking ego knows nothing' (*1895*, p. 229); he added that knowledge of a split-off mental region 'we owe, above all, to Binet and Janet' (p. 249). There is an appreciative essay on Binet in Robinson *1978*.

questions in writing. In this way his personality is divided. There is a consciousness that talks with the first questioner, and another consciousness that exchanges ideas with the second' (*1892*, p. 317). Binet showed convincingly that what happens in cases of hypnotic anaesthesia is not that the conscious experiences that would normally have occurred have been eliminated, but that they have somehow been split off or displaced. This is transparently so in the case of negative hallucinations. For example, a subject X is presented with five cards, all similar except that one of them is marked by a little cross; under hypnosis X had been told that he will not see the card marked with a cross, and now he does indeed see only the four unmarked cards. 'How', Binet asked, 'does it come about that he does not confuse the invisible card with the others? It must be that he recognises it. . . . Whence this apparently paradoxical conclusion—that the subject must recognise the invisible object in order not to see it' (p. 301). And the hidden observer method reveals that one part of the subject does indeed recognize it. Binet cited the following instance. A hypnotized subject called Lucie had been forbidden by Janet to see those of the cards on her lap that were marked with a cross; and she did not. But when asked in a low voice to write what she had in her lap, Lucie$_2$ (as we may call the "hidden observer" within Lucie) wrote: 'There are two papers marked with a little cross.' When asked why Lucie had not returned these cards to Janet, Lucie$_2$ answered: 'She can not, she does not see them' (p. 321). Binet reported a variation on the above: all the cards were marked with numbers, the "invisible" ones having a number that is a multiple of six. The results were the same, though the "hidden observer" now had to do some mental arithmetic in order to pick out the ones the other self was not to see.

It seems to me that the mistake of treating cases of divided consciousness as cases in which no consciousness is at work was repeated by Kathleen Wilkes in her 1984. She there defended the thesis that both common-sense psychology and neuroscience should discard the idea that consciousness is a real phenomenon (p. 241). One piece of supposedly supporting evidence she reported as follows:

> subjects are hypnotized, told they will feel no pain, and then one arm is put into a stream of circulating iced water. This is rapidly experi-

enced as unpleasantly painful by the unhypnotized; but subjects under hypnosis may sincerely report that they feel no pain, and will leave their arm in the water for long periods, apparently untroubled. On the other hand, and *with* the other hand—if it is supplied with pencil and paper—the subject typically provides a simultaneous running complaint about the intensity and unpleasantness of the pain (see Hilgard [*1977*], pp. 135-203). Such forms of dissociation, common enough in hypnosis and elsewhere, make nonsense of the attempt to describe what is going on in terms of consciousness or its absence. Nor seems there to be a fact of the matter whether the hypnotized subject is *really* in pain or not. (Wilkes 1984, p. 234)

But the fact of the matter is that a consciousness has here been split into two, one of which is in pain and the other is not. Hilgard had obtained these results with the help of the hidden observer method. Here, he explained, a hypnotist says to the hypnotized subject something like this: 'When I place my hand on your shoulder, I shall be able to talk to a hidden part of you that knows things . . . that are unknown to the part of you to which I am now talking. The part to which I am now talking will not know what you are telling me or even that you are talking' (1979, p. 59). Rather as Lucie$_2$ saw the cards that Lucie was not allowed to see, so the hidden observer hypnotically installed within this subject experienced the pain that the subject was not allowed to experience.

Wilkes also drew support for her away-with-consciousness line from the uncanny phenomenon of epileptic automatism (1984, p. 231). Here, subjects may go through some complex and demanding performance with an efficiency only a little below par, although they had, according to their own subsequent account, completely blacked out beforehand. Wilder Penfield, who devoted much of his life to treating epileptics, had some interesting examples of this. Patient A was a pianist; if he was playing when an attack of petit mal came on, he would, after a slight interruption, continue playing with near-normal dexterity (*1975*, p. 39). Consideration of his case, which does not seem too problematic, will be postponed to § 4.7 below. But other cases were highly problematic. For instance, patient C drove his car home after blacking out with an attack of petit mal. Driving a car requires continuous adjustments to one's perceptions of changing

road conditions. Now C did admittedly go through some red lights; his driving efficiency was somewhat below par. But he got the car back safely; if he was quite without consciousness, how did he do as well as he did?

Binet extended his 'divided consciousness' hypothesis to epileptic automatism, imputing 'a double psychological life' to at least some patients (*1892*, p. 40). This hypothesis has the great advantage that it offers an explanation for the above kinds of skilled responses in situations that vary unpredictably. Penfield based his assumption that 'the patient becomes suddenly unconscious' (*1975*, p. 39) at the outset of an attack of automatism on the subsequent reports of the patients. But their total amnesia for the period is, of course, consistent with the alternative assumption that another, separated consciousness had taken over, leaving no trace in the normal memory. Perhaps Binet's hypothesis extends to that rather lowly form of automatism, sleep-walking; he reported in connection with cases of supposedly total hysterical anaesthesia that 'the anaesthesia adapts itself to the practical requirements of the subject. He is generally able to perceive what he needs to perceive' (*1892*, p. 296).

Wilkes was not dismissive of consciousness in her discussions (1981; *1988*, pp. 109f) of another case of divided consciousness, the remarkable case of Miss Beauchamp, of which a classic study was made by her physician, Morton Prince (*1908*). Her story, or rather "their stories", would have been reduced to a scrappy catalogue of bizarre episodes if the teller had tried to edit out consciousness and comply with Otto Neurath's injunction to stick to behaviour 'that one can observe and "photograph" scientifically' (*1931*, p. 361). A video camera might have caught the following: a youngish woman wakes up and is obviously frightened on finding herself naked and precariously posed on top of a pile of furniture in a bedroom. Call that Scene 2. The previous evening the camera might have recorded this woman as she piles up furniture, undresses, climbs cautiously to the top, stretches out, and closes her eyes. Call that Scene 1. What was going on? Prince discerned several distinct personalities occupying the same body at different times. The three most notable of these he labelled '*B* I', 'Sally', and '*B* IV'. Very much in line with Binet's fundamental hypothesis, they each had their own moral character and stream of consciousness. In most cases a personality had a total amnesia for

periods when another personality was "out". But Sally was an exception. As Wilkes put it:

> whenever B I, B IV or B II were in control, Sally coexisted as a second consciousness, aware of all their actions and of the thoughts of B I and B II, while keeping her own counsel. In fact it was only when Sally herself was 'out' that there were not two coexisting streams of thought, and when she merely coexisted, her stream of consciousness and even her sensory experience might be very different from that of the primary personality. For example, . . . she claimed to know all about B I's dreams, even those B I had forgotten; she described with amusement the weird and chaotic thoughts of B I in delirium; she did not attend if B I or B IV were engaged in some occupation that bored her . . . [O]n the other hand, if B I was walking along in a vague trance, not noticing much around her, Sally might be attending with interest to small details of the passing scene. (1981, p. 341)

There was intermittent warfare between these very different personalities, and the explanation for the above-mentioned scenes is that Sally, who hated *B* I, was making preparations in Scene 1 for *B* I's awakening in Scene 2.

Back now to the sergeant: how explain his uncanny accuracy in correcting that letter? Let $Sergeant_2$ denote this man when in an abnormal condition. It seems incredible that $Sergeant_2$ could have so nicely executed that once-only task as a blind automaton. But can Binet's hypothesis do any better? How could a consciously seeing $Sergeant_2$ correct a letter that wasn't there? Well, Binet's hypothesis could be strengthened in a certain way. It is well known nowadays that some "idiot-savants" possess a photographic memory. Oliver Sacks (*1985*, Part Four) reported several such cases (including that of José, written off by the hospital attendant as 'just a Xerox', p. 207). "Photo-copying" performances by such people have been carried out under experimental conditions. The subject is presented with a complex visual scene (St. Pancras Station, say, or a New York skyline) which he stares at intently. The scene is also photographed, using a wide-angled lens, from the same viewpoint. The subject then goes back to his drawing board, from which the scene is not visible, and there executes, rapidly and without hesitation, a highly detailed drawing of it. Except that it may need a left-right inversion, this turns out to match the suitably enlarged photograph well-nigh perfectly,

though it might occasionally show four windows, say, where the photograph shows three. It seems that the subject has a photographic memory of such hallucinatory intensity that it is as if he were bending over a sheet of paper on which outlines of the chimneys, windows, cranes, roofs, and so on, show up so sharply that he has only to trace them, which he does quickly and accurately. So perhaps Sergeant₂ was like an idiot-savant who could still "see" his handwriting after the page had been withdrawn.

Epiphenomenalism and the Futility of Pain Who first spelt out the survival-value argument for the efficacy of consciousness? I was a shade surprised to find the idealist philosopher F. H. Bradley touching on it in a paper 'On the Supposed Uselessness of the Soul' (1895). He there pointed out that epiphenomenalism appears to be inconsistent 'with another prevailing doctrine', namely Darwinism: for 'when the Darwinian view is applied to the soul, the soul apparently must be of service', must do something. Before that, William James had got hold of the argument after reading Darwin's *Descent* (1871).[43] He was provoked by Huxley's Automata paper (1874) to present it in a rebuttal, 'Are We Automata?' (1879). He afterwards incorporated it into Chapter 5 of his *Principles of Psychology* (1890). His presentation starts with what, in the restatement of it in § 4.2 above, is the minor premise: 'It is very generally admitted, though the point would be hard to prove, that consciousness grows the more complex and intense the higher we rise in the animal kingdom.' So consciousness seems to be something which, like the animal's bodily organs, helps in the struggle for existence. Then comes our lemma: 'But it cannot help him without being in some way efficacious and influencing the course of his bodily history' (*1890*, i, pp. 141–42). He had a good argument against epiphenomenalism as a way of avoiding the survival-value argument for the efficacy of consciousness. It was as follows. It is an empirical fact that there is a rough correlation between x being good (bad) for an animal survivalwise, and the animal finding x pleasant (unpleasant); but there would be no reason to expect such correlations if sensations of pleasure and pain as such make no difference to

43. See Richards *1987*, pp. 433f. James's evolutionary argument for the efficacy of consciousness is discussed from a standpoint similar to my own in Lindahl 1997, pp. 615f.

behaviour; indeed, it could just as well have been the other way round (p. 146); your hand being over a flame might give you a delicious thrill but neurobiological processes would still cause you to whip it away.[44]

Nature occasionally runs an experiment in which an otherwise healthy individual lacks a sense of pain.[45] Roland Puccetti recounted the story of Miss C., who was quite impervious to electric shock and other tests for pain, and for whom the word 'pain' meant nothing; she had never known even physical discomfort. She came in for a lot of burns and other injuries, which often became badly infected because unnoticed by her, but was otherwise a normal, healthy, intelligent girl, with an active social life. And she gradually learnt to be more efficient in guarding against injury. Yet she died at 26. What defeated her was something she could not guard against: her lack of sensitivity to muscular discomfort. Her right hip began giving trouble, and this led to progressive muscular weakening and bone deterioration. Puccetti identified the underlying cause thus: 'unable to feel discomfort when standing too long on one leg or sleeping too long on one side of her body, she did not make all those little postural adjustments we make unconsciously, to relieve stress on the skeletal structure. In the last month of her life Miss C. reported pain for the first time, in the left hip. But by then it was too late' (1975, p. 261). Of course, not all pains have biological utility, and it would be nice, as Puccetti remarked, if an analgesic mechanism switched off those pains which do not (p. 263). That would allow mortally wounded individuals to expire peacefully. But natural selection had no reason to devise such a mechanism.

Consider the role of sensation in evolving protection against the strategy, widely adopted by plants and living creatures, of being at once conspicuous and toxic. At a lowly level we may have a non-sentient creature, call it species A, whose only protection is a physiological withdrawal mechanism triggered by bodily contact with the toxic object. Species B (which might be species A at a later evolutionary stage) does better than that. As well as a physiological withdrawal mechanism it has a rudimentary sensitivity, and bodily contact is accompanied by stinging sensations which

44. James was followed here by McDougall *1905*, p. 159; see Bacrac 1991, p. 11.
45. See Dennett *1991*, p. 61 and the references cited there.

speed up withdrawal. This reduces the poison that gets into the blood stream, though without eliminating it. Species C again does better. It has a sense of taste and a visual sense. Members of C who try eating these conspicuous objects find them disgusting, spit them out, and avoid them in future. (Tinbergen reported that when young and inexperienced birds take the caterpillars of cinnabar moths 'into their mouth, they reject them with signs of disgust, such as violently wiping their beak.' These caterpillars are conspicuous, with alternating black and yellow rings, and those birds subsequently refused them altogether, having learnt their lesson.)[46] Species D does better still. It has a sense of smell; finding the toxic objects malodorous, it avoids direct contact with them. All such developments of specialized kinds of sentience make good evolutionary sense if the stinging sensations, nasty tastes and smells, and so on make a contribution to behaviour. They would be pointless complications if they were mere accompaniments of an underlying physical process that would work just as efficiently without them.

The strategy of being at once conspicuous and toxic obviously relies on would-be predators having a *visual* sense. Presumably the earliest "eyes" did not give rise to visual sensation. Darwin wrote: 'The simplest organ which can be called an eye consists of an optic nerve, surrounded by pigment-cells and covered by translucent skin, but without any lens or other refractive body' (*Origin*, 6th ed, p. 144). An optic nerve that reacts to shadows has biological utility for some non-sentient creatures, such as barnacles and sea squirts; a sea urchin 'turns its pointed needles in the direction of danger, and the pincerlike jaws at the base of the needles stand up, ready to seize any enemy that comes too close' (Wooldridge *1968*, p. 61). But again it seems obvious that the eye's biological utility will greatly increase when it provides visual imagery, so that, among many other such things, birds can notice caterpillars' black and yellow stripes. Why should evolution have brought about capacities for visual imagery if a creature's sensations make no difference to its bodily behaviour? Isn't visual imagery of benefit to eagles? On the sandy ground a well-camouflaged snake is silently sliding forward; high up an eagle is circling.

46. Cited by Alister Hardy (*1965*, p. 141). Tinbergen referred to Windecker. And see Tinbergen *1953/65*, p. 96.

A moment later the snake is on its way to the eagle's nest. Are we really to accept from epiphenomenalism that any visual experiences the eagle may have had did nothing to assist it in this efficient performance? (As we shall see later, the remarkable phenomenon of blindsight does not tell against the present claim.)

Epiphenomenalists are often surprisingly casual with regard to their philosophy of mind. Consider Huxley. Ingemar Lindahl has drawn attention to the following discrepancy. Huxley wrote: 'It is experimentally demonstrable—any one who cares to run a pin into himself may perform a sufficient demonstration of the fact—that a mode of motion of the nervous system is the immediate antecedent of a state of consciousness' (1874, p. 238). Soon afterwards, he asked whether there is any evidence that states of consciousness may, conversely, cause changes to the nervous system, and answered: 'I see no such evidence' (p. 240). Lindahl comments:

> The remarkable thing is that Huxley accepts a combination of inter-subjective and introspective evidence as sufficient for establishing that a relation of the first kind is causal—the one from the nervous system to the conscious experience—but that he does not accept a similar type of evidence as sufficient for establishing that a relation of the second kind is also causal—the one from the state of consciousness to the firing of motor neurones. Why would the succession of pricking oneself being immediately followed by a sensation of pain, be more reliable than the succession of experiencing oneself deliberately initiating an act of pricking oneself being immediately followed by an act of pricking oneself? If one is willing to accept the former succession as causal, why not accept the latter? (1997, p. 615)

Huxley wrote as though nonchalantly running a pin into oneself is the easiest thing in the world. Have you ever tried? I did, once, when I was at school and we were obliged to produce a drop of blood to examine under the microscope. It took about ten volitions and repeated self-exhortations to stop being such a coward.

Here is an example of Huxley being careless as to the implications of his epiphenomenalism. In 1868 he delivered a lay sermon in Edinburgh; in his peroration he declared:

. . . the plain duty of each and all of us is to try to make the little cor-
ner [of the world] he can influence somewhat less miserable and
somewhat less ignorant than it was before he entered it. To do this
effectually it is necessary to be fully possessed of only two beliefs: the
first, that the order of Nature is ascertainable by our faculties to an
extent which is practically unlimited; the second, that volition [foot-
note omitted] counts for something as a condition of the course of
events. (1868, p. 163)

Volition *counts* for something? For an epiphenomenalist, voli-
tion-experiences do not affect the course of events. When Huxley
published this address a quarter of a century later, he attached to
the word 'volition' the following footnote: 'Or, to speak more
accurately, the physical state of which volition is the expression'.
But this is not a minor emendation that can properly be left to a
footnote. It nullifies the original. As he put it later: 'the feeling we
call volition is not the cause of a voluntary act, but the symbol of
that state of the brain which is the immediate cause of the act'
(1874, p. 244). Your volition-experiences warn you how your
brain is about to cause you to act.

Or consider Mach. His *1906* has a chapter on 'The Will' in
which he avowed epiphenomenalism in the opening sentences,
and treated volition-experiences in the same way as Huxley. Three
pages later he recounted his experience of a stroke which com-
pletely paralyzed his right arm and leg. He had vivid dreams of
playing the piano and writing, accompanied by astonishment at
the ease with which he wrote and played. When he woke up he
suffered bitter disappointment (pp. 175–76). But shouldn't bitter
disappointment have set in long before, when he first became
convinced of epiphenomenalism? Did he not then awaken as if
from a long pre-scientific dream in which it seemed astonishingly
easy for his thoughts to control the motions of his pen?

A philosopher who at one time seemed to recognize that
epiphenomenalism is a ground for despair is Bertrand Russell.
This was in 'A Free Man's Worship' (1903). The matter is compli-
cated because he there gave several further grounds for metaphys-
ical despair, some of them rather spurious.[47] One was that Man 'is

47. He said later that he had written this piece at the most unhappy time of his life
(*Auto*, i, pp. 149–150).

the product of causes that had no prevision of the end they were achieving' (p. 47); to which a Darwinian can only say, *Of course!* As G. G. Simpson put it, man is the result of a 'process that did not have him in mind. He was not planned' (*1950*, p. 344). Another, which he did rather go on about, was that we are mortal; we have only a brief time before we are 'seized by the silent orders of omnipotent Death' (p. 56). Another was that Man finds himself in 'an alien and inhuman world' (1903, p. 48) in which omnipotent matter rolls on its relentless way. Well, animals often establish territories for themselves (Ardrey *1966*, passim), and humans are not backward in that respect. (When he wrote this piece Russell was living in Grantchester in the Whiteheads' home; there the visual *Times* no doubt appeared at breakfast with 'admirable exactitude at the same time' as the tactual *Times*,[48] and the mill-stream on which his bedroom looked out was probably the nearest approximation to omnipotent matter rolling on its relentless way.) The world's seeming alien and inhuman may be more the result of human doings than of natural factors (the sun often shone on Auschwitz).

Before I come to what, if valid, would have been a genuine ground for Russell's despair let me turn for a moment to a fictional character. Mme Raquin, in Zola's story *Thérèse Raquin*, is paralyzed by a stroke and becomes an 'imprisoned mind buried alive in a dead body'. Some years earlier her son Camille and her adopted daughter Thérèse had married. Then came tragedy: Camille was drowned in a boating accident when he was out with Thérèse and their friend Laurent. Some time later Thérèse married Laurent, and the couple lived with Mme Raquin. And now, sitting paralyzed with them talking to each other oblivious of her presence, she learns that they had been adulterers and had drowned Camille. When her old friends come round as usual next Thursday evening to play dominoes, she makes a supreme effort of will, a little life briefly enters her hand and fingers as she desperately tries to spell out the terrible truth. She gets as far as 'Thérèse and Laurent have . . .', but can get no further.

Back to Russell. Epiphenomenalism says that our mental life consists of flickerings cast by physical processes on which they

48. See Whitehead *1919*, p. 194.

have no feedback. As Russell rather romantically put it: Man's 'hopes and fears, his loves and beliefs, are but the outcome of accidental collocations of atoms' (p. 47); his outward life is controlled by 'resistless forces' (p. 48), leaving him 'helpless' (p. 49) and 'powerless' (p. 56). Russell's idea was that we can retain a residual freedom by becoming aware of the hopelessness of our condition and maintaining an inner defiance towards the imprisoning world around us (p. 48): 'In this way mind asserts its subtle mastery over the thoughtless forces of Nature' (p. 53); fearless contemplation of fate effects a liberation from fate (p. 55).

But wait! Mme Raquin was indeed helpless and powerless when it came to expressing the terrible truth in her possession; but Russell had no difficulty in that respect. Everyone knows his joke about the letter he received from an eminent logician, Mrs. Christine Ladd Franklin, saying that she was a solipsist, and was surprised that there were not more like her.[49] Yet his own position was rather similarly paradoxical. He got his pen to express the thought that thoughts are impotent with respect to behaviour. Russell reported Wittgenstein writing to him from Trattenbach that the men of Trattenbach are more wicked than the men of other places (*Auto*, ii, p. 100). Suppose that Wittgenstein had instead written: 'The men of Trattenbach are totally illiterate'. This sentence is not illogical in itself; but when written by a man of Trattenbach a pragmatic contradiction is generated: this act of writing it refutes what it asserts. And a pragmatic contradiction occurred when Russell published an article saying that thoughts are powerless in relation to outward life. As William Kneale remarked, belief in the efficacy of thought is presupposed by both sides in any debate about the efficacy of thought (1959, p. 454).

§ 4.6 Control-Motor Dualism

Having assayed the negative implications of Darwinism for epiphenomenalism let us now begin to consider its implications for dualist interactionism. The latter will here be construed as a twofold thesis that applies to human and other large animals,

49. *1948*, p. 196. I tracked down this reference via Musgrave *1993*, p. 105.

including chimps, wolves, and leopards. Thesis (1): such an animal consists of a motor system under a central control system. (How 'central control' should be read will be indicated shortly. But I may mention here that it does not cover quasi-autonomous local controls for circulatory, digestive, respiratory, immune, and other sub-systems.) Thesis (2): within the animal's central control system consciousness is typically playing a significant role. We will turn to (2) in the next section. Thesis (1), with which this section is concerned, stands in opposition to classical behaviourism which saw animals as monistic systems responding in determinate ways to environmental stimuli. It was an essential part of the behaviourist view that the "arc" between stimulus and response is short. Thus Watson declared: 'The behaviorist claims that there is a response to every effective stimulus and that the response is immediate' (*1930*, p. 15); and Skinner endorsed that: 'The process of operant conditioning is committed to immediate effects' (*1971*, p. 120). Let us now try out these ideas against real examples of animal behaviour. (If this armchair philosopher sometimes appears to write knowingly about how animals comport themselves in the wild, it is because I am an inveterate watcher of wild life television films, especially those made by David Attenborough and his associates.)

As we saw in § 4.1 above when we looked into Wallace's idea of reserve powers, the utility of a biological feature may not show itself in "ordinary", relatively undemanding, circumstances. Thesis (1) above does not claim that an animal's central control system is playing a vital role when, for example, it is quietly grazing, its bodily system functioning efficiently under its various local controls. For a fair test between the two hypotheses we need to turn to animals' performances in times of more or less dire necessity as when, for example, a predatory animal with an empty stomach urgently needs to catch a prey. For my first example I take a pack of wolves in northern Canada. (I will write in the present tense although it is many years since I saw the admirable film on which what follows is based.) They remain in the vicinity of a herd of moose, on which they prey from time to time, employing the following scheme. While the main pack pads menacingly after the herd, keeping it moving slowly in one direction, one wolf, presumably self-chosen (the top wolf perhaps), slips away and, keeping out of sight, makes a detour until he is ahead and to one

side of the herd; he then turns and streaks through it. In open country a moose can run faster than a wolf, but the moose who see this wolf coming can take little avoiding action because of the press of animals around them. His task is to inflict just one gash while dodging the flying hooves. If he succeeds, the wolf pack will patiently follow the spoor of the wounded moose, who can be expected to weaken, and eventually to get detached from the herd. It may be several days before the wolves go in for the kill. Although their hunger pangs are presumably growing painfully sharp towards the end of this long drawn-out process, these animals do not lose patience; they exhibit a wolfish version of the steely tenacity that we shall find Spinoza imputing to free human beings.

For my second example I take a leopardess who leaves her two hungry cubs in the lair and sets off in search of food. Eventually she spots an impala. Let S denote her sighting of this desirable object; does S trigger a response R as envisaged by behaviourists? Well, she does not go bounding after it. This motor system is under tight central control. What S initiates is not a response of that kind, but a tense state of preparedness. She moves quietly, keeping downwind and out of sight of the impala, slowly getting closer. Eventually, perhaps ten minutes after her first sighting, she is close enough to spring; and on the present occasion she accurately anticipates the impala's escaping movement. (She is by no means invariably successful; her prey are also well-tuned motor systems under skilled control.) Let S now denote the sight and smell of that fresh meat. Again, this does not trigger a response R as envisaged by behaviourists; rather, it initiates another drawn-out performance as she gets the carcass back to her cubs, a taxing business calling for great vigilance if she is to preserve it from various marauders.

In § 6.2 below the following question will be raised concerning Cartesian volitionism: for how long could a single volition hold sway? An analogous question can be put to behaviourism. How long a stretch of animal behaviour could count as the response to a single stimulus? I don't know what the official reply is, but it seems obvious that a behaviourist would have to agree that in the case both of the wolves and of the leopardess there was not one S-R but a series thereof. And since the series of S's, the prods the animal gets from its close environment, have no theme

or unity, it would be sheer coincidence if the series of R's fell into place like steps in the execution of a relatively long-term plan. But what would be sheer coincidence for animals seen as monistic systems being prodded this way and that by external stimuli is what we should expect for animals seen as powerful motor systems under an ongoing and skilful central control.

The boundary between central control and motor system has to be fuzzy. Is the shaft from the car's steering-wheel part of the control system? It does some controlling but is itself under control. A control system infiltrates into and merges with the controlled system. And the same is true of animals, with efferent nerves from the cortex infiltrating effector muscles and tendons. But although the boundary is fuzzy, some parts are clearly on one side of it and others on the other. In the case of a car, steering-wheel and brake and accelerator pedals are clearly on one side with pistons, sparking plugs, and cooling system (under its local thermostatic control) on the other. In the case of a leopard, its brain and central nervous system are mostly on one side, its powerful hindquarters, claws, and teeth on the other.

Let us now consider this dualistic hypothesis in relation to the Darwinian theory of variations and natural selection. One point that follows from what has just been said is that a single variation, though it might happen to affect both control and motor system, will typically affect either the one or the other. To which we may add that in cases where it affects both, having effect E_C on the control system and effect E_M on the motor system, there would be no reason to expect E_C and E_M to fit in with one another, any more than one would expect the effects of a sudden change of temperature on a car's driver and on the car's engine to fit in with one another. To suppose otherwise would be to introduce a kind of coadaptation. Our earlier repudiation of Wallace's claim that two characters that act together can be expected to vary together extends to cases where one pertains to the control system and the other to the motor system.

Let us now turn to an interesting model put forward by Popper.[50] He based it on the assumption that an organism's

50. He first put it forward in 1961; see his *1972*, pp. 272f. For the chequered history of the piece see Watkins 1995, pp. 191f.

behaviour-controlling part and its executive part are genetically independent of one another. (He stressed that this is just a falsifiable conjecture, but the potential falsifiers he offered all involved coadaptation.) Its message was that in evolution it is developments in the control system that lead the way. His basic idea here was that while no harm is done if control-capacity outruns motor-power, the converse will have more or less lethal consequences. We may illustrate this from the fairy story of the Sleeping Princess, in which the Dwarf puts on seven-league boots in order to reach the Good Fairy quickly. But surely he would never meet up with her so long as he wore those boots. Seven leagues is over 20 miles, and he would have been zig-zagging erratically all over the countryside and forever missing his target, his motor-power grossly exceeding his control-capacity.

Let C and M denote respectively the control-capacity and motor-power of some rather simple system. Suppose to begin with that C is fixed while M can be varied. Given that M can outrun C as well as lag behind it, we may assume that there is an intermediate value of M that is optimal relative to C, or at which C and M are, as Popper put it (*1972*, p. 278), 'in exact balance'; just how this should be understood we will consider shortly. Let C and M be initially in a state (i) of exact balance. If we also allow C to vary, we can envisage two alternative developments: into a state (ii) in which M receives increment DM with C remaining constant; and into a state (iii) in which C receives increment DC with M remaining constant:

C	C	$C + \Delta C$
▬▬▬	▬▬▬	▬▬▬
M	$M + \Delta M$	M
(i)	(ii)	(iii)

FIGURE 4.1

We may call these three states respectively "balanced", "over-powered", and "under-powered". Popper declared that a shift to (ii) would be *lethal* while a shift to (iii), although bringing no immediate advantage, may later be *extremely favourable* (p. 278).

I will refer to this as the Spearhead Model Mk I. As it stands, it is exposed to several objections. Here is one. Imagine an over-powered state coming about in the following way. Some time ago the system was under-powered, with C exceeding M considerably. Since then C has remained constant and there have been 100 successive small increments of M; the 99th increment brought the system into balance and the 100th tipped it over into a slightly over-powered state. On Popper's account the first 99 increments will be favourable and the 100th will be lethal. Continuity considerations argue against this.

The source of the trouble, I believe, was Popper's implicit use of an all-or-nothing notion of control, whereby the motor system is either fully under control or else, the moment M rises above a critical level, quite out of control. As well as generating major discontinuities, this has the unwanted implication that, given a system in a balanced or under-powered state, mutations that bring about increases of C will not be advantageous so long as M remains constant. Then why should such mutations get preserved? Popper side-stepped this question. One of his sentences began: 'Now once a mutation like this is established . . .' (*1972*, p. 278), but how it could get established he did not say. His admission that mutations of this kind are 'only indirectly favourable' makes his model vulnerable to the objection that variations are selected according to their actual utility irrespective of any potential utility or disutility they may have. (In § 5.4 below we will find Wallace stressing this point.)

It might also be objected to Popper's account that it seems to presuppose that a motor-system's power is always used to the full; yet one has only to think of limousines in a cortege to see that this is not so. But there is a reply to this. Here as elsewhere we need to consider the utility of a biological feature, not in undemanding circumstances, but in times of dire necessity. Imagine that one of those limousines is now being used as a getaway car, with a police-car in pursuit; it may well happen that its driver draws on more of its engine-power than he can keep under control, perhaps with lethal results. (Within a few weeks of first putting that thought on paper I read in the newspaper of six cases where a getaway car crashed in the course of a chase; in one case the police-car crashed.) While rejecting the suggestion that the system will get hopelessly out of control the moment M outruns

C, however slightly, we can agree that the statistical risk of its getting out of control increases the more M outruns C.

Let us now incorporate these points in a revised model. Imagine a fleet of 100 racing cars and a corps of 100 racing drivers. The machines are as similar to one another as is consistent with the power of their engines varying widely. The racing circuit, which changes from race to race, is a twisting one that always includes some quite long straight stretches ending in hairpin bends. In the interest of safety the physical road is wide, but it has a rather narrow centre lane, painted white, on either side of which are grey areas, with black areas beyond them. Cars are required to stay in the white lane. Straying into a grey zone, equivalent to getting partially out of control, incurs a stiff penalty, while straying into a black zone, equivalent to getting right out of control, incurs disqualification. The cars go round the circuit one at a time. They are timed, and any straying into grey or black zones is recorded. Racing takes place in all weathers unless the lanes are obscured by snow.

The drivers are repeatedly shuffled among the cars, and in due course a pecking order is established. Assume that there is a metric, analogous to Elo-ratings in chess, for the drivers' racing skills or C-values, as well as a metric for the cars' powers or M-values. Drivers with a high C-value are not heavier than other drivers; the high C-value carries no hidden cost. The combination of a certain C-value with a certain M-value will determine a level of *racing fitness*, as we may call it in analogy with the notion of evolutionary fitness.

We now select a driver with a middling C-value and ask what M-value would suit him best. Assume that the least powerful car will be too slow for him. What about the most powerful car? If he fully exploits its power on a straight stretch he might tend to get at least partially out of control at the next hairpin bend, especially in slippery conditions. So assume that he would be best suited by a car with a middling M-value. Now a driver with a higher C-value would do better with that same car; so we find the following asymmetry: starting with a combination of middling C- and M-values, an increase in M with C remaining constant is disadvantageous and an increase in C with M remaining constant is advantageous. In the following diagram (for help with which I am grateful to Max Albert and George Vanberg), C-values are repre-

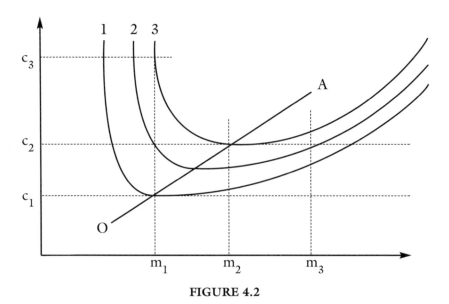

FIGURE 4.2

sented along the vertical axis and M-values along the horizontal axis. Each isobar (their numbers have only an ordinal significance) depicts a uniform level of racing fitness.

That the combination (c_2, m_1) has the same racing fitness as (c_2, m_3) means that the advantage of higher speed made possible by m_3 is offset by a tendency to incur more penalties. The line OA (which need not have been straight) represents pairings of a given C-value with its optimum M-value. There is no optimum C-value for a given M-value; unilateral increases in C generally increase fitness, though they eventually become unrewarding at low M-values; that is why the isobars eventually become vertical on the left. Control capacity is running ahead of motor-power in combinations above the OA-line, and lagging behind in combinations below it. Positions on this line will be called equilibrium positions. They correspond to the balanced states in the Mk I version.

There is not a big difference between the Mk I and Mk II versions in cases where C remains constant and M has attained an equilibrium or balanced position. In both versions there is a *stabilizing* pressure with changes in either direction being selected

against. But there is a striking difference between the two versions with respect to the pressures on C in cases where M remains constant. In the Mk I version, C is under no pressure to increase; even a large DC would leave fitness unchanged. It might be of great potential utility, but natural selection has no foresight and selects according to actual utilities. But in the Mk II version, C is nearly always under a *directional* pressure to increase. Thus with M constant at m_1, a unilateral increase of C from c_1 to c_2 would raise actual fitness from level-1 to level-2. Indeed, with M constant at m_1 there would be pressure on C to keep on rising until the utility of a DC eventually becomes zero and the fitness-isobar becomes vertical, at c_3. If C ever reached that high level its condition would be similar to C's condition in a balanced state in the Mk I version. It would be under what, in § 5.6 below, will be called a *maintaining* pressure: that is, downward changes would be selected against, but upward changes would not be selected either *for* or *against*; not *for* because they have only potential and no actual utility, and not *against* because they have no actual disutility. (Our Mk II Model includes the assumption that a high C-value is cost-free. Although plausible in relation to racing-car drivers, it is unrealistic in relation to central nervous systems, and in § 5.7 below *net* biological utilities will be taken into account.)

The Mk II Model is also too simplistic in restricting motor-power to one dimension; it is as if we attended just to a leopard's speed over the ground, ignoring the power of it spring, the strength of its jaws . . . But a more realistic, multi-dimensional model would presumably carry the same lesson, namely that control-capacity, or the C-factor as we may call it, can be expected to *run on ahead of motor-power*. Unilateral increases in motor-power have utility only if they fit in with already existing control-capacity. To put it in the terms of the diagram: any straying into the area below the OA-line would be selected against, but there is nothing to stop an evolutionary development rising above it. The C-factor may run on ahead of motor-power, but motor-power can develop only along paths marked out by this dominant partner. In short, some evolutionary developments are spearheaded by advances in central control. The bearing of this on the mind-body relation will now be looked into.

§ 4.7 Consciousness and the C-Factor

A champion billiard-player surveys the table, selects a promising combination, positions his body, sights along his cue, and makes a shot. There is a clack, and one ball proceeds as if drawn by an invisible string into the intended pocket, while the other comes to rest nicely positioned for the next shot. Huxley would have said that this was done by a player who is conscious but whose consciousness made no contribution, a conscious automaton. Well, his action could no doubt be simulated by a non-human automaton. This might consist of: (i) electronic sensors to determine the balls' exact positions on the table; (ii) a computer programmed, when supplied with the relevant data, to (a) calculate the various possible combinations presently open to it, (b) single out from these the most profitable one, and (c) calculate just how the cue should be moved to bring this about; and (iii) a cue-manager which to executes the computer's instruction under (c).[51] But in the case of our human billiard-player, the measuring and calculating and controlling of the cue were all done mentally. Popper said that the biological function of the mind is closely related to the mechanisms of control (*1977*, p. 114); and in cases like this it certainly seems that there *is* a "ghost" controlling the "machine". In the Epilogue we will consider the philosophical difficulties attending this idea. But in the meanwhile we may proceed on the common-sense assumption that with such skilled human performances, consciousness is, typically, a significant component in the C-factor.

Sometimes a billiard-player sights along his cue and makes trial movements with it, only to abandon that plan and turn to another combination. There may be a considerable time-lag before the thinking finally issues in executive action. Richard Dawkins stressed the survival-value of dummy runs (simulation exercises, critical previewing): 'The trouble with overt trial is that it takes time and energy. The trouble with overt error is that it is often fatal. Simulation is both safer and faster' (1976/89, p. 59). What, to borrow the title of Gilbert Ryle's 1968, is "Le Penseur" doing? A possible answer is that he is rehearsing possible solutions to a serious practical problem, such as how to catch a wild pig

51. This is an elaboration of a famous remark by Milton Friedman (*1953*, p. 21).

observed in the neighbourhood. But Dawkins seems to have got matters back to front when he added: 'The evolution of the capacity to simulate seems to have culminated in subjective consciousness'. Our ancestors were not able to export their simulation exercises to computers. They could have carried them out only if they already had a sufficiently well-developed consciousness.

Given that consciousness is typically figuring decisively in the C-factors of the higher vertebrates, what light if any is thrown on the question of mind-body interaction by the Spearhead Model? The great difficulty for dualist interactionism has usually been taken to be the supposed impossibility of something immaterial acting upon something material. That difficulty will be postponed until the Epilogue. In the meantime let us turn to another difficulty which has not been much noticed just because the first has tended to monopolize attention here, and which will still arise if the first is overcome. Descartes said that the *slightest* movements caused by the soul in the pineal gland may alter *very greatly* the course of the animal spirits which flow down the nerves to the muscles, whose contractions determine limb movements (*Passions*, § 31). So if the soul were to make a small error when moving the pineal gland, this might get amplified disastrously. Fortunately, that doesn't seem to happen, at least in normally functioning individuals; how is the soul able to get it right? We may call this the 'sure-touch' problem.

A modernized version of Cartesian interactionism, at least with respect to the brain, was provided by Eccles (*1977*); and the sure-touch problem recurs there. He adopted what (in § 4.4 above) was called Strategy III, claiming that the brain has evolved but the soul has a supernatural origin; and he agreed that this poses the question as to how the soul comes to be in liaison with the brain (p. 560). His answer gave to what he called the 'liaison brain' a role to very similar to the role Descartes gave to the pineal gland. (A minor difference is that for Descartes the pineal gland had a fixed location, whereas for Eccles the liaison role was played by different parts of the brain at different times.) Rather as Descartes had affirmed that in humans the soul is able to move the pineal gland because it is so vanishingly small, so Eccles declared that the liaison brain, being only a minute fraction of the whole brain, is susceptible to the 'weak actions' of the mind (pp. 356–364); the

mind 'does not act on the cortical modules with some bash opera-
tion, but rather with a slight deviation. A very gentle deviation up
or down is all that is required' (p. 368).

So the mind does not bash the brain about but treats it gently.
Good; but how is the divinely created soul able to get its 'very
gentle' deviations just right? There are two possibilities as to the
understanding of the brain that the soul brings with it: (i) it has
no prior understanding and has to acquire all of it aposteriori; (ii)
it comes endowed with some innate understanding. Possibility (i)
runs up against the sheer complexity of the cerebral cortex.
Imagine finding yourself for the first time in the control cabin of
some complex mechanical system. It confronts you with some
10,000 controls each with some 10,000 positions (Eccles esti-
mated that the cerebral cortex consists of something of the order
of 10,000 modules each containing something of the order of
10,000 neurones; *1977*, pp. 228, 242). You have been given no
prior training or instruction, and you have no manual. Mistakes
may be lethal. It seems out of the question that you could acquire
a mastery by a process of trial and error. Possibility (ii) overcomes
that difficulty; before sending a soul into a body God endows it
with whatever foreknowledge it is going to need. But that would
pose a theological difficulty for Eccles that did not trouble
Descartes, who had God in full command on both sides of the
mind-body divide. But for Eccles and other adherents of strategy
III, the "design" and construction of the body and its brain is left
to the blind play of natural forces; so if God is to pre-attune the
soul to the brain he will need to do some fieldwork. For instance,
to endow the soul with a sure touch with respect to speech organs
he would need a detailed knowledge of the Broca and Wernicke
areas. An Eccles-type hypothesis requires God to act as middle-
man between soul and brain.

Someone who accepts the Spearhead Model can say, *Je n'ai pas
besoin de cette hypothèse.* If the motor system evolved along paths
marked out for it by a C-factor of which the mind is an integral
part, there is no need for a Third Party to prepare the latter for its
controlling functions. We saw earlier that, given that a rudimen-
tary sensitivity somehow arose during the evolution of living crea-
tures, evolutionary theory can account for the proliferation of
stinging sensations, tastes, smells, and visual imagery that has
undoubtedly occurred. And we can see now that, given that con-

sciousness somehow got into a central control system in the course of its evolution, evolutionary theory can account for its enhancement in that role.

By no means everything in one's consciousness at a certain time belongs in one's C-factor. When our billiard-player was preparing to make his shot, his awareness of the colour of the table's surface would have made no contribution to his control of his cue. We might say that this part of his visual awareness was without efficacy on this occasion. And that an item in consciousness has efficacy does not guarantee it a place in the C-factor. You are at a cocktail party, your attention focussed on the young lady before you, the other voices merging into a collective buzz and hum. It seems that our minds have a module for monitoring subthreshold material for items we need to be alerted to; for suddently, from somewhere behind you, you hear someone say your name. This new item in your consciousness may have a certain efficacy, causing you to start and glance round, but presumably it won't take control: you won't turn your back on your partner and march up to this other person. Or consider pain; this too may have efficacy without taking control. While driving on a motorway you, let us suppose, experience an unpleasant stabbing sensation. You don't allow it to affect your driving, and before long it goes away and you forget about it. A month later the same thing happens, and you again forget about it. Then it happens a third time; although it goes away you now decide to ask your doctor about it. So this intermittent pain came to have efficacy: you behaved differently because of it. But we may feel that it gave your C-factor a prod from without, so to speak, rather as did your hearing your name.

A crucial experiment is possible between the hypothesis that consciousness is essential to the C-factors of larger animals and Huxley's "conscious automaton" hypothesis. Recall cases mentioned in § 4.5 above where someone carried on with a skilful performance after blacking out, for instance Penfield's patient A who, after the onset of an attack of petit mal, would carry on playing the piano, after a momentary hesitation, with near-normal dexterity. Our hypothesis allows that this can happen in cases where, through long practice, the playing has become "physiologized" and there is "finger memory" of the music, but retrodicts that it would not have happened if patient A had been struggling

with an unfamiliar score. Huxley's hypothesis says that continued playing would have been equally possible in the latter case, since the accompanying stream of consciousness was making no contribution and its abrupt cessation would not, in itself, affect the performance.

So to carry out the crucial experiment all we need is a device for inducing an onset of petit mal at the press of a button, and a supply of co-operative concert-pianists willing to have an attack induced while playing a piece. The experiment would be in two stages. In stage one, they play only pieces with which they are thoroughly familiar. The hope is that at least some of them carry on playing, perhaps after a momentary hesitation, after we press the button. (If this hope is disappointed the experiment is aborted.) For stage two we commission a composer to write a brand new score, containing plenty of demanding passages and with no repetitions and no echoes of existing works. We ask each of those pianists who survived stage one to play this piece of which they have no previous awareness. We press the button when they are half-way through. The Huxley hypothesis predicts that their playing will continue, ours that it will stop.

Chapter 5
Genes, Brains, and Creativity

Has the survival-value argument for the efficacy of consciousness defeated epiphenomenalism and related bottom-up views only to land us in a more far-reaching and comprehensive bottom-up view? That argument clearly presupposes *mind heredity*, as we found the young Darwin saying (in § 4.2 above). Neo-Darwinism is grounded in genetics; if it dispels the view that our mental life is 'but the outcome of accidental collocations of atoms', does it not replace it by the view that it is the outcome of naturally selected collocations of genes? And is this any less soul-destroying? The aim of this chapter is to assess the bearing of modern genetics on our view of ourselves. Its basic message will be simple. The gene-controlled processes which result in, among other things, the formation of the embryo's brain, are indeed *bottom-up* processes: the end-product is "higher" than the bits of deoxyribonucleic acid that control it. But the brains of human beings endow them with, among other things, a degree of creativity which results in various *top-down* processes (a concept that will be elucidated in § 5.5 below).

As to genic control of the construction of the brain: if I understand it, Gerald Edelman's theory of neuronal group selection says that the control is not over individual neurons, the numbers of which are perhaps too astronomical to allow of individual control. So the brains of identical twins need not be neuronally identical. If one thinks of the wiring of the brain in terms of neuronal pathways, then 'the genetic code does not provide a specific

wiring diagram' (*1992*, p. 83). However, if one thinks of the "wiring" as constituted by neuron *groups*, then it seems that genetic control is pretty precise—which is just as well, since we know that even a small amount of mis-wiring in the brain can have devastating effects.[1]

§ 5.1 Genes and Behaviour

Genophobia, as we may call an irrational fear of genes, is presumably inspired by an image of a creature doing what it does because its genes are programming it to do so, leaving it no choice. So let us begin by looking at cases where something like that is happening.

In this book I seldom talk about a "gene-for-*x*". The idea that each phenotypic character is controlled by a gene and that each gene controls a character is what Ernst Mayr called "bean-bag genetics" (*1976*, p. 36). A gene's influence may spread over several characters (pleiotropy), and how it affects them may vary very much, according to its genetic context; for instance, it may be activated by other genes. It may also vary according to environmental context; a plant's genome may instruct it to grow tall if at a low altitude and short if at high one, for instance (Lewontin *1982*, pp. 21f). And even if a certain character, say eye colour, were controlled by a single locus on the genome, this would be a pair of genes, or genotype. For individual organisms, it is the genotypes *AA*, *Aa*, and *aa* that have fitness-values rather than the component genes. It can happen that a recessive gene *a* which is advantageous in heterozygotic combinations is lethal in homozygotic combinations, in which case the gene-pool for the population to which the individuals belong will maintain a small but stable proportion of *a* relative to *A*. Elliott Sober speaks in this connection of a 'mortality tax' (*1984*, p. 41). However, in the present context, where we are considering the starkest kind of genic control over behaviour, we may think in terms of an innate

1. To give just one frightening instance, a viral infection in the hippocampus can destroy the ability to lay down new memories, so that one believes at each successive moment that one has just woken up after being "dead" for years; see Blakemore *1988*, pp. 54f.

program for behaviour B having been installed in a creature as a result of its inheritance of gene (or genes) b.[2]

Behaviour in accordance with such a program is called instinctive, robotic or, for reasons that will transpire in a moment, sphexish. It typically requires an external stimulus to trigger it. Getting hatched or born is a major trigger. A newly hatched chick, for instance, needs to start emitting the right cheeps, otherwise its mother would destroy it as an intruder in the nest.[3] And it needs to hold its beak in the correct way to receive food, otherwise its parents would not know what to do about feeding it.[4] And it needs to respond appropriately to warning calls and signals.[5]

Behaviour in relation to the opposite sex also calls for a good deal of innate programming. To begin with, there is the problem of recognizing a potential partner. Most birds have been found to lack an innate image of their conspecifics (Lorenz *1970*, pp. 124f). Instead, they have an innate mechanism for forming an image from the first moving object they experience (imprinting). But it would not do for a cuckoo to take its conspecific image from a "parent"; it needs a more costly program that will give it an innate image. Another area where innate programs are often operating is in courtship. Lorenz gave a striking example of this. On the first occasion that a male salticid spider tries to copulate with a female, he must, if he is not to be eaten by her, execute a complicated courtship dance without putting a foot wrong (*1965*, p. 25; and see Dawkins *1996*, pp. 41f). No room for negative conditioning there! His genes must pre-program his performance precisely. Innate programs are again needed, of course, by females in dealing with their progeny. A female of the *Sphex* species of wasp follows the following routine (or sequence of sub-routines): she paralyzes without killing a caterpillar; lays her eggs in the caterpillar; bores a tunnel; drags the caterpillar into the tunnel; seals the entrance and flies off. Her eggs will be kept warm, nour-

2. See Mayr *1976*, p. 23.

3. A 'deaf hen invariably kills all of her own progeny immediately after hatching' (Lorenz *1965*, p. 36).

4. If young song birds 'fail to gape, the parent bird looks at them, then looks round "helplessly", as if quite at a loss' (Tinbergen *1953/65*, p. 43).

5. '[I]mmediately after hatching, certain birds will automatically crouch down in the nest when a hawk passes overhead' (Wooldridge *1968*, p. 68).

ished, and protected, and they will inherit a routine for burrowing their way into the outside world after they hatch. Douglas Hofstadter (1982, p. 20) turned the name of this species into a label for robotic behaviour.

Sometimes it is not easy to know whether skilful behaviour is an instantiation of a fixed routine or a "voluntary" initiative. In his observations on animal life in Chile, Darwin remarked: 'The puma is described as being very crafty: when pursued [by a pack of dogs], it often returns on its former track, and then suddenly making a spring on one side, waits till the animals have passed by' (*Beagle*, p. 258). When I first read that, I supposed that each puma who used this clever trick for evading the dogs had thought it up for itself. I am now more inclined to suppose that they inherited a fixed routine. If so, it needs a well-tuned triggering mechanism to get the timing right.

As so far reviewed, fixed-action routines seem well suited for survival. They provide a 'fast, cheap, portable mechanism', as Daniel Dennett put it (*1991*, p. 179), and one that is generally reliable. It is as if the creature's behaviour were being skilfully master-minded. But not always. Once triggered, such a routine runs of its own accord and cannot be revised or adjusted in response to unusual circumstances. That is the essence of sphex-ishness. And a sphexish creature in unusual circumstances may seem to be under the control of a malevolent puppet-master. A reliable sign that behaviour is sphexish is that the creature persists with it in circumstances that render it futile, rather as my first electronic typewriter would go on furiously hammering away with its daisy-wheel after the paper supply had run out. After a wasp had dragged a caterpillar into the tunnel she had bored, an experimenter extracted it and placed it across the entrance to the tunnel, which she was now in the process of sealing up; she carried on regardless.[6] In another case the wasp, after dragging the caterpillar to the entrance of the tunnel, went inside to "inspect" it. The experimenter now moved the caterpillar a few inches. When she emerged she dragged the caterpillar to the entrance and again went inside to "inspect" it. This was repeated forty times.[7] She

6. E. S. Russell *1945*, p. 104.
7. Wooldridge *1968*, p. 70.

had got stuck in a sub-routine. Here is an example from pigeon behaviour. A mother and father pigeon took turns sitting on the nest, the mother taking the night shift. Then she was killed by a cat, and the nestlings died from cold during the night. But for two days the father kept up the routine, sitting on the nest from morning till late afternoon.[8] Things may miscarry rather similarly when the imprinting process occurs under abnormal circumstances. Lorenz had a goose which had grown up with his barnyard chickens: 'in spite of the fact that we bought for her . . . a beautiful gander, she fell head over heels in love with our handsome Rhode Island cock, inundated him with proposals, jealously prevented him from making love to his hens and remained absolutely insensible to the attentions of the gander' (*1952*, pp. 133–34).

One genophobic strategy has been a variation on what in § 4.4 above was called strategy III: allow that genes play a determining role in the formation of our bodies, but insist that our minds are formed by the culture into which we are born. This idea inspired the influential culturalism of Franz Boas and his pupils, such as Ruth Benedict, Edward Sapir, and Margaret Mead, whose *Coming of Age in Samoa* (1928) enormously popularized the message. (Her beautifully written book turned out to be scientifically worthless; she was taken in by the shameless fibbing of two young Samoan girls playing a prank on her; see Derek Freeman *1983/96*.) The neo-Darwinian account of the child's acquisition of a first language, which we will touch on in § 5.5 below, provides a crisp answer to culturalism: the particular culture in which the child is brought up does of course play a decisive role in its acquisition of its native language; but culture can play this role only because of a powerful inherited potential to acquire the grammar and vocabulary of whatever language the child is exposed to. But this chapter will also present a more comprehensive answer. There will be no originality in it, the reader will be relieved to hear, only borrowings from authorities. It will be an elaboration on this statement by Dawkins:

> By dictating the way survival machines . . . are built, genes exert ultimate power over behaviour. But the moment-to-moment decisions

8. Lorenz, cited in Russell *1945*, pp. 103–04.

about what to do next are taken by the nervous system. Genes are the primary policy-makers; brains are the executives. But as brains became more highly developed, they took over more and more of the actual policy decisions . . . The logical conclusion of this trend, not yet reached in any species, would be for the genes to give the survival machine a single overall policy instruction: do whatever you think best to keep us alive'. (*1976/89*, p. 60)

We may call a movement in line with this trend 'a move up the Dawkins ladder'.

Before considering how far up the Dawkins ladder our species has come it may be helpful to look into an attempt to defuse geneticism that proceeds along very different lines. If Lamarckism were generally accepted, genophobes would presumably be genophiles, seeing genes, not as alien homunculi steering us survival machines along their selfish paths, but as owner-friendly guides, beneficiaries of our ancestors' best endeavours. And we will now look into an attempt, due to James Mark Baldwin and others near the end of the nineteenth century, to show that Darwinism can simulate Lamarckism.

§ 5.2 Baldwin Effect

The idea to be considered now is that a genetically entrenched pattern of behaviour may be a reflection of intelligent behaviour that had originally been adopted voluntarily, a kind of top-down process. Robert Richards succinctly summarized a long and obscure quotation from Baldwin's *1902* as saying that animals acquire 'innate behaviors similar to behaviors they originally had to learn' (*1987*, p. 482). Where Baldwin Effect occurs, there Nature imitates Art; a successful pattern of behaviour having been thought up and put into practice, genetic mutations subsequently occur which fix it. One distinguished philosopher who has hailed the Baldwin Effect in recent years is Popper (see his *1972*, chapter 7; and see the section entitled 'Naturalistic Intellectualism' in D'Agostino *1986*, pp. 128f); another is Dennett.

However, the label 'Baldwin Effect' has sometimes been extended to other ideas which resemble Baldwin's idea in some ways but also differ importantly from it. In one case (that of Alister Hardy 1957) to which we will turn later, the difference

was a big improvement. (Rather similar ideas were aired at about the same time by Erwin Schrödinger in his *1958.*) But I will first mention two other cases.

C. H. Waddington sought to establish experimentally the genetic assimilation of acquired characters. He subjected *Drosophila* pupae to a heat shock. In a few cases the wings of the emerging flies lacked some or all of a small cross vein. By breeding selectively from these he eventually established a line of flies most of which lacked this vein despite not having been subjected to heat shock.[9] G. G. Simpson (1953) equated this with Baldwin Effect (to which he was opposed). But with Baldwin, the acquired characters that are supposed to get genetically encoded are the eventual result, not of some physical trauma, but of voluntary and intelligent modifications to behaviour. He was seeking to put some mind and rationality into evolutionary developments.

Here is a more recent finding to which the label Baldwin Effect has been extended. Hinton and Nowlan (1987) devised a neural network model with the following all-or-nothing character. It has twenty on/off connections. With all twenty correctly set the organism gains a big survival advantage, but having nineteen or fewer correctly set brings no advantage at all. If the fixing of the settings were left entirely to random mutations, the probability that all twenty would eventually be correct would be vanishingly small (an astronomical amount of co-adaptation would be needed). But the authors introduced an element of plasticity into this imaginary hardware: each of the twenty settings may be genetically determined to be (1) *fixed on*, or (2) *fixed off*, or (3) *switchable*. Individuals may inherit any one of the possible distributions of these three alternatives over the twenty connections, with mutations determining the actual distribution. In a large population over a long enough time there is, it seems, a high probability that in the case of a few individuals all the fixed settings they inherit happen to be correct; and a few of these individuals may, through random trials with the switchable ones, hit the jackpot. They will then retain these settings and have more progeny than the others. Provided there are ways of registering such

9. I am relying on Maynard Smith's summary, *1958*, pp. 293–96.

hits, the process can be a blind one, with a randomizing device doing the switching. Hinton and Nowlan ran a computer simulation, which showed more and more of the genetically fixed settings becoming correctly fixed, and the number of genetically fixed settings increasing, though never to twenty. After reporting this, Steven Pinker went on to say that when the authors submitted their results to a journal they 'were told that they had been scooped by a hundred years. The psychologist James Mark Baldwin had proposed that learning could guide evolution in precisely this way' (*1997*, p. 179). But nothing in Baldwin's idea is analogous to this voluntary tweaking of the switchable connections of the organism's neural network.

Dennett took up Hinton and Nowlan's 1987 in a section entitled 'Evolution in Brains, and the Baldwin Effect' in his *1991*. He there spoke of the human brain's 'unrivaled plasticity' (p. 190) which gives us an edge over our 'hard-wired cousins who cannot redesign themselves'. He seems to have meant that the brain's *hardware* is adjustable. He almost made it sound as though you could get in there and tweak it yourself. At another place he spoke, apropos our brains, of 'individual redesign-by-self-manipulation' (p. 293). (I side with Steven Pinker in believing that our brains can 'be rewired only if the genes that control their wiring have changed', *1994*, pp. 350–51.) According to Dennett; the brain's ability to reorganize itself adaptively 'not only gives the organisms who have it an edge over their hard-wired cousins who cannot redesign themselves, but also reflects back on the process of genetic evolution and *speeds it up*. This is . . . known as the Baldwin Effect' (p. 184). What I called hitting the jackpot Dennett calls hitting on a Good Trick; and Baldwin Effect occurs when a Good Trick moves into the genome (p. 190). After virtually reproducing these passages in his *1995* Dennett remarked: 'The way I have just described the Baldwin Effect certainly keeps Mind to a minimum, if not altogether out of the picture; all it requires is some brute mechanical capacity to stop a random walk when a Good Thing comes along, a minimal capacity to "recognize" a tiny bit of progress, to "learn" something by blind trial and error' (pp. 78–79). Baldwin had sought to put some mind and rationality into genetic developments; Dennett sought to take it out.

Let us now go back to Baldwin Effect à la Baldwin. The kind of Lamarckian inheritance of acquired characters for which

Baldwin sought a Darwinian simulation related, not to the black-smith's muscle-power, still less to his injured back,[10] but to his intelligently developed *skills*. At about the same time when he first put forward his hypothesis, in a 'A New Factor in Evolution' (1896), similar ideas were put forward, quite independently it seems, by C. Lloyd Morgan and Henry F. Osborn (see Richards *1987*, pp. 398f, 480f). And in consultation with them Baldwin drew up the following statement:

> organisms which survive through adaptive modification will hand on to the next generation any "coincident variations" (*i.e.* congenital variations in the same direction as adaptive modifications) which they may chance to have Time is thus given to the species to develop by coincident variation characters *indistinguishable* [my italics] from those which were due to acquired modification, and the evolution of the race will proceed in the lines marked out by private and individual adaptations. It will appear as if the modifications were directly inherited, whereas in reality they have acted as the fostering nurses of congenital variations. (1898)

Here, the terms 'adaptive modification', 'acquired modification', and 'adaptation' all denote "voluntary" behavioural innovations made by individual animals without genic prompting, while the terms 'variation', 'coincident variation', and 'congenital variation' denote heritable and instinctive ways of behaving.

In the 1940s a famous episode occurred when tits began pecking through the metal caps of milk bottles; the practice was soon spreading like an epidemic.[11] This would have been a paradigm case of Baldwin Effect if what happened was this: At first a few tits, perhaps just one, pioneered this novel method without genic assistance; then the method began to spread by imitation; then came coincident variations turning it into a genetically encoded "fixed-action pattern"; and these genes eventually spread through the tit population.

Now to the difference between Baldwin Effect and what may be called Hardy Effect. Hardy suggested that a change of interest,

10. See Cronin *1991*, p. 40.
11. For a survey of the considerable literature on this episode see Kennedy *1992*, pp. 46–49.

whether externally or internally instigated, might lead to new patterns of behaviour with the consequence that certain bodily mutations that would previously have been unfavourable now become favourable:

> If a population of animals should change their habits (no doubt often on account of changes in their surroundings such as food supply, breeding sites, etc., but also sometimes due to their exploratory curiosity discovering new ways of life, such as new sources of food or new methods of exploitation) then, sooner or later, variations in the gene complex will turn up in the population to produce small alterations in the animal's structure which will make them more efficient in relation to their new behaviour pattern.[12] (*1965*, p. 170)

In his 1957 Hardy had given the example of a bird switching its attention, perhaps in a time of shortage, from insects in the open to insects in the bark of trees, this new pattern of behaviour being copied and spreading within the population. These proto-woodpeckers may have proceeded rather clumsily at first; but going after this rich new food supply with tools not well adapted to the task proved at least marginally more rewarding than persisting with old habits. So new habits developed; and mutations that made the bird's bodily structure better adapted to these new functions now became advantageous, though they would previously have been disadvantageous. So new shapes of claws, beak, and tongue began to evolve.[13] There is a partial anticipation of Hardy's idea in Darwin's Notebooks. After summarizing the view of a contemporary biologist as: 'Instincts & structures always go together', he commented that this is not so, the instincts may vary *before* the structure does *as with the woodpecker*.[14]

12. Darwin had asked whether habits generally change first and structure afterwards or vice versa (*Origin*, p. 141); he was inclined to give the priority to habits; see Barrett *1980*, p. 190, C124, C165.

13. The existence of Hardy Effect has been empirically confirmed, according to Mayr: 'Bock (1959) showed that the primitive woodpeckers, which had switched to the behavior of climbing on tree trunks and branches, still had essentially the ancestral foot structure' (*1982*, p. 612). Mayr added: 'Many if not most acquisitions of new structures in the course of evolution can be ascribed to selection forces exerted by newly acquired behaviors'. The Galapagos Woodpecker-finch provides a nice example of an extended phenotype (see Dawkins *1982*); it adapted its beak to *holding a twig* with which to get at the insects in the bark; see Lack *1947*, pp. 58–59.

14. Barrett *1980*, p. 84, § 71; see Gruber's commentary on this in Barrett *1980*, pp. 116–17, and see *Origin*, p. 134. There is also some anticipation of Hardy's idea in

There is one similarity between Hardy Effect and Baldwin Effect but three important differences. The similarity is that both start out from individual initiatives not genically prompted. Two of the differences are that with Hardy Effect, subsequent genetic variations introduce something both *new* and *anatomical*, such as the woodpecker's tongue and beak, whereas Baldwin Effect only fixes *behaviour* and behaviour that was *already occurring* (it was with this latter point in mind that I italicized the word *indistin-guishable* in the above Baldwin-Morgan-Osborn quotation). A consequential difference is that if the same mutations had occurred in the absence of those individual initiatives, then with "Hardy Effect" they would have been *dis*advantageous (birds that continued to attend to insects only in the open would be disadvantaged by changes to claws, beak, and tongue equipping them with an unused ability to get at insects in the bark of trees), whereas with Baldwin Effect they would still have been advantageous (the tit population would have been no worse off if their new method of getting at the milk in bottles had been wholly the result of genetic variations).

E. O. Wilson's sociobiology seems to presuppose Baldwin Effect, though he did not use this term. In his *1975* he had characterized sociobiology as 'the systematic study of the biological basis of all social behavior' (p. 4). But in their *1981* he and his collaborator Charles J. Lumsden made it the central tenet of human sociobiology 'that social behaviors are shaped by natural selection' (p. 99). As Philip Kitcher remarked (*1985*, pp. 332–33), this shift from 'behavior' to 'behaviors' is indicative of their idea that what natural selection has kitted us out with is not an all-purpose decision-making tool but a repertoire of more or less specialized skills. (In §§ 5.5–5.7 below an intermediate possibility between specialized skills and an all-purpose capacity will be introduced.) According to their theory of gene-culture coevolution, there is a feedback from culture to evolution; innovative cultural practices, if successful, get encapsulated in 'underlying epigenetic rules' that are underwritten by 'prescribing genes' (Lumsden & Wilson *1983*, pp. 152–54). As a thought-experiment, they envis-

McDougall *1911*, chap. 18. Something like Hardy's idea was arrived at independently by Popper, and he too illustrated it with the woodpecker example (*1972*, p. 279). He later made ample acknowledgements to Hardy in his 1975, *1977*, and 1982.

aged a "blank slate" species (which is what Watson took the human species to be) whose choices are all determined by non-hereditarian, cultural factors; but that, they said, could not last:

> It is inevitable that some of the choices . . . will confer greater survival and reproductive ability . . . [and] that over a period of generations new genetic mutations and recombinations will arise that predispose individuals to make the adaptively superior choices. The new genetic types will spread through the population. (p. 60)

For instance, the use of stone implements within a group might have begun with a cultural choice not prompted or guided by any underlying epigenetic rule; but individuals who made this choice enjoyed

> . . . a higher rate of survival and reproduction. So those who possessed epigenetic rules directing them to the right choices were better represented in later generations. Genes prescribing the most efficient epigenetic rules spread through the population over many generations. (p. 119)

The result would be a co-operative pulling together, or 'synergy' to borrow a term Maynard Smith has used in this connection (*1989*, p. 57), of cultural and genetic developments.

Before asking whether Baldwin Effect does in fact occur in the animal kingdom, let us ask whether it would be desirable within human societies. As we saw, it has been hailed on the ground that it entrenches rationality. Yes, but yesterday's rational behaviour may no longer be appropriate today. How desirable would be the long-term genetic fixing of Good Tricks in a population? Here is a thought-experiment. Two widely separated tribes, M and N, have very similar ecological environments, and their gene-pools are as similar as is consistent with Baldwin Effect being at work only in tribe M. Each tribe is settled on one bank of a wide river. And in both of them pioneering individuals have invented rafts, enabling them for the first time to cross to the other bank. This new practice catches on and spreads by imitation. And then members of tribe M start inheriting genes for raft-building, rather as birds inherit genes for nest-building: building rafts becomes something they can all do naturally and well. And tribe N? Wilson and

Lumsden made the point that when traditional knowledge is not genetically encoded there is a risk that it will deteriorate or be lost (*1983*, p. 158). Yes, that might happen, though a critical rationalist will add that there is also the possibility that the know-how is sustained by a lively tradition, with local innovations being tried out and, if good, catching on. But whether or not raft-building has deteriorated in tribe N, we can imagine a one-time raft-builder pioneering a new kind of craft, a dug-out canoe. Before long rafts are being seen as cumbersome and liable to break up, and are increasingly superseded by these faster and more durable craft. And tribe M? Well, their Good Trick has moved into the genome and they are presumably genetically fixated on raft-building. If an intelligently invented and developed skill or action-pattern got genetically entrenched, with genes for it spreading through the population, it seems unlikely that there could soon afterwards be a second round which replaced it with a different pattern.

This last point calls attention to the disparity between the time-scales for evolutionary and for cultural developments. This disparity bedevils the Wilson-Lumsden theory of gene-culture *co*evolution. They suggested that culture greatly speeds up genetic evolution. It surely does intensify selection pressures; but would that speed up the whole process sufficiently? They claimed that the acceleration reduced the typical time-span for an important development to a thousand years. 'In as few as fifty generations—about a thousand years—substantial genetic evolution can occur in the epigenetic rules guiding thought and behavior' (*1983*, pp. 152–54). Maynard Smith found the assumptions needed to engender this remarkable acceleration extremely implausible (*1989*, p. 57.) But suppose that it could happen; would it be sufficient? A glacier's movement would be much accelerated if it increased from one centimetre to two metres per year, but it would still be very slow in comparison with a river's flow. How far would our western societies have got if major innovations in agriculture, or navigation, or communications . . . had been spaced out at thousand-year intervals?

Hominid evolution as envisaged by Wilson & Lumsden seems to be going *down* the Dawkins ladder. Instead of an increasing delegation by genes to brains, the system of epigenetic rules becomes more comprehensive and specific as gene-culture coevo-

lution proceeds: 'the genes supply much more than simply the general ability to solve problems. They equip the mind with specific rules' (p. 62). These rules are 'growing in strictness and power' (p. 148). The genes are becoming ever more bossy, interfering in areas where decisions had previously been delegated to the brain. Baldwin Effect would preserve rationality in a more or less petrified form. As Anthony O'Hear put it, our comparatively large brains have the great advantage that old solutions to old problems do not inhibit us (he actually wrote 'destroy us' which is perhaps too strong) when we confront new problems (1987, p. 35). And forty years earlier Dobzhansky & Montagu had said that 'genetic fixation of behavioral traits in man would have been decidedly unfavourable for survival' (1947, p. 588). Let us now ask whether there is as a matter of fact any reason to expect Baldwin Effect to occur anywhere in the animal kingdom.

We might restate Baldwin's hypothesis as follows. Let B and β stand respectively for a certain phenotypic behaviour-pattern and for a genetic encoding that would render B heritable and instinctive, where β may be either a single gene brought into existence by a single mutation, or some more complicated genetic string brought into existence in some more or less extended, step-by-step manner. In the latter case we may use Δβ to denote a step towards the establishment of β. Suppose that behaviour B was originally adopted "voluntarily" by a few individuals within a population at a time when there was as yet no β or Δβ in the population's gene-pool. B proved advantageous and spread by imitation. Baldwin's hypothesis says that all this may foster, perhaps in a step-by-step way, the genetic variation β which renders B instinctive and heritable; and β may eventually spread through the gene-pool.

Is there any reason to suppose that such a process occurs in nature? It is of course possible that B's coming into existence happens to be followed, without any causal connection, by mutations that bring β into existence, rather as a woman who dyed her hair green might have descendants who chanced to receive, all at once or sequentially, a mutant gene for green hair. But for genuine Baldwin Effect to occur, the prior occurrence of B must raise the probability that the co-incident variation β will get established in the gene-pool. To use Baldwin's term, B must somehow *foster* β. How could that happen?

In the above Baldwin-Morgan-Osborn declaration two distinct claims were conflated: (1) an animal that makes the "private and individual" modification B to its behaviour, where B is adaptive, thereby raises its chances of passing on any genetic variations it may receive; (2) this raises its chances of passing on a *coincident* variation β. Claim (1) is obviously true: if B has survival value, then animals that adopt B do indeed raise their chances of passing on their genes, including any mutant ones. But is there any reason to suppose, in line with claim (2), that animals that adopt B thereby raise their chances of transmitting a mutant β to their descendants? Popper said, with a gesture towards Baldwin, that successful trial-and-error solutions 'increase the probability of the survival of mutations which "simulate" the solutions so reached, and tend to make the solution hereditary' (*1972*, p. 245). Put in our terms, he was saying that hitting on B as a successful solution to a recurring problem increases the probability that gene β for B will get established. But why, and how? With genetic mutations the wind bloweth where it listeth. It would be Lamarckism to impute to the acquired characteristic B a propensity to engender β.

A defender of Baldwin Effect might propose the following answer. We start with a population consisting of B-ers, who all practise B voluntarily, and non-B-ers. There now occurs a rare mutation that brings into existence Δβ or perhaps the complete β for the first time. We exclude Lamarckism by postulating that this mutation has the same probability of occurring in a non-B-er as in a B-er; so the adoption of B has no influence on its occurring. But a difference opens up when we consider its transmission to later generations. If p and q are the average probability of, respectively, B-ers and non-B-ers transmitting their genes, including any mutant ones, to descendants, then since B is adaptive we have $p > q$. When it first occurs, a genetic mutation affects only the sex cells of the recipient. So if it occurs in a non-B-er it will have no effect on the behaviour of the animal, and the latter's expectation of transmitting its genes will be unaffected. So this rare mutation will have a better chance of being preserved and transmitted to later generations if it occurs within a B-er. It is in this sense, so this answer goes, that the "voluntary" adoption of B might be said to foster the "coincident variation" β.

That this answer will not do can be shown by the following analogy. Some members of a human population in a malarial area have adopted the new practice of taking anti-malarial tablets. Call them *takers*. If p and q are, respectively, the average probabilities of takers and of non-takers transmitting their genes, including any mutant ones, to descendants, then p > q. And now a rare mutation occurs somewhere in the population that ushers in a gene giving increased resistance to malaria. This rare mutation will have a better chance of being preserved and transmitted to later generations if it occurs within a taker. So the practice of taking anti-malarial tablets would have fostered an anti-malarial variation. Yes; but the mutation might equally have been one that gives *reduced* resistance to malaria, in which case the practice of taking anti-malarial tablets would have fostered a *countervailing* rather than a coincident variation.

For Baldwin Effect to occur it is not enough that the "voluntary" adoption by individuals of the advantageous B will foster the transmission of *any* mutant genes that these individuals receive; for these might include some countervailing variation β', incompatible with the genetic encoding of B. It would need to foster the right kind of genetic variation. Let r and r', be the probability, before the first adoption of behaviour B, of an occurrence of respectively a mutant β and a mutant β', within the population. A proponent of Baldwin Effect now faces a dilemma. (1) If the "voluntary" adoption of B leaves the probabilities unchanged, there is no Lamarckism but also no Baldwin Effect. (2) If the "voluntary" adoption of B raises r and lowers r,, there is Baldwin Effect but also Lamarckism. This dilemma is not mitigated if we replace β by Δβ. The way to avoid the dilemma is to set Baldwin Effect aside.

§ 5.3 A First Step up the Dawkins Ladder

Why should there be this ladder? Why did not natural selection leave all creatures, large and small, relying on robotic routines? For our purposes, what differentiates robotic creatures from the leopards and wolves who exemplified a control/motor dualism in § 4.6 above is their lack of a C-factor. They do have information-processing systems that enable them to locate relevant features of their environment; the wasp is able to find a caterpillar and a suit-

able place in which to bore a tunnel. But once an information-processing system has triggered a routine, this will proceed autonomously unless physically impeded or frustrated (for instance, by a human experimenter). That would work well for a creature whose eco-niche was stable and relatively simple, the dangerous things in it regularly signalling their presence in one or other of just a few ways. The creature might even acquire a certain discrimination; for instance, it might act according to the rule, 'If it's red and small, stay where you are and puff yourself up; if it's red and large, lower your head and scuttle back to your burrow.' But eco-niches are liable to change in significant ways. The change may be abrupt, with the arrival of a new kind of danger that does not signal its presence in any of the old ways. This happened to the birds in the Galapagos islands with the arrival of the *Beagle*; Darwin reported that they were so extremely tame that the sailors could kill as many of them as they wished. And it was the same in the Falkland Islands, with one exception: 'the black-necked swan—a bird of passage, which probably brought with it the wisdom learnt in foreign countries' (*Beagle*, p. 385). Or there may be creeping changes; for instance, predators may evolve innocent-seeming disguises.

One might at first suppose that our robotic creature could evolve defences against such changes by widening the range of signals that will trigger an escape-routine. For instance, they might come to include all bird-shaped objects and not just owl-shaped ones, and all rustling noises and not just glimpses of something moving in the undergrowth. The trouble with that is that the creature would spend so much time and energy "escaping" from what were often harmless things that, as Thorpe put it, life becomes impossible (*1956*, pp. 62–63).

Natural selection has evolved a compromise solution for this *either* not-wide-enough *or* too-wide dilemma. In certain paradigm cases, such as the appearance of owl-like shapes to grey geese or hawk-like shapes to song sparrows, the process works as before: a signal throws a switch from *off* to *on* and the routine again proceeds quasi-autonomously. Thus when grey geese, or song sparrows, were repeatedly exposed to a harmless dummy of an owl, or of a hawk, they persisted with the same escape routine. Their reaction might temporarily become less vigorous through fatigue, but once they had recuperated, it was as vigorous as ever. But in

other cases the signal may throw the switch from *off* to some intermediate position which allows a certain scope to the individual's judgement; for instance, it may put the individual into a state of high alert in which it asks itself, 'Real danger or false alarm?'. If experience increasingly indicates that certain signals do not indicate danger, so the creature's habituation, to use Thorpe's term, to them increases; it may eventually pay *no* heed to them. Thorpe reported an experiment in which pigeons were subjected to the regular firing of pistol shots; at first, this alarmed them greatly, but later it 'produced habituation, and the pigeons eventually became quite immune to them, displaying no response at all' (p. 300). It seems unlikely that scarecrows scare crows. The worm-seeking birds in our vegetable garden are so well habituated to humans digging that they tend to get in the way of the spade. So much for a first, short step up the Dawkins ladder. Now for a rapid and far-reaching ascent.

§ 5.4 Large Hominid Brains

It seems that the size of our ancestors' brains three million years ago was somewhat larger, relative to body-size, than that of any other creatures. Since then it has increased threefold.[15] It is generally agreed that this exceptional evolutionary development must have involved some kind of positive feedback in which an increase in x has effects y which promote further increases in x and so on. Once started, a positive feedback cycle has to come to an end fairly soon, otherwise x would be heading out towards infinity; and paleoanthropological findings suggest that this one came to a halt some 150,000 to 100,000 years ago.

Two main explanations are extant as to what might have brought about positive feedback in the case of this particular x. In one, y is culture. Robin Fox suggested that as hominid brains grew in power they would tend to generate richer group cultures, which would generate new selection pressures favouring the evolution of still more powerful brains (1971, p. 291). Richard Leakey has said something similar (*1992*, p. 212). Insofar as a community's culture results in artefacts such as traps, individuals

15. See Johanson and Edey *1981*; Leakey and Lewin *1992*; Jerison, 1985.

who can exploit them intelligently will tend to do better; and insofar as it results in socio-political organization, individuals with a more "Machiavellian" intelligence will tend to do better.[16] In his *1994* Pinker suggested a positive feedback explanation for the enlargement of the language areas of the human brain: 'Selection could have ratcheted up language abilities by favoring the speakers in each generation that the hearers could best decode, and the hearers who could best decode the speakers' (p. 365).[17]

The other main explanation is in terms of sexual selection. Fisher showed that there will be positive feedback between x and y, and the potentiality of a runaway process, if x is a feature in one sex, such as the plumage of male birds, for which members of the other sex show a mating preference and y is reproductive success.[18] Here, positive feedback is partly brought about by the built-in competitiveness within sexual selection. Matt Ridley speaks in this connection of the Red Queen Effect (*1993*): if each male is striving to be a little x-ier than his competitors they will all need to run faster to stay in the same relative place. An explanation in terms of sexual selection does not exclude the previous one. They may well be complementary. But in what follows I will be relying mainly on this latter one, partly because there has in recent years been an explosive revival of interest in Darwin's hitherto largely neglected theory of sexual selection,[19] and partly because this theory has been applied very interestingly and persuasively to the evolution of hominid brains, especially by Geoffrey Miller, some of whose ideas are highly pertinent to this chapter's main theme.

It may be objected that sexual selection typically goes with a more or less conspicuous sexual dimorphism, female preference for a male feature resulting in the enhancement of that feature in the male only—but women's brains have swollen along with

16. For this concept see e.g. Byrne and Whiten (eds.) *1988*.
17. I was startled to find Pinker holding that the tripling in size of the human brain does not call for runaway positive feedback, but was 'leisurely by evolutionary timekeeping' (*1997*, p. 194). This increase was not like, say, the increase in the male seal's body-size to six times that of the female's, which presumably called for little or no increase in internal complexity. This expansion of the cerebrellum must have involved an exponential increase in the complexity of its micro-circuitry.
18. *1930*, p. 137; and see Dawkins *1986*, chap. 8.
19. Buss *1994*; Cronin *1991*, Part 2; Matt Ridley *1993*.

men's, in glaring disanalogy with peahen's tails. However, as Miller points out (1998), dimorphism is not a necessary consequence of sexual selection. Both sexes share essentially the same genome, except of course for their sex chromosomes which do a lot of activating of some and suppressing of other genes; and although genes for a sexually selected feature, such as a large tail, antlers, or whatever, often are suppressed in females, this need not be the case. With parrots, for instance, gaudiness tends to be shared equally by both sexes.[20] Crudely put, Miller's thesis is that during the long pre-history of our species she preferred, in the absence of television and women's magazines, a man who would provide her with, among other things, some novelty and variety; and to provide this he needed *inventiveness.*

It seems clear that some inventiveness was already there, three million years ago, to be sought after by ancestresses of ours like Lucy (about whom see Johanson & Edey *1981*). Chimpanzees already show a certain inventiveness—as when, for example, in Wolfgang Köhler's experiments they solved the problem of getting hold of out-of-reach bananas (Köhler *1927*), or when, as Jane Goodall filmed them doing, they got at termites in a narrow hollow by dipping a stick in and licking it like a spoon. To prepare the way for this new kind of explanation for our swollen-headedness let us first consider how well a straightforward natural selectionist theory of evolution could handle it. Wallace had an argument purporting to show that human inventiveness was not a product of natural selection. As well as ushering in the most serious of the disagreements between him and Darwin it raises some interesting issues which are pertinent here.

Wallace was mentioned in § 4.4 above as adopting, though only briefly, what was there called strategy II, which accepts natural selection for other creatures but would exclude humans from its scope. He employed what Cronin calls a 'surplus to requirements' argument.[21] It involved the following assumptions.

> W1: All inherited features of a naturally evolved animal are adaptations brought about by natural selection.

20. See Matt Ridley *1993*, p. 139; he referred to Jones and Hunter 1993.
21. The following discussion largely retraverses territory surveyed in Cronin *1991*, pp. 353f.

W2: Natural selection selects variations according to their actual utility and irrespective of any potential utility or disutility they may have.

W3: The brains of our ancestors 100,000 years ago were as large as ours are today.[22]

W4: But their intellectual needs were far smaller than ours are today.

From W3 and W4 he concluded:

W5: The brains of those ancestors had an unused, potential capacity that was surplus to their requirements.

And from W5 in conjunction with W2 he concluded:

W6: The human brain is not a product of evolution.

As he put it: the human brain is 'not explicable on the theory of variation and survival of the fittest' since it gave the pre-historic races a capacity that had

> no relation to their wants, desires, or well-being. How, then, was an organ developed so far beyond the needs of its possessor? Natural selection could only have endowed the savage with a brain a little superior to that of an ape, whereas he actually possesses one but very little inferior to that of the average members of our learned societies. (1869, p. 392)

He concluded that man's brain and all that accompanies it must have been produced by a Higher Intelligence (p. 394). (There is an echo of these ideas in Nagel's *1986*, pp. 80f. Where, Nagel asks, has our scientific prowess come from? We possess 'an enormous excess mental capacity, not explainable by natural

22. Wallace put it at 35,000 years, but it is generally agreed nowadays that hominid brains had stopped expanding by the earlier date; see e.g. Dobzhansky *1962*, p. 189. We now know that by his later date some pre-historic people were already making marvellous cave paintings (see e.g. Leakey and Lewin *1992*, p. 314), which would have ruined his case.

selection'; its existence calls for 'something—we know not what' to play the role that Descartes said was played by God.)

Wallace's logical derivation was valid; and since conclusion W6 is false, as we shall later find him conceding, there must be something wrong with at least one of the premises. There are no problems with W2, which expresses the fact that natural selection has no foresight, or with W3. But W1 and W4 are both problematic. The former reflects the fact that, as Gould put it, Wallace was 'an ardent selectionist who far out-Darwined Darwin in his rigid insistence on natural selection as the sole directing force for evolutionary change' (*1978*, p. 50). It is open to three objections. One is that it overlooks the fact that an evolutionary process may as it were throw up "unintended" by-products; if features *a* and *b* were separately selected for, and if their co-presence brings in train feature *c*, then *c* is a "spandrel" (Gould & Lewontin 1979); it got selected without being selected *for* (O'Hear *1997*, p. 103). However, that objection is not relevant here; it is not credible that such a conspicuous and central feature as the brain should have come in on the coat-tails of something else. The second objection to W1 is that it disregards what may be called Golden Spin-Off arguments. These have the form: 'True, *y* is a luxury that is surplus to survival requirements; however, *y* is a spin-off from *x*, which is (or was) of great survival value'. For instance, *x* might be an inbuilt disposition of our ancestors to be curious about their local surroundings which may contain hidden dangers, and *y* might be a larger, scientific curiosity about one's wider surroundings. Penrose suggested in similar vein that our tendencies to philosophize about life, self . . . are "baggage" carried by beings whose consciousness has been selected by natural selection for some quite different reason (*1989*, p. 528). The third objection is that W1 repudiates sexual selection.[23] But this too we can set aside for the present, since we are now considering human inventiveness in relation to natural selection and prior to any reinforcement by female preference. Premise W4 may seem trivially true; our ancestors 100,000 years ago did not fill in tax returns or solve crossword puzzles . . . But we shall find that it hides an important untruth, as Darwin was to point out.

23. On Wallace's negative attitude to sexual selection see Cronin *1991*, pp. 123f.

Wallace's swerve into supernaturalism was tacked on at the end of a long, unsigned review of the works of Charles Lyell. He sent a copy to Darwin, who wrote back:

> I have been wonderfully interested by your article . . . Your exposition of Natural Selection seems to me inimitably good . . . If you had not told me I should have thought that [its concluding remarks on man] had been added by someone else. As you expected, I differ grievously from you, and am very sorry for it. (F. Darwin *1888*, iii, pp. 115–16)

At this time (April 1869) Darwin was engaged on *Descent*, and in it he included an answer to Wallace. For our purposes it might be restated thus: Wallace overlooked the fact that the discovery of comparatively primitive techniques for survival by pre-historic men may have called for as much inventive capacity as did that of our far more sophisticated techniques. His actual words were:

> He [man in the rudest state] has invented and is able to use various weapons, tools, traps, etc., with which he defends himself, kills or catches prey, and otherwise obtains food. He has made rafts or canoes for fishing or crossing over to neighbouring fertile islands. He has discovered the art of making fire, by which hard and stringy roots can be rendered digestible, and poisonous roots or herbs innocuous. . . . These several inventions, by which man in his rudest state has become so pre-eminent, are the direct results of the development of his [mental] powers. . . . I cannot, therefore, understand how it is that Mr. Wallace maintains, that "natural selection could only have endowed the savage with a brain a little superior to that of an ape." (*Descent*, pp. 72–73)

So Darwin saw natural selection as favouring inventiveness. He wrote that 'in the rudest state of society, the individuals who were the most sagacious, who invented and used the best weapons or traps . . . would rear the greatest number of offspring' (*Descent*, p. 196), adding that it is 'highly probable that with mankind the intellectual faculties have been mainly and gradually perfected through natural selection' (p. 197).

But there is a problem here. It would not have arisen if our forebears had lived in a Hobbesian state of nature, so that the

benefits of an invention would typically accrue just to its inventor. But Darwin conjectured that our progenitors became social at a very early period; and with socialization comes *imitation*. He held that propensities to imitate antedated human inventiveness: 'Apes are much given to imitation' (*Descent*, p. 109); and there is exper- imental evidence of primates imitating successful innovations.[24] If within a group there are propensities to imitate as well as to invent, we can expect a lively curiosity about what other fellows are up to, and a readiness to steal their better ideas. If there are genes for inventiveness in their gene-pool, these will be accompa- nied by genes for plagiarism. As Darwin put it: 'if some one man in a tribe . . . invented a new snare or weapon . . . the plainest self-interest . . . would prompt the other members to imitate him; and all would thus profit' (*Descent*, p. 198).

But if successful inventions are going to be exploited by oth- ers, why did Darwin expect the original inventor to have more progeny? Might not the original inventor be at greater risk than imitators? It has often been suggested that a Popperian method of hazarding bold conjectures, and seeking to test them to destruc- tion, sponsors a 'Live dangerously' strategy.[25] Popper himself sought to restrict this method to theoretical contexts where we can let our hypotheses die in our stead. But that restriction could hardly apply in pre-historic times. A philosophy that puts a strong emphasis on fallible human inventiveness has to reckon with the possibility of pioneering, exploratory individuals going down with their hypotheses. Trying out a new kind of device, being one's own "test-pilot", may involve considerable risk. Perhaps an inven- tive individual who made an original raft with the intention of crossing over to a fertile island found it breaking up when he was only half way across; perhaps the first successful crossing was made by an imitator who shrewdly profited from the original idea plus its inventor's pioneering mistakes.

24. A chimp, presented by a human supervisor with a number of manipulation puz- zles, could solve some, while others were too difficult for her; but after closely watching the supervisor solving these latter, she mastered them herself (Hayes and Hayes 1951). In another, more famous experiment biologists lured a troop of Japanese macaque monkeys out of the forest by scattering sweet potatoes on a nearby beach. One monkey with a touch of genius hit upon the idea of washing the sandy potatoes in sea water. The practice gradu- ally spread, and ten years later nearly all of them were doing it (Wilson *1975*, p. 170).

25. See e.g. Gellner *1974*, p. 172.

Darwin might have parried this by appealing to something to which he did appeal when dealing with altruistic propensities, such as patriotism, fidelity, courage, and a readiness to sacrifice oneself for the common good. Don't these disadvantage their possessors? How can natural selection explain them? Darwin sought to meet this difficulty by appealing to what is now called group-selection: with 'strictly social animals, natural selection sometimes acts on the individual, through the preservation of variations which are beneficial to the *community*' (*Descent*, p. 94, my italics). Fleshed out with a little schoolboy genetics, his idea could be put like this:— Let A be an altruistic propensity, beneficial to the community but risky for individual possessors of it, and let α be a genetic encoding that would render A heritable and instinctive. Imagine two warring tribes that are as similar as can be except that gene α prevails in tribe M's gene-pool whereas gene α', for A', prevails in tribe N's, where A', is a selfish counterpart of the altruistic A. Tribe M wins, in line with Darwin's expectation; gene α gave its members a better chance of surviving than gene α' gave tribe N's members; hence natural selection will favour α. Darwin could easily have extended this line of thought to inventiveness; the quotation given earlier about the individuals who invented the best weapons or traps rearing the most offspring goes on to say that the *tribes* which included the most such men 'would increase in number and supplant other tribes' (*Descent*, p. 196).

But the inference from 'A is good for the group' via 'therefore A is good for the members of the group' to 'A will be selected for' is invalid, as everyone knows nowadays.[26] The present A does not constitute an "evolutionarily stable strategy" but is open to "invasion", to use Maynard Smith's terms (1974, *1982*): "backsliders" endowed with a mutant α', will, if undetected, benefit from the altruism of others without paying their subscription; their chances of surviving and passing on their genes, including this mutant one, will have improved.[27]

26. Though I didn't in Watkins 1976, which was written under the influence of Wynne-Edwards's *1962*. I was glad to find such a distinguished evolutionist as R. S. Trivers reporting that he fell under Wynne-Edwards's spell for a while (*1985*, pp. 80f).

27. As to how neo-Darwinism accounts for altruistic behaviour, see Axelrod *1990* and Cronin *1991*, Part 3.

So we must not follow Darwin in turning to group-selection to handle the possible cost of unusual inventiveness. But sexual selection suggests an answer here. If our raft-building pioneer's unusual inventiveness gave him something—a knack for story-telling, say—which womenfolk appreciated and which his imitators lacked, then he may have been helped to pass on his genes before his raft started breaking up. However, a sexual selectionist explanation for "swollen" brains faces two difficulties. The first, which would not attend a natural selectionist explanation, involves a distinction between *biological* and *reproductive* utility. Say that an enhancement of a phenotypic feature has biological utility if it favours the survival of individuals who get it, and reproductive utility if it increases their chances of having progeny. Biological utility brings reproductive utility in its train, but not vice versa. Even if a process of sexual selection began with females making a 'sensible choice',[28] going for a feature which has some kind of utility, the process typically so exaggerates the chosen feature that marginal enhancements of it begin to acquire biological disutility before the positive feedback process comes to a halt. Sexual selection can proceed so long as marginal biological disutility is offset by marginal reproductive utility , but if this "line of equilibrium", as Ridley calls it (*1993*, p. 143), is crossed the species will tend to go extinct. (Perhaps this is what happened with the Irish Elk, the biological disutility of its enormous antlers eventually exceeding their reproductive utility.[29]) But the tremendous expansion of hominid brains does not seem to have brought biological disutility in its train; if it was driven by sexual selection, how did it avoid doing so?

The second difficulty was much emphasised by Wallace, and has continued to exercise some of the best minds in evolutionist thinking to the present day. It relates to the *wide variations*, not so much in brain size, but in the mental faculties of normal, healthy people. We might call it the "duffers and geniuses" problem. Wallace insisted that features that are adaptations due to natural selection spread through the species and become pretty uniform. Miller (in press) holds that this sort of uniformity results

28. Cronin *1991*, p. 188, reporting Wallace.
29. According to Gould, their span ranged up to 12 feet; he adds that they were probably shed and regrown annually (*1978*, p. 79).

only from natural selection; an account of the expansion of hominid brains in sexual selectionist terms can also account for the wide variations in mental abilities. He cites evidence to the effect that in a certain species of bird there is more variation in their tails than in their wings, the wings being a product of natural and the tails of sexual selection. But what about paradigm examples of sexual selection? Aren't all peacocks' tails splendid and all male seals enormous? We will come back to these issues in § 5.6 below. There an idea of which there was already a hint in Darwin will be presented which will simultaneously resolve both the above two difficulties.

§ 5.5 Downward Causation and Meta-Capacity

The idea of downward causation was deployed by Donald T. Campbell in his 1974: biological systems are hierarchically structured, and there is downward causation when 'the distribution of lower-level events and substances' is partially determined by higher-level factors (p. 180). Popper took up Campbell's idea, saying there is 'downward causation whenever a higher structure operates causally upon its substructure' (1978, p. 348). But how are we to tell, when one factor acts on another, whether they are at different levels and, if so, which is at the higher level? Neither Campbell nor Popper gave a clear answer. In one limiting case there is a clear answer. If within a biological system there is emergence of a new kind of property, and this property causally affects properties at lower levels, then there is downward causation (see Kim *1998*, p. 229). But one would like to extend the idea to intermediate levels. Edelman, who accepts the survival-value argument for the efficacy of consciousness (*1992*, p. 113), has put forward an idea that seems to involve downward causation (though he didn't use this term) within consciousness; he supposes that most animals have only what he calls "primary" consciousness, but a few of them, including ourselves, have evolved "higher order" consciousness; and the latter, as well as bringing in new factors such as self-awareness, modifies and enriches the former. But again it is not obvious whether, say, a keen sense of humour is higher than, say, a strong logical sense. My policy will be to attempt a general characterization only after we have looked at some intuitively strong examples of downward causation.

One example is already provided by the Spearhead Model in §
4.6 above, where there is downward causation from an animal's
C-factor to its motor system. Downward causation also manifests
itself clearly enough in modern ideas about the acquisition and
use of language. I am inclined to accept that a latent linguistic
ability in Washoe and their other famous chimp pupils was elicited
by Allen and Beatrix Gardner and their co-workers.[30] But with
respect to language we humans are surely in a league of our own,
at least among land creatures. The human genome's largest pro-
ject is the building of the brain, and within that its largest sub-
project is, it seems, the building of a language capacity. This genic
work has a bottom-up character; as Pinker crisply put it, 'it is the
precise wiring of the brain's microcircuitry that makes language
happen' (*1994*, p. 364). And via their control of this construction
the genes install a powerful psychological module that makes
acquiring a first language child's play.

In the bad old pre-Chomskian days of S-R psychology, it was
popularly assumed that children are taught their mother tongue
by operant conditioning, mostly by their mothers. But in what
language could the teaching of a first language proceed? One
answer was the pre-vocal language of gestures. Collingwood
already saw that this answer is incoherent:

> The reason why no mother teaches language in this way is that it
> could not possibly be done; for the supposed gestures of pointing
> and so forth are themselves in the nature of a language. Either the
> child has first to be taught this language of gestures, in order to help
> it in learning English, or it must be supposed to 'tumble to' the ges-
> ture language for itself. But if it can do that, we want to know . . .
> why it cannot (as it in fact does) 'tumble' in the same way to English.
> (*1938*, p. 227)

One recalls Lorenz's point (quoted in § 4.4 above) that for
learning to begin, something innate must already exist that
makes learning possible. There must be, as Pinker (*1994*, p. 20)
quoted Darwin saying, some 'instinctive tendency' for language
acquisition.

30. See Brown *1970*, pp. 208–231 for a cautious appraisal, and Linden *1975*, for a
popular account.

This L-factor, as we may call it in line with the C-factor (at one time I called it the "Chomsky-factor"), enables children to pick up and decipher the hidden syntax of the language being spoken around them and to store it so that it becomes second nature, enabling them to structure their own utterances with no conscious awareness of doing so. Its existence is attested by the enormous disparity between input, consisting of vocal sounds, and output which, by the age of three or so, includes a varied array of meaningful, grammatically structured sentences. We should not be deceived here by the fact that young children speak mainly in "telegraphese" (Brown & Fraser 1963). A child bangs his spoon and cries 'Milk!'; his mother brings him some. Later, he points to the milk bottle and pronounces 'Milk'; she says 'That's right'. Then he points to a jug and pronounces 'Milk?'; she says 'No, that's yoghurt'. He would not have made his meaning clearer if he had said 'Bring me milk!', 'That's milk', and 'Is that milk?'. It has often been observed that a child's grammatical mistakes, as in 'Where those dogs goed?',[31] attest to the fact that the child is not merely playing back adult talk but forming sentences of its own in accordance with grammatical rules of which it has a basic grasp, though not in full command of their irregularities.

Of course, in learning its mother tongue a child normally benefits from lots of adult feedback especially from its mother; but it seems that this mostly concerns vocabulary and getting facts right, the grammar being left to take care of itself (see Roger Brown *1970*, pp. 201–02). Pinker reported (*1994*, p. 281) an attempt by a psycholinguist to correct a minor grammatical error which his small daughter had a habit of making. He got nowhere; her own grammatical instinct, though not yet fully matured, was in full command and impervious to this sort of outside correction. (Incidentally, a survey in America in the late 1960s showed the grammaticality of adults' colloquial speech varying inversely with educational endowment; it was lower among middle-class than working-class speakers, and lowest in the proceedings of academic conferences!)[32]

31. I take the example from Brown *1970*, p. 103.
32. Pinker *1994*, p. 31, citing William Labov.

The L-factor exercises a very potent kind of downward causation. That its existence in, say, an English child is both temporally and causally prior to that child's acquisition of the English language is attested by the fact if the child had been adopted at an early enough age into a Basque or Chinese or Hopi speaking milieu it would, again within quite a short time, have attained a good working know-how of the grammar of this very different language. And once internalized, the grammar exercises a control over the speaker's executive performances which is no less strong for being largely unnoticed. Monsieur Jourdain was understandably surprised to learn that in saying, 'Nicole, bring me my slippers and give me my night-cap', he was speaking *prose*. He was unaware of any prose-forming rules being at work; but they were and they would not have allowed him to put words in a wrong order such as, 'Me bring slippers my Nicole'.

The essential role in language, as well as in perception and thinking generally, of what he called supra- or meta-conscious rules was stressed by Hayek (*1967*, pp. 60f). Try supposing that we could be simultaneously aware of what we are saying and of the grammatical rules in accordance with which we are speaking; so that when a newly self-conscious M. Jourdain asks Nicole, 'Is the night-cap I wore last night clean enough for me to wear tonight?', he might at the same time be commenting to himself, 'Now I'm turning an indicative into an interrogative by bringing to the front the "is" after the first noun-phrase'. It seems obvious such a meta-commentary would have interfered with the first-order performance causing "centipede effect". (When a centipede was asked how he could co-ordinate all those legs he said that it was easy—and has been paralysed since. Popper gave a nice example. Adolf Busch was asked by a fellow violinist how he played a certain passage. 'He said it was quite simple—and then found he could no longer play the passage', *1994b*, p. 116.) Hayek's point was that a meta-level commentary would in any case have to proceed in accordance with rules, to articulate which a meta-meta-level commentary would have been needed; an attempt to articulate everything would open up an infinite regress.

It seems that the L-factor may atrophy in a child deprived of all linguistic stimulus over an extended period; and if that happens there seems to be little hope that the loss can be made good by a subsequent attempt to teach the child a first language. In the

famous case of the wild boy, aged eleven or twelve, found naked and speechless in woods near Aveyron in 1797,[33] such an attempt was made by a Dr. Itard, a student of Locke and Condillac and a disbeliever in innate ideas. He had recently been appointed to an institute for deaf mutes in Paris, to which he took the boy, whom he called Victor. He got nowhere trying to teach him spoken French; presumably the vocal sounds which constitute the main linguistic input for a normal child remained meaningless noise for Victor. But he made some progress with written French. He first tried to get Victor to identify a small number of individual words. This went quite well, and after a time Victor learnt to distinguish words whose spelling was nearly similar. Then came associating words with things. At first Victor associated the word *livre* with one particular book, but after a time he learned to associate it with this or that book. Later he learnt to pair cards saying *grand livre* and *petit livre* with, respectively, a big book and a small book, and went on to attach *grand* and *petit* to, respectively, a big nail and a small nail. He also learnt the names of certain actions, such as *dropping* a book or a nail or a key. But that seems to have been about as far as he could get. He seems to have been unable to catch on to the existence of grammar and the possibility of linking words together to form sentences. The story of Victor is a reminder that there are several distinct stages in the ascent to normal competence in a first language and that the attainment of one level is a necessary but not a sufficient condition for ascent to the next. At each stage an upward breakthrough is called for; children normally make these effortlessly.

With children who are young enough and in good interaction with one another, the L-factor is so potent that it can set to work even when they are not provided with a mother tongue. The following incident, discovered by Derek Bickerton (see Blakemore *1988*, pp. 180f and Pinker *1994*, pp. 32f), has become famous. Children of migrant workers who had been brought to Hawaiian sugar plantations from various parts of the world were isolated from their parents and supervised by an adult who spoke to them in a grammatically unstructured pidgin, so they got some vocabu-

33. I rely in what follows on Roger Brown *1958*, pp. 3f. For the rather similar case of the girl Genie, see Curtiss et al. 1974.

lary but no syntax. Without adult help they instinctively worked this up into a new, richly expressive and grammatically structured Creole.

> The adults who create pidgin speech are not able to provide it with any structure; they're past the critical age at which syntax develops. The children, however, are not. Syntax develops in them . . . naturally It's natural, it's instinctive. and you can't stop them from doing it. I think the only explanation you can have for the way syntax works is that, somehow, it is built into the hard wiring of the brain. (Bickerton, quoted in Blakemore *1988*, p. 181)

Another incident, reported by Pinker (*1994*, pp. 36f), involved deaf children. There had been no sign-language in Nicaragua because deaf people remained isolated from each other; but in 1979 schools for deaf children were created. The official idea was to train them in lip-reading. According to Pinker this invariably fails, and it did here; but a sort of pidgin sign-language developed among children who at this stage were ten or older. When children as young as four joined in, there was a remarkable transformation, analogous to what happened in Hawaii; a grammatically structured language developed: 'The children can use it in jokes, poems, narratives, and life histories, and it is coming to serve as the glue that holds the community together' (p. 37). Chomsky wasn't romantically exaggerating when he said that language is "reinvented" each time it is learned (*1968*, p. 75). Children with no language to re-invent may invent one of their own.

We can imagine a Recording Angel watching over the development of human language. He might record in red what he regards as true breakthroughs and in black what he regards as horizontal extrapolations from what was there before. Thus he might record in red the first use of a descriptive phrase to denote something absent or as yet non-existent. (In § 6.2 below we will find Schopenhauer saying that whereas animals are pulled by the rough, visible strings of what is perceptually present, human thinking is also drawn by fine invisible threads.) Also in red would be the first question. Sometimes he might hesitate between black and red. Suppose that certain ancestors of ours counted up to ten, using their fingers. They taught their children these numbers by raising one finger and pronouncing their word for 1, then raising

a second finger and pronouncing their word for 2, and so on. Suppose that they then introduced a term for this operation of raising another finger. This would be their word for +1. The Angel might at first incline to an entry in black, on the ground that they are only giving a name to something already there; but he might switch to red when he realised that this seemingly horizontal extension implicitly introduces all the natural numbers.

For a second example of downward causation I turn to a striking example of meta-capacity in Artificial Intelligence, which is both perspicuous and interesting in its own right. Call the program by which a computer's moves are determined when it is playing a game of chess, say, an *executive* program. If you buy a commercial program of this kind it will have no ability to learn. It may be very smart; but should you outsmart it and then take it back to where it made a wrong reply to a good move of yours, it will make that reply again (or, if it used a randomizing device, give it the same weighting as before). But imagine a meta-program to have been installed above an executive program, making learning possible. In the 1960s A. L. Samuel devised such a two-level program for draughts (checkers). Much of its executive program was fixed and incorrigible. It always employed a minimax strategy, selecting moves on a 'best of the worsts' principle. It always searched down the branching possibilities for just three moves ahead (though if in doing so it reached a board position which it had previously analysed, it tacked the result of its previous analysis onto the current one). And it had a fixed set of rules, thirty eight in all, for evaluating board positions. One of these was a paramount rule; it evaluated possible future states of the board relative to its present state just in terms of pieces lost/gained. It was given a fixed, high weighting. The other rules evaluated board positions in terms of such things as mobility and degree of control over the centre. It was through adjustments to their weightings that learning took place. At any one time over half of them had a zero-weighting. When a rule's weighting first fell to zero it went to the back of the queue of unemployed rules, and the one at the front now got a positive weighting. The weightings were adjusted in the light of results as the computer played other players and especially itself again and again.

In the early stages of its career this two-level program was playing 'like a duffer'; but it was soon beating Samuel and went

on to beat a champion player.[34] I find this a more impressive achievement than the defeat of the world chess champion Kasparov in 1997 by 'Deep Blue'. The latter had enormous calculating power and it drew upon a huge store of human play by world champions and other grandmasters (including Kasparov himself of course). By contrast, the calculating power of Samuel's program was severely restricted, as we saw, and it was stored only with games that *it* had played. Its rise to champion level was all its own doing, with no plagiarism of human performances. It is ironic that Samuel had recently been insisting, against Norbert Wiener's gloomy prognostications, that with computers 'nothing comes out which has not been put in'.[35] In this case, what was put in was a weak executive program together with a meta program, and what came out was the same meta program and a champion-defeating executive program.

Now to a general characterization of downward causation. In this AI example the successive executive programs were clearly subordinate to the meta program which was, so to speak, "innate"; it was there at the beginning and brought about changes in the executive programs which did not bring about changes in it. And in the previous example, first-order or executive skills were subordinated to something innate at a meta-level. In both these intuitive examples of downward causation we have a meta-level something that involves a mix of inventiveness (real or simulated) and critical monitoring, the inventiveness sometimes issuing in new kinds of executive performance to be monitored for its success or otherwise. We may call that meta-level something *meta-capacity*. And we can say that the exercise of meta-capacity involves downward causation.

Wallace's mistake was to consider executive skills and overlook meta-capacities. Imagine that we could get in touch with Wallace. We first explain that, since his time, machines called computers have been invented with "brains" made of electronic hardware on which software programs can be installed. We then tell him that a draughts-playing machine has had a meteoric career, at first playing very primitively but getting ever stronger and eventually beat-

34. See Samuel 1963, 1967; Apter *1970*, pp. 72f; Wooldridge *1968*, p. 105.
35. Samuel 1960, p. 741.

ing a champion player. His first surmise might be that ever stronger programs had been installed in it, one after another. We tell him that no additional software was installed during this period. He might have responded to this with the suggestion that it possessed from the outset a *potential* for championship play, but for some reason only a little of this capacity was actualized in the early stages. We could then tell him that this was a two-level program with a meta-capacity for improving its executive capacity, and that *all its meta-capacity was being used at full stretch from the beginning*—rather as our ancestors 100,000 years ago may have had as much meta-capacity as ourselves and have used it at full stretch in the development of rafts, tools, traps, weapons. . . .

§ 5.6 Evolution and the I-Factor

Back now to Wallace and the "duffers and geniuses" problem. Wallace sought to guard himself against the accusation that there is no metric in this area by putting various numerical glosses on his claims. I am not sure that we need a metric. If I told you that I rank Mozart *slightly* above Haydn and both of them *much* above Stephen Foster (grateful though we should be for 'Old Folks at Home' and 'Swanee River'), would you say that in the absence of a metric here I should say only that I rank Mozart above Haydn and Haydn above Foster? In any case it seems that there is a rough-and-ready metric at least for inventiveness. As well as intelligence tests there are tests for creativity in children. These typically involve open-ended questions; as well as getting more marks for more answers, children get more marks for uncommon answers. So for the question 'What might this drawing illustrate?'

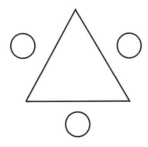

FIGURE 5.1

the answer 'Three mice eating a piece of cheese' scored more than 'Three people sitting around a table'; and for the question 'What uses could a newspaper be put to?' the answer 'Rip it up if angry' scored more than 'Make paper hats'.[36] (Unless prepared ad hoc, computers would be non-starters at this sort of test.)

Wallace seems to have supposed that if human minds had been products of natural selection we would all be equally mathematical *and* equally musical. . . . (In this section 'equally' is short for 'roughly equally' and permits of minor variations.) A possible answer would be, first that there is an underlying inventiveness which may get very variously specialized, with one individual being a duffer at maths but musically talented while another is tone-deaf but a great spinner of yarns; and second, that this underlying inventiveness is equally powerful in all of us. Before scrutinizing this answer let us take a brief look at the historical background. Wallace rather took it for granted that serious inequalities here, by telling against natural selection as the maker of souls, tell in favour of God. But such inequalities also pose theological difficulties; if human minds are God-given, why are we so unequally gifted, with some people being duffers and others geniuses of one kind or another? (I will go along with the word 'genius' though I don't really like it; calling X a genius is a bit like calling X a saint; it tends to set X apart from the rest of humanity and to carry the innuendo that anything X does will be stamped with a superior quality; but the author of one work of genius may run out of inspiration or botch the next job.)

This problem was wrestled with in the seventeenth century, at least with respect to cognitive ability. It was a main thesis of Bacon and of Descartes that genius actually gets in the way of the advancement of science. What is needed is not genius but Method (with a capital M to denote the one true method). Bacon suggested that, the Method having been provided, it is as if lines and circles, which were previously drawn freehand with very varying skill, can now be drawn very well by anyone with the help of rulers and compasses: 'The understanding must not therefore be supplied with wings, but rather hung with weights, to keep it from leaping and flying' (*NO*, i, 104). As he put it in the Preface

36. I am relying here on Wallach and Kogan 1972; see also Torrance 1965.

to *NO*: 'There remains but one course for the recovery of a sound and healthy condition—namely, that the entire work of the understanding be commenced afresh, and the mind itself be from the very outset not left to take its own course, but guided at every step; and the business be done as if by machinery.' Descartes also took an egalitarian view: 'what is called Good sense or Reason, is by nature equal in all men'; and what is needed for the advancement of science is not genius but the patient application by ordinary minds of the right Method: 'those who proceed very slowly may, provided they always follow the straight road [that is, the one true Method], really advance much faster than those who, though they run, forsake it' (*Discourse*, pp. 81–82).

But these men expelled the need for genius from science only to reintroduce a new need for it outside science. If mankind could make no significant discoveries while methodologically untutored, but will proceed to discovery after discovery under the guidance of a Method, then to discover this Method becomes the supreme cognitive task. But the would-be discoverer, be it Bacon or Descartes, will have no Method to guide him; so unless God lends him a hand, he will need a quite exceptional innate ability.

What does critical rationalism say about genius in science? Agassi called the "ruler-and-compass" approach an egalitarianism of mediocrity. Then is the critical rationalist approach an elitism of genius? He answered *yes* to genius and *no* to elitism: 'Instead of an egalitarian theory of mediocrity, or an elitist theory of genius, I propose an egalitarian theory of genius' (*1981*, p. 206). Although Agassi did not have in mind Wallace's difficulty for evolutionary theory, it is as if he had answered Wallace by saying that we are all geniuses of some kind.[37] Pinker has taken a similar line: 'And what about genius? How can natural selection explain a Shakespeare, a Mozart, an Einstein, an Abdul-Jabbar?'[38] His answer: 'The genius creates good ideas because we all create good ideas; that is what our combinatorial, adapted minds are for.' Natural selection has made geniuses of us all. And if the guidelines adopted in Chapter 2 above allowed us to accept a proposition into our world-view

37. His own words were: 'almost everyone, after all, is possibly a genius of some sort, perhaps of an unheard-of sort' (p. 205).
38. Pinker *1997*, p. 360. Abdul-Jabbar was a great basketball player.

because we would like it to be true, I would gladly accept this. But I don't believe it. The Agassi-Pinker thesis implies that Kant and his faithful old servant Lampe whom we will meet in § 6.3 below, were both men of genius, though Lampe's circumstances may have been less propitious than Kant's for its exercise. Well, it's logically possible.

Back now to Wallace. His dalliance with Strategy II (which would exclude us, body and soul, from the scope of natural selection) was brief. He came to accept our 'descent from some ancestral form common to man and the anthropoid apes' (*1889*, p. 461), and switched to Strategy III. His claim now was that people's artistic, mathematical, and musical faculties, their wit and humour, are not only surplus to requirements so far as survival is concerned, but that we are endowed with them *to very varying degrees*, which would not happen under natural selection (pp. 469–470). Darwin was far from dismissive of this claim. After remarking that natural selection brings about pretty uniform adaptations with respect to bodily structure, he continued: 'The case, however, is widely different, as Mr. Wallace has with justice insisted, in relation to the intellectual and moral faculties of man' (*Descent*, p. 196).

There seems to be a fairly general consensus at the present time that a serious problem for evolutionary theory is posed by variations of the kind highlighted by Wallace. Geoffrey Miller, about whose proposed solution some doubt was expressed at the end of § 5.4 above, has put the problem very clearly. If we call human behaviour that does not fit the standard criteria for adaptation by natural selection *marginalized*, this includes things like art, music, humor, and sports: 'Basically, the problem is that some people are very much better at these things than others' (in press). Earlier, G. C. Williams (the distinguished evolutionist and co-founder with W. D. Hamilton of "selfish gene" theory) recognized a genuine difficulty here. Our 'cerebral hypertrophy', as he called it, yields a *wide spread* of mental capacities; these enable nearly everyone to learn at least a simple trade, many of us to enjoy good literature and play a fair hand of bridge, and a few to become great scientists, poets, or generals. Why the variance? He said that despite the arguments of, for example, Dobzhansky & Montagu (1947, quoted in § 5.2 above), he did not accept that advanced mental capabilities have ever been directly favoured by

selection; geniuses don't seem to do better, reproductively, than people of moderate intelligence (*1966*, p. 14). His hypothesis was that genius may be a spin-off from the fact that precocious verbal understanding in a child would reduce the risk of accidental death. (Pinker took up this idea as helping to account for the spurt in language-acquisition that occurs—quite generally, it seems—in infants when they begin walking, *1994*, pp. 289–290). Yes, but this runs into Wallace's point: if linguistic precocity has important survival advantages, it should spread pretty *uniformly* through a species, as seems to be the case. After offering his hypothesis rather unenthusiastically, Williams added: 'if anyone has a better theory, I hope he will let it be known, because the problem is surely an important one' (*1966*, pp. 14–16). Well, I do actually believe that the theory now to be offered is better.

It involves what I call, in partial analogy with the L-factor, the *I-factor*. This is the combination of whatever features in the cerebral cortex make for inventiveness. Its various components will be assumed to be genetically independent of each other. For exposition's sake it will also be assumed that each of them varies in some simple linear way. My small amendment to evolutionary theory, here, is to bring in the one-sided kind of selection pressure which, in § 4.6 above, was called a *maintaining* pressure. This can be explained by comparing it with *stabilizing* and *directional* pressures.

Let *x* be a variable magnitude associated with some bodily character; for instance, the length of a certain bird's beak. Assume that *x* is genetically controlled and that a population's gene-pool contains genes that generate a normal distribution of values for *x* within the population:

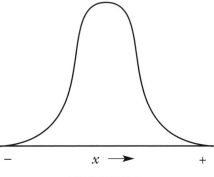

$$x \longrightarrow$$

FIGURE 5.2

With other variables remaining constant, x will normally have an optimum value, which it may be more realistic to think of as a small interval rather than a mathematical point. If the mean value of x within the population currently coincides with the optimum value, x will be subject to a *stabilizing* pressure, as shown in the next diagram:

FIGURE 5.3

Here, the thickened interval in the middle of the x-axis represents the optimum value of x, and the lengths of the downward arrows represent the strength of the negative pressures on deviations from the optimum. With the passage of time the bell-shaped curve will grow narrower and the variance between extreme values of x will decrease. The utility to an individual of a mutation giving it a marginal increase Δx of x will of course be positive when x is below the optimum value and negative when x is above it. If I-factors were subject to a stabilizing pressure, the latter would work against 'prodigies of genius', to use Darwin's term, no less than prodigies of stupidity.

When x is subject to a *directional* pressure, the chief difference from the foregoing is that the mean value for x does not coincide with the optimum value:

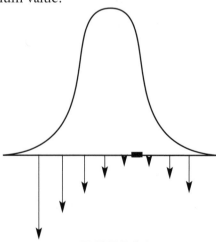

FIGURE 5.4

With the passage of time the distribution curve, as well as growing narrower, should shift sideways until the mean value equals the optimum value, whereupon the pressure will become stabilizing.

Now to a maintaining pressure. Let x now be a variable magnitude associated with a component of the I-factor. The distinction about to be drawn was alluded to, tantalizingly briefly, by Darwin when he remarked that whereas the excessive development of, say, a beak would be disadvantageous, 'we can see no definite limit to the continued development of the brain and mental faculties, as far as advantage is concerned' (*Descent*, p. 230). Restated in the present terminology, he was saying that when x relates to the power of the human brain and mental faculties, the net utility of Δx, as x increases, may never turn negative. Does that mean that it will always remain positive, so that there would always be a directional pressure on x to increase? No; instead of either always remaining positive or eventually turning negative, the net utility of Δx may at some stage start diminishing but approach zero tangentially. Where that is the case there will of course still be a directional pressure on x to increase so long as the net utility of Δx remains positive. Assume that the mean value of x increases to a level at which the net utility of Δx sinks to zero. Then x will be under no pressure to increase further. However, it will have reached not an *optimum* but a flat plateau of *optimality*. The net utility to an individual of a mutation giving it a further marginal increase Δx will not be positive but nor will it be negative. Selection pressures will discourage genes for values of x below its lowest optimal value but will be indifferent to ones above this value. Where such a *maintaining* pressure obtains, values for x might be distributed thus:

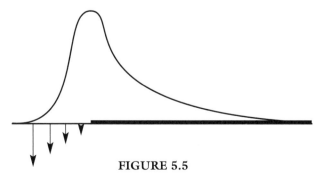

FIGURE 5.5

With the passage of time the variance to the left of the lowest optimal value will decrease as it would under a stabilizing pressure; but there will be nothing to prevent the variance to the right increasing. Genes for an exceptionally high value of x that got into the gene-pool would neither be driven out nor sweep through it.

The present model can explain how genius is possible but rare. Suppose, rather simplistically, that, between them Shakespeare, Mozart, and Einstein needed very high values for five components of the I-factor, with each man needing a different triplet of these. Over on the far right there may be hanging around a few rare genes in the human gene-pool for very high values for each of the ten components. The probability of receiving any one of these genes will be very low. If I-factor components are genetically independent, the probability of receiving all three of them will be almost, but not quite, infinitesimal.

Incidentally, the present idea can be extended to account for the exceptional manipulative control of a Paganini, say, or a cardsharper. Of course, such control can be enormously improved by practice. Houdini said that as well as having to work with great delicacy and lightning speed, he had had to make his fingers super-fingers in dexterity, and to train his toes to do the work of fingers.[39] In so training his fingers and toes he assuredly actualizing a potential that few of us possess to anything like the same degree. The Spearhead Model in § 4.6 above showed that if control capacity C rises to an optimal level under directional pressure it then, with constant motor-power M, C becomes subject to a maintaining pressure. So C-factors are analogous in this respect to I-factors.

§ 5.7 Modularity

Nowadays the idea prevails in evolutionary psychology that the mind is not a general-purpose problem-solving and decision-making organ but a system of modules each dedicated to a more or less specialized task, such as mate selection, or kinship estimation. We may call this the thesis of *the modularity of mind*, to borrow

39. Kellock *1928*, p. 3.

the title of Jerry Fodor's *1983*, or for short the modularity thesis. One confirmation of it has been found especially striking. In § 5.4 above it was mentioned, apropos group-selection, that carriers of genes for altruism would be at risk from those carrying genes for free-riding, provided the latter could avoid being found out. The risk would be reduced if natural selection had endowed altruists with a cheat-detection module. Evidence for the existence of such a module was found by Leda Cosmides (1989) in an ingenious way. The following simple logic test, devised by Peter Wason, is failed by a surprisingly high proportion of educated people. There are four cards showing, say:

<div align="center">

H 4 E 7

</div>

You are told that any card with a vowel on one side has an odd number on the other side. Which cards do you turn up to test this hypothesis? Many people rightly answer 4 (it may have a vowel on the other side) and E (it may have an even number on the other side) but wrongly include 7 (the hypothesis is consistent with it having a vowel or a consonant on the other side). However, Leda Cosmides (1989) found that if these letters and numerals are replaced by real life features that relate to "cheating" situations, such as accepting help but giving nothing in return, then there is a sharp reduction in the failure-rate. It looks as though there is a cheat-detecting module.

A rather similar situation has been found in connection with randomization. An impala being pursued by a leopard does not simply run as fast as it can; it injects some sudden swerves into its flight. Such behaviour has been called 'protean' (Humphries & Driver 1970) after Proteus the sea-god who sought to elude capture by changing shape. Game Theory has long recognized the importance, in competitive situations, of mixed strategies which one keep one's opponent guessing by injecting some randomization into one's moves (see for instance Rapoport *1966*). Do we humans have a module for proteanism? Some recent findings are rather interesting in this connection. It is well known that subjects who are simply asked to write down a sequence of 0's and 1's that will be a good approximation to a random sequence usually perform poorly. But that changes for subjects in genuinely competitive conditions, for instance with player A writing 0 or 1 and

player B predicting, B winning a dollar from A if the prediction is right, and losing a dollar to A if it is wrong, the game to be repeated a large number of times. In cases like these, sequences of 0's and 1's become much better approximations to random sequences.[40]

Let us now consider how the idea, presented above, that our large brains give us various kinds of meta-capacity bears on the modularity thesis, given that the C-factor, L-factor and I-factor count as modules. I suspect that the modularity thesis has run into hostility by seeming to suggest that the human mind is an assemblage of largely self-contained units, each functioning in its own routinized way, and issuing in a repertoire of behaviors of the kind we saw Kitcher wrinkling his nose at in § 5.2 above. The charge of self-containment obviously cannot be levelled at the first of the above three modules. And there seems to be an important relationship between the other two. As we saw, getting human speech under way, ontogenetically as well as phylogenetically, requires inventiveness; and though language may not be an absolute prerequisite for inventiveness, it surely helps. Another point is that when the two of them are collaborating the result may be the opposite of routinized. In an attempt to avoid the charge of anthropocentrism I will bring in some rather striking supporting evidence provided by dolphins. They have, it seems, some kind of linguistic capacity,[41] and sometimes a remarkable inventiveness has been elicited in them by human trainers. For instance, they have sometimes been called on to win a reward by behaving in a way that is different from anything they have done before. Robert Trivers reported that they soon caught on to what was required, and 'began to pour out large numbers of invented patterns never before seen in captivity or sea, such as corkscrew swimming and gliding upside-down with the tail out of the water' (1983, pp. 1205–06). I think that in watching a performance of that kind I have seen an I-factor at work. The immediate effect on the dolphin of the trainer's instruction was that it started swimming round and round the pool, very fast but otherwise normally, as though thinking furiously. After a time it leapt high out of the

40. Rapoport and Budesco 1992; and see Miller 1997.
41. Jerison 1985, p. 128, with acknowledgement to Herman 1980.

water, swivelled to one side and then to the other and made some further contortions before falling back into the water. Its inventiveness seemed clearly to involve a kind of downward causation in which its normal executive routines were, for the time being, radically revised on instructions "from above".

* * * * *

I will conclude this Part One by drawing a partial analogy between the gene-controlled, ontogenic development of a human being as understood here, and the development of human history as understood by Marx and Engels. One feature of their view is of course that it divides history into stages. A genome is sometimes naively pictured as aiming from the beginning at the construction of an adult phenotype. In fact, of course, development goes through stages and the genome has to meet requirements stage-by-stage. (One has only to think of the caterpillar-chrysalis-butterfly sequence.) Genes must be switched on, and off, to bring them into play in the right order. With regard to the newborn infant, an ability to breathe and to suck is essential; an ability to say 'Thank you, madam, the agony is abated' (allegedly Macaulay's first words) is surplus to requirements. Strawson envisaged two histories of a human being, one in the language of physics, chemistry, neurology and physiology, the other in the language of Folk Psychology (*1985*, p. 56), and asked what the relation between these two histories would be. Well, imagine Laplace's Demon to have acquired an additional intuitive capacity: as well as seeing unerringly into the physical make-up of things, minds are transparent to him, he can read them like a book. He keeps a dual record, in physicalese and in mentalese, of an individual from the moment of conception through until early manhood. We may further imagine him to have an unerring ability to relate items by means of causal arrows; he may insert arrows between an item recorded in one language and an item recorded in the other language as well as between items in the same language. According to the view adopted here, his record will go through three main stages. In the first stage he will follow the genome supervising embryological development; this will be a physicalist stage in which the wiring of the infant brain is being carried out but there is as yet nothing to go into his Folk

Psychology record. And then, at birth or soon afterwards, the second stage begins; our Demon now detects the first flickerings of sentience. The baby is beginning to turn into a bundle of sensations. This will be an epiphenomenalist stage, with arrows to mental items from physical items but not vice versa.

Except that it happens all the time, this is indeed an astonishing development ('sheer magic', as we found a distinguished evolutionist calling it in § 4.3 above). And for many thinkers, the emergence of consciousness from pre-conscious matter constitutes *the* mind-body problem. Thus Nicholas Humphrey writes: 'The mind-body problem is the problem of explaining how states of consciousness arise in human brains' (*1992*, p. 2). But according to the views developed in the present book, consciousness does not merely emerge; quite soon it begins playing an active role. It is here that the analogy with the materialist philosophy of history comes alive. While it regards material factors as the ultimate determinants in history it allows that a stage is reached where the political-ideological superstructure is no longer a mere epiphenomenon being carried along by its infrastructure, but comes to exert a strong feed-back effect on the course of historical struggles.[42] Our Demon will begin to detect intermittent downward causation. At first it will be rather faint: eyes beginning to focus on objects of interest, some incipient graspings . . . ; but downward causation becomes increasingly prominent as the child's mind, with its insatiable curiosity and imperious egocentrism, grows stronger. The stage of dualist interaction becomes established.

Of course, a mind always remains dependent on its neurological infrastructure, rather as a fighter pilot is dependent on the proper functioning of his enormously complex aircraft; but that does not make him a passenger in it.

42. See e.g. Engels 1890.

PART TWO

Freedom

Chapter 6
Historical Review I: Hobbes, Descartes, Schopenhauer, Kant

The aim in Part Two is to show that critical rationalism supports a 'Third View' of human freedom which, unlike classical empiricist and classical rationalist views, is at once distinctive, naturalistic, and viable. By way of preparation we will examine some of those earlier views. This will not be intellectual history for its own sake. It will be selective and critical, a search for features to be preserved, perhaps in a modified form, and for wrong turnings and cul-de-sacs to be avoided. The present chapter begins with empiricist views, proceeds to Descartes and Schopenhauer, and thence to Kant. The whole of the next chapter will be devoted to Spinoza; despite major disagreements between them, our Third View draws importantly on Spinoza's view.

§ 6.1 Freedom and Heteronomy: Hobbes

Is our journey necessary? What's wrong, an objector may ask, with a levelling concept of freedom, such as Hobbes's? That tough-minded naturalist declared: 'A FREEMAN, is he, that in those things, which by his strength and wit he is able to do, is not hindered to do what he has a will to do' (*1651*, p. 108, in italics in the original). This was echoed by Huxley: a greyhound chasing a hare is a free agent, because it is acting in accord with its desire to catch the hare; if held back by the leash it is not free, being prevented by an external force from following its inclination. (Presumably a hare being chased by a greyhound is also a free

165

agent, acting in accord with its desire to escape.) Likewise a human agent is 'free when there is nothing to prevent him from doing that which he desires to do' (1874, pp. 240–41). Isn't that, our objector might continue, just the sort of down-to-earth, no-nonsense concept that critical rationalists and naturalists alike should welcome? And doesn't it provide a working criterion for those who hold that freedom should be maximized? To maximize freedom on a Hobbesian definition is to allow as many people as possible to do as much as possible of what they want to do, the sole justification for the State to curtail a particular freedom being that not to do so would permit behaviour that would result in a greater curtailment of other freedoms. What's wrong with that? And will your distinctive theory, supposing that you come up with one, serve any purpose other than to flatter those who, like Bishop Wilberforce, snobbishly wish to distance themselves from gorillas?

Well, our Third View, as well as allowing that human beings may attain a kind of autonomy or self-direction that is not open to apes (if it didn't it wouldn't be distinctive), also allows that they may sink into kinds of heteronomy that are not open to apes. And we shall find that Hobbes's definition of freedom allows people sunk in certain kinds of heteronomy to be classed as "free". B. F. Skinner, who spoke contemptuously of 'autonomous man' to whom 'we readily say good riddance' (*1971*, p. 196), might have asked, What's wrong with heteronomy? Well, let's look into certain kinds of heteronomy permitted by Hobbes's definition. According to this hard determinist, your will is necessarily predetermined; and if you are not now hindered from doing whatever you now have a will to do, you are now free no matter how your will may have been predetermined. Your will may be under someone else's hidden control, in the manner described by Rousseau in this advice to a potential tutor:

> let him [your pupil] always think he is master while you are really master. There is no subjugation so perfect as that which preserves the appearance of freedom, for in that way the will itself is captured. Is not this poor child . . . at your mercy? Are you not master of his whole environment so far as it affects him? Cannot you make of him what you please? His work and play, his pleasure and pain, are they not, unknown to him, under your control? No doubt he ought only

to do what he wants, but he ought to want to do only what you want him to do. (*Émile*, pp. 84–85)

One can imagine this sort of skilful manipulation being exercised over an adult, resulting in a subtle and far-reaching kind of heteronomy.

Daniel Dennett has dismissed this line of thought: the free will literature has a tradition of 'thought experiments featuring sneaky manipulators' (*1984*, p. 37). He waved these aside, confidently asserting that it is easy to make the 'evil trickster's job' virtually impossible (p. 38). He made only joking references to hypnosis. But experimental investigations into hypnotic phenomena have elicited some disturbing facts about the human mind which have come uncomfortably close to showing how Rousseau's idea of capturing a subject's unsuspecting mind might actually be carried out. Let us look into this.

However it comes about, it is a fact that the mind of a subject in a hypnotic trance may become wholly subordinated to the voice of another person: 'My thoughts were an echo of what you were saying', and 'Your voice came in my ear and filled my head', are typical of reports given by hypnotic subjects on being asked, after arousal, what a hypnotic trance had been like (Hilgard *1965*, p. 139). As Hilgard put it, 'there is a psychological fusion between subject and hypnotist: . . . the hypnotist's words are confused with the subject's own thoughts' (p. 24). It is widely supposed that a hypnotized subject cannot be got to do something at odds with his deepest preferences and moral convictions; 'people will not do things under posthypnotic suggestion which run very strongly counter to powerfully ingrained dispositions of theirs' (Grünbaum 1972, p. 612). But there is striking counter-evidence to this. Martin Orne (1979, pp. 553–54) reports an experiment, originally carried out in 1939, and repeated with essentially the same results in 1952 and 1965, in which deeply hypnotized subjects were induced to 'pick up a poisonous snake with their bare hands; to remove, with their bare fingers, a penny from a beaker of fuming nitric acid where it was obviously in the process of dissolving; and finally to throw this acid at a research assistant.' When Orne repeated the experiment, the group included some "simulators", that is, subjects who had not been hypnotized, but whose role was to try to deceive the experimenter into believing

that they had been (a role in which they were remarkably success-
ful). They did the same as the hypnotized subjects, explaining
afterwards that they were sure that the experimenter would not
allow anyone to get hurt; but the subjects who had been hypno-
tized assuredly believed that the snake was poisonous and that the
beaker contained nitric acid.

One significant exception, from our point of view, to the thesis
that deeply hypnotized subjects can be got to do just about any-
thing is that they cannot be got to "do their own thing". Gill and
Brenman had an experiment in which it was suggested to the sub-
ject that he should not act like a robot but be as free and sponta-
neous as possible. The subject

> usually expressed his "spontaneity" by opening his eyes, getting up
> from the chair, roaming aimlessly around the room, carrying out a
> few awkward and obviously artificial acts (for example, looking out of
> the window at nothing, leafing through a magazine), and shortly
> thereafter sitting down again only to sink back into a passive immo-
> bile state—sometimes closing his eyes, but more often just sitting in
> a rather depressed and quiet torpor. Usually, when we questioned
> him at this point about his thoughts and feelings, the response would
> be a slow and halting, "I don't feel like doing anything." Sometimes
> he would then ask what he should do. (*1959*, pp. 37–38)

The kind of hypnotically induced heteronomy that is most rel-
evant in the present context is that exhibited by a seemingly wide-
awake subject acting out a suggestion put to him earlier, under
hypnosis. It is well known that such a subject feels no strange
compulsion when acting out such a suggestion, even if it is really
quite alien to him; on the contrary, he feels that he has his own
compelling reasons to do it, however bizarre it may seem to out-
side observers (who may be impressed by the ingenuity of the
rationalizations that the subject conjures up to justify his doing
it). Suppose that it was suggested to him yesterday that as from
noon today he will feel hungry; but it was also suggested to him
that he will decline all food. Noon comes, he feels hungry, and
various foods of kinds he likes are offered to him. He proves
highly resourceful in giving what seem to him genuine reasons for
declining these offers. For how long might a post-hypnotic sug-
gestion remain effective? Had it been suggested to our subject

that he will *never* eat again, would he be in danger of starving to death? There has not been much research on this question of duration because a responsible experimenter will normally debrief his subjects before they leave the laboratory, with the intention that they return to their daily lives with no alien deposit in their minds. But what evidence there is suggests that the post-hypnotic effect usually wears off quite quickly.

To make a thought-experiment which tells against a Hobbesian definition of 'freedom', imagine hypnotic powers as they exist to have been enhanced in two ways: first, instead of wearing off quite quickly, suggestions made under hypnosis may retain their full post-hypnotic strength for months on end; and, second, hypnotists can trick people into being hypnotized involuntarily. The motivation of a 'sneaky manipulator' Y who, in our thought experiment, is going to put person X into this state does not strictly concern us; but we may imagine that Y is an underworld boss and X is his "Man Friday" who has, in the past, sometimes exhibited a worrying streak of independence. So Y tricks X into being hypnotized, and a new era commences. Objectively, in his outward behaviour, X is now unfailingly obedient; but subjectively, all sense of subordination has vanished. Even when he is executing a suggestion that he would have rebelled against if he had received it as an order during the previous era, he now feels himself to be carrying out his own plan. He perfectly exemplifies Rousseau's idea that, while X should do only what X wants to do, X should want to do only what Y wants X to do. We may call X's state one of extreme *internal heteronomy*.[1] It is precisely his illusion of autonomy that makes X's heteronomy total: how can he rebel against his boss when he erroneously believes himself to be his own boss?

It may be suggested that Hobbes's definition should be restricted to cases where the agent has not been deprived of his ability to choose, as hypnotized and brain-washed subjects have been (Benn and Weinstein 1971, p. 210). But now consider an

1. What I am calling 'internal heteronomy' was called 'heterarchy' by the late Stanley Benn, who wrote: 'it is possible that the *actions* of a heterarchic person may not be interfered with at all; he may have been too well programmed for that to be necessary. Though in one sense he has been deprived of his freedom, the wrong that has been done to him is quite different from that done by making him a prisoner, a bondsman, or by blackmailing him' (*1988*, p. 167).

extreme case of *external heteronomy* or enslavement, where X's life is again under alien control, but no longer exercised covertly. His ability to choose hasn't been "got at", it's just that the options he can choose between are either to obey or else be flogged, shot, or whatever. So long as he does not suffer from muscular paralysis or some other physical interruption, but continues to do what he has a will to do within his situation, he satisfies Hobbes's definition of freedom.

And even if we exclude from its scope all cases of subordination to another, whether 'sneaky manipulator' or slave master, Hobbes's definition would still let in cases of what we may call *self-inflicted heteronomy*. A heroin addict, desperate for a fix, bares his arm, inserts the needle, doing what he now wants above all to do. By Hobbes's and Huxley's definitions he is, for now at least, a free man.

§ 6.2 Freedom and Volition: Descartes and Schopenhauer

A majority of those who have philosophized about freedom have given the central place to *willing*, sometimes to willing as such, as with Descartes and Schopenhauer, and sometimes to moral willing, as with Kant. The big difference, here, between Descartes and Schopenhauer was of course that for Descartes the will is free whereas for Schopenhauer it is causally determined. It was indicated at the outset that the idea of free will is not essential to our Third View. The examination of Descartes's use of it will suggest that this is just as well; and the examination of Schopenhauer will suggest that bringing the will within the scope of determinism does not improve things. These matters will occupy the present section. Afterwards we will turn to Kant and then, in the next chapter, to Spinoza who was famously dismissive of free will. He could be said to be among a minority who have given the central place, not to willing, but to *knowing* (as in 'And ye shall know the truth, and the truth shall make you free'). We might say that the central place is given to *conation* by Descartes and Schopenhauer, to *cognition* by Spinoza, and to *creation* by our Third View.

Descartes The search in Part Two is for a view of human freedom that is distinctive, naturalistic, and viable. Descartes's view

was distinctive: what gives us the possibility of freedom, according to him, is our possession of something which other animals lack entirely, namely a mind or soul. Descartes often gave the impression that he regarded the soul as immortal. Thus in the *Discourse* he wrote of 'reasons which go to prove that our soul is in its nature independent of body, and in consequence that it is not liable to die with it' (p. 118). However, a close reading of the passage from which this is taken shows that it does not actually assert that the soul *is* immortal. Or consider the *Meditations*; the full title of its first edition, put into English, is: 'Meditations on First Philosophy in Which Is Proved the Existence of God and the Immortality of the Soul'. However, inside the book Descartes almost immediately explained that he had not actually proved the latter (p. 141); and the title of the second edition was adjusted to reflect this, replacing (in the French translation) 'immortalité de l'âme' by 'distinction de l'âme d'avec le corps'. Descartes's private view seems to have been rather sceptical. 'As for the state of the soul after this life,' he wrote to Princess Elizabeth,[2] 'I am not as well informed as M. [Sir Kenelm] Digby. Leaving aside what faith tells us, I agree that by natural reason alone we can make favourable conjectures and indulge in fine hopes, but we cannot have any certainty' (*Letters*, p. 185). The question before us in what follows will be the viability of Descartes's view of the freedom-giving role of the soul in this life.

Descartes had intended to write a work, *Le Monde*, that would consist of two treatises, one on light and one on Man. The latter, *L'Homme*, was to be in three parts. The first would depict the body of a hypothetical "man" created by God to be 'as much as possible like us' except that it lacks a soul; the second would be about the soul and the third about the union of soul and body. Only the first of these three parts had been written when he abandoned *Le Monde* on learning of the Church's condemnation of Galileo in 1633; however, the subject-matter of the other two parts was taken up in the *Meditations*, the *Passions*, and the *Principles*. *L'Homme*, published posthumously in 1664, presents man's body as a hydraulic machine with liquids circulating along

2. Daughter of Frederick V of Bohemia and niece of Charles I of England; her brother, Elector Palatine Karl Ludwig, invited Spinoza to be Professor of Philosophy at the University of Heidelberg (Wolf 1910, p. lxxxix).

tubes and filaments. (Descartes had been most impressed by the charming automated figures, depicted in the frontispiece to *L'Homme*, which he had observed in the royal gardens at Saint-Germain-en-Laye. The water that drives these figures, he wrote, is able 'to make them play certain instruments or pronounce certain words according to the various arrangements of the tubes through which the water is conducted', AT-130). As well as the circulatory system with the heart at its centre, this body has a system of nerves (or tubules) with the pineal gland at its centre, with animal spirits circulating along them, controlling the contractions of muscles and tendons.

Descartes claimed that the movements of this machine's limbs follow naturally from the disposition of its organs, like the movements of a clock or other automaton, and that they imitate very well those of a real man (AT-202). This soulless "man", it seems, would function as efficiently at the biological level as a real man. Then what difference is made to bodily behaviour by the fact that a real human body is in intimate union with a soul? Well, the only way the soul can affect the body-machine is by altering the flow of the animal spirits; and it famously does this, as was touched on earlier (in §§ 4.4 and 4.7 above), via the pineal gland. How decisive are the differences made when the soul interferes with the natural flowing of the animal spirits? Mean by 'volitionism' the thesis that acts of will determine bodily behaviour unfailingly, and by 'libertarianism' the thesis that acts of will are not causally predetermined. Descartes upheld both theses. He declared that whenever the soul desires something, it produces the appropriate bodily movement by causing the pineal gland to move in the requisite way (*Passions*, § 41). And in his eyes this power was of enormous value: it gives man his principal perfection (*Principles* I, 37). Descartes found himself to be extremely limited in comparison with God in all respects except just one: in the freedom of his will he was God-like (*Meditations*, pp. 174–75). It is in exercising one's will, and only in so doing, that one is free: 'to will and to be free are the same thing' (*Replies*, p. 75).

People often exercise what seems to be free will when they are indifferent between *a* and *b* and have to choose one of them; but Descartes regarded that as the lowest grade of liberty (*Meditations*, p. 175). Then suppose that I regard *a* as unambiguously better

than *b*. Such cases pose a dilemma for a libertarian: either I cannot but opt for *a* and therefore have no real freedom of choice here, or I am genuinely free to opt for the inferior *b*. Descartes chose each horn at different times. Here he is choosing the first: 'the more I lean to the one . . . the more freely do I choose and embrace it' (ibid). That reduces the act of will to something like Hobbes's 'last act of deliberation'. But in a letter written some time later he spoke of the will's positive power to override such a rational decision: 'it is always open to us to hold back from pursuing a clearly known good, . . . provided we consider it a good thing to demonstrate the freedom of our will by so doing'; in following the worse although we see the better 'we make more use of that positive power' (*Letters*, pp. 159–160). One feels sympathy with Schelling's remark that to be able to decide for or against something without any motivating reasons would 'only be a privilege to act entirely unreasonably' (*1809*, p. 382). I do not say that we should take this latter view as the more authentic expression of Descartes's volitionism; but if we do, his Free Man is beginning to look like his Machine "Man" with a randomizing device in its control centre.

In the view of freedom to be presented in Chapter 8 an important role will be played by the idea of a *sustained* course of endeavour. Could this idea be accommodated within Descartes's system? If he had asked (which so far as I know he never did) how long a single volition could continue to control bodily behaviour, he would presumably have said that it depends on how long one and the same setting of the pineal gland could continue to regulate the animal spirits in appropriate ways. Much would depend on whether the behaviour had a routine character. He allowed that a single volition can set in motion a certain pattern of bodily behaviour (*L'Homme*, AT-197). The same setting could keep me tramping along a familiar path for a long time; it would not need first a volition to move the left foot and then one to move the right foot. . . . But if I were picking my way through mine-infested territory, each deliberate step would presumably call for a new setting. So the question becomes: might a sequence of Descartes-style volitions exhibit a cumulative tendency, so that it is as if they fitted into a coherent, long-term plan? I see no reason why they should. A particular act of a free will, according to Descartes, is not constrained by anything external to it and hence

not by this will's past decrees. The more free are my acts of will, the more nearly should my progress (if that is the word) resemble a random walk. So much for a libertarian version of volitionism. Now to an anti-libertarian version.

Schopenhauer Twenty years after the publication in 1819 of the first edition of his magnum opus, *The World as Will and Representation*, Schopenhauer submitted anonymously to the Norwegian Scientific Society a brief and lucid *Essay on the Freedom of the Will* (1841) for a prize (it won). This essay is strongly naturalistic in its approach; and it may seem to fulfil the expectation that a naturalistic view of human freedom will be levelling or eliminative. In the last chapter he announced: 'The result of our preceding exposition was to recognize the complete annulment of all freedom of human action and its thorough-going subjection to the strictest necessity' (p. 93). However, he went on to locate freedom in a higher region, after which he declared: 'Consequently, my exposition does not eliminate freedom' (p. 99). In this work, while totally repudiating Descartes's libertarianism, he appeared to uphold a strong volitionism: 'my body will immediately perform [an action] as soon as I will it, quite without fail' (p. 16). He also spoke of the will's 'absolute power over the parts of the body' (p. 17). And for our purposes the interest of this work is to find out what becomes of a strong volitionism when subsumed under a rigorous determinism.

Unfortunately, Schopenhauer's thesis of the will's sovereignty over bodily actions is turned into a tautology by a main metaphysical thesis of his *1819/44*. We touched briefly on Schopenhauer's ultimate and seemingly paradoxical metaphysical position in § 4.3 above, where we found him declaring that mind and matter are really one and the same thing, considered from two opposite points of view. And in line with that he held a dual-aspect theory of willing and behaving: 'The act of will and the action of the body are not two different states . . . connected by the bond of causality; they do not stand in the relation of cause and effect, but are one and the same thing, though given in two entirely different ways' (*1819/44*, p. 100). He there went on to declare the whole body to be nothing but objectified will. Even 'involuntary movement following on mere stimuli' counts as volitional; conversely, cases where a resolution about the future fails to be carried out, as

when a beginner on a nursery slope grimly mutters 'This time I *will* get my weight on the outer ski' and again fails to do so[3]—these are 'not real acts of will' (ibid).

In his *1841*, however, Schopenhauer did not avow the 'dual-aspect' thesis; rather, he there gave, as we shall see, every appearance of adhering to a dualist interactionism. (If he had been challenged about this discrepancy he might have answered that in this prize essay he was speaking with the vulgar.) And since the present aim is to find out, not so much what Schopenhauer really believed, but what becomes of volitionism when conjoined with determinism, we may proceed on the (no doubt mistaken) assumption that he intended all that he says in this essay to be taken at face value. He there said that the belief of philosophically untutored people that the will is free is an illusion, but one which arises in an understandable way as the natural verdict of self-consciousness. My self-consciousness is what would remain if the part of my consciousness that is directed outwards were subtracted from my total consciousness. What my self-consciousness tells me is that I am a being that *wills* and that my will is sovereign. It tells me: 'You can do whatever you will'. And this announcement, properly understood, is quite correct: if I will to do *x*, then I shall indeed do *x*, and if I instead will to do *y*, I shall indeed do *y*. But are both options—willing to do *x* and not *y*, or willing to do *y* and not *x*—open to me? Is my will free? As Schopenhauer put it: 'We grant that his *acting* depends entirely on his willing, but now we want to know on what his willing itself depends. Does it depend on nothing at all or on something?' (*1841*, p. 19). But this question baffles my self-consciousness; having no cognizance of anything external to my willing, it can only assume that my willing depends on nothing (p. 20). But this natural verdict (than which there is nothing, he quoted Descartes saying, we comprehend more clearly and perfectly) really results from the myopia of 'stupid self-consciousness' (p. 81). The matter stands very differently when it is investigated from without instead of from within; as a disciple of Kant, Schopenhauer considered it incontestable that the law of causality holds sway throughout the phenomenal world (p. 28). The question 'whether man alone constitutes an

3. I owe this example to Noretta Koertge.

exception to the whole of nature' (p. 21) is answered with an emphatic *no*. I can do whatever I will to do, but what I will to do is causally necessitated (p. 24).

Taken at face value, the volitionism which Schopenhauer propounded in his *1841* involves a strong kind of dualist interactionism, far removed from epiphenomenalism with its denial that the mental has any causal influence. He suggested that our thoughts exercise a causality, though of a somewhat arcane kind, over our bodily behaviour. Causality operates differently at different ontological levels. At the mechanical level, effects are exactly proportional to their causes; and this is also the case, though less obviously, at the chemical level. But at progressively higher levels, there is a growing disproportion and heterogeneity between cause and effect. At the animal level, the activating causes are motives (*1841*, p. 32).

> Complete separation [of cause and effect] in animal life first occurs when actions are called forth by motives. In this process the cause, which up to this point was still materially related to the effect, is now completely disengaged from it and is of quite different nature: it is something initially immaterial, a mere idea. Hence in the case of a motive which originates the motion of an animal, that heterogeneity between cause and effect, their separation from one another, their incommensurability, the immateriality of the cause and, consequently, its apparent lack of content as compared with the effect, has reached the highest degree. (p. 39)

And this disproportion becomes even more pronounced when we turn to humans. Brutes lack abstract concepts:

> they have no ideas other than perceptual ones . . .; they live only in the present. . . . They can choose only among the things which spread themselves out perceptually before their limited field of vision.
> . . .
> On the other hand, by virtue of his capacity for non-perceptual ideas, . . . man has an infinitely larger field of vision, which includes the absent, the past, and the future. Because of this he can . . . exercise a choice over a much greater range than the animal His action . . . proceeds rather from mere *thoughts* which he carries around everywhere in his head and which make him independent of . . . the present. (p. 35)

He gave this picturesque summary of this latter difference: men's 'actions are guided, as it were, by fine invisible threads (motives consisting of mere thoughts), whereas the actions of animals are pulled by rough, visible strings of what is perceptually present' (p. 36). And near the end of his book he said that our 'consciousness of self-determination and originality' is not deceptive (p. 98).

But now his thoroughgoing causal determinism makes itself felt. He insisted that we must not be 'misled by the just described immaterial nature of abstract motives which consist of mere thoughts' (*1841*, p. 42); for in a case where 'mere thoughts [are] struggling with other thoughts, until the most powerful of them becomes decisive and sets the man in motion', the process 'takes place with just such a strict causality as when purely mechanical causes work on one another' (p. 46). Schopenhauer's determinism turns his volitionism into something virtually indistinguishable from epiphenomenalism. Let E be a bodily performance, M the volition behind it, and C the physical state of the world at some time in the remote past. Taking his words at face value, Schopenhauer was here presenting a dualistic volitionism, with an immaterial factor M causing bodily changes E, to which we must now add that M was predetermined by physical conditions C. We may represent this by:

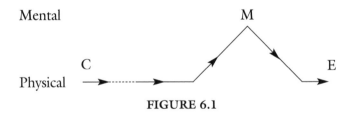

FIGURE 6.1

According to epiphenomenalism, M is merely an effect and causes nothing. We may represent this by:

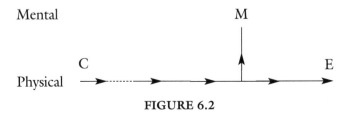

FIGURE 6.2

How significant is this difference? In both cases, bodily behaviour E was fixed long ago by C; does it matter whether the causal arrows go from C to E via M, or to M and to E with no arrow from M to E? I do not see that it does. One could say that determinism renders volitionism or any other kind of dualist interactionism non-robust: the mental items are so embedded in a physicalist context that they make no independent contribution. David Armstrong has made much the same point: if a physical event brings about a spiritual event which brings about a further physical event, there are laws which would permit us to predict the second physical event from the first physical event; how then 'do we decide that a spiritual event does play a part in the causal chain?' (*1968*, p. 360). Another way to make the same point is to suppose that we *know* determinism to be true, but do not know whether epiphenomenalism or interactionism is true. Then it would be uncertain whether the causal processes that lead to E make a detour through M or by-pass M, but it would be certain that in either case E is predetermined by C.

Schopenhauer seemed briefly to hold out the prospect that a man might, by dint of his human capacity for a kind of thinking that is not tied to current perceptions and which has a touch of imagination and originality, break free to some extent from the fetters of his past, and perhaps enrich his little corner of the world by contributing something new to it. But this prospect was soon snuffed out by his determinism:

> [A] man's character remains unchanged and . . . the circumstances whose influence he had to experience were necessarily determined throughout and down to the last detail by external causes, which always take place with strict necessity and whose chain, entirely consisting of likewise necessary links, continues to infinity. Could the completed life course of such a man turn out in any respect, even the smallest, in any happening, any scene, differently from the way it did?—No! . . . Our acts are indeed not a first beginning; therefore nothing really new comes into being through them. (*1841*, p. 62)

Human beings never originate anything and there is nothing new under the sun.

Schopenhauer's essentialism told in the same direction:

For every thing-in-being must have a nature which is essential and peculiar to it, in virtue of which it is what it is, . . . and whose manifestations are called forth of necessity by causes . . . [A]ll this is just as true of man and his will as of all other beings in nature. He too has an essence in addition to existence, that is, fundamental properties which make up his character and require only an outside inducement in order to reveal themselves. (*1841*, p. 60)

Such an essentialism implies that, however much something may change over time, it has, appearances to the contrary notwithstanding, an unchanging, indeed an unchangeable, character. And Schopenhauer vigorously endorsed this implication with respect to man: 'The character of man is *constant*: it remains the same, throughout the whole of life' (p. 51).

At this point Schopenhauer's thinking drew rather close to that of a thinker for whom he expressed much contempt tinged with some reluctant admiration. In his *Of Human Freedom* (1809) Schelling postulated a strange sort of predestination (p. 387). What I do as I live out my short sojourn on this earth has all been predestined from the beginning, not by God, or by fate, but by ME in 'a life before this life'. The present little me is acting out a play authored by ME in another existence (whether long ago in time, or outside time, or both, was left obscure). (Schelling did not explain how the play authored by Napoleon's original SELF dovetailed so neatly with the play authored by Wellington's original SELF.) Schopenhauer's idea here has a formal resemblance to Schelling's: my character, essence, or nature, is *given*; it's always been there and nothing I do can change it. It is non-transparent and difficult to fathom, even by myself; it reveals itself only through what I do (*1841*, p. 62). Yet for any circumstances in which I might be placed, it predetermines exactly how I would act. *If* one could decipher men's characters, and also know their circumstances, 'one could predict with assurance, indeed calculate, every action' (p. 58). Schopenhauer was here echoing Kant, who had said: 'if it were possible to have so profound an insight into a man's mental character . . . as to know all its motives, even the smallest, and likewise all the external occasions . . ., we could calculate a man's conduct for the future with as great certainty as a lunar or solar eclipse' (*CPrR*, p. 231).

According to Schopenhauer a person's character was laid down, not at the beginning of time, but by sexual act of creation. As Magee says (*1983/97*, p. 209), Schopenhauer was alone among philosophers in recognizing the metaphysical centrality of sex, and in discussing sex in a candid, unaffected manner. He was a thoroughgoing hereditarian (see the chapter, 'The Hereditary Nature of Qualities' in his *1819/44*, ii, pp. 517–530). His views on heredity may sound strange and naive to our ears, but they have this in common with modern ideas: something of decisive importance is fixed, once and for all, at the moment of conception. Imagine that we could get in touch with him and give him a quick rundown on modern genetic theory. He could easily accommodate the idea that one's genome is fixed at conception. He might have gone on to revise his above-quoted remark to say that a Demon who could read men's *genomes*, and also know their circumstances, could predict their every action. All of which highlights the importance of what was said in the previous chapter about the human brain's meta-capacity for revising first-order capacities in inventive ways. Schopenhauer's view holds for creatures at the bottom of the Dawkins ladder but not for those high up.

I mentioned that Schopenhauer turned towards the end of his essay to a 'Higher View' of freedom. This was essentially the same as Kant's, of whom he declared: 'Kant's presentation of the relation between the empirical and the intelligible character and thereby of the possibility of uniting freedom with necessity . . . is one of the most beautiful and profound ideas brought forth by that great mind, or indeed by men at any time' (*1841*, p. 96). Then let us turn to Kant himself.

§ 6.3 Freedom and Morality: Kant

Kant's distinctive view of freedom, or autonomy, involved reverence for the moral law. He also developed a tough-minded naturalism according to which saints and sinners are alike immersed in heteronomy. And his 'most beautiful and profound' idea, was that immersion in heteronomy does not preclude the possession of autonomy; we can and do occupy two worlds simultaneously. It is my conviction that a worthwhile view of human freedom has to show how it can be attained, not in some other world, but in this

one. I will argue, without originality, that Kant's "two-worlds" doctrine broke down. I will go on to suggest that Kant himself, late in life, allowed interaction between entities he had previously segregated into non-interacting worlds. I will conclude with a question about the relation of freedom and morality: could a mature person's conduct through life be (not merely negatively constrained but) positively directed and controlled by a self-imposed moral law?

Speculative Reason and Naturalism A bracing naturalism pervades Kant's critical philosophy as presented in the first edition (1781) of *The Critique of Pure Reason* (henceforth *CPRA*) and in the *Prolegomena* (1783). He proceeded as if in compliance with our second rule of exclusion (in Chapter 2), which says that we should exclude existential claims without including their negations where there is no good case for inclusion. He did, famously, claim that there are compelling reasons to include one pure existential statement: there must be *something* behind appearances; appearances cannot just be floating around unattached. So reason must postulate the existence of things-in-themselves even though we can know nothing positive about these supersensible things beyond the bare fact that they exist.[4] But that was exceptional. With respect to metaphysical questions ('Did the world have a temporal beginning?', 'Does God exist?', 'Is the soul immortal?') calling for an existential answer, he said that it had been the hereditary fault of rationalist metaphysics to try to put pure reason to a transcendent use by investigating matters lying beyond the limits of possible experience.

CPRA is famous for its rejection of existential claims concerning God and immortality, not as false, but as groundless propositions for which only pseudo-proofs had been offered. As well as its devastating demolition of all possible "proofs" for the existence of God, there was its critique of the 'First Paralogism of Pure Psychology'. This was Kant's label for an argument for immortality that proceeds from the premise that judgements of mine ('I know that . . .', 'I believe that . . .', 'I doubt that . . .') always have the same logical subject, to the conclusion that 'I'

4. Musgrave (*1993*, p. 221) points out that we can know some negative things about them; for instance, that they are not in space or time.

denotes a substance that cannot perish. Kant scorned this argument: it 'is palming off upon us what is a mere pretence of new insight. We do not have, and cannot have, any knowledge whatsoever of any such subject' (A 350); it is supersensible. The concept of the I, Kant declared, 'cannot yield us any of the usual deductions of the pseudo-rational doctrine of the soul, as, for instance, the everlasting duration of the soul' (A 351; and see *Prolegomena*, §§ 46–48). This criticism was reworked and expanded (B 406–428) in *CPRB*, the second edition, to deal with an attempt by Moses Mendelssohn[5] to plug a gap in a standard argument for the immortality of the soul. The standard argument ran: a soul, being essentially simple, cannot disintegrate; this leaves the possibility that a soul may abruptly vanish. Mendelssohn tried to plug this gap by saying that an existent can vanish only by successively losing parts of itself; and something essentially simple has no parts to lose. To this Kant retorted that something essentially simple may *vary in intensity*, and its intensity may sink to zero.

Another striking feature of *CPR* is its causal determinism. According to Kant, the Law of Causality applies without qualification to all phenomena, mental no less than physical. Human beings are as fully enmeshed in the deterministic processes of nature as any other natural objects. The prospects for human freedom look bleak: 'as regards this empirical character there is no freedom' (A550 = B578). And of the will in its non-empirical character we can know nothing at all, it being supersensible. One recalls Wittgenstein's 'Whereof one cannot speak, thereof one must be silent'. If Kant had left it at that, it is hard to see how he could have avoided an eliminative view of freedom. But of course he did not leave it at that.

Practical Reason and Freedom I begin with some dates. Kant's first work in moral philosophy, the *Groundwork of the Metaphysics of Morals* (henceforth *Groundwork*) appeared in 1785, four years after *CPRA*. It is concerned with ontological questions that require positive answers if a genuine morality is to be possible. In 1787 came the heavily revised *CPRB*; in 1788 the *Critique of Practical Reason* (henceforth *CPrR*); and in 1793 his *Religion*

5. Grandfather of the composer.

Within the Limits of Reason Alone (henceforth *Religion*). Kant introduced his idea of freedom in *Groundwork*. He there said that an activity is not free if it proceeds in accordance with laws of nature; for in that case it is determined by causes external to it and exemplifies heteronomy. So a free will must be a pure or non-empirical will that acts in accordance with a law of another kind, the moral law. But won't such a law be external to this pure will, which would still be in a state of heteronomy in obeying it? According to Kant, just this assumption had wrecked all previous thinkers' attempts to discover the principle of morality: 'it never occurred to them that [man] is subject only to *laws which are made by himself* and yet are *universal*' (p. 432). But while you may make for yourself a law that is formally universal, won't its content reflect your personal values? In obeying it won't you be obeying *your* moral law rather than *the* moral law? Kant rebutted this suggestion with his idea that the moral law is at once synthetic and apriori; like the other synthetic apriori categories, it is imposed on each individual by that individual's own reason (in this case, practical reason) and is at the same time universal and invariant for all individuals.

Two questions cry out for an answer. According to *CPR*, reason knows nothing about things-in-themselves in a supersensible realm; but that is where Kant locates free will. So one question is, How can we know anything about it? Another question is: can it make any difference to conduct? Let us take this latter question first. It seems clear that, according to the naturalistic doctrines of *CPR*, Kant should have answered that it cannot. My conduct belongs within the phenomenal world, or kingdom of nature, and proceeds in accordance with the laws of nature. It is causally predetermined. My noumenal self is free just because it is outside the phenomenal world. Surely the price for that is impotence with respect to anything inside the phenomenal world? Near the end of *Groundwork* Kant claimed to have surmounted the dilemma that practical reason is either submerged in the sensible world, or else 'flapping its wings impotently' (p. 462). His solution was, of course, that we belong simultaneously to two worlds. In the sensible world we are 'under laws of nature (heteronomy)', but in the "intelligible world" we are under laws that 'have their ground in reason alone' (p. 452). On the one hand, we are free moral legislators. 'On the other hand, it is just as necessary that everything

which takes place should be infallibly determined in accordance with the laws of nature' (p. 455). For 'both characteristics [being free and being a part of nature] not merely *can* get on perfectly well together, but must be conceived as *necessarily combined* in the same subject' (p. 456). So a noumenal ME, with a Free Will attuned to the Moral Law, co-exists with the empirical me. But doesn't the empirical me go about its (perhaps immoral) business heedless of the noumenal ME's directives? Kant said that the will of rational living beings has a *kind* of causality (p. 446). What kind? Kant admitted that it is a kind with which we have no acquaintance (p. 453); and he agreed that within the intelligible world in which the "causality" of free will is supposed to operate there is 'a total absence of springs'.[6] It seems clear that instead of saying that a free will has causality of an indescribable kind, Kant should have candidly admitted that it has *no* causality.

So Kant "combines" moral freedom with causal determinism by locating one in an unknowable shadow world, and the other in the world where the action is. Let X be a saintly person and Y a scoundrel; could the phenomenal difference between X and Y be due, on Kant's view, to some difference between their noumenal selves? No. A noumenal self could no more turn wicked than a thing-in-itself could turn black. This answer is borne out by what Kant himself said about 'the most hardened scoundrel' (*Groundwork*, p. 454): considered as a member of the sensible world, he has a bad will; yet considered as a member of the intelligible world, his will is as pure as that of any other noumenal self. (One of the desiderata for our Third View will be that it should not render all people equally free, or equally unfree.) But empirical selves get caught up differently in the causal processes of the natural world, with the result that X behaves well and Y badly. A noumenal self *is* 'flapping its wings impotently'.

Back now to our first question: if we can know nothing of supersensible things-in-themselves beyond the bare fact of their existence, how could Kant know that pure egos enjoy free will and revere the moral law? Well, pure reason splits into speculative reason and practical reason, and these have different provenances

6. Abbott's translation (p. 98); Paton has: 'Here all sensuous motives must entirely fail' (p. 462).

and powers. Practical reason can apprehend things unknown to speculative reason. Kant justified this as follows. Its provenance is duty and the moral law, both of which are supersensible; hence practical reason 'inevitably goes beyond the limits of sensibility' (*CPR*, B xxv). And this makes possible a happy collaboration between speculative and practical reason. The former prepares the way for the latter by declaring a No Go area. This keeps out unwanted intruders, including the empirical sciences, yet leaves the area open for occupation by practical reason. Kant first broached this idea a shade cautiously:

> But when all progress in the field of the supersensible has thus been denied to speculative reason, it is still open to us to enquire whether [practical reason enables us] to pass beyond the limits of all possible experience. Speculative reason has thus at least made room for such an extension; and if it must at the same time leave it empty, yet none the less we are at liberty, indeed we are summoned, to take occupation of it, if we can, by practical [reason]. (B xxi–xxii)

And occupy it we can:

> So far, therefore, as our Critique limits speculative reason, it is indeed *negative*; but since it thereby removes an obstacle which stands in the way of the employment of practical reason, . . . it has in reality a *positive* and very important use (B xxv).

He added that the assumption of *God, freedom and immortality* becomes permissible only when speculative reason has been deprived of its pretensions to transcendent insight; 'I have therefore found it necessary to deny *knowledge*, in order to make room for *faith*' (B xxx).

When we ask speculative reason for news about the soul (Is it free? Is it immortal?), it stonily answers 'No news'; whereupon practical reason reassuringly adds: 'No news is good news'. Speculative reason abstains from asserting that supersensible egos are subject to the law of causality; this leaves practical reason free to assert that they are not. Kant wrote:

> But if our Critique is not in error in teaching that the object is to be taken in a twofold sense, namely as appearance and as thing in itself; if . . . the principle of causality therefore applies only to things taken

in the former sense, namely, in so far as they are objects of experience—these same objects, taken in the other sense, not being subject to the principle—then there is no contradiction in supposing that one and the same will is, . . . in its visible acts, necessarily subject to the law of nature, and so far not free, while yet, as belonging to a thing in itself, it is not subject to that law, and is therefore free. (CPR, B xxvii–xxviii)

Practical reason's ability to read meanings into the silences of speculative reason was shown again when Kant turned a distinction between the sensible world and an *unknowable* world of things-in-themselves into a distinction between the sensible world and the *intelligible* world (*Groundwork,* p. 451). Can something unknowable be intelligible? He wrote:

> although I have an *Idea* of [the intelligible world in which practical reason operates] . . ., yet I have not the slightest *acquaintance* with such a world My Idea signifies only a "something" that remains over when I have excluded from the grounds determining my will everything that belongs to the world of sense . . . ; yet with this "more" I have no further acquaintance. (p. 462).

And this residual *je ne sais quoi* is "intelligible".

God and the summum bonum Further restorations after the ravages of *CPR* were carried out in *CPrR*. Freedom was now joined by God and immortality. In the preface to *CPrR* Kant was much concerned about the seeming inconsistency between its positive doctrines and the negative doctrines of *CPR*. He called this apparent conflict 'the enigma of the critical philosophy, viz. how we deny objective reality to the supersensible use of the categories in speculation, and yet admit this reality with respect to the objects of pure practical reason. This must at first seem inconsistent' (*CPrR*, p.108, italics omitted). How did he deal with this seeming inconsistency? His moral philosophy is famous for its repudiation of inferences from factual premises, say about divine commandments, to a moral conclusion about what we ought to do. But he now seemed to countenance inferences in the other direction. He argued that since the moral law commands me to make the *summum bonum* the object of my will, the *summum bonum* must be possible (*CPrR*, p. 266); and he added that it is

possible only if God exists and also the soul, with its freedom and immortality.

Let 'B!' and '∃G' be short for, respectively, 'Promote the *summum bonum*!' and 'God, freedom and immortality exist'. According to Kant, practical reason prescribes B!, and B! presupposes ∃G. Does practical reason thereby establish the existence of God, freedom, and immortality? There are places in *CPrR* where he appeared to be saying that it does. Thus at one place he said that the concepts of God, freedom, and immortality have now been shown to 'actually have objects; because practical reason indispensably requires their existence for the possibility of its object, the *summum bonum*' (p. 278). But shortly afterwards he modified the wording, now saying that these concepts actually have '(*possible*) objects' (his parentheses, my italics). And it turns out that this argument from the moral law does not, after all, establish this existential conclusion. An existential proposition, Kant pointed out, affirms that a 'concept *in the understanding* has an object corresponding to it *outside the understanding*, and this it is obviously impossible to elicit by any reasoning' (p. 283).

And for Kant a proof of ∃G would in any case prove too much; it would enable everyone to *know* that an endless existence lies ahead in which one's happiness will be proportioned (*CPrR*, p. 265) to one's morality in this life:

> *God* and *eternity* with their *awful majesty* would stand unceasingly *before our eyes* (for what we can prove perfectly is to us as certain as that of which we are assured by the sight of our eyes). Transgression of the [moral] law would, no doubt, be avoided. . . . [But] most of the actions that conformed to the law would be done from fear, a few only from hope, and none at all from duty. . . . [A]s in a puppet-show, everything would *gesticulate* well, but there would be *no life* in the figures. (p. 294)

It transpires that what the argument from the moral law was supposed to establish is not that God, freedom, and immortality actually exist but only that I, as a moral being, must have faith in their existence: 'I *will* that there be a God, that my existence in this world be also an existence outside the chain of physical causes . . ., and lastly that my duration be endless; I firmly abide by this, and will not let this faith be taken from me' (p. 289); for if any of

the above failed to exist, 'then the moral law . . . which commands us to promote [the *summum bonum*] is directed to vain imaginary ends, and must consequently be false' (p. 251). Kant mentioned 'a very subtle and clear-headed man' who 'disputes the right to argue from a want to the objective reality of its object. . . . I quite agree with him in this, in all cases where the want is founded on *inclination* . . . But in the present case we have a want of reason springing from an objective determining principle of the will, namely, the moral law' (p. 289n). But how does it help if the demand that some factual proposition be true has a moral rather than a hedonic character? Won't a cosmos deaf to hedonic wants be equally deaf to moral demands?

In a striking passage in *The Critique of Judgement* (1790), Kant considered the predicament of a good man who seeks to obey the moral law for its own sake and not for any personal benefit, and who becomes persuaded that there is no God and no after-life:

> Deceit, violence, and envy will always be rife around him, although he himself is honest, peaceable and benevolent; and the other righteous men that he meets in the world, no matter how deserving they may be of happiness, will be subjected by nature, which takes no heed of such deserts, to all the evils of want, disease, and untimely death, just as are the other animals on the earth. And so it will continue until one wide grave engulfs them all—just and unjust, there is no distinction in the grave . . . (p. 452)

Kant concluded that if this man is 'to remain faithful to the call of his inner moral vocation', then 'he must assume the existence of a *moral* author of the world, that is, of a God' (p. 453).

But instead of an argument of this kind underpinning religion, it may rebound against morality. Let P! be a prescription which presupposes factual proposition F on an *ought*-implies-*can* principle; that is to say, F must be true or else P! could not be obeyed; for instance, P! and F might be 'Doff your hat!', and 'You are wearing a hat'. The prescription P! might simply be withdrawn (as in 'You do not have to doff your hat') or replaced by a contrary prescription (as in 'Keep your hat on'). We may represent the former by 'not-(P!)' and the latter by '(not-P)!'. The above relation of presupposition may now be represented by

the arrow in 'not-F → not-(P!)'. If we call an inference from P! to F an *ought*-implies-*can* inference, we may call one from not-F to not-(P!) a *can't*-implies-*not-ought* inference. It might seem that to accept P! and proceed to F, and to accept not-F and proceed to not-(P!), are equally permissible; but that is not so. Suppose that you are morally disposed to accept P!; then you will *hope* that F is true. But since you have no reason to assume that the world conforms itself to your moral demands, you may not conclude that F is true. Contrariwise, if experience obliges you to reject F as false, you must proceed from your acceptance of not-F to the acceptance of not-(P!). You may say that the present F, concerning God and an after-life, is in no danger of getting empirically falsified. True; but equally there is no hope of it getting verified; a question-mark will always hang over it. Kant called a belief in God and an after-life, arrived at in the above way, a *rational* faith. But to hope that this existential proposition is true and to fear that it is false are two sides of the same coin. When Kant said he had found it necessary to deny *knowledge* to make room for *faith*, he should have added that this could not be a rational faith.

Heinrich Heine long ago dealt briefly and devastatingly with Kant's shift away from the austere naturalism of his critical philosophy after his turn to moral philosophy:

> . . . after the tragedy comes the farce. Up to this point Immanuel Kant has pursued the path of inexorable philosophy; he has stormed heaven and put the whole garrison to the edge of the sword; the ontological, cosmological, and physico-theological bodyguards lie there lifeless; Deity itself, deprived of demonstration, has succumbed; there is now no All-mercifulness, no fatherly kindness, no other-world reward for renunciation in this world, the immortality of the soul lies in its last agony—you can hear its groans and death-rattle; and old Lampe is standing by with his umbrella under his arm, an afflicted spectator of the scene, tears and sweat-drops of terror dropping from his countenance. Then Immanuel Kant relents and shows that he is not merely a great philosopher but also a good man; he reflects, and half good-naturedly, half ironically, he says: 'Old Lampe must have a God, otherwise the poor fellow can never be happy. Now, man ought to be happy in this world; practical reason says so;—well, I am quite willing that practical reason should also guarantee the existence of God'. (*1835*, p. 119)

From Two Worlds to One Dualistic World I turn now to a shift in Kant's thought that occurred in his last major work. *Religion* is concerned with the relation between morality and religion. Incidentally, for collectors of famous footnotes it contains this choice item:

> Though it does indeed sound dangerous, it is in no way reprehensible to say that every man *creates a God* for himself, nay, must make himself such a God according to moral concepts For in whatever manner a being has been made known to him by another and described as God, yea, even if such a being had appeared to him (if this is possible), he must first of all compare this representation with his ideal in order to judge whether he is entitled to regard it and to honor it as a divinity. . . . Without this all reverence for God would be *idolatry*. (p. 157n)

In this book Kant had, it seems, become dissatisfied with his attempted reconciliation, by means of his "two-worlds" doctrine, of a thoroughgoing causal determinism with freedom and morality.

The book is concerned with human evil (he spoke of 'a long litany of indictments against humanity', including unprovoked cruelty and much else; pp. 27f). What is the ultimate source of the propensity to do evil? It is not grounded in man's 'sensuous nature and the natural inclinations arising therefrom', for these are not directly related to evil (p. 30). And it is not inherited: 'surely of all the explanations of the spread and propagation of this evil through all members and generations of our race, the most inept is that which describes it as descending to us as an *inheritance* from our first parents' (p. 35). So it is not naturally generated by causes within the phenomenal world. Kant gave its source as man's free will: an evil man is one who has *chosen* to put self-love above the moral law as his controlling maxim (p. 31); and this choice 'must have originated in freedom' (p. 33). Such a choice constitutes a momentous meta-decision as to the kind of maxims that will govern one's first-order decisions. It is made, Kant said, by a *free* will, and it results in *radical* evil (p. 32). This is a dramatic shift. Previously, free will existed in a noumenal realm, pure and undefiled, and guided by reverence for the moral law. Now, it is intervening crucially in the phenomenal world and with profoundly disturbing results.

Now comes a perplexing complication. One might suppose that if the choice to put self-love above the moral law is *free*, then some selves will make it and others will make the opposite choice; and one might further suppose that neither choice is irrevocable. But Kant insisted that this radical evil is in every man, even the best (*Religion*, p. 27), and that it cannot be extirpated (p. 32). This brings about an astonishing bouleversement of his earlier position whereby a hardened scoundrel, though he has a bad will phenomenally considered, has a pure will qua member of the intelligible world. Now it is the other way round. In the case of people who would normally be counted as good, the 'empirical character is then good, but the intelligible character is still evil' (p. 32). I do not find the thesis that, considered as noumenal selves, Socrates and Nero are equally evil an improvement on the thesis that they are equally good. (Goethe declared that Kant had wantonly beslobbered the mantle of philosophy with the shameful stain of radical evil; see Friedenthal *1965*, p. 340.) For our purposes the point to be preserved from the foregoing is that Kant, in *Religion*, came round to some rather strange kind of dualist interactionism whereby an individual's conduct in the phenomenal world could be decisively affected by something that Kant previously located in another world.

Morality Constitutive of Autonomy? Let us now set aside both the idea that practical reason can only flap its wings impotently and the idea that a noumenal self opts for evil once and for all, and assume (as one generally does when reading Kant on morality and the Categorical Imperative without being over-mindful of other parts of his philosophy) that X's practical reason can influence X's bodily conduct. On this assumption an important issue opens up between the view of freedom to be presented in Chapter 8 and Kant's view as generally (though not universally) understood. Without belittling morality in any way, our Third View will not make it integral to the idea of personal autonomy. Kant, by contrast, is generally read as equating being autonomous with being moral. Let us say that agent X enjoys autonomy if X's conduct is positively directed by self-imposed principles or internally generated ideas, such principles and ideas being *constitutive* of X's autonomy. Then Kant's thesis, on the usual interpretation, is that X's understanding of and reverence for the moral law is constitu-

tive of X's autonomy. Since I do not want to get involved in tricky questions of Kantian scholarship as to Kant's real position, I will speak here of the "Kantian" thesis that morality is constitutive of autonomy. The question now is whether that thesis depicts a genuine possibility.

For Kant, moral actions are done under the guidance of the moral law. Now a universal moral law by itself can no more tell you what you should do next than scientific laws by themselves can tell you what will happen next. In both cases the major premise would need to be supplemented by a minor premise consisting of singular statements about the relevant circumstances. So imagine that X is fed a continuously updated situational report which faithfully portrays all relevant features. To simplify matters, assume that X always acts in conditions of certainty, knowing all the possible choices and what the outcome of each of them would be. For Kant the moral law is of course embodied in the categorical imperative. So the question becomes: could the categorical imperative, suitably supplemented in this way, steer X through life? If so, the answer to the larger question is, yes: X's full autonomy exemplifies itself in nothing but morally right action. X's life may not be too ascetic; health and vigour are needed for acting well, and on occasion drinking a glass of champagne, say by way of a toast, may be morally right; but the supreme reason for any action by X will always be that it was called for by the moral law.

Decision theorists mean by a *choice-set* a full list of all the alternative actions open to an agent in a particular situation. Let us represent this by $\{A_1, A_2, \ldots A_n\}$. The "Kantian" thesis implies that the categorical imperative always singles out just one member of this set, say A_1, as morally right, rejecting the others as impermissible. All but one of Kant's formulations of the categorical imperative rely on the idea that any action has its own distinct *maxim* or principle. On these formulations the categorical imperative famously requires you to act only on that maxim which you can at the same time will that it should become a universal law (*Groundwork*, p. 421). So the "Kantian" thesis further implies that it always is the case that one and only one member, say A_i, of the choice set has a universalizable maxim. If all this is so, then the "Kantian" thesis yields the result that a fully autonomous agent X is someone who at all times is on moral auto-pilot: what-

ever choices X's situation may present, one of them flashes green, the others red.

There are at least two arguments against this being a genuine possibility. First, the same conduct can fall under different descriptions involving different maxims, or may seem not to fall under any maxim. In June 1893 Admiral Tryon signalled to the Mediterranean Fleet ordering the two columns, headed by the flagship HMS *Victoria* and HMS *Camperdown*, to turn inwards 180°—with the result *Victoria* was rammed by *Camperdown* and sank with the loss of 356 men.[7] One wonders what Kant would take as this action's maxim. Second, there obviously are genuine moral dilemmas. An off-duty nurse is in a shopping district when a bomb explodes. To her left a baby is screaming with blood running down its face. To her right an old man seems to have lost a foot. It would surely be preposterous to say that since the moral law prescribes attending to the old man it proscribes attending to the baby, or vice versa.

And what guarantee is there that the categorical imperative will always single out just one member of $\{A_1, A_2, \ldots A_n\}$; why should not two of them, A_i and A_j, both have universalizable maxims, both of them being permissible rather than obligatory? The distinguished Kantian scholar H. J. Paton suggested that Kant endorsed this possibility (*1947*, pp. 141–42). On this interpretation, the categorical imperative requires you to act on *a* maxim which you can at the same time will that it should become a universal law, but may leave you free to choose between A_i and A_j on extra-moral grounds. This is a welcome relaxation. But the requirement always to act on a universalizable maxim still involves an over-severe restriction. Kant was quoted in Chapter 1 declaring that a work of genius is something 'for which no definite rule can be given'; in other words, the act (or sequence of acts) of producing it does not have universalizable maxims. So the categorical imperative in formulations involving universalizability would proscribe all creativity, not to mention joking and other wayward activities.

Kant's one formulation of the categorical imperative that does not bring in universalizable maxims requires us always to treat a

7. I discuss this disaster at some length in Watkins 1970, pp. 211f.

person never simply as a means, but always at the same time as an end (*Groundwork*, p. 429). He claimed that this principle is 'at bottom' the same as the previous ones (p. 437); but it seems significantly different, and free of the baleful implications considered above. It blocks off impermissible areas, but within permissible areas leaves people free to follow a course of their own. For instance, it does not forbid a painter to have a young woman pose in the nude for him, but it does require him, should he do so, to treat her, not as just an artistic prop, still less as a sex-object, but as a fellow member of the kingdom of ends. But this restores the idea of morality allows individuals to be self-directing and only puts constraints on what they do. Stanley Benn's *A Theory of Freedom* (1988) has two conceptions of autonomy: being a 'self-determining project maker' (p. 8); and conducting one's life by a self-imposed law à la Rousseau and Kant. We would rather say that self-determining project makers should constrain what they do by self-imposed laws.

Chapter 7
Historical Review II: Spinoza

Will we fare better with Spinoza than we did with Kant in our quest for a distinctive view of human freedom that stays within a naturalistic framework? The omens may seem promising. His *Ethics* culminates in Part V with a distinctive view of human freedom, Part IV having been on human bondage. And he proclaimed a strong naturalism: man is a part of nature (IVAp7) whose affects and properties will be investigated 'just like other natural things' (IVP57S), for we need to look a little into this forbidding but strangely mesmeric work.

§ 7.1 Preview

Denote by 'Fortune', with respect to a person X, anything external to X that is variable and bears on X's well-being. (Just how the boundary between internal and external might be drawn will be considered later.) Spinoza saw Fortune as immensely threatening: 'nothing evil can happen to a man except by external causes' (IVAp6) and 'human power is very limited and infinitely surpassed by the power of external causes' (*E*, IVAp32). Again: 'we are driven about in many ways by external causes, and . . . like waves on the sea, driven by contrary winds, we toss about, not knowing our outcome and fate' (IIIP59S). As Jonathan Bennett put it, man is 'infinitely outgunned by the universe' (*1984*, p. 283).

Is there any way by which we, as rational men, might preserve our freedom in the face of Fortune? I begin with a way which

some people have attributed to Spinoza. We might call it the "hermit way". (Nietzsche wrote a poem entitled *To Spinoza* which concluded with the line: 'Hermit! Have I recognized you?'.[1]) It says that we should minimize exposure to the vagaries of Fortune by extinguishing desire for things in the outside world beyond what is needed for sheer survival. Isaiah Berlin spoke of 'a strategic retreat into an inner citadel' (*1958*, p. 20). Without attributing it to Spinoza, Bennett called it a strategy of avoiding 'hope and fear by sheer conative contraction' (*1984*, p. 325). Although Spinoza's words may sometimes have supported a reading along these lines, I am confident that this was not his view.

Assume for present purposes that, rather as a measure for a bank account has a middle zero between credit and debit, so there can be a cardinal scale for utility with a middle zero between happiness and unhappiness. Imagine a graph that records an individual's utility over time. In the case of a "panter", as we may call someone who pants after wealth, fame, or sensual pleasure, we would expect, on Spinoza's psychology, an irregular curve with occasional narrow peaks separated by wide and often deep troughs. Our hermit should on average do better than that. Forgoing the pleasures of attaining x would be more than offset by forgoing the pains involved in the pursuit of x, where x is the sort of thing the "panter" seeks. The hermit's utility-graph, so long as his berries lasted and he was not caught by a bear or whatever, would be a flattish curve staying close to the horizontal axis through the middle zero. But *that* was not what Spinoza wanted. He was seeking 'something which, once found and acquired, would continuously give [him] the greatest joy, to eternity' (*TdIE*, § 1). He wanted a straight curve *high up*.

Spinoza spoke out against hermit-like withdrawal. He saw no merit in your cutting yourself off from innocent pleasures, provided of course that you do not over-indulge or become dependent on them: 'It is the part of a wise man, I say, to refresh and restore himself in moderation with pleasant food and drink, with scents, with the beauty of green plants, with decoration, music, sports, the theatre, and other things of this kind, which anyone

1. See Yovel *1989*, ii, p. 132.

can use without injury to another' (*E*, IVP45S).[2] More impor-
tantly, he insisted that men very much need the friendship and
companionship of other men: 'there is nothing more useful [to
man] than man' (IVP18S); 'only by joining forces can they avoid
the dangers that threaten on all sides' (IVP35S). True, in a society
torn by sectarian strife and mob violence, men can be highly dan-
gerous to one another, as Spinoza knew all too well. But accord-
ing to him, the solution for that is not hermit-like withdrawal but
well-designed democratic institutions: 'A man who is guided by
reason is more free in a state, where he lives according to a com-
mon decision, than in solitude, where he obeys only himself'
(IVP73). (It was to work out that political solution that Spinoza
broke off, before starting the final Part V of the *Ethics*, to write
the *Tractatus Theologico-Politicus*.)

And Spinoza had a more philosophically interesting reason for
rejecting the "hermit way". The further our hermit goes in trying
to cut himself off from the outside world, the more will he be
turned in on himself. Carried to the limit, this would mean that
his mind had only itself to exercise itself upon. Spinoza summed
up his anti-hermit outlook thus:

> . . . it follows that we can never bring it about that we require noth-
> ing from outside ourselves to preserve our being, nor that we live
> without having dealings with things outside us. Moreover, . . . our
> intellect would of course be more imperfect if the mind were alone
> and did not understand anything except itself. There are, therefore,
> many things outside us which are useful to us, and on that account
> to be sought. (*E*, IVP18S)

For Spinoza, trying (unavailingly) to disengage oneself physi-
cally from the outside world was not the way to freedom.

There would seem to be two main alternatives to the "hermit
way". You might engage with Fortune, using all your courage and
resourcefulness in attempting to stay on whatever course you have
set yourself. Or without disengaging yourself physically from it,
you might rise in thought above Fortune to a higher plane. I will
use "Conquer Fortune" as a label for the former, and "Transcend

2. According to Feuer (*1958*, p. 200), Spinoza was here listing things condemned by
Calvinism.

Fortune" for the latter. My thesis will be that Spinoza at different times adopted both ways. This is in line with Leszek Kolakowski (1973, p. 294), who wrote that Spinoza saw freedom in two ways, now as picking one's way amid objects by understanding and sensible effort (which sounds like "Conquer Fortune"), now as haughty resignation from the world of objects (which sounds like "Transcend Fortune").

The first of these two labels has some sanction in Spinoza, who spoke of a rational man striving to conquer fortune (*E*, IVP47S). This did not mean trying to bend Fortune to his will. A free man likes the friendship of other free men and wants nothing for himself that he does not desire for others (IVP18S). He does not seek to manipulate other people. (Nor does he try to control the weather.) It means that he strives not to allow Fortune to conquer him. Of course, Fortune conquers everyone in the end; but, as Spinoza famously said, a 'free man thinks of nothing less than of death' (IVP67). And perhaps for a few decades a free man will succeed in following a path of his own making before being gunned down by Fortune.

The claim will be that Spinoza started with something like "Conquer Fortune" which, however, got transmogrified by other ideas in his system into something like "Transcend Fortune".[3] The ideas that brought this about were partly metaphysical (most notably his determinism and mind-body parallelism) and partly epistemological (most notably his classical rationalism and the accompanying down-valuing of empirical knowledge). The end-result of this process, it will be claimed, was a kind of metaphysical escapism; and the process went hand in hand with the subversion of the tough-minded, naturalistic view of man previously affirmed by Spinoza.

§ 7.2 "Conquer Fortune"

A man is conquered by Fortune when he is 'defeated by causes external, and contrary, to his nature' (*E*, IVP20S). So to be free in the "Conquer Fortune" sense is to be undefeated by external

3. The OED entry for 'transmogrify' says: 'to transform (utterly, grotesquely, or strangely)'.

causes. For the time being let us understand 'external' somewhat naively as referring to factors that are literally outside oneself. Not being defeated by external causes is consistent with being severely buffeted by them. Consider the captain of a sailing vessel whose intended destination is a harbour on the far side of a rocky headland. High winds have sprung up and seas are mounting. He will be buffeted but not conquered by Fortune if, by vigilant and skilful seamanship, he nurses her round the rocky headland and into port. More generally, we might suppose Spinoza to have held that a man remains free if he avoids defeat by external causes by facing up to them and coping with them coolly and skilfully, not allowing them to deflect him significantly from the course he had set himself. Thus Spinoza wrote that freedom requires 'presence of mind in danger' (IVP59S), and said that a free man brings 'skill and alertness' to his dealings with other people (IVAp13).

Suppose that our captain had prudently turned back and reached a safe anchorage where he waited for the storm to abate; would he then have been defeated by Fortune? No; for Spinoza, a free man is not cowardly but nor is he foolhardy: 'a free man chooses [timely] flight with the same tenacity or presence of mind, as he chooses a contest' (*E*, IVP69C). Our sea-captain would have suffered only a temporary setback. Physically considered, the essence of every living thing (Spinoza actually said *every* thing, inanimate as well as animate) is a striving or *conatus* to persevere in its being and enhance its power (IIIP6, P7). The fundamental imperative that this generates overrides any conflicting imperatives.

Let us refer to the foregoing as "Conquer Fortune" Mk I. Now comes a major amendment. For Spinoza did not draw the internal/external distinction in the above, naive way. We need to remember here that he was a classical rationalist for whom Reason functions independently of both sense-experience and passion; and he endowed it with what must nowadays seem absurdly exaggerated powers, with respect both to knowing and to acting. As well as using your reason to cognize fundamental cosmological truths you can, so Spinoza said (though we will find that he was here writing an uncashable cheque), act in accordance with its dictates alone. Sensations and feelings have external causes, reason is self-directing. Spinoza's internal/external distinction equates your nature with your reason and makes your *affects*

(emotions, passions), such as love, hate, hope, fear, despair, pity, indignation, envy, pride, shame, anger, greed, and lust (see *E*, II/192–202), external to your nature. Fortune does not just confront you straightforwardly with external threats; it may, to put it anthropomorphically, make you its plaything (IVP15). You are in bondage to Fortune if you are driven about by your affects, nursing envy, seething with indignation, doing this from greed or that from vengefulness. Spinoza wrote:

> Man's lack of power to moderate and restrain the affects I call bondage. For the man who is subject to affects is under the control, not of himself, but of fortune, in whose power he so greatly is that often, though he sees the better for himself, he is still forced to follow the worse. (II/205)

Acting rationally carries with it, so Spinoza said, a kind of joy which is not an externally caused affect (*E*, IIIP58,59). Your reason can anaesthetize affects that are contrary to it. Let us call this the MkII version of "Conquer Fortune". Some may find its picture of a free man is rather chilling. As well as not allowing himself to be affected by hate, anger, fear, or envy, he does not allow himself to be touched by pity (IVP50) or, it seems, by love (except the intellectual love of God). Spinoza spoke of marriage with guarded approval (IV, app. 20), seeing it as a stable companionship of a kind made necessary by the need for procreation; but love can be excessive (IVP44) and can easily turn to hate.

But Spinoza's view, as so far depicted, surely has an austere nobility. A free man 'complies with no one's wishes but his own' (*E*, IVP66S) Unlike a "panter" desperately pursuing transient things, and unlike a hermit grubbing for acorns, a free man 'does only those things he knows to be the most important in life' (IVP66S) or knows 'to be most excellent' (IVP70D). What these things are we will consider later. (As to doing *only* those things, Spinoza conceded that it is not in a man's power 'to be always at the peak of human freedom', *TP*, ii, 8.) He brings to the task cool nerves, a steely purpose, strength of character, and tenacity of mind. He eschews all emotional indulgence and is not haughty or proud; he hates no one, despises no one, mocks no one, is angry with no one, and envies no one (*E*, IVP73S, II/136). He cares nothing for the disapproval of others. If he has enemies, he treats

them as parts of nature, requiring skilful handling like any other natural obstacle or danger. The great multitude of people are not wise and free. It is they who are like waves 'driven by contrary winds', oscillating between hope and fear, between ignorant uncertainty and superstitious dogmatism, between intolerance and craven submission.[4] A free man, on the other hand, is unwavering in the conduct of his life.

All this was well exemplified by Spinoza's own imperviousness to external lures and threats throughout his own life. He devoted himself almost exclusively to intellectual projects that he rightly believed to be of high importance; and he displayed a basic imperturbability towards the hostility and intolerance that his work often provoked, especially from religious zealots. His comment on his anathematization has become famous: 'This compels me to nothing I should not otherwise have done' (Pollock *1880*, p. 17). He did beat a partial retreat when he prudently decided to postpone publishing the *Ethics* upon learning that the theologians and the Cartesians were ganging up against him (*Corr*, p. 334). But he may generally be said to have complied with no one's wishes but his own as he proceeded, with only minor hiccups, on his daring intellectual voyage.

"Conquer Fortune" MkII is still an extroverted strategy, still oriented towards external factors, even if some of these have infiltrated one's psyche. The commander of a beleaguered citadel infiltrated by fifth columnists now has inside enemies to deal with; but he must still cope with the enemies outside. Our sea-captain may have had feelings of sea-sickness and fear to contend with, but he still had to cope with the threat from wind and sea. However, "Conquer Fortune" loses its extroverted orientation when its conversion to "Transcend Fortune" is complete. We must now turn to the ideas that brought about this conversion.

§ 7.3 Baleful Philosophical Ideas

Metaphysical ideas will be considered first, epistemological ones afterwards. As was said earlier, we are on the look-out for, among other things, ideas to be avoided when we come to our Third

4. See Yovel *1989*, i, ch. 5.

View in the next chapter. One such idea is Spinoza's all-or-noth-
ing distinction between *acting* and being acted upon, or pushed
around, by Fortune. He laid down that a person X *acts* (and is
free) if and only if what X does is determined by, and clearly and
distinctly understandable through a knowledge of, X's nature
alone; otherwise X is being *acted upon* (*E*, IIID2; this echoes the
earlier definition ID7: 'That thing is called free which exists from
the necessity of its nature alone, and is determined to act by itself
alone'). This excludes our sea-captain who nursed his vessel safely
through hazardous conditions; what he was doing is not under-
standable through a knowledge of his nature alone; we would also
need to know about his external situation. It will be a desidera-
tum for our Third View that it presents freedom not as an all-or-
nothing state but as permitting of degrees.

It was remarked in connection with the "hermit way" that
Spinoza did not regard trying to disengage oneself physically from
the outside world as a way to freedom. That is true; but it has to
be added that for Spinoza physically engaging with the world
automatically results in unfreedom. 'We are acted on' (and hence
unfree), Spinoza flatly announced, 'insofar as we are part of
Nature' (*E*, IVP2). If one is to attain freedom at all it one will
have to be able to disengage oneself in some non-physical sense
from Nature and transcend Fortune.

Another factor that told against "Conquer Fortune" was
Spinoza's choice of God as the supreme exemplar of freedom.
God does not wrestle with adversity or get himself out of a tight
corner with presence of mind. There is nothing external to him;
he is situationless. Nor does he engage in creative activities, bring-
ing into existence something not implicitly contained in what was
there before; everything was always there. His "acting" consists in
thinking timeless truths. To achieve a freedom akin to God's, one
needs to transcend one's local situation and achieve a situationless
state in which one cognizes timeless truths.

I turn now to a more deep-seated difficulty. "Conquer
Fortune" presupposes what in Chapter 2 was called the agency-
assumption, namely the common-sense assumption that when you
are acting rationally the relevant part of your bodily behaviour is
under your mental control; having promised to ring a friend and
tell him what the committee's decision was, your fingers are now
pressing the correct digits on the telephone. (The control may be

imperfect, especially if you are tired, nervous, or under the influence of alcohol.) The classical view of the mind-body relation that is most supportive for the agency-assumption is Cartesian interactionism. Now when Spinoza was wearing his "Conquer Fortune" hat, as when he said that a rational agent may decide on timely flight, he tended to write like a Cartesian interactionist. Indeed, he sometimes seemed to impute to human reason an exaggerated degree of control over bodily behaviour. Here is an example. Having laid down, as a dictate of reason, the proposition that a free man always acts honestly and never deceptively (*E*, IVP72), he asked whether a free man may not act deceptively to save his life. His answer was *no*; if reason recommended deception to this man on this occasion, it would (Spinoza fallaciously claimed) be recommending deception to all men on all occasions; a free man, it seems, would rather die than lie. Remember that for Spinoza to remain alive belongs to the conatus of every organism; any living body absolutely rebels at the prospect of being killed. Yet here Spinoza was supposing that a free man can quell this basic animal instinct at the behest of the mere idea that deception is never permissible.

Something approximating to what Spinoza was here envisaging does occasionally occur. In the early 1940s the Ravensbrueck concentration camp contained a number of Jehovah's Witnesses. At one time their "Block Senior" was Margarete Buber-Neumann. She reported:

> The Witnesses were, so to speak, "voluntary prisoners," for all they had to do to secure their immediate release was to sign the special Bible Students' form which read: "I declare herewith that from this day on I no longer consider myself a Bible Student and that I will do nothing to further the interests of the International Association of Bible Students." . . .
> "I don't understand why you don't sign this ridiculous form," I said one day to an elderly "Witness." After all, promises made under duress have no moral significance and no binding value . . ."
> "No," she replied firmly. "We could not reconcile that with our consciences. . . ." (*1949*, p. 227)

And an idea which seems irrelevant to their basic self-interest, ordinarily understood, sometimes drives people to extraordinary

feats of endurance. In his diary for his first Antarctic expedition, Captain Scott described a period of appalling conditions during which they tramped further and further away from their base, adding: 'Nothing has kept us going during the past week but the determination to carry out our original intention of going on to the end of the month' (*1905*, p. 604).

But any influence of mind on bodily behaviour is ruled out by a fundamental metaphysical component of Spinoza's system. In Chapter 3 above we touched very briefly on Spinoza's cosmic parallelism, encapsulated in the proposition: 'The order and connection of ideas is the same as the order and connection of things' (*E*, IIP7). His idea was of course that, *pace* Descartes, there is one substance, God-or-Nature, of which Thought and Extension are attributes. (It has infinitely many other attributes, but they do no work in his system and will be left out of account in what follows.) Changes under one attribute are in one-to-one correspondence with changes under the other, but there is no causal interaction between the two series. Each event under the attribute of extension is causally predetermined just by antecedent physical events, and an analogous proposition holds for the corresponding events under the attribute of thought. A human individual is a microcosm of all this. An individual's mind is at once the idea of its body and a fragment of the Thought-side of God-or-Nature. The body's movements are completely predetermined just by antecedent physical causes. There is a perfect correlation but no causal interaction between mind and body: 'The body cannot determine the mind to thinking, and the mind cannot determine the body to motion' (*E*, IIIP2). He was scornful of those philosophers who 'seem to conceive man in nature as a dominion within a dominion', believing that man disturbs the world around him (*E*, II/138).

The co-ordination problem this raises was spelt out in Chapter 3 under the label 'How did Spinoza's fingers do it?'; how for instance did they write the *Ethics* without assistance from his mind? Where common sense might say that Spinoza crossed out a passage after spotting an inconsistency, the present doctrine says that his fingers absent-mindedly did this for him. True, there was a corresponding thought in his mind about the need to cut out the inconsistency, but this had no causal influence on his fingers. What answer did Spinoza give to this very obvious objection?

After remarking that most men are firmly persuaded that the body does many things under the control of the mind, and in particular that paintings, temples—and, he might have added, books—can be made only under the direction of the mind, he remarked that they do not know what the body can do, and pointed to the things 'sleepwalkers do in their sleep, which they wonder at while they are awake' (*E*, IIIP2S, II/143). He seems to have had an exaggerated respect for the achievements of sleepwalkers; if they sometimes pull off rather remarkable feats, there are many things they never do. Has anyone heard of a sleepwalker threading a needle, for instance? In any case, this answer clearly implies that Spinoza's earlier talk, in connection with "Conquer Fortune", about the need for presence of mind in the face of danger was out of order; he might as well have said that a sleep-walker in unfamiliar surroundings needs presence of mind.

Let us now turn to epistemological ideas of Spinoza's that militated against "Conquer Fortune". That a wise man can engage in infallible cognizing of timeless truths is the central plank of Spinoza's theory of knowledge. This puts a great divide between empirical thinking ("knowledge of the first kind"), a relatively low kind of thinking, and the highest kind of thinking, namely apriori cognizing ("knowledge of the third kind").[5] His inspiration here was, of course, Euclid's *Elements*: he would do for God-or-Nature what Euclid had done for space.

It was pointed out in Chapter 1 that the discovery of non-Euclidean geometries in the nineteenth century defeated the claim that Euclid's *Elements* constitutes a synthetic apriori theory of the structure of space. But suppose that Euclidean geometry is made up of synthetic apriori truths, as Spinoza assumed. Would that have vindicated the latter's conception of apriori cognizing as starting with self-evident axioms and proceeding deductively therefrom? Ryle emphasized that it is a big mistake to suppose that a finished propositional system mirrors the thinking that produced it: 'Epistemologists very frequently describe the labours of build-

5. I ought in strictness to have said 'Knowledge of the second and third kinds', but I want to discard details that are superfluous relative to the concerns of the present book. Knowledge of the third, as distinct from the second, kind is intuitive and non-inferential; its role is to establish axioms rather than to derive theorems. Spinoza had previously divided empirical, as well as rational knowledge, into two sub-kinds, yielding a total of four kinds of knowledge; see *KV*, II, iv, 9 and *TdIE*, 19.

ing theories in terms appropriate only to the business of going over or teaching a theory that one already has; as if, for example, the chains of propositions which constitute Euclid's "Elements" mirrored a parallel succession of theorising moves made by Euclid in his original labours' (1949, p. 289). When Euclid embarked on his great project, much geometrical knowledge, including Pythagoras's theorem, already existed.[6] Euclid's distinctive achievement was to axiomatize this knowledge (no doubt revising and enlarging it in the process). For him to adopt a proposition as an axiom, it would by no means have sufficed that he intuited its truth or had a clear and distinct idea of its content. He needed as axioms a set of propositions satisfying the following conditions: (1) each is logically independent of the others; (2) none of them is genuinely decomposable into two or more independent axioms; (3) they are collectively sufficient for the deductive delivery of all wanted theorems without unwanted consequences. Constructing such an axiom-set can only have been a trial-and-error process.

The impact of Spinoza's (illusory) ideal of apriori cognizing on "Conquer Fortune" was devastating. That sort of thinking was supposed to yield infallible knowledge with empirical thinking yielding mere opinion. Someone engaging in apriori cognizing is active and self-determining: one who is led by reason is 'a free man'; one who is led by opinion is 'a slave' (E, IVP66S). Our sea-captain who piloted his vessel safely through hazardous conditions fails the requirements for freedom twice over, by allowing his thinking to sink to the empirical level as well as by allowing external factors to help to determine what he does. I suggested earlier that the process which transformed "Conquer Fortune" into "Transcend Fortune" was linked to the process which unravelled Spinoza's seemingly tough-minded naturalism. Let us take a preliminary look into this before turning to "Transcend Fortune" and thence to immortality.

As we saw earlier, Haeckel praised Spinoza for his tough-minded naturalism. But Friedrich Schleiermacher famously called him a God-inebriated man (and also, less famously, a holy out-

6. According to Proclus, Pythagoras sacrificed an ox to celebrate his discovery of this theorem; see Heath 1925, i, p. 350n. Heath saw no reason to question the received view that Pythagoras discovered the theorem named after him.

cast);[7] and with justification. Where Spinoza said that man is a part of nature he could equally have said that he is a part of God, given his pantheist thesis that there is one substance that is Nature *and* God, or *natura naturata* and *natura naturans* (a distinction that will be elucidated shortly). Schopenhauer was dismissive of this pantheist thesis. To equate God with the world 'is merely a polite way of giving the Lord God his *congé*.'[8] A lot that is nasty and painful goes on in the world; calling it all 'God' put Schopenhauer in mind of a prince who abolished the nobility, not by stripping them of their titles, but by ennobling all his subjects.[9] Hume also spoke of Spinoza's atheism (*Treatise*, I, iv, 5). And pantheism does give the same answer as atheism to the question, 'Is there anything above or beyond the world around us?'.[10]

But to shrug aside Spinoza's pantheism as a disguised atheism is a mistake, and one that would render unintelligible his conception of freedom, at least in the "Transcend Fortune" guise it came to assume. When what had generally been regarded as two distinct things with contrasting natures, call them *a* and *b*, are declared to be one and the same thing, there are contrasting ways in which the previous concepts of them may be revised. At one extreme, the concept of one of them, say *a*, may be held constant and that of *b* radically revised to conform with that of *a*. This would be reductionist. At the other extreme, *a* and *b* may both be conceived as retaining all the (non-negative) properties previously attributed to them, and as gaining all the (non-negative) properties previously attributed to the other. We may call that ampliative. Had Spinoza's identification been reductionist, it would indeed have been a disguised atheism. But it was ampliative: in his concept of God-or-Nature, God gains the attribute of extension and Nature gains the attribute of thought.

If Spinoza could continue to distinguish God from Nature after putting God = Nature, it was because, or so he claimed, the one substance could be seen as God from one point of view and

7. See Roth *1954*, p. 210.
8. Quoted approvingly in Haeckel *1899*, p. 103.
9. *1819/44*, ii, p. 350; and see pp. 590f and 644f.
10. According to Yovel (*1989*, ii, pp. 51–52), it was largely because of his pantheism that Spinoza became a hero of left-Hegelians such as Ludwig Feuerbach, who called him 'The Moses of modern free-thinkers and materialists'.

as Nature from another. This brings us to his distinction between
(i) *natura naturans* (literally "nature naturing") and (ii) *natura
naturata* ("nature natured"). In line with Stuart Hampshire
(*1951*, pp. 46f) and others, I give a central place in his philosophy
to this distinction. Wolfson (*1934*, i, pp. 253f) made an illuminat-
ing comparison between Spinoza's and Thomas Aquinas's use of
it. For Aquinas, (i) above denoted God considered as the immate-
rial Creator of the natural world while (ii) denoted the natural
world considered as God's creation. And with Spinoza (i) and (ii)
still denote, respectively, active Creator and passive Creation. His
novel twist was to add that they denote *the same thing*, God-or-
Nature, though understood from different points of view.
Understood as a totality of *modes* (individual things and their
properties) it is *Natura Naturata*, and consists of effects. But
understood as a *totality* of modes with no cause external to itself,
this same thing is *Natura Naturans*.[11] Considered under the
attribute of Thought, *Natura Naturata* consists of ideas in a one-
to-one correspondence with particular things and processes on its
corporeal side, whereas *Natura Naturans* consists of God's think-
ing qua Creator. So there are two very different kinds of cosmic
thought. Our minds, as the ideas of our bodies, necessarily partic-
ipate in ideas of the former kind. But Spinoza could proceed from
the thesis that you and I are a part of nature to the thesis that our
minds, as well as being the ideas of our bodies, are also 'a part of
the infinite intellect of God' (*E*, IIP11C), and can participate in
God's thinking qua Creator. Doing this is to engage in active,
apriori thinking. This idea motivates "Transcend Fortune" as the
way to human freedom. Fortune, for you, can now be understood
as *Natura Naturata* insofar as it affects you; and you are sunk in
Fortune insofar as your thinking is aposteriori and your affects are
passions. But you can transcend Fortune by making an intellectual
ascent from turbulent *Natura Naturata* to the glassy calm of
Natura Naturans. Something like this is the leitmotif of the con-
cluding Part V of the *Ethics*.

11. My one serious disagreement with Bennett's *1984* concerns this distinction. He
pronounced it 'quite without significance in the *Ethics*' (pp. 118–19). But he replaced it by
a not very different one of his own, which he does consider important, between (i) 'God
seen from above' and (ii) 'God seen from below'.

§ 7.4 "Transcend Fortune"

"Conquer Fortune" had not yet been completely swallowed up by "Transcend Fortune" by the end of Part IV; there the idea was still alive that we should counter adversity if we can; we should bear calmly those things that are adverse to us *if we realize that we do not have the power to avoid them* (IVAp32). In an earlier passage summarizing the ways in which knowledge of his doctrine 'is to our advantage in life', Spinoza had said that, besides 'giving us complete peace of mind' and teaching us 'wherein our greatest happiness' consists, it teaches us to bear calmly things *not in our power* (IIP49S, II/136). There had been no suggestion that we should not grapple with adversity whenever we can hope do so effectively.

But in Part V, which Spinoza started writing some five years after breaking off to turn to *Tractatus Theologico-Politicus*, "Conquer Fortune" has been swallowed up. There is what may appear to be a trace of it at one place, where he spoke of dangers being 'overcome by presence of mind and strength of character'. But a closer look reveals that he was there talking about overcoming, not the dangers themselves, but rather the fear of danger.[12] In Part V he came close to a position captured in a striking entry which Wittgenstein made in his notebook in June 1916:

> I cannot bend the happenings of the world to my will: I am completely powerless.
>
> I can only make myself independent of the world—and so in a certain sense master it—by renouncing any influence on happenings. (Quoted in Monk *1990*, p. 141)

With "Conquer Fortune" you try not to suffer the slings and arrows of outrageous fortune by taking avoiding action or counter-action. With "Transcend Fortune" you try, rather, to nullify suffering by thinking about it in a special, rational way. H. A. Wolfson summarized Spinoza's claim about the therapeutic power of rational understanding as follows:

12. 'To put aside fear . . . we must recount and frequently imagine the common dangers of life, and how they can best be avoided and overcome by presence of mind and strength of character' (VP10S).

Were we only to know the nature of our emotions in all their bearings and in relation to all their causes, the emotions themselves would become an object of intellectual contemplation and would thereby cease to be passions. The pain they cause us would be forgotten in the pleasure afforded by the very act of understanding them. We should cease to be the slaves of our passions and become their masters. (*1934*, ii, pp. 271–72)

Let us try this out on a non-fictional example. Walking with your wife on an ill-lit pavement at night, you are attacked by two young muggers who try to snatch her handbag. Both of you struggle with them and shout for help, and they run off empty-handed. But during the struggle you twisted your ankle; it is now painful, and you are angry. What would Spinoza, wearing his "Transcend Fortune" hat, recommend?

Well, you should start by dropping the thought of an external cause of the pain; that should nullify your anger.[13] But what about the pain itself? Well, you can lessen it by remembering that it, like all other happenings, is a necessary part of the universe.[14] Can you go further and actually nullify it? There are places where Spinoza seems to concede that you cannot. Thus in the preface to Part V he said that he intended to show what kind of dominion reason has over the affects, adding 'that it does not have an absolute dominion over them' (*E*, II/277); at another place he said: 'if clear and distinct knowledge does not absolutely remove them [the affects insofar as they are passions] . . ., at least it brings it about that they constitute the smallest part of the mind'. (VP20S, II/294)

But there are other places where he seems to impute almost magical remedial powers to the intellect: forming a clear and distinct idea of the pain will work wonders. An affect is harmful only insofar as it prevents you thinking;[15] but in forming a clear and

13. 'If we separate emotions, or affects, from the thought of an external cause, and join them to other thoughts, then the love, or hate, toward the external cause is destroyed' (VP2).

14. 'The more this knowledge that things are necessary is concerned with singular things, which we imagine more distinctly and vividly, the greater is this power of the mind over the affects, as experience itself also testifies. For we see that sadness over some good thing which has perished is lessened as soon as the man who has lost it realizes that this good could not, in any way, have been kept' (VP6S).

15. 'An affect is only evil, or harmful, insofar as it prevents the mind from being able to think' (VP9D).

distinct idea of it, you will be actively thinking; ergo it will no longer be harmful. But can you form a clear and distinct idea of it? (For Descartes, a pain is a clear but not a distinct idea.) Well, it turns out, rather remarkably, that you can form a clear and distinct concept of its physical counterpart, the twisted and swollen ankle;[16] and it further turns out, again rather remarkably, that you can proceed from this to a clear and distinct idea of the corresponding pain.[17] Moreover, by forming a clear and distinct idea of it, you will stop it being a passion,[18] and transform it into something with which you will be fully satisfied,[19] and which you can relate to your idea of God.[20] Clearly, getting your ankle twisted was a blessing in disguise.

The reasoning, if that's the word, with which this normally rigorous and tough-minded thinker proceeded, in Part V, to the conclusion that the most excellent remedy for your pain is for you to have a true knowledge of it,[21] is open to several obvious objections. First, how can you attain a *true conception* of a happening which had a cause after deliberately separating it in thought from the idea of an external cause? For Spinoza, falsity consists of mutilated ideas (see *E*, IIP35); won't this separation yield one of these? Second, how can you regard this contingent happening as *necessary* when you are contemplating it in isolation from its cause? Third, why in any case should viewing it as necessary reduce the affect? Earlier, Spinoza had written: 'An affect toward a thing we imagine as necessary is *more* intense, other things being equal, than one toward a thing we imagine as . . . not necessary' (IVP11, my italics). As he truly remarked to a correspondent, 'wicked men are no less to be feared, and no less pernicious,

16. 'There is no affection of the body of which we cannot form a clear and distinct concept' (VP4).

17. 'From this [namely, proposition VP4, quoted in the previous footnote] it follows that there is no affect of which we cannot form some clear and distinct concept. For an affect is an idea of an affection of the body' (VP4C).

18. 'An affect which is a passion ceases to be a passion as soon as we form a clear and distinct idea of it' (VP3).

19. '. . . in this way the mind may be determined from an affect to *thinking those things which it perceives clearly and distinctly, and with which it is fully satisfied*' (VP4S, my italics).

20. 'There is no affection of the body of which the mind cannot form some clear and distinct concept (by P4). And so it can bring it about (by IP15) that they are related to the idea of God' (VP14D).

21. We 'can devise no other remedy for the affects which depends on our power and is more excellent than this, which consists in a true knowledge of them' (VP4S, II/283-4).

when they are necessarily wicked' (*Corr*, p. 297). Fourth, the claim that we can turn something passive and painful into something active and hence not painful (perhaps even joyful), by forming a clear and distinct idea of it implies that we can alter the past! According to classical rationalism, it is because clear and distinct ideas are not externally caused that they are active and not passive. So Spinoza was in effect saying that an externally caused pain ceases to be externally caused once we form a clear and distinct idea of it; but as Bennett pointed out (*1984*, p. 336), once something's been caused to exist it's too late to turn it into something uncaused.

This doctrine of rational psycho-therapy, when conjoined with Spinoza's mind-body parallelism, has an implication which Spinoza ought to have contemptuously dismissed. He had re-affirmed his parallelism at the beginning of Part V: 'In just the same way as thoughts and ideas of things are ordered and connected in the mind, so the affections of the body, or images of things, are ordered and connected in the body' (VP1). Just suppose that your thinking about your painful ankle in the above way *would* get rid of the pain. Bennett pointed out that mind-body parallelism implies that 'if Spinoza's psychotherapy succeeds on the mental side, then the physical side will automatically be taken care of' (*1984*, p. 331); forming a clear and distinct idea of the pain in your ankle will also cure the swelling. Bennett drew attention to a passage where Spinoza appeared to accept the implication; it reads: 'So long as we are not torn by affects contrary to our nature, we have the power of ordering and connecting the *affections of the body* according to the order of the intellect' (*E*, VP10, my italics).

Now to a different question: what does a free man who is led by reason actually *do*? We heard earlier that he does only those things he knows to be most important. What sorts of thing are these? Hampshire said that for Spinoza a man is most free 'when he cannot help drawing a certain conclusion, and cannot help embarking on a certain course of action in view of the evidently compelling reasons in favour of it' (1960, pp. 206–07). The idea is, presumably, that having drawn this conclusion at a certain time, he then embarks on this course as soon as he can. But a free man lives according to the dictate of reason *alone* (*E*, IVP67D); as we saw, if he brought in empirical thinking he would start sinking

into "slavery". This means that his reasoning will be a-temporal: 'It is of the nature of Reason to regard things as necessary and not as contingent. . . . they must be conceived without any relation to time' (*E*, IIP44C2D). We saw that "Conquer Fortune" allowed a free man to choose timely flight; but that could not happen under "Transcend Fortune"; from premises supplied by reason alone one could never deduce conclusions like, 'When dusk falls, slip away quietly'. Minor premises about his present, time-bound situation would be needed. Reason as understood by Spinoza may be able to issue blanket prohibitions (such as 'Never act deceptively') valid for all men at all times, but it can never, by itself, positively prescribe the doing of a certain act by a certain person at a certain time. Bennett found the notion of the 'dictates of reason' occurring in the *Ethics*, explicitly or by implication, in twenty one propositions in none of which are they given any definite prescriptive content (*1984*, pp. 308-9). For Spinoza, a free man who is *acting* is not engaging in any kind of bodily performance. Then what is he doing? The answer is: thinking timeless thoughts, engaging in apriori cognizing. This does not manifest itself in outward behaviour or issue in any objectivization of itself. (We found Spinoza insisting that such things as buildings and paintings are brought into existence by the human body 'without the direction of the mind'.) It is a self-contained kind of internal activity that is supposed to yield that 'greatest joy, to eternity' which Spinoza had made the goal of his philosophizing.

At the end of the *Ethics* Spinoza said that his way to salvation is difficult, adding: 'But all noble things are as difficult as they are rare.' Where did the difficulty lie? At one place he indicated that his way to salvation involves perfecting the intellect, and that certainly sounds dauntingly difficult. However, the passage continues: 'But perfecting the intellect is nothing but understanding God, his attributes, and his actions, which follow from the necessity of his nature' (*E*, II/267). Again, understanding God sounds dauntingly difficult. But Spinoza held that 'God's infinite essence and his eternity are *known to all*' (IIP47S, my italics); and when a correspondent asked him whether he had as clear an idea of God as he had of a triangle, he answered that he did, though his idea of God was incomplete (*Corr*, p. 289). He seems to have held that apriori cognizing comes naturally to those prepared to empty their minds of material that is alien to it. If there is nothing to

hinder the wise man from intuiting essences and making deductions therefrom, what more need he do, to attain freedom in the "Transcend Fortune" way, than lie back in a warm bath, close his eyes, and begin ratiocinating? The roof may be leaking and his wife may have left him. No matter; he will be above all that, active and self-determining in a timeless realm, enjoying the greatest self-esteem (*E*, IVP52) and the highest joy one can hope for (IVP52S).

§ 7.5 Immortality

This doctrine we have just been considering occupies the first half of Part V of the *Ethics*. What was he saying in the second half? The standard view is that he was there saying little more than that there can be, in the words of Anthony Kenny (who was not here discussing Spinoza), 'fugitive acquaintance with unchanging objects and temporary grasps of eternal truths' (*1975*, p. 9). This interpretation is open to several prima facie difficulties. Why did Spinoza conclude the first half of Part V by remarking: 'With this I have completed everything which concerns this present life. . . . So it is time now to pass to those things which pertain to the mind's *duration* [my italics] without relation to the body' (II/294)? Was he trying to gull his readers? And when, almost at the end of the book, he contrasted the ignorant man who ceases to be as soon as external causes cease acting on him, with the wise man who 'never ceases to be, but always enjoys true peace of mind' (VP42S), what else could he have meant by these words than that the ignorant man's mind does not survive his bodily death, whereas the wise man's mind (or part of it) does? Another consideration that argues for Spinoza meaning what he was saying here is his having affirmed a doctrine of immortality quite unambiguously in the unpublished *Short Treatise* (henceforth *KV*). He had there spoken of the soul being released from the body and achieving union with God.[22]

However, there is a decisive difference, with respect to immortality, between this earlier work and the *Ethics*. In *KV* there are still traces of a Cartesian view of the soul; for instance, it is there

22. *KV*, II, xix, 13; and see II, xxiii, entitled 'Of the Immortality of the Soul'.

said that the soul has the power to move the animal spirits.[23] And a Cartesian view of the soul is consistent with a doctrine of immortality. But although, as we saw, what Spinoza said about the dictates of reason and their control over the wise man's conduct may have sounded suspiciously like Cartesian interactionism, that position was, of course, officially repudiated in the *Ethics*; far from being separable things, mind and body were now said to be different aspects of one thing: 'the mind and the body are one and the same thing, which is conceived now under the attribute of Thought, now under the attribute of Extension' (*E*, IIIP2S). The Morning Star cannot outlast the Evening Star if these are one and the same thing under different descriptions; and the mind cannot survive the body if these are one and the same thing under different attributes.[24]

But we should remember that a wise man's mind participates in the thought-side not only of *natura naturata* but also of *natura naturans*, the latter being eternal. Perhaps Spinoza was arguing along the following lines: (i) a wise man spends much of his life cognizing necessary truths; (ii) necessary truths are eternal; (iii) a part of a mind that cognizes eternal things is itself eternal; (iv) a part of a mind that is eternal cannot perish. Spinoza certainly accepted (i) and (ii). What about (iii)? It looks fishy; if I take a quarter of an hour off from weeding the garden to examine the truth that there is no greatest prime number, my thinking has an a-temporal intentional object, but that does not make my thinking a-temporal. Well, Spinoza declared it to be certain that the mind is eternal insofar as it conceives things under the aspect of eternity (*E*, VP31S); so presumably he also accepted (iii). What about (iv)? Suppose we concede, for argument's sake, that a part of a wise man's mind that cognizes necessary truths is eternal; would it follow that it cannot perish? To many Spinoza scholars, the inference from '*x* is eternal' to '*x* is immortal' is invalid by Spinoza's own definitions, which make *eternity* and *infinite duration* mutually exclusive (*E*, ID8). If someone asks 'Did *x* exist

23. The 'soul, though it has nothing in common with the body, nevertheless can bring it about that the spirits, which would have moved in one direction, now however move in another direction' (II, xx, 3).
24. That Spinoza may have been a shade uneasy about his claims for the mind's eternality is perhaps indicated by *E*, VP41.

before I was born?', or 'Will *x* exist after I am dead?', then the true answer in either case is 'Yes' if *x* has infinite duration. But if *x* is eternal, such questions involve a category mistake; as Spinoza put it, 'in eternity there is neither *when*, nor *before*, nor *after*' (IP33S2). But if (part of) a mind is to survive the death of its body, it must exist before and after that temporal event. In short, it must exist in time like an indestructible atom, and not outside time like an eternal truth. If part of a wise man's mind were eternal that would *disqualify* it from enduring after death.

Broad said that while the first four books of the *Ethics* convinced him that Spinoza 'was a great and a very honest thinker, of an extremely "tough-minded" sort', the second half of Part V left him gasping (1959, p. 721). Bennett said that he would have preferred to pass over in sad silence the second half of Part V; 'Why did Spinoza write it?'(*1984*, pp. 374–75). From fear of personal extinction? Perhaps; but I think that we need to recall here the supreme goal that Spinoza had set himself when he set out on his philosophical quest: to discover 'whether there was something which, once found, would continuously give me the greatest joy, *to eternity.*' In the *Ethics* he sought to show the way to this: it involved renouncing a "panter's" way of life in favour of apriori thinking about God-or-Nature. To some of his readers this might seem like an invitation to give up their good Dutch gin in favour of a very dry sherry—*unless* his way led to salvation, not just from the disappointments, hangovers, and indignities that attend hedonic pursuits, but from personal extinction as well. So there was heavy pressure on him to conclude that his way leads to a kind of happiness that continues forever. As Martha Kneale said: 'Had his attempt succeeded, it would have been an enormous triumph. He would have shown that a pure naturalism can offer the certainty of salvation in place of the hope put forward by revealed religion' (1973, p. 240).

Further discussion of commentators' views on Spinoza on immortality is relegated to an appendix.

<p align="center">* * * * *</p>

The claim in the opening sentences of Chapter 1 that a mistaken theory of knowledge can have disastrous consequences for a philosophy of freedom is illustrated all too well in Spinoza's case.

True, other baleful ideas besides epistemological ones were at work in the slide from "Conquer Fortune", with its idea of not allowing adversity to deflect you significantly from the course you have set yourself, to the metaphysical escapism of "Transcend Fortune". But to attempt to segregate "free men" from "slaves" by bringing in an impossible kind of supposedly error-free and experience-transcending apriori thinking was bound to lead to failure. The question now is whether, if we retraverse this problem-area under the guidance of a good theory of knowledge and standing by the naturalistic view of "Man's Place in Nature" outlined in Part One, we can arrive at a worthwhile view of freedom.

APPENDIX

Spinoza on Immortality: Standard and Dissenting Views

The standard view may have been inaugurated by Frederick Pollock, who wrote: 'Spinoza's eternal life is not a continuance of existence but a manner of existence; something which can be realized here and now as much as at any other time and place; not a future reward of the soul's perfection but the soul's perfection itself' (*1880*, p. 294). It has been perpetuated by many subsequent commentators. H. H. Joachim (*1901*, pp. 292f) seems to have shared this view (though at one point he put in the remark 'At death we are "shaken free",' which tends in the other direction). Ruth Saw suggested that Spinoza was saying only that there will be times during a wise man's life when his mind enters the eternal system of God's thinking (*1951*, p. 131). Hampshire inclined to a similar view: 'It seems—but this must be conjectural—that we sometimes have experiences of complete and intuitive understanding, and that on such occasions we feel and know ourselves to be mentally united or identified with the eternal order of Nature' (*1951*, p. 176). Leon Roth wrote: 'Spinoza is talking about immortality, but it is an immortality which has no connexion with temporal existence, but which is a spiritual state achieved and enjoyed in this life' (*1954*, p.152). H. F. Hallett said that Spinoza's kind of "immortality" does not involve 'durational persistence, or an after-life' (*1957*, p.161). Lewis Feuer said that Spinoza 'rejects the ordinary theory of immortality', the eternity

of the human mind having nothing 'to do with time or duration' (*1958*, pp. 223–24). Errol Harris (1975) claimed to be challenging the standard view, but he seems to have ended up endorsing it; after equating 'man's immortality' in Spinoza's system with the 'knowledge and love of God' (pp. 257–58), he concluded: 'Immortality, then, while being no extended duration beyond the temporal life of the body, consists in the mind's transcendence of the body's finite limits' (p. 261). In a section entitled 'Salvation and Immortality', Yovel said that Spinoza was claiming only that 'the mind attains a form of eternity within this life and while the body, too, endures' (*1989*, i, p. 169). So far as I know, Yovel is the only supporter of the standard view who tackles its implication that Spinoza was here intentionally misleading the reader. He added in a foot-note that Spinoza's 'famous sentence, "it is time now to pass to those things which pertain to the mind's *duration* without relation to the body" . . . is clearly incoherent or intentionally misleading' (p. 231, n. 15). Yovel could view the latter possibility with equanimity because he held, broadly in line with Leo Strauss's *1952*, that Spinoza with his "Marrano" background 'was a grand master of dual language and equivocation' (p. 29).

Those who hold that Spinoza meant what he said in the last half of Part V divide into those (including Broad, Bennett, and myself) who are dismayed by it and those who are not. The latter include Kneale, Donagan, and Wolfson. Referring to adherents of the standard view, Kneale wrote: 'These writers have been influenced, I believe, not only by those passages in which Spinoza draws a sharp line between duration and eternity, but also by the thought that Spinoza could not be putting forward anything so vulgar as the doctrine of personal survival after death. But this seems to me precisely what Spinoza is putting forward' (1973, p. 237). She rejected the claim that, for Spinoza, anything eternal is a-temporal; something may be sempiternal (exist at all moments of time) without being eternal, but if it is eternal it is sempiternal. And she claimed that Spinoza came to recognize this. Donagan likewise held that, properly understood, Spinoza's definitions of 'eternity' and 'infinite duration' both involve sempiternity, the difference being that the existence is necessary in the case of eternity and contingent in the case of infinite duration (1973, p. 244).

If being eternal does after all involve enduring through all time, then Spinoza's assertion that part of a wise man's mind is

eternal has the startling implication that that part not only will exist forever after death but always had existed before birth. The mind-body parallelism would break down in both directions. Wolfson accepted this implication (*1934*, ii, p. 292). In support he quoted Spinoza as follows (he was using the Hale White translation):

> It is impossible, however, that we should recollect that we existed before the body, because there are no traces of any such existence in the body. . . . [Although] we do not recollect that we existed before the body, we feel that our mind . . . is eternal.

Here is the quotation with Wolfson's ellipses partially restored, in italics:

> It is impossible, however, that we should recollect that we existed before the body, because there are no traces of any such existence in the body, *and also because eternity cannot be defined by time or have any relation to it.* . . .
> Although, therefore, we do not recollect that we existed before the body, we feel that our mind, *in so far as it involves the essence of the body under the form of eternity* is eternal, *and that this existence of the mind cannot be limited by time nor manifested through duration. Only in so far, therefore, as it involves the actual existence of the body can the mind be said to possess duration* (*E*, VP23S).

I read this as saying that we do not recollect existing before the body for the good reason that the mind endures only while the body endures; however, we feel our mind to be eternal in some a-temporal sense. Actually, this scholium provides what is perhaps the best support for the standard view; it is as if Spinoza, realizing that if 'Part of a wise man's mind is eternal' were to imply that it always will exist, then it would *also* imply that it always has existed, preferred to cut off both implications.

Chapter 8
A Third View of Human Freedom

Before we embark under the guidance of critical rationalism on the search for a view of freedom distinct from classical empiricist and classical rationalist views, we need some general desiderata for any distinctive view of human freedom. Our historical review was undertaken partly with the negative aim of finding mistakes to be avoided. One of these, surely, was Kant's uniform appraisal of all people, from saints to hardened scoundrels, as equally free (qua noumenal selves) and as equally unfree (qua phenomenal selves). A worthwhile view of freedom should surely be more discriminating. Would it be sufficiently discriminating if it treated freedom as an all-or-nothing state, classifying people as either free or else unfree, rather as some religions classify souls as either *saved* or else *damned*? Spinoza, who generally proceeded in this way, classifying people into the wise few who are free and the ignorant many who are slaves, allowed at one point that it is impossible always to be at the peak of human freedom. And we should surely agree with D. J. O'Connor that freedom is not an all-or-nothing property but a matter of degree (*1971*, p. 121). As well as allowing that people may vary widely, an adequate view should allow that an individual may have considerable ups and down with respect to freedom. We would not have got far enough from a dichotomizing view if we merely replaced the thesis that mankind splits into two classes, those who are free and the rest who are unfree, with the thesis that a line can be drawn with everyone above it always more free than everyone below it. The primary concern should not be with classifying or ranking persons, but with appraising different human states with respect to freedom.

221

§ 8.1 Three Freedom-Scales

How should we set about this task? Could we depict an ideal limit of absolute or perfect freedom and then assign degrees of freedom to human states according as they approximate it? Another negative lesson can be learnt from Spinoza, here. At the beginning of § 7.3 above we touched on his "all-or-nothing" view that person X is free if and only if X is purely self-determining. To allow for degrees of freedom let us recast this as the proposition that X is more free the more nearly X's state approximates one of pure self-determination. Now if this latter is to serve as an ideal limit we must be able to form a clear and distinct idea of it. But what happens when we try to carry to the limit an idea of X becoming less and less other-determined and more and more self-determining? For my part, I find the idea dissolving. I cannot even conceive of an *x*, human or otherwise *existing*, let alone *acting*, in entire independence of everything external to *x*.

If the idea of an upper limit to human freedom dissolves when we try to give it a definite content, the alternative that suggests itself is to assign higher degrees of freedom to human states according as they distance themselves from some lower limit(s). Now in examining Hobbes's definitions in § 6.1 above we have already met two lower limits, namely: (1) extreme *internal heteronomy* in which a subject's unsuspecting mind has been thoroughly infiltrated, through some kind of super-hypnosis, by an outside controller; and (2) extreme *external heteronomy*, where a subject's bodily behaviour is subject to an outside controller. And to these a third may now be added. Autonomy is usually contrasted just with heteronomy. But the term derives from the Greek word *autonomia*, meaning self-rule or self-control; and this has two contraries: being under the control of something not oneself, and not being under control. A ship in mid-ocean might start steaming in an eccentric way because she has been hijacked by pirates or because her steering gear has broken down. So let us add to the above: (3) extreme *disonomy*, where self-control is lost without passing to an external agency. (I at first called it 'disnomy' in line with 'dislike' and 'discomfort'; but to enable it to be pronounced in line with 'aut*o*nomy' and 'heter*o*nomy', I inserted the otherwise gratuitous 'o'.)

The idea of disonomy can be elucidated with the help of the hypothesis, argued for in § 4.6 above, of a control-motor dualism. Assume that an individual's motor system as such remains essentially intact, as did our rogue ship's engines. Then there are two main ways in which a state of disonomy could come about: (a) the control system's internal integrity is still intact but pathways from it to the motor systems are interrupted; or (b) the control system itself has been disabled. Here is a striking example, reported by Oliver Sacks (*1985*, chapter 3), of disonomy of the first kind. A robust and self-reliant young woman called Christina, in hospital in preparation for a minor operation, had the frightening experience of abruptly losing all proprioceptive sense of her body: unless she looked at them, she could not tell where her arms or her legs were, or even whether she *had* arms and legs. 'For about a month afterwards,' Sacks reported, 'Christina remained as floppy as a ragdoll, unable even to sit up' (p. 48).[1] Her mind was still intact, but for a month or more she could no longer get her limbs to obey it. If that condition had persisted it would have exemplified a virtually total disonomy. However, she refused to give in. It turned out that her motor systems, although no longer under spontaneous internal control, were intact; and she gradually discovered alternative ways to control them, rather clumsily; although she could not feel her limbs, she could see them and somehow supervise their movement from without.

Disonomy of the second kind can be induced by a well-known drug (there is no need to give its name here) which might almost have been devised for the benefit of rapists. If a small tablet of it is dropped into a young woman's drink she will notice nothing unusual; it is (at the time of writing; one hopes this will be changed) odourless and colourless, and will leave no tell-tale traces in her body afterwards. She may later be observed being escorted to a taxi apparently under her own control, though perhaps slightly inebriated. Actually, although her body is in quite good working order, her mind has been temporarily anaesthetized; the control it would have exercised has been disabled and she will put up no resistance when undressed and

1. A similar case is recorded in Cole *1992*.

used as a sex object. (She may have certain flashback experiences afterwards.)

We may think of states (1), (2), and (3) above as "absolute zeros": each of them is such that there could not be a worse state beneath it. If we attend only to extreme states, always assuming that motor systems as such are in working order, there would seem to be no logical possibility of further absolute zeros: central control either is not working (disonomy) or is working; if working, it either is or is not under external control; if under external control, the latter is either covert (internal heteronomy) or overt (external heteronomy).

Each of these "absolute zeros" may be seen as fixing the lower limit for a freedom-scale. These scales will be assumed not to have a discoverable upper limit. One could envisage each of them as black at one end and becoming progressively less dark but without ever becoming white. They will also be assumed to be merely comparative or ordinal. Thus if *u*, *v*, and *w* were progressively higher positions on one of these scales, one could not make statements about them—say, that the interval between *u* and *v* is greater than the interval between *v* and *w*—that one could make if they were positions on a temperature scale. However, such a scale does in principle permit the following kind of quantitative measure. Take a representative sample of, say, 1,000 individuals, and assume that any pair of them, say *a* and *b*, could in principle be ordered comparatively, as *a* > *b* or *a* < *b* or *a* = *b*, where '*a* > *b*' means that *a* is higher up the scale (further from zero) than *b*. This would allow the scale to be divided into percentiles, the bottom percentile being the interval containing the ten individuals lowest down, and conversely for the top percentile. One might now equate being high up (low down) on the scale with being in, say, the top (bottom) five percentiles.

Let us now consider these scales separately. While their lower limits are theoretically indispensable, positions on them that are above zero but more or less low down are of more practical interest, and it is worth looking into some of these. I begin with internal heteronomy. A zero state for this was conceived as resulting from a planned piece of ideally effective brain-washing. So one way to proceed to non-extreme states here is to consider ones where the brain-washing is unplanned and imperfect. A lot of unplanned brain-washing is typically going on in society, as people

uncritically soak up values and beliefs from the culture around them. I found it rather striking that a brain-washing effect could still be exercised by a magic-oriented culture on an independent-minded, science-oriented western anthropologist studying that culture. E. E. Evans-Pritchard reported that in the course of his long sojourn alone among the Azande he came to react 'in the idiom of witchcraft' to their misfortunes, so that on noticing a neighbour's poor crop he would wonder who had cast the spell; he added that 'it was often an effort to check this lapse into unreason' (*1937*, p. 99). We might call people with an above-average propensity to absorb the ideology of their society *inward conformers.*

Another kind of non-extreme state of internal heteronomy results if one's mind comes to be dominated by one particular item which develops into an idée fixe. Although the process may be involuntary, we may call it *self-inflicted*, since it is not inflicted from without. It can be very injurious. For instance, the character Kirilov in Dostoyevsky's *The Possessed* came to be gripped by the idea that he could achieve a 'terrible new freedom' by killing himself; and after long, brooding delays he eventually carried out his idea. No outsider had instilled it; his subjugation to it was self-inflicted. Rather similarly, the character Leverkühn in Mann's *Doctor Faustus* came to be possessed by the idea of going with a *diseased* prostitute; he eventually carried it out, with the consequence that he too was destroyed, though more slowly, sinking into a state of increasing disonomy when the disease he duly contracted reached his brain. These are only fictional cases, you may say; is there self-inflicted heteronomy in real life? Well, the case of Kirilov seems to have some basis in fact; it seems that Dostoyevsky modelled him on a certain Smirnov, one of a group of revolutionary students tried in St. Petersburg in 1871 for the murder of a fellow student.[2] An obsession with gambling is another real-life example of self-inflicted heteronomy (Dostoyevsky himself got through much of his two wives' fortunes as a result of a compulsion to play roulette). Hume remarked that there are people so obsessed by the idea of revenge that they 'knowingly neglect every consideration of ease,

2. Magarshack 1953.

interest, or safety' (*Enquiries*, # 254). I know of a case where X carried on a vengeful vendetta against Y long after Y had died; it was as if X was in thrall to a ghost.

Extreme external heteronomy, like extreme internal heteronomy, was thought of as a planned condition; and here too we can turn to conditions that are unplanned but tightly constrain what the individual can do, for instance extreme poverty. We may call them *anonymously* imposed. A somewhat different kind of external heteronomy results when workers have to conform their bodily movements with the impersonal demands of a conveyor-belt (as in Charlie Chaplin's *Modern Times*). Another kind of non-extreme external heteronomy parallels the idea of inward conformism mentioned earlier with that of outward conformism. The behaviour of a successful outward conformer will be almost indistinguishable from that of an inward conformer; but whereas the latter internalizes certain values, the former only pretends to assent to them. We can also modify the idea of full-fledged external heteronomy by reducing the time-span (examples of short-lived but still grim and harrowing states of external heteronomy will be offered in § 8.4 below).

As to disonomy: alcoholism and other forms of addiction typically have a lowering effect. Laziness and indecisiveness tend to work in the same direction, though less strongly. As one's energy, stamina, courage and resolve increase, and the surer is one's mental control over one's bodily performances, the further one gets from the zero on this scale. Ignorance as to one's situation may also induce a kind of disonomy. You wake up in a strange place with no recollection as to how you got there. (Perhaps your body was dumped there after you had been kidnapped and doped, but you have no recollection of any of that.) It is dark. You shout; there is no answer. Your motor-system, unlike Christina's, is amenable to control, but what directions should you give it? You are in a state of *disorientation.*

If X is further than Y from at least one of these zeros without being closer to either of the others, we can say that X currently has less unfreedom or more autonomy than Y. There would be incommensurability if X were further from one zero but closer to another. That can happen. In § 8.5 below we will consider two striking but contrasting examples of such incommensurability. But in general there are reasons to expect a rough-and-ready correla-

tion between an individual's performances on different scales. For instance, being timid, or cowardly, or lazy, or indecisive, may encourage subordination to a stronger personality. Again, an outward conformism may, when it is a strain to maintain the pretence, slide over into inward conformism. And its imprint may linger on, as self-inflicted heteronomy, after an external factor has fallen away. In Katherine Mansfield's story, 'The Daughters of the Late Colonel' two sisters who had been dominated by their father while he lived remained in his thrall after he died, reaching decisions by asking themselves, 'What would father want us to do?'.[3]

There is no disagreement with Kant over what he said about *enlightenment.*

> Enlightenment is man's release from his self-incurred tutelage. Tutelage is man's inability to make use of his understanding without direction from another. Self-incurred is this tutelage when its cause lies not in lack of reason but in lack of resolution and courage to use it without direction from another. *Sapere aude!* "Have the courage to use your own reason!"—that is the motto of enlightenment. (1784, p. 35)

Under 'self-incurred tutelage' you open your mind to alien occupation, which sounds like a fairly low position on our internal-heteronomy scale. Why do some people sink into such a condition?

> Laziness and cowardice are the reasons why so great a portion of mankind . . . remains under lifelong tutelage, and why it is so easy for others to set themselves up as their guardians. It is so easy not to be of age. If I have a book that understands for me, a pastor who has a conscience for me, a physician who decides my diet, and so forth, I need not trouble myself. I need not think. (Ibid)

In another work Kant spoke of 'the lazy and pusillanimous cast of mind . . . which entirely mistrusts itself and hangs back waiting for help from without' (*Religion*, p. 50). Restated in our inelegant terminology, he was saying that a poor performance along the disonomy scale tends to encourage a poor performance on the

3. Stanley Benn drew attention to this story, *1988*, p. 165.

internal-heteronomy scale.

There is a rather similar rapprochement between some of J. S. Mill's ideas and the ideas of the present chapter. Like Kant, who declared that reason can accord sincere respect only to that which has been able to sustain the test of free and open examination (*CPR*, A xi), Mill was in many ways a good critical rationalist. His *Liberty* (1859) broke with the classical empiricist tradition in which his *Logic* (1843) was embedded, especially in repudiating the no-invention-of-ideas thesis: 'nothing was ever yet done which some one was not the first to do, and . . . all good things are the fruits of originality' (*Liberty*, p. 268); what is needed for intellectual (and moral) progress is bold new ideas plus fearless criticism. An opinion should be accepted, though only tentatively, when 'with every opportunity for contesting it, it has not been refuted' (p. 231). His idea of individuality was like Kant's idea of enlightenment in calling for movement away from certain nega-tive states. Its attainment calls for a strong will, mental vigour, moral courage, and energy (p. 272), which sounds like a position well up on our disonomy scale. He said that the lives of people who lack individuality are 'pinched and hidebound' and 'cramped and dwarfed' (p. 265), which sounds like our anonymous het-eronomy. He also wrote: 'In our times, from the highest class of society down to the lowest, every one lives as under the eye of a hostile and dreaded censorship' (p. 264), which sounds like out-ward conformism. But outward conformism may slide over into inward conformism, and Mill also declared that society 'practises a social tyranny more formidable than many kinds of political oppression, since, though not usually upheld by such extreme penalties, it leaves fewer means of escape, penetrating much more deeply into the details of life, and *enslaving the soul itself*' (p. 220, my italics). That sounds like internal heteronomy.

§ 8.2 "Transcend Fortune" Revisited

The aim in this chapter is to show that critical rationalism sup-ports a view of freedom or autonomy that satisfies the above desiderata and can rightfully replace Spinoza's view. We saw Spinoza declaring that a free man does only things he knows to be 'most important' or 'most excellent' and giving a classical ratio-nalist answer to the question 'What are these things?'. But that

question is wrongly put; it suggests that there are some people, perhaps only a few, who are free and who do things that other, unfree people do not do. The question should rather be: 'What human states exemplify an unusual degree of freedom or autonomy?', which leaves open the possibility that there can be significant variations with respect to freedom between individuals and within one individual. To this revised question Spinoza's answer would have been that it is states in which human thinking is at its best. This was his "Transcend Fortune" way to freedom, the transcendence consisting in rising above one's external situation to a plane at which one's thinking is not prodded along by sensory inputs or other external stimuli but is purely self-determining.

Critical rationalism agrees that an activity that exhibits an unusual degree of freedom or autonomy involves high level thinking, and also that high level thinking exhibits transcendence, but it understands this very differently. The decisive feature of *alpha-events*, as we may call major theoretical breakthroughs in science, is the absence of a heuristic path from explanandum E to explanatory theory T; the latter's propositional content massively transcends what was there before. Only inventive thinking could get it onto the drawing-board. But there must be a logical path back from T to E (perhaps to a slightly revised E'; this qualification will be omitted in what follows). The creativity must be on target; E must "fall out" naturally from T. 'Fortune' is not an ideal label for the problem-situation presented by E, but it has a certain appropriateness; after all, E is "out there", a challenge to scientists; and if 'Fortune' is allowed, then "Transcend Fortune" is a not inapt slogan for a successful response to this challenge.

In fields outside science there also occur events with an essentially analogous structure. Consider humour, which will play a small but non-trivial role in our Third View of human freedom. In analogy with *explanandum* as a name for the target of a scientific explanation, we might introduce *jocandum* as a name for the target of a joke. In itself a jocandum may be nothing to laugh about. The *jocandum* for an endless stream of subversive jokes was the unhappy condition of Poland under Communism, in which ordinary citizens might be queueing for fish-bones while party members took advantage of the hard-currency shops. One of them ran:

Qu: Why is Poland like America? *Ans*: In America you can freely crit-
icise President Reagan; you can buy nothing with zlotys but virtually
anything if you've got enough dollars. In Poland you can freely criti-
cise President Reagan; you can buy nothing with zlotys but virtually
anything if you've got enough dollars.

The joke is on target, but there is no heuristic path to it from
its jocandum. I don't know whether Kant classed good jokes
along with poetry as things for the creation of which there can be
no recipe, or with scientific advances which, he claimed, may be
brought about by industry and imitation; but they should be
classed along with both poetry and scientific advances as things
for the creation of which there can be no recipe, the making of
which involves transcending Fortune.

I have not found a term analogous to *explanandum* and
jocandum to denote the subject of an artist's or sculptor's com-
mission, but let us now look into a famous alpha-event outside
science, namely the painting by Michelangelo of the vault of the
Sistine Chapel. As told by Ernst Gombrich, the story goes like
this. He had earlier received a commission to erect a great tomb
for Pope Julius II; thrilled by this, he 'immediately travelled to
the famous marble quarries at Carrara, there to select the blocks
from which to carve a gigantic mausoleum. The young artist was
overwhelmed by the sight of all these marble rocks, which
seemed to be waiting for his chisel to turn them into statues such
as the world had never seen' (*1950/95*, p. 231). But then he
learnt that this project had fallen through; furious, he returned to
Florence. Later, the Pope summoned him back to Rome, and
called upon him to paint the vault of the Sistine Chapel.
Gombrich continued:

> Michelangelo did all he could to evade this commission. He said
> that he was not really a painter, but a sculptor. He was convinced
> that this thankless commission had been palmed off on him through
> the intrigue of his enemies. When the Pope remained firm, he
> started to work out a modest scheme of twelve apostles in niches,
> and to engage assistants from Florence to help him with the paint-
> ing. But suddenly he shut himself up in the chapel, let no one come
> near him, and started to work alone on a plan which has indeed con-
> tinued to 'amaze the whole world' from the moment it was
> revealed. (p. 232)

A believer in free-will might claim that when he shut himself up alone in the chapel a Cartesian-type volition occurred ('I *will* do that ceiling'); but it is more likely that he began being overwhelmed by new, unbidden ideas. Previously, his mind still dominated by thoughts of marble and sculpture, he could hardly bear to undertake the Pope's commission; and now, his mind filled with new visions, he could hardly bear not to. If we here use 'Fortune' to denote the initiating external circumstances, namely the Pope's 'thankless commission', then we might say that if Michelangelo had stayed with his initial, minimalist scheme he would have been, not conquered of course, but temporarily incommoded by Fortune. Instead of which he amazingly transcended Fortune.

There is no possibility of an individual's mind being under alien control if no one else even has the ideas that are guiding what this individual is doing. However, this last is not a guarantee of autonomy. We need to bear in mind what, in § 8.1 above, was called self-inflicted heteronomy. Things can go badly wrong if the inventive prong of critical rationalism is functioning but not its critical prong. Kirilov was inventive in coming up with the idea that he could achieve a special kind of freedom by killing himself; but he should have been more critical of it. For instance, he might have asked himself for *how long* he would enjoy this special freedom. As an atheist with no belief in an after-life, Kirilov would not have believed that he would enjoy it after the deed was done; and merely intending to do it would hardly be enough, since there would always be the possibility that he would chicken out. That leaves the period when he was actually squeezing the trigger; is that long enough, he might have asked himself, to make it worthwhile?

A word now as to the importance of alpha-events. Locke had an argument for the existence of God which ran as follows:—Reality is multi-levelled; what exists at a higher level is not reducible to, and could not have been generated by, what exists at a lower level (*Essay*, IV, x, 10-11; Locke put inert matter at the lowest level, and human experience and knowledge at the highest level). At each level there is ontological novelty; the stuff at this level was not implicit in what was there before. It could have been brought into existence only by divine creation. The original stuff, inert matter, would never have existed if God had

not created it; and it being created, motion would never have existed if God had not, in addition, created it; . . . nor minds, if God had not created them. In opposition to Locke's no-invention-of-ideas thesis, critical rationalism claims that there is human creativity, with concepts that were not implicit in what was there before being woven into essentially novel propositions. And when this novel content is objectified and rendered publicly accessible, whether as a work of science or a work of art, there is *man-made* ontological novelty. Someone who pulls off an alpha-event does something, if only locally and on a small scale, of a kind that Locke supposed that only God could do. This provides us with a critical rationalist replacement for Spinoza's idea of a free man doing things that are 'most important' or 'most excellent'.

§ 8.3 A "World" of One's Own

The main counter-claim to Spinoza's scornful dismissal of the Cartesian idea that man is a dominion within a dominion who disturbs the world around him was presented in Chapter 3; it was that some individuals, Faraday for instance, have thought up and developed novel ideas which have had highly disturbing effects on life on our planet. In the present section a subsidiary counter-claim will be adduced. It is something of an optional extra, and could be discarded without affecting the main argument. It takes off from Popper-Lynkeus's good saying that when a man dies *a world goes out of existence*.[4] The thesis will be that the authors of disturbing new ideas typically think them up and develop them within a "world" of their own, the latter being understood, not as a physical locale such as a studio or library, but in an immaterial sense: one can sell or give away bits of one's library but not bits of one's "world".

Of course, an occupant of a "world" remains part of the public world (as does a sleeper on a park bench, away in a dream-"world"). The phrase 'of one's own' is to indicate that one per-

4. Quoted in Popper *1977*, p. 3. 'Lynkeus' was a pen-name; his legal name was Josef Popper, born 1838, died 1921. There is a substantial entry on his interesting life and work in *The Encyclopedia of Philosophy* (ed. Paul Edwards). Freud said that Popper-Lynkeus had independently discovered the idea central to his own theory of dreams (1923). Mach saluted him (1883/1933, pp. xvii, xxi, 604, 608–09). Einstein included a tribute to him in the section 'About Friends' in his *1954*.

son's "world" cannot be shared or entered by another person (although a close colleague or biographer may get to know a lot about it). Remarks like 'Beethoven played an important role in Schubert's "world"' must be understood as referring, not to the flesh-and-blood Beethoven whom Schubert seems not to have encountered,[5] but to Schubert's internalized representations of the man and his music. The relation of a "world" to its occupant's stream of consciousness is analogous to that of a workshop, with its tools and sketches and bench with a work-in-progress on it, to what its occupant does taken sequentially. A stream of consciousness can't be wound back or replayed, but you may take up a problem or project in your "world" that you left in an unfinished state a year ago.

This concept of a creative person's "world" allows us to distinguish between *internal* problems, which arise within it, and *external* problems, which do not. The distinction is complicated by the fact that an internal problem may have started as an external problem, as we saw in the case of Michelangelo when he received that 'thankless commission'. It can also happen that a problem that came to occupy the centre of a person's "world" started as a seemingly trivial puzzle. When Russell first found himself in a difficulty over whether the class of all normal classes, that is, classes that are not members of themselves, is or is not normal, he thought that there must be some trivial error in his reasoning (*1959*, p. 76). But it led to a momentous period of his life: 'Every morning I would sit down before a blank sheet of paper. Throughout the day, with a brief interval for lunch, I would stare at the blank sheet. Often when evening came it was still empty' (*Auto*, i, p. 151). He was wrestling with a deep-seated problem at the foundations of mathematics. By contrast, he confronted an external problem when, in October 1948, aged 76, he found that the flying-boat in which he had landed at Trondheim was sinking. He reported afterwards that he was 'mainly concerned to save my attache case'. But that was an out-of-date imperative from a

5. Reed *1987*, p. 92. And Schubert came to figure, if only briefly, in Beethoven's "world". Schindler reported that, to distract the great man during his last illness, he presented Beethoven with a collection of songs and melodies by Schubert, who had been unknown to Beethoven. For several days Beethoven could not part from them, frequently crying that in Schubert a divine spark lives (Sonneck *1926*, p. 175).

"world" which he now had to abandon, at least temporarily. He soon realized that solving his present problem meant letting go the attache case and swimming to the rescue boat.[6]

There are objective markers for this distinction. To ask someone 'What's my problem?' apropos an internal problem would always be absurd, but might be in order apropos an external problem; Russell might well have asked a member of the flying-boat's crew what their problem was. Another objective marker involves predictability. A suitably positioned observer Y of a person X facing an external problem will often be able to predict X's behaviour from a knowledge just of X's external circumstances and without any acquaintance with X personally (more about this in § 8.4 below). Thus someone in the rescue-boat might have predicted that the white-haired gentleman would let go his attache case and swim; but a hidden observer watching Russell staring at those blank sheets could not have predicted what, if anything, he would write on them.

It seems rather obvious in the case of creative writers that they spend a good deal of time in "worlds" of their own. When Tolstoy was writing *War and Peace*, the "world" of his characters could seem more real to him than the public world: 'Sometimes his family saw him emerge from his study wearing a far-off expression, absent-minded and happy—it was hard for him to get his bearings in real life after spending hours in the company of his heroes.'[7] The reality for him of this other "world" and its inhabitants is indicated by the following incident. A painter submitted to him portraits he had made of some of the characters in *War and Peace*.

> The author experienced a childish delight when he saw his heroes' portraits: as though they were real people. He knew them so well that he began writing to the artist to suggest that he retouch this feature or that in order to obtain 'a better likeness'. He could not have been more precise in his suggestions had he been writing about his own family: 'Can't Helene be given more bust . . ? . . . Pierre's face is very well done, but his forehead should be made more thoughtful by adding a furrow, or two bulges above the eyebrows. . . . Prince

6. *Auto*, iii, pp. 45–46; when G. E. Moore, then 75, learnt of this exploit he is said to have exclaimed: '*I* could have done that!'

7. Troyat *1965*, pp. 392–94.

Andrey is too tall and his attitude should be more casual, scornful, gracefully negligent. . . . Princess Bolkonsky is remarkably successful. . . . Hippolyte's portrait is perfect, but it would be better to lift his upper lip slightly. . . .[8]

A workshop or studio may provide something of a sanctuary for an artist or craftsman working in it, and the "world" of a creative person busy on a project may provide something analogous. It may come to seem cold and empty if that work is finished and there is no new project to turn to. This seems never to have happened to Mozart or Beethoven, but it did happen to Tolstoy when he finished *War and Peace.* 'Tolstoy felt tragically bereft. Bewildered, disconnected, he went on dreaming of the phantoms he had let loose in the world, whose fate he could no longer alter'.[9] It can also happen that a "world" ceases to provide a sanctuary when outside forces become too invasive. Wittgenstein was in Vienna when war broke out in 1914, and he enlisted immediately as a private in the Austrian Army. He had with him the unfinished manuscript of what was to become the *Tractatus* and he could withdraw from the 'vile and stupid people'[10] around him into a "world" of his own and work on this. A biographer writes: 'Headaches, tiredness, shells overhead, and danger often occur on days when he also worked better than usual'.[11] This protective shell was transparent and did not obscure the outside world or interfere with his performance of his public duties, which seems to have been exemplary.[12] But external factors sometimes became too strong. During the summer of 1916, when the Austrian army was in retreat before a Russian offensive, he recorded in his diary: 'Yesterday I was shot at. I was scared! I was afraid of death. . . . From time to time I become an *animal.* Then I can think of nothing but eating, drinking, and sleeping. Terrible!'.[13] I suggest that what he then became was a man who had lost the protection of his "world".

8. Ibid, p. 406.
9. Ibid, pp. 415–16.
10. See Monk *1990,* p. 139.
11. McGuinness *1988,* p. 226.
12. He was recommended for the Gold Medal for Valour, the highest military honour (Monk *1990,* p. 154), though in the event he received a lesser decoration.
13. Quoted in Monk *1990,* p. 146.

Freud drew a parallel in this connection between creative writers and children engaging in wish-fulfilling play: 'Might we not say that every child at play behaves like a creative writer, in that he creates a world of his own . . . ?' But it seems to me that Freud did not sufficiently distinguish between two kinds of "world". Both put protective shells around their occupants, but of different kinds. The shell may be transparent, so to speak, shutting out unwanted noise but leaving things in plain view. (According to Freud, it is like that with children, who distinguish clearly enough their world of play from reality; 1908, p. 144.) Winston Churchill, whom no one would accuse of a tendency to shut out the real world, said of the writing of his first book: 'It built an impalpable crystal sphere around one' (*1930*, p. 218), which suggests transparency. Or the shell may be opaque, shutting unwanted reality as well as unwanted noise. The reason why Freud did not observe this distinction may have been that he linked "world"-formation with the pleasure-principle as against the reality-principle.[14] If the real world contains features that you find harsh or unbearable, the pleasure-principle encourages you to turn away from it and construct an illusory "world" in conformity with your own wishes (*1930*, p. 81). The implication seems to be that the pleasure-principle encourages retreat into a delusional "world", while the reality-principle encourages facing up to the real world. (The implied suggestion that scientists who comply with the reality-principle do not occupy "worlds" of their own will be rebutted shortly.)

In this connection it is instructive to look at a case to which Freud assigned a crucial role in the early development of psychoanalysis (*1910*, pp. 9f), namely the case of "Fräulein Anna O.". She had been treated during 1880–82 by Freud's friend and collaborator Josef Breuer. (His treatment came to take up several hours each day; when his wife became jealous he abruptly broke it off, with unfortunate results.)[15] Breuer reported that this girl,

> who was bubbling over with intellectual vitality, led an extremely monotonous existence in her puritanically-minded family. She embellished her life in a manner which probably influenced her deci-

14. It seems that Freud first introduced these terms in his 1911.
15. Jones *1953–57*, i, pp. 245f.

sively in the direction of her illness, by indulging in systematic day-dreaming, which she described as her 'private theatre'. While everyone thought she was attending, she was living through fairy tales in her imagination. (*1895*, p. 22)

Freud suggested that the lesson to be learnt from her case is that when 'phantasies become over-luxuriant and over-powerful, the conditions are laid for an onset of neurosis or psychosis' (1908, p. 148). It is widely supposed that the borderline between genius and madness is wafer thin. On Freud's view, excessive inventiveness is the danger here. But there is an alternative hypothesis. Breuer's report, quoted above, went on to say that before her mental illness set in, Anna O. 'was always on the spot when she was spoken to', so that people were unaware of her withdrawals to her private theatre. At that time her private "world" seems to have had a transparent surround. Perhaps her trouble was not that her inventiveness became over-luxuriant, but that she came to combine it with an exclusion of the outside world.

Freud over-extended his parallel between children at play and creative writers, together with his assumption that both are engaging in wish-fulfilment. The writer, he said, 'creates a world of phantasy', adding that every fantasy is 'the fulfilment of a wish, a correction of an unsatisfying reality' (1908, pp. 143–46). But Freud landed himself in a difficulty here. For he held that if day-dreamers were to communicate their fantasies to other people, which they do not normally do, being ashamed of them, they would 'repel us or at least leave us cold'. Then how can creative writers enthral us if they are, at bottom, only peddlers of day-dreams writ large? Freud's answer was delphic: 'How the writer accomplishes this is his innermost secret' (p. 153). I do not challenge Freud's likening of creative writers to children at play, but my own guess is that children enjoy the scenes they are inventing not merely for their flattering, wish-fulfilling role, but also for what we might call, with acknowledgements to Anna O., their 'private theatre' factor.

Let us now view the idea of a scientific community in the light of the above ideas. Having discarded Freud's association of "worlds" exclusively with the pleasure-principle, we have no more reason to deny that creative scientists occupy "worlds" than that

creative writers do. And surely Newton, when 'voyaging through strange seas of thought alone', occupied a "world" which contained many things that had no counterpart in the "worlds" of his contemporaries. Critical rationalism allows for a middle view between classical empiricism, which saw human beings, like other animals, as induction-machines being instructed by prods from the external world they all inhabit, and Leibniz's version of classical rationalism, which saw human beings as monads shut up each in a windowless "world" of their own, seeming to look out upon an external reality, but actually experiencing a virtual reality generated by the Supreme Program which pre-establishes harmony between the different "worlds". It allows that scientists occupy "worlds" of their own which are not windowless. A hypothesis thought up within one "world", if it passes an initial critical examination there, will typically be put into the public domain for public discussion. (This is in line with Popper's equation of scientific objectivity with inter-subjectivity, or friendly-hostile co-operation between scientists; *1945/66*, ii, p. 217.) Something similar no doubt holds for the mathematical community. (For an insider's view of a mathematician's "world" see, for example, G. H. Hardy *1940*, p. 92.)

So much by way of a partial rehabilitation of the Cartesian view of man as a 'dominion within a dominion'. Let us now turn from "worlds" and their internal problems to the handling of problems external to them.

§ 8.4 "Conquer Fortune" Revisited

"Transcend Fortune" is related to activity that lifts one rather high up on the internal-heteronomy scale. "Conquer Fortune" will be understood as coping with factors that threaten to drive one rather low on the external-heteronomy scale. We might say that someone driven low down on that scale by external factors has been "conquered by Fortune".

The rational handling of practical problems is the subject of decision theory. Orthodox (that is, Bayesian) decision theorists are not much given to talk about human freedom; but if pressed, they might say something along the following lines: 'Decision theory is about making optimal choices in given situations. People

whose choices were invariably optimal would be as free as their circumstances permit. Of course, a person's circumstances may be adverse; but to act irrationally or sub-optimally in adverse circumstances would only make things worse. One can only make the best of whatever situation one is in.' We might use "Accommodate to Fortune" as a motto for this approach.

It will be a thesis of the present section that critical rationalism calls for a significant departure from orthodox decision theory. The latter introduces a 'perfect knowledge' assumption. This has two components. First, you the agent can list all the alternative choices (options, strategies) open to you in your current problem-situation. It is as if you are given a list of alternatives and are required to tick one. Second, for each of those possible choices you can list all its possible outcomes or "prizes" (which may be negative). Decision theorists readily admit that the perfect knowledge assumption is an idealization, but one which is needed if their theory is to yield determinate results. Their theory classifies decision-making under conditions of three kinds: (i) certainty, (ii) risk, and (iii) uncertainty. Under (i), each choice has just one outcome or "prize". Under (ii), some or all of the choices have two or more possible "prizes", each with an objective probability; for instance, a choice might give you a 90% chance of winning £1,000 and a 10% chance of going to jail for six months. Under (iii), the situation is as in (ii) except that in some or all cases there are no objective probabilities. Decision theory further assumes that your preference-ordering over all the possible outcomes is complete: for any pair (x, y) of possible "prizes", you either prefer x to y, or prefer y to x, or are indifferent between x and y. (This completeness assumption, which is again an idealization, will not be challenged in what follows.)

Under (i), optimal decision-making consists, obviously, in making a choice whose prize is better, or not worse, than the prize associated with any other choice. The guiding idea of modern decision theory has been to try to assimilate rational decision-making under (ii) and (iii) to the paradigm case of (i). Under (ii), it is as if the prizes of some or all of the choices are lottery-tickets. An important feature of Bayesian decision theory is its claim that such a lottery-ticket has a utility (its expected utility) that is as definite as the utility of a single prize. This claim is connected

with the further claim that utilities can be located on an interval-scale.[16] Let *a*, *b* and *c* be prizes such that you prefer *a* to *b* and *b* to *c*. You have a choice between the middling *b* and a lottery giving you some probability p of getting the superior *a* and the complementary probability of getting the inferior *c*. If p = 0 you obviously prefer *b* since the "lottery" would now be offering you the certainty of the inferior *c*; conversely, if p = 1 you obviously prefer the "lottery" which would now be offering you the certainty of the superior *a*. So continuity considerations suggest that there must be an intermediate value of p at which you would be indifferent between *b* and the lottery. Suppose that this value is 0.25; then for you the expected utility of the lottery giving you a 25% chance of *a* and a 75% chance of *c* equals the utility of *b*. This would mean that you could locate *a*, *b* and *c* on an interval-scale for utility, the interval between *a* and *b* being three times that between *b* and *c*. Thus under (ii), the decision-maker can choose as if under (i), with single prizes replaced by lottery tickets. As to (iii): the Bayesian version of decision theory says that where objective probabilities are not available, the decision-maker should plug the gaps with subjective and perhaps arbitrary probabilities, and proceed as if under (ii). A famous alternative is to adopt the minimax rule whereby the decision-maker takes into account only the worst possible outcome of each lottery ticket; he then chooses the best of these "worsts" as if under (i).

For the 'perfect knowledge' assumption to be satisfiable, the agent's problem-situation must have a mappable layout and the agent must be in a position to map it. We might say that in such a case the agent's problem-situation is *given*. Now critical rationalism does not deny that some problem-situations are indeed given, for instance in what Spiro Latsis (1972) called 'single-exit' situations. Here, although the situation may, formally considered, have two or more possible exits, they all have a No-Go character except one. Here is an example. In Occupied France during the War, German SS men who suspected a village of harbouring a resistance-fighter often lined up all the men in front of machine-guns, with all the women facing them. The women were then told to identify the resistance-fighter; otherwise all the

16. The locus classicus, here, is of course von Neumann and Morgenstern *1944*, pp. 1 and 17f.

men would be machine-gunned. It seems that this method always worked. The women were in a single-exit situation. If the resistance-fighter was not identified he would still be killed and all their menfolk as well. The label "conquered by Fortune" seems fitting for people rationally obliged by external circumstances to behave in such a way.

According to orthodox decision theory, an agent's problem-situation is a product of external circumstances and internal factors, the latter being the agent's utilities (values, preferences). No other personal factors are allowed, except under conditions of uncertainty when subjective probabilities are admitted. When the perfect knowledge assumption is satisfied, with all decisions allowed by external circumstances listed and their expected utilities calculated, then the problem-situation is *given* and so too is its solution. Only calculation is needed.

Critical rationalism agrees that some problem-situations are indeed given; but it says that in other cases there may be no heuristic path to a good solution from a knowledge of one's practical problem-situation. Practical problems may be analogous in this respect to theoretical problems. In these cases it is not that the 'perfect knowledge' assumption could have been but was not satisfied; rather, the 'perfect knowledge' assumption did not apply. A problem-situation may be indeterminate in that a resourceful and inventive agent might discover unobvious possibilities in it that other agents would not have noticed. A decision theorist might reply that if agent X notices possibilities that an agent Y would have overlooked, that only means that Y's situational knowledge would have been defective. Let us examine this in relation to an example.

It is the summer of 1940 and a group of British prisoners-of-war is being marched along a French country road. A lorry with a manned machine-gun brings up the rear of the column, and there is a motorcycle patrol. It looks as though their situation is given, and that it has a "single-exit" character; other things being equal (none of them has suicidal tendencies, will go berserk or have a heart attack . . .) they will proceed as their captors intend and end up in a German PoW camp, conquered by Fortune. But one of them does not accept his situation as given. Wing-Commander Basil Embry, who had been the pilot of a Blenheim bomber when he was shot down over northern France, is now

thinking up possibilities of escape.[17] He has noticed that a ditch
runs beside the road, and he forms the following plan. After the
next halt, he will take up a position on the side of the column
next to the ditch, partially hidden from the guards by taller men
around him; a colonel will watch the guard on the lorry, telling
Embry when he is looking away, while Embry watches the other
guard. When both guards are looking away, Embry will make a
headlong dive into the ditch (he had been a rugger player and was
good at diving tackles). The plan worked.

Might we say that Embry was in a given problem-situation but
a multi-exit one? Well, it is always possible after the event to treat
the thinking up of something new as the first detection of some-
thing already there; and the ditch was already there, of course. But
was the ditch qua something-to-dive-into-and-hide-in already
there? It seems more realistic to say that Embry's thinking brought
a new possibility into existence. In any case, there can be no doubt
that in the long succession of ensuing problems that he con-
fronted, before he eventually reached England unconquered by
Fortune, it was often spur-of-the-moment inventiveness that saved
him. External problems come in various shapes and sizes. Some
are unprecedented and call for innovative thinking. Some are fast-
changing and call for rapid thinking. Some are crucial: make a mis-
take and disaster follows. Many of the problems he faced were
unprecedented and fast-moving and crucial. Here is an example.
Embry had slipped away from a farm house, leaving behind three
dead German soldiers (convinced that they had decided to kill
him, he killed them silently, one by one). And now, a few days
later, he has been arrested, and is being interrogated by SS intelli-
gence officers. His line is that he is an Irishman and a member of
the IRA; that he did good sabotage work in pre-War England
before getting caught, and gaoled. He then escaped, and got away
to Belgium. Then came the war, and the German invasion; he has
been driven south with the other refugees. At this point he is asked
what language he speaks in Ireland. Of foreign languages Embry
has only some schoolboy French and a little Urdu. He answers:
'Erse'. He is told to speak to them in Erse. He says: '*Burra-pag
jeldi karo*' and '*Dawazer bund karo!*' (Hindu-stani for 'Bring me a

17. His story is told in Anthony Richardson *1950*. Embry later became an Air Marshal.

large whisky and soda' and 'Shut the window.') He is next asked who is in charge of the Irish Army. '"Michael O'Leary," said Embry, making up the first name that came to mind. . . . He added that he thought everyone would have known that. Of course they knew it, the Intelligence Officer replied testily . . ., they'd wanted to know whether Embry did' (Richardson *1950*, p. 149). They let him go. In its more heroic versions "Conquer Fortune" is like "Transcend Fortune" in that both call for an ability to think up ideas and execute them skilfully, though the nature and urgency of the problems to be solved are different.

If one wanted a personification of "Conquer Fortune", Houdini would be a strong candidate. Put in our terminology, he regularly invited Fortune, for instance in the shape of prison officers, to try to conquer him. For example, he has his wrists manacled together, and then his ankles, after which the two sets of manacles are shackled together; he is then lifted into a wooden crate, empty but for some heavy weights, which is boarded up, long nails being hammered into the planks; the crate is then lowered into the Hudson river. Surely he will be conquered by Fortune? But in due course he is seen, safe and well, swimming vigorously.[18] As well as inventiveness, "Conquer Fortune" typically calls for qualities beyond the purview of philosophy, such as physical stamina and courage and perhaps athletic prowess.

In the examples of "Conquer Fortune" so far considered, the situation which seems to have X in its grip is sharply defined, time-wise. But many people are born into a state of what I called anonymous heteronomy, and a state of this kind may extend indefinitely in time, and to break out of it quite early on, as did for instance Charlie Chaplin,[19] Anton Chekhov,[20] and

18. The exploit of Houdini's that I like best took place in Washington D.C. in 1906. Eight of the top security prison cells in Murderers' Row were then occupied either by condemned murderers or by men charged with murder. Houdini had himself locked, naked after a strip search, in an unoccupied cell. He eventually reappeared with the eight prisoners still locked up, but all in different cells! We know rather little about the ideas that inspired Houdini's more astonishing feats, since he guarded his professional secrets well, though there are some revelations in Brandon *1993*. He was a true scholar of his craft, amassing a unique collection, now in the Library of Congress, of over 5,000 works on "magic" and related subjects.
19. When Chaplin was twelve his father died from drink; soon afterwards he had to shepherd his mother to an asylum. See Chaplin *1964*, pp. 68f.
20. Chekhov left school and became homeless when his father, who regularly beat him, went bankrupt. See Troyat *1984*.

Michael Faraday,[21] is also to "Conquer Fortune" in a remarkable way.

§ 8.5 A Round-Up of Loose Ends

Free Will Our Third View can allow a modest role to free will. If I am undecided between *a* and *b*, either because I regard them as equally good or because I am uncertain which will turn out better, I will not perform well along the disonomy scale if I dither indecisively; my will should serve as a tie-breaker without undue delay. And something like free will can play a more interesting role than the resolving of Buridan's Ass situations. In § 5.7 above it was mentioned that it may be important to keep one's opponent guessing by injecting some randomness into one's behaviour; something like Epicurean swerves may be called for. A view that makes free will the be-all of human freedom, as Descartes's did, is of course wide open to Spinoza's riposte that one believes one's will to be free only because one is ignorant of its causal determination (*E*, IIIP2S, II/143). And if in a particular case an outside observer could go on to point out a determining cause, the claim that this agent acted freely in a Cartesian sense would have been debunked. But a view that allows free will as a source of proteanism is not open to that kind of debunking. If you have adopted a strategy which calls for some tactical randomness, you may try to generate this internally, or you may rely on some randomizing device. Suppose you do the latter. Then an onlooker could truly say that your seemingly free choices are being determined by external factors (coin tossing, dice rattling, or whatever). So what? Provided your opponent is not privy to the instructions your randomizing device is giving you, you are acting no less rationally than you would have been if you had been generating the choices internally.

But our Third View's main concern is not with single acts driven by single volitions, but with cases where a sustained course is driven by ideas some of which are novel. Nagel has denied that an account of freedom can be given that is compatible with an objec-

21. Faraday, who had virtually no elementary education, started as an errand boy. See L. P. Williams *1965*.

tive or external view of ourselves; when we consider our actions 'simply as part of the course of events in a world that contains us among other creatures and things, it begins to look as though we never really contribute anything' (*1986*, p. 113). Well, there's got to be something wrong with a view that makes it look as though Michelangelo, Beethoven, . . . never really contributed anything. If an "objective" view misses out on the decisive factors, here, namely the ideas these men brought to their tasks, it must be discarded as inadequate. Anyone who retorts that the execution of their tasks owed nothing to the ideas and everything to their causally determined physical correlates, is referred to the objections epitomized in Chapter 3 by 'Whence the pre-established harmony?' and 'How did Spinoza's fingers do it?'.

Dictators How does our Third View appraise the freedom of great dictators? Kant would have had no problem here; if morality is constitutive of autonomy, then these men, the maxims of whose acts are for the most part the opposite of what the categorical imperative requires, are in a state of heteronomy *period*. But the upshot of our brief examination of Kant's moral philosophy in § 6.3 above was that morality cannot be constitutive of autonomy, it can only constrain what more or less autonomous people do. Our Third View does not say that exemplars of "Transcend Fortune" are licensed to transcend morality; no moral exemptions are claimed for authors of alpha-events. Their protective bubbles are supposed to be transparent and we may hope that they would be jerked out of their "world" by a cry for help no less than by a smell of burning. But it has to be admitted that they may, as a matter of fact, be too absorbed when at work within their "world" to give much attention to ordinary moral requirements; it may be as if they had put up a 'Do Not Disturb' sign.[22] Paul Gaugin symbolizes the conflict that may exist between morality and unusually autonomous activity; his repudiation of his bourgeois existence left a wife and four children unprovided for.

22. As Margaret Boden remarked, 'People who live a normal life, filled with diverse activities largely prompted by other people's priorities (employers, spouses, babies, parents, friends), cannot devote themselves whole-heartedly to the creative quest' (*1990*, p. 258). Cyril Conolly famously declared: 'There is no more sombre enemy of good art than the pram in the hall.'

Rather as a scene of evil-doing may exhibit a sinister kind of beauty, may not a dictator engaged in evil-doing on a massive scale exhibit a sinister kind of autonomy?

It must be conceded that great dictators perform very well, at least in their heyday, along two of our three freedom-scales, the ones for external-heteronomy and for disonomy. No one accuses them of allowing themselves to be pushed around by other people, or of being lazy or timid. But how do they perform on the internal-heteronomy scale? It was suggested in § 8.1 above that someone engaged on an alpha-event involving new ideas and an ontological enrichment of our human world, gets about as far from its zero as it is humanly possible to get. How do dictators perform on this scale?

Since there are names I prefer to pass over, I will take Christopher Marlowe's "Tamburlaine" as a stand-in for the real men. Marlowe had a poetic insight into the kind of thinking that seems to fuel the vaulting ambition of such men. Although his play may well misrepresent the historical Tamerlane, I will proceed as if it were a true historical record. Marlowe's Tamburlaine dreams, not of not being conquered by Fortune, but of conquering Fortune and bending it to his will. Early in the play he encounters a group of Persian horsemen sent to capture him, and he addresses their leader, Theridamas, thus:

> Forsake thy king, and do but join with me,
> And we will triumph over all the world;
> I hold the Fates bound fast in iron chains,
> And with my hand turn Fortune's wheel about:
> And sooner shall the sun fall from his sphere
> Than Tamburlaine be slain or overcome. (I, 1, ii)

It seems that this is not just skilful propaganda designed to win over a suggestible Theridamas, but that Tamburlaine believes this dream of omnipotence. From a critical rationalist point of view it is of course a mad dream; but for a time his unbroken run of victories lends it an air of verisimilitude. But this cannot last. He falls ill. And now a paranoiac unrealism manifests itself. That *he* is mortal he refuses to accept: 'Sickness or death can never conquer me' (II, V, i). When his condition worsens, he concludes

that the gods have grown envious of him and are trying to do him down; so he declares war on them (without explaining how he will wage it).

What sort of triumph over all the world did he envisage? The answer becomes increasingly clear: he would turn the world into a vast wasteland. On one occasion he promises to

Conquer, sack and utterly consume
Your cities and your golden palaces. (II, IV, ii)

On another occasion he issues the order

. . . drown them all, man, woman and child
Leave not a Babylonian in the town. (II, V, I)

To his sons he cries:

Be all a scourge and terror to the world
Or else you are not sons of Tamburlaine. (II, I, iii)

So where Transcend Fortune at its best involves ontological enrichment, if only locally and on a small-scale, of our world, Tamburlaine's ideal was ontological impoverishment on a global scale. Purged of its unrealism, Tamburlaine's speech to Theridamas might have gone like this:

Forsake thy king, and do but join with me,
And we will leave ever so many people dead,
And ever so much earth scorched,
Before we get our comeuppance.

The suggestion in § 8.1 above that we can generally expect a fairly good correlation between an individual's performances along our three freedom-scales was accompanied by the rider that there are exceptions. Great Dictators provide an example.

Freedom under Adversity Let us now turn from dictators to their victims. Can our Third View provide any substitute for Spinoza's thesis, examined in § 7.4 above, that you can rise above a bad situation through reason alone? If you are low down on the

external-heteronomy scale, a rational understanding of your situation by itself cannot improve your position on *that* scale. It might open up new opportunities of escape; but to pursue that line of thought would carry us back to "Conquer Fortune". Let us restrict the present discussion to cases where Fortune has one in a grip from which reason could reveal no escape.

The initial effect on innocent people of being arrested under a terror regime seems typically to be one of incredulity and disorientation. Later, when they become more familiarized with a situation which, they learn, has many other innocent victims in its grip, they are likely to want a rational understanding, not just of their own individual plight, but of the whole crazy situation. The authors of a book on the Stalinist Purges of which they were victims, reported that no question excited prisoners so much as 'Why? What for?'; they identified as many as seventeen different hypotheses which were 'tirelessly discussed'.[23] There is also, typically, a desire to preserve as much of the truth about it as one can. And quite a few involuntary students of the cruel ways of dictatorships have written very revealingly about them. Thus Margarete Buber-Neumann (*1949*) described two successive experiences, under Russian Communism in the 1930s and then under German Nazism. Eugenia Ginzburg (*1967*) described an ordeal under Russian Communism from 1937 to 1955. Paul Ignotus (*1959*), Gyorgy Paloczi-Horvath (*1959*), Edith Bone (*1966*), and Bela Szasz (*1971*) described experiences under Hungarian Communism. All these people had an unwavering resolve to discover, preserve and, if possible, eventually publish the truth about the crazy system which had them in its grip. The difficulties that a lone anthropologist in darkest Africa might face are trifling compared to what these people faced. Merely to preserve a historically accurate personal record with nothing to write with or on was a major feat. For instance, Paul Ignotus put facts into doggerel verse as a way of committing them to memory.[24]

In what follows I will concentrate on just one member of this remarkable band, namely Alex Weissberg. He was born in Cracow in 1901, of Jewish extraction. He became a physicist, and a

23. Beck and Grodin (these names are pseudonyms) *1951*, pp. 182–83.
24. Personal communication.

Communist. In 1931 he left Vienna to take up an important position in the prestigious Ukrainian Physical Technical Institute in Kharkov. In March 1937 he was caught up in the Great Purge. In January 1940, as a consequence of the Soviet-Nazi Pact, the GPU handed him over to the Gestapo. He was released into the Cracow ghetto. He went underground, but was caught and sent to a concentration camp. From then on he exemplified "Conquer Fortune". He escaped (!) from the camp and reached Warsaw, where he took part in both (!) uprisings. And he survived (!) (his wife, father, and brothers all perished). However the present discussion will be restricted to the period, recounted in his classic *Conspiracy of Silence* (1952), as a political prisoner in Kharkov, Kiev, and Moscow, a period in which physical escape was out of the question.

In the early days of his solitary confinement Weissberg was mentally numbed and disorientated. Like virtually all the other prisoners, he was entirely innocent of the preposterous charges on which he had been arrested; and he was now required to concoct a "confession" which would implicate further innocent people. The system for extracting "confessions" was labour intensive: a prisoner on the "conveyor" was subject to non-stop interrogation night and day, requiring the full-time attention of three GPU men. Hardly any prisoners could withstand this for long.[25] But Weissberg was beginning to learn the ropes. He would eventually break down and volunteer to write out a confession. Later, strengthened by the respite, he would withdraw it. This happened three times, after which the GPU gave up trying to get the "confession" they wanted from him.

He came to see his situation as a local part of a massive explanandum. He perhaps differed from other prisoners who were asking 'Why? What for?' in seeking to determine not only the nature but the magnitude of the phenomenon to be explained. He arrived at a remarkably good quantitative estimate. Helped by the numbered receipts that newly arrived prisoners were given for the possessions of which they were stripped, his final estimate of the overall number of political arrests during the Great Purge was

25. See Conquest *1968*, p. 144. Weissberg reported the case of a fanatical anarchist who survived 31 continuous days and nights on the "conveyor", *1952*, p. 388.

about 5.5% of the population, or a total of about eight million (p. 320). This estimate has stood up well.[26]

As to 'Why? What for?': when he was arrested Weissberg was doing work of value to the Soviet Union, as were the many scientists, doctors, engineers, Red Army officers . . . who were also arrested. Why this weakening of the State, and at a time when it faced a serious threat from Nazi Germany? Weissberg's approach was that of a methodological individualist; he analysed the situations of the individuals involved, especially the GPU men. Why did those who were servicing this crazy system behave as they did? Compared with an academic anthropologist investigating an alien cult from the outside, he did have certain advantages to offset such disadvantages as near-starvation and not being able to make notes;[27] these included a limited degree of privileged access to inside sources when GPU men themselves started getting arrested.[28]

He saw that the system had tremendous positive feedback built into it. For their part, interrogators were keen to display above-average productivity; and when their resistance eventually collapsed, innocent victims tended to implicate several more innocent persons from their own social milieu; thus the arrest at an early stage of a doctor, for example, would probably lead to several further arrests of doctors, and each of these later arrests would probably lead to arrests of still more doctors, and so on. Weissberg probably understood the unplanned dynamics of the Great Purge better than many of those on the other side.

What does our Third View have to say about his attainment of a good scientific understanding of the heteronomous situation in which he and several million others were trapped? This understanding of it did not bring his release any closer or improve his physical condition in any way. His position on the external-heteronomy scale remained appallingly low. But with respect to internal heteronomy it was otherwise. His mind, far from being

26. Beck and Grodin put the percentage at not less than 5% (*1951*, pp. 66–67); Conquest put the total at 7–9 million arrests (*1968*, p. 527).

27. He wrote of a time when he was one of 30 prisoners on hunger strike: 'Somehow I felt that one day I should get out of the clutches of the G.P.U. and be able to tell my fellow men abroad just what was happening in Soviet Russia. I repeated the names of these twenty-nine men in the same order perhaps a hundred times' (*1952*, p. 382); but he subsequently forgot all but one of them.

28. See for example his long "interrogation" of an ex-interrogator, *1952*, pp. 400–06.

infiltrated by would-be controllers, displayed a marvellous intellectual independence. Intellectually, he rose above the system which was imprisoning his bodily existence. It was as if, once he was over the initial shock of finding himself in hell, he had made *Sapere aude!* his motto and the workings of hell his explanandum, and had in due course come up with a remarkably good explanans for it. This finding complements the earlier finding about great dictators. While doing unusually well, for a time at least, with respect to external heteronomy, dictators do poorly with respect to internal heteronomy. Some of their victims, while doing poorly with respect to external heteronomy, do unusually well with respect to internal heteronomy.

Beta-Plus Achievements Only a privileged few pull off alpha-events. Let us now lower our gaze somewhat and turn to what may be called beta-plus achievements which lack some of the distinguishing characters of alpha achievements but have much the same structure, involving a degree of transcendence. Perhaps the simplest relaxation is to drop unprecedentedness. Boden calls an idea P-creative if it is 'fundamentally novel with respect to *the individual mind* that had the idea', and H-creative if, in addition, no one in the whole of human history had had it before (*1990*, pp. 32f). So an event that is P-creative but not H-creative would be an example of a beta-plus event. Ramanujan, the untaught mathematical genius from Madras whom Hardy brought to Cambridge, had sent Hardy an untidy manuscript containing numerous mathematical discoveries of his. Many of these had in fact already been discovered; according to Hardy he 'rediscovered an astonishing number of the most beautiful analytic identities', such as Riemann's Zeta function and Poisson's summation formula.[29] With these he was not H-creative. For a historian of mathematics it of course makes an enormous difference whether an important discovery, arrived at quite independently by mathematician X, merits a certificate of H-creativity. And it may be something of a tragedy for X if it turns out afterwards that essentially the same result had already been obtained by mathematician Y. But if the prior discovery had no influence, direct or indirect,

29. Hardy *1940*, p. 14; and see Snow 1967, pp. 30f.

on X's discovery, it makes not a jot of difference to the latter considered as a personal achievement; this exhibits exactly the same transcendence as it would have done if it had been H-creative. And this would remain the case if not just one but many people had anticipated X's discovery. All this applies mutatis mutandis to discoveries in cooking, the inventions by our forefathers of tools and weapons, and so on. In § 5.3 above it was suggested that Chomsky was right to say that 'the language is "reinvented" each time it is learned'; so that each small child exhibits P-creativity in acquiring a first language.

The objection was raised against Spinoza that what he saw as the highest kind of thinking, and as constituting "Transcend Fortune", brings nothing into existence beyond itself. By contrast, alpha-events issue in a new, publicly existing durable product. It is this which justifies the claim that "Transcend Fortune" results in the ontological enrichment of our world. But we can sympathize with Schlick's contention that 'it is quite inessential to the concept of artistic creation that it should give rise to *enduring* works'; if 'Beethoven had played a sonata just once to himself, and it had never been written down', we would not have to deny that this once-only achievement was an artistic creation (1909, p. 9). This suggests another rather simple relaxation of the idea of an alpha-event: retain the idea that the thinking should issue in something beyond itself, but allow this to be something transient. We might speak in this connection of *throw-away creativity*. A product of throw-away creativity may happen to get picked up and preserved. An unrehearsed conversational exchange with flashes of wit and repartee would still exhibit throw-away creativity even if it happened to be recorded on tape. I once saw a film about Picasso in which, walking along a beach, he came across some sea-wrack; he stopped, stared at it intently, made a couple of swift adjustments, and then walked on, leaving behind a stunning piece of statuary. The fact that it was recorded on film does not stop this being a product of throw-away creativity. (Conversely, that a product of creativity happens to get thrown away, as happened to Thomas Carlyle's French Revolution manuscript when he lent it to Mill,[30] does not turn it into throw-away creativity!) People who engage in throw-away creativity thereby raise them-

30. See Mill, *Works*, xii, p. 252.

selves, if rather causally, above their local circumstances.

Humour Humour, which often exemplifies throw-away creativity, has a place in our Third View. It seems to be something distinctively human. Some animals possess something like the smiles and laughter that go with high spirits and playfulness (see Darwin *Expression*, pp. 196f). But there seem to be no counterpart among them to our chuckling, and occasionally bursting into laughter, over a joke. I have found an unexpected confirmation for this. As we saw in § 4.2, Darwin's *Descent* is pervaded by a continuity-thesis according to which virtually every feature of human mentality already appears, if only in a rudimentary form, in the higher vertebrates. It would have fitted in very well with this thesis if he could have pointed to some rudimentary kind of pre-human humour. The second edition of that book, in 1874, has a very thorough index, running to 77 pages, and I have combed it carefully for entries in this connection. I found just one. There are no entries for "Comic", "Funny", "Jokes", "Laughter", or "Wit", but under "Humour" I found the following: 'sense of, in dogs, 743'. I turned eagerly to page 743, but there Darwin is dealing with the brilliant plumage of certain male birds; there is nothing about either dogs or humour. Under 'Dogs' there is a long entry, with references to their memory, reasoning faculties, moral qualities, quasi-religious feelings, sympathy, and conscience; but there is no reference to their humour. I began to wonder whether that reference was a joke.

Humour also keeps us apart from computers. In his story 'The Ordeal of Mr Mathews' (*1963*, i, pp. 424-29) James Thurber tells how at a party he (Thurber) and a Mr Mathews get stuck together, away from the other guests. Thurber is in cracking form; witticisms pour from him. But they pass Mr Mathews by; when told Disraeli's response to a lady who asked what the difference is between a misfortune and a calamity (namely, 'If Mr Gladstone were to fall into the Thames it would be a misfortune. If someone pulled him out it would be a calamity'), he comments: 'Great deal of bickering among the English in those days.' Thurber's performance peaks with a story about a publisher who, he says, 'had hit on the idea of having me do new illustrations for "Alice in Wonderland." I said, "let's keep the Tenniel drawings and I'll rewrite the story".' Mr Mathews comments: 'Fellow

thought you were an artist instead of a writer, eh?'. Fed with a transcript of Thurber's words at this party, a computer would presumably do no better than Mr Mathews did; there are no tell-tale signs, which a computer could be programmed to detect, marking out humorous passages. But suppose there were, and that a computer could search documents signalling 'This is funny' when it found them. This computer would now be behaving, not like Mr Mathews, but like the German philosopher who, after inspecting a spoof issue of *Mind* called *Mind!*, solemnly pronounced that the advertisements in it are funny; it was not that he found them funny, but he inferred that they must be since everything else is (Russell tells this story somewhere).

A word now about humour under adversity. Insofar as the adversity has an internal source, we can agree with Richard Gregory: 'Humour is the supreme therapy for maintaining and restoring sanity' (*1986*, pp. 10–11). When Fortune has taken a bad turn from which there is no extricating yourself, jokes may help to preserve a certain inward autonomy. A certain humorous insouciance may be similar in that respect to scientific curiosity. My favourite example of this is the reply by Disraeli, during his last illness about whose outcome he was under no illusion (Blake *1966*, p. 747), on being told that Queen Victoria had inquired about the possibility of visit: 'Better not; she would only ask me to take a message to Albert'. His mind was not being conquered by Fortune.

Summary The first view of human freedom we considered was associated with classical empiricism which sponsored a levelling view, seeing animal and human cognizing as a passive process in which the mind is instructed by experience to form expectations about the world. When combined with determinism, as it was by Hobbes and Hume, this view left no room for spontaneity or inventiveness; it had human beings, like other animals, being nudged along by causal processes, never originating anything. The second view was associated with classical rationalism. This says that while part of the human mind is as classical empiricism says it is, there is another, higher part: human beings are unique in possessing, as well as a sensory apparatus, an intellectual faculty that enables them to understand the world in a privileged, apriori way; and when they do so, their minds are no longer passive and

conditioned, but active and unerring. And it equated human free-
dom with the employment of this special faculty. But when we
asked classical rationalists what a free man actually *does*, we got a
dusty answer. Spinoza and Kant were famous determinists, and
according to their determinism the outward behaviour of a free
man, no less than that of an unfree man, proceeds down a causally
predetermined route. Then what does a free man's pure rational
thinking achieve? Although the answers given by these two men
are somewhat different, they could be summarized as saying that
it achieves an ascent (I nearly said 'retreat') to a "higher" plane
where one loves God (Spinoza) or reverences the moral law
(Kant). So far as outward behaviour is concerned, reason is 'flap-
ping its wings impotently', Kant's disclaimers notwithstanding.

Critical rationalism repudiates both classical empiricism's sen-
sationalism and classical rationalism's intellectualism. Human
thinking at its best is essentially different from the accounts given
of it by these two philosophies. For one thing, it is inventive, as is
shown by the astonishing upsurge of science during the last four
centuries, with theories that typically far transcend the empirical
basis in their scope, precision, and theoretical ontology. And for
another, it remains fallible, as is shown by the successive over-
throws of earlier theories during the growth of science. And of
course scientific thinking has great efficacy, as its more remarkable
technological exploitations show. We saw that classical determin-
ism had a deadly influence on the philosophies of freedom of
Schopenhauer, Kant, and Spinoza. The indeterminism sponsored
by critical rationalism does not depend on the ontological chance
introduced by modern microphysics; it could survive the disap-
pearance of that. Rather, it involves the important middle possi-
bility between chance and necessity opened up by the
combination of newly invented scientific theories and their tech-
nological exploitations. In those cases the coalition of an inventive
mind and deft fingers may involve many people, whereas in the
arts analogous coalitions typically occur within the same person.

I daresay that this Third View of human freedom will be
accused of elitism. For it is indeed discriminating. It says that one
has a low degree of freedom if one is bogged down in otherness,
thinking stale thoughts, or trapped in some lying ideology, and
that one's freedom improves the more one succeeds, by dint of an
inventiveness that one keeps under critical control, in transcend-

ing otherness and making a way of one's own that leaves the world a little richer than it would otherwise have been. But although discriminating it is not "elitist" in the sense of envisaging an aristocracy of free individuals. It does not grade individuals as such, but the various states which individuals may be in, often only temporarily. It allows that an individual might briefly rise high, whether in a "Transcend Fortune" or a "Conquer Fortune" way, and then sink into a badly heteronomous condition. Insofar as it is elitist, it is so with respect, not to the people themselves, but to the ideas that, from time to time, are guiding what they do and the skill with which they are being executed.

Epilogue
Mind and Body

The philosophy of mind that runs through the book is loud and clear. It says that consciousness (i) *exists* and (ii) *does something* with respect to bodily performance. The traditional name for this position is *dualist interactionism*. However, 'dualism' should here be read as saying that there are *at least* two categories, for important roles have been given in this book to factors that do not fit into either of Descartes's. For instance, the L-factor has a meta-conscious character, and the I-factor seems to do its most vital work hidden from consciousness. Not much attention has been given to Popper's "World 3", but that human thinking can produce objective entities that partially transcend its grasp was illustrated when ancestors of ours were pictured (at the end of § 5.6 above) counting only to ten but unwittingly letting in an infinity of natural numbers. At a less lofty level, I also accept, as entities that do not fall into one or the other category cocktail parties (Searle *1992*, p. 60), and the cache of old love letters in desk A above. But it will help keep the issue sharp if, for the present, we focus on just a dualism of brain processes and conscious processes.

In olden times there was a presumption that processes require a substance to proceed in; thus temperature changes require a caloric substance and light waves require an ether as sound waves require air to undulate in. But that presumption was discarded, and our ability to think and feel and perceive will here be assumed to require a mental substance no more than light requires an

ether. The Cartesian idea of a mental substance is in any case at odds with the naturalistic world-view developed in Part One, especially with its *No mind without brain* component.

I mentioned earlier that when Spinoza was wearing his "Conquer Fortune" hat he seemed to lapse into Cartesian interactionism, and that the latter is the classical mind-body position that chimes in best with the agency-assumption of common sense. Since Descartes it has also become the philosophy of mind most decried by philosophers. My claim will not be that dualist interactionism, shorn of substances and set within an evolutionist perspective, is a good philosophy of mind, only that the alternatives to it are worse. At the present time philosophizing in this area is often highly esoteric, but the underlying problem-situation is starkly simple: consciousness exists and seems to have some efficacy over the flesh-and-blood creature that embodies it; but is it not impossible that something immaterial can affect something material? Geoffrey Warnock put it succinctly: the mind-body problem arises because mind-body interaction is at once undeniable *and* incredible (1979). Philosophers who accept dualist interactionism as undeniable are greatly outnumbered by those who reject it as incredible. (There are also those who declaim against it on Sundays and go along with it on weekdays.) The first part of this Epilogue will be directed against those who seek to avoid the first horn. Its conclusion will be that attempts to deny, hush up, or otherwise skirt round seemingly undeniable facts relating to consciousness are up against something too integral to the drama of human existence to be written out of it. The second part will examine the other horn. Its conclusion will be that the main reason, historically, for finding these seemingly undeniable facts incredible is not a good one and that no good one has taken its place.

But first I will propose some *Don'ts* which should be observed by anyone philosophizing in this area. The first is a moral one. (1) *Don't* be cowed by philosophical correctness. Searle has spoken of a prevailing 'terror of consciousness' (*1992*, p. 55). Dennett seems to have appointed himself a guardian of this kind of philosophical correctness, laying down that 'dualism is to be avoided *at all costs*' (*1991*, p. 37, his italics)—which implies that you are still to avoid it however much you may fear that it is true. Philosophical correctness with respect to dualism is not confined to

philosophers; it is also strong in medical schools, for instance. But of Snow's two cultures (*1961*), the "literary" one is sunk in Folk Psychology. As Peter Strawson famously remarked, Folk Psychology contains

> the ordinary explanatory terms employed by diarists, novelists, biographers, historians, journalists, and gossips, when they deliver their accounts of human behaviour and human experience—the terms employed by such simple folk as Shakespeare, Tolstoy, Proust and Henry James. (*1985*, p. 56)

And many of the giants within the "scientific" culture have respected Folk Psychology. (We earlier found Einstein denying that physics could make a takeover bid for the time of everyday experience.) But in philosophy the dominant idea seems to be that dualism is for priests and other peddlers of comforting myth and is a *trahison des clercs* for would-be members of a science-oriented republic of learning. It is a sign of the times that David Chalmers's *1996* caused such a stir; he boldly affirmed (i) above: consciousness exists! But he denied (ii); he accepts the causal closure of the physical (p. 170); consciousness can't do anything. It is as if, starting out from Hobbes's materialism, we had got as far as Huxley's epiphenomenalism.

(2) *Don't* try to eat your cake and have it too; alternatively: *Don't* give with one hand and take back with the other. Earlier we encountered infringements of this *Don't* by Schopenhauer and Schlick. Here I will mention one rather striking one by Monod. After referring to Descartes, he continued: 'Objective analysis obliges us to see that this seeming duality within us is an illusion; but an illusion so deeply rooted in our being, that it would be vain to hope ever to dissipate it' (*1970*, p. 148). Let p be the proposition that we are dualistic creatures; then Monod seems to be saying that p is false (grounded in illusion), but will have to be retained (it is an illusion from which we cannot free ourselves). Perhaps Monod had in mind the example of optical illusions: aren't they things from which we cannot free ourselves even when we know they're illusory?

FIGURE E.1

When we look at the famous Muller-Lyer figure we see line *a* as distinctly longer than line *b*. If we now measure them and find that they are of equal length, we still see them as unequal. However, there is no paradox here; we can discard what is false and retain what is true. The statement '*a* appears longer than *b*' is true and should be retained and the statement '*a* is longer than *b*' is false and should be discarded. If a soldier who has lost his right leg has painful "ghost limb" experiences, then the statement 'His right foot is causing him pain' is false while the statement 'It feels to him as if his right foot is still there and causing him pain' is true. And if Monod was right (as no doubt he was) about our seeming duality, then a statement to the effect that we seem to be dualistic creatures is true. Whether monists can show that although we seem to be we are not really dualistic creatures is another question.

(3) *Don't* talk in a third-person way about an unfamiliar something and then say that *that*'s what consciousness is (though it may be in order for you to say that it is what gives rise to consciousness). As Searle put it: 'The ultimate absurdity is to try to treat consciousness itself independently of consciousness' (*1992*, p. 20). There are sentences in Roger Penrose's *1994*, whose subtitle is 'A Search for the Missing Science of Consciousness', which appear to infringe this *Don't*, for instance: 'On the view that I am tentatively putting forward, consciousness would be some manifestation of this quantum-entangled internal cytoskeletal state and of its involvement in the interplay (OR) between quantum and classical levels of activity' (p. 376). And there is a blatant infringement in Dennett's *Consciousness Explained* (1991). More than half way through this long book, and after a lengthy discussion of what he calls "von Neumannesque" or "Joycean" machines, there is a section entitled 'But is this a theory of consciousness?' in which he writes:

I have been coy about consciousness up to now. I have carefully avoided telling you what my theory says that consciousness is. I haven't declared that anything instantiating a Joycean machine is conscious and I haven't declared that any particular state of such a virtual machine is a conscious state . . .

. . . at last it is time to grasp the nettle, and confront consciousness itself, the whole marvelous mystery. And so I hereby declare that YES, my theory is a theory of consciousness. Anyone or anything that has such a virtual machine as its control system is conscious in the fullest sense, and is conscious *because* it has such a virtual machine. (p. 281)

So now you know what happens when you wake up: it's one of these virtual machines starting up. Dennett didn't say whether a Joycean machine can feel embarrassment or see jokes.

(4) *Don't* prop up your philosophy of mind with declarations about an *x* that is beyond our, and your, ken. Nowadays, *x* is usually the future course of science. In earlier times *x* was usually God; and some supposedly tough-minded current positions are descendants from a theological position which becomes untenable when its theological support is withdrawn. When I remarked in Chapter 3 that the 'How did Spinoza's fingers do it?' problem disappears when divinity is called upon to supervise the process, it would have been more historical to say that the problem appeared when divinity was left out. Let m_i be Spinoza having a certain thought and b_i be his writing it down; and let m_j be him later becoming dissatisfied with what he has written and b_j be him crossing it out. The common-sense view of what was happening might be pictured, rather crudely, thus:

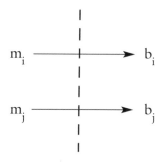

FIGURE E.2

What response might we expect from a seventeenth-century philosopher who does believe that God exsists and does not believe that mind can bring about movements in the body? Well, that description fits Geulincx whose response may be crudely represented thus:

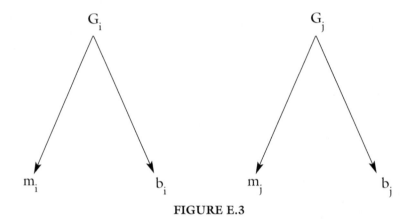

FIGURE E.3

Occasionalism says that on each occasion of a seeming mind-body interaction there is divine co-ordination. To a tidy theological mind, these ad hoc acts of divinity are crying out to be unified in some way. One way, of course, was Leibniz's: God at the creation pre-established a once-and-for-all harmony that will go on unfolding indefinitely. But since we are talking about his fingers, let us consider Spinoza's way, which may be crudely represented thus:

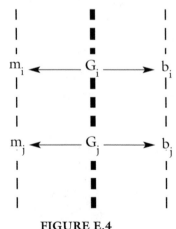

FIGURE E.4

For epiphenomenalists and others who agree with Geulincx that mind cannot bring about movements in the body because they accept the closure of the physical (as for instance does Kim *1998*, pp. 229f), and discard any such central co-ordinating pillar, the co-incidence between Spinoza's thoughts and his fingers become inexplicable.

This need for divine harmonization remains if the bodily changes are replaced by mental representations. Idealism is another position that collapses when theological support is withdrawn. It needs, as it got from Leibniz and Berkeley, a divine co-ordinator to pre-establish harmony between private theatres. This need disappears when idealism collapse into the single-ego doctrine of solipsism; but solipsism requires this ego to assume a quasi-godlike creativity.[1] One wonders whether Mrs. Christine Ladd Franklin noticed that her position required her to compose all the books she read and plays she went to and music she heard, and to create her mother and father and the other people in her life, including Bertrand Russell.

But as I said, nowadays infringements of the present *Don't* usually invoke the future course of science. We will encounter several such infringements below. I may perhaps mention that this *Don't* was not infringed when the ultimate physical theory (UPT) was invoked earlier in this book; the argument never depended on the actual arrival of UPT. Nor did it depend on UPT having a content that would underwrite the position being argued for. On the contrary, when it was used in the argument for indeterminism in Chapter 3, UPT was assumed for argument's sake to be deterministic.

I now turn to anti-dualist philosophies of mind that have been popular in post-war Anglo-American philosophy. They will be

1. Alan Musgrave sent me a poem by Sylvia Plath entitled 'Soliloquy of the Solipsist'. The last verse reads:

I
Know you appear
Vivid at my side,
Denying you sprang out of my head,
claiming you feel
Love fiery enough to prove flesh real
Though it is quite clear
All your beauty, all your wit, is a gift, my dear,
From me.

taken in a quasi-logical rather than a temporal order, starting with the one in the most far-reaching disagreement with dualist inter-actionism, namely eliminative materialism, and ending with one that disagrees with it least, namely Rylean behaviourism.

Eliminative materialism It was mentioned in connection with Spinoza's equation of God and Nature that very different claims may be being made when it is claimed of two seemingly distinct things, *a* and *b*, with seemingly contrasting natures, that they are one and the same thing, or that *a* = *b*. (When geometry text-books speak of two numerically distinct triangles, *a* and *b*, being "identical" they should say *congruent*, to be written '*a* + *b*'.) Such an identity claim always entails that for any property f, *a* is f if and only if *b* is f; but by itself it does not say how the hitherto received concepts of *a* and *b* are to be revised. Let F and G stand, respectively, for all the positive properties that the received con-cepts had imputed to *a* and to *b*, and suppose that they also imputed not-G to *a* and not-F to *b*; so *a* and *b* were conceived to be as unlike each other as they could be. The claim that *a* = *b* would be maximumly reductionist if it reduced the concept of *a* to that of *b* which it left undisturbed, and maximumly ampliative if the concept of *a* retained F and gained G and conversely for *b*. Mind-brain identity theories of various stripes have been put forward.

Eliminative materialism may be seen as a maximumly reduc-tionist kind of identity theory. It says that nothing is done by con-sciousness for the same reason that nothing is done by phlogiston: there is no such stuff. Here is Paul Churchland's admirably unequivocal statement of it: 'The bald statement of eliminative materialism is that the familiar mental states do not really exist' (*1984*, p. 48). Our supposed mentality is illusory; we are really material creatures through and through. Eliminative materialism does not infringe our second *Don't* (it says, in effect, that there is no cake) nor the third (it does not say of an unfamiliar something that *that* is what consciousness is). But it does infringe our fourth *Don't*. It calls in aid something which none of us can know about, namely future developments in science; it says that the neuro-sciences are going to reveal at some future date that the concepts of Folk Psychology, such as belief, desire, fear, pain, and joy, are like the concepts of caloric and phlogiston in denoting nothing.

(Richard Rorty had previously infringed this *Don't*: 'Just as we now want to deny that there are demons, *future science* [my italics] may want to deny that there are sensations', 1965, p. 179.)

Stephen Stich once commented on such eliminativist claims: 'even if the eliminativist can establish that the predicates of commonsense psychology denote nothing, this thesis is profoundly uninteresting' (1991, p. 241). How blasé can you get? Eliminativism is not something to nod over, whether in boredom or agreement. How would Stich respond if, on asking for a local anaesthetic during a visit to the dentist, he got the reply: 'Haven't you heard? It's been established that "pain" is a common-sense predicate that denotes nothing. We don't use anaesthetics any more.' If ever there was a target for Moore's rule, discussed in Chapter 2, that a speculative metaphysical proposition should be rejected if it conflicts with a common-sense proposition which we know with certainty to be true, this is it.

What answer could eliminative materialists (or radical behaviourists) give if asked whether patients should be given a general anaesthetic before undergoing major surgery? They might try something like: 'Yes; the anaesthetic has a tranquillizing effect which allows the surgeon to get on with the job.' That this answer will not do is shown by shocking incidents in which an "anaesthetic" leaves the patient completely paralyzed *and fully conscious* during the operation. I was startled to find an expert estimating that such incidents occur in about 200 (nearly 1%) of the operations in the UK each year; he reckons that in the 1950s and 1960s the rate had been as high as 3–5%.[2] C. S. Peirce had imagined a drug that would eliminate all subsequent memory of the suffering, however terrible it had been (*Papers*, 6.521). Dennett (*1978*, pp. 209f) imagined combining such a drug with curare which, by itself, induces total paralysis but no loss of consciousness. This mixture would score top marks for its tranquillizing effect, and for hospital administrators it would have the advantage over curare on its own that when patients "woke up", all would be forgotten. There would be no behavioural difference between a patient being operated on under it and under a

2. Dr Gareth Jones, Professor of Anaesthesia at Addenbrookes Hospital, Cambridge, as reported in *The Independent*, 4 August, 1994.

genuine anaesthetic, only the little psychological difference that the patient is in silent agony.

Churchland did not explain how "the familiar mental states" can be familiar and yet not exist. Presumably he regarded them as illusions, as appearances which do not correspond with reality. But with respect to illusions there is an asymmetry between eliminative materialism and eliminative idealism. As Searle put it: with respect to consciousness 'we cannot make the appearance-reality distinction because the appearance is the reality'.[3] To put it theologically, it is conceivable that God decided (perhaps on economy grounds) to create consciousness and only the illusion of matter; but it is not conceivable that God decided to create matter and only the illusion of consciousness. Without consciousness there could be no illusions.

Non-reductionist identity theories Let us now turn to the position that results when the claimed identity is not reductionist but ampliative, with each side gaining what had been regarded as properties belonging exclusively to the other side. It is sometimes supposed that the identity theory in this sense was invented in Australia in the late 1950s by U. T. Place and J. J. C. Smart, soon to be joined by Armstrong.[4] In fact, it had already been formulated in the 1st century B.C. by Lucretius (*Rerum*, bk iii). His argument was very simple:

Premise 1: There is two-way interaction between mind and body.

Premise 2: Body can be moved only by body.

Conclusion: The nature of mind is bodily.

Essentially this argument reappears in David Lewis's 1966: experiences have physical effects; but 'physical phenomena have none but purely physical explanations' (p. 99); therefore experiences must be physical states.

Astronomers made an ampliative identification when they put the identity sign between 'the Morning Star' and 'the Evening

3. *1992*, p. 122, italicized in the original.
4. See for example Place 1956, 1960; Smart 1959, 1961; Armstrong 1965, *1968*, chap. 17.

Star'. These two denoting phrases have, in Frege's terminology, a *sense* as well as a reference, and their distinctive senses were preserved when their references were merged. Let *a* and *b* now be stand-ins for these two denoting phrases, and let F and G now be stand-ins for the predicates 'the last planet to disappear in the morning' and 'the first planet to appear in the evening'. Then we may say that it is *conceptually true* that *a* is F and that *b* is G. (Lewis said that 'the identity theory does not imply that whatever is true of experiences as such is likewise true of neural states as such', 1966, p. 101. Take this to be equivalent to '. . . whatever is conceptually true of experiences is likewise conceptually true of neural states'.) When '*a* = *b*' is ampliative and true, what is conceptually true of *a* will usually be contingently true of *b*, and vice versa. The equation of the Morning Star with the Evening Star yielded the unexpected information that the Morning Star is the first planet to appear in the evening and conversely for the Evening Star. It left neither of them "wearing the trousers", gave no licence for statements like, 'The so-called Evening Star is really a *morning* star'. All it eliminated was a mistaken bit of duplication; the heavens lost none of their beauty. One now got two "starry" phenomena for the price of one, so to speak.

Defenders of the mind-brain identity theory might similarly claim that they employ Ockam's Razor only to cut out unnecessarily multiplied entities; and they could add that this renders interaction between mind (= brain) and body no more problematic than that between a bus and its engine, a point made by Keith Campbell (*1984*, p. 88). After saying that the traditional picture is an interactionist one requiring two-way causal action between body and mind, Armstrong could go on to say: 'In my view, we all have this picture because it is, by and large, a correct one. Mankind has had abundant opportunity to observe, theorize and meditate on this topic. Through the ages they have found this picture forcing itself upon them almost irresistably. I think the moral is that the picture embodies a true theory' (*1984*, p. 105). The identity theory in its ampliative version would allow us to retain what in Chapter 2 was called the agency-assumption.

Smart and Armstrong made acknowledgements to Feigl, who in turn made acknowledgements (*1958/67*, p. v) to Schlick, who had formulated the identity theory in his *1925* (§§ 31–35). Schlick (p. 301) drew attention to the continuity between it and

Spinoza's parallelism. (Told that two sequences proceed in parallel, it is natural to think of them as separated; after all, two parallel lines must, by Euclid's fifth postulate, be at a distance from one another, otherwise there would be one line. But for Spinoza's parallelism a better analogy is the surface of a geometrical sphere seen as concave from within and convex from without. A point on one of them *is* the corresponding point on the other.) But in place of two attributes of a single substance Schlick put two languages or conceptual schemes, mentalese and physicalese, for describing a common domain. Later, we will find him highlighting features of the mental which seem to have no counterpart within the physical domain; we will also find him saying (in opposition to Lucretius's premise 2 above) that even if the physical and the mental were two different domains, that would be no obstacle to causal relations between them; so he sometimes seemed to be defending dualist interactionism. But he was saying, in effect, that you can eat a *rich* cake and have it too. What seemed to be ontological dualism turned out to be only a conceptual dualism; anything real 'can be designated both by psychological concepts and by physical ones' (p. 310).[5]

Place put forward the hypothesis that consciousness is a process in the brain as 'a reasonable scientific hypothesis' (1956, p. 44). It is a general hypothesis; before turning to it, let us ask what are the conditions for a singular identity statement to constitute a reasonable scientific hypothesis. Let us simplify the problem by assuming a clearcut divide with *objects* on one side and *language* on the other, the objects all being non-fuzzy and the language's denoting phrases all being unambiguous. As with 'the Morning Star' and 'the Evening Star', denoting phrases such as a and b will be assumed each to have a sense which renders it conceptually true that a is F and that b is G. And it will be assumed that a true identity statement '$a = b$' of the ampliative kind with which we are here concerned generates new contingent truths such as 'a is G' without disturbing previous conceptual truths. It will also be assumed that there is, at any given time t, a well-

5. This may help to explain the seeming oscillation between physicalism and idealism which we found when we looked into some of Schlick's ideas in § 4.3 above.

defined and internally consistent body K of relevant and reliable knowledge.

A necessary condition for '$a = b$' to be a reasonable scientific hypothesis is that there is no property ϕ of which K says that a is ϕ and b is $\sim\phi$. Let 'a' now be a stand-in for 'the Fourth Man', the sense of this denoting expression being 'the longest-standing British agent working for the Soviet Union after the defections of Burgess, Maclean, and Philby'. Let K be knowledge available at various stages to security officials in MI5. For a long time K allowed them to say only that $a = x$, where x might be any one a number of possible candidates. Let 'b', 'c', and 'd' respectively denote the then Surveyor of the Queen's Pictures, the head of an Oxbridge college at a certain time (I made it Oxbridge because Blunt was himself director of an institute within my own university), and the first leader of the Parliamentary Labour Party. Then although '$a = b$' turned out to be true, '$a = c$' might have been a reasonable scientific hypothesis at some stage; but '$a = d$' was never a candidate, since d (Keir Hardie) had a known property, namely having died in 1915, that a was known not to have. (If 'e' were 'The Piltdown Man', '$a = e$' would be conceptually impossible, like 'The morning star is the evening stillness'.)

Let us now turn to general statements involving identity. Consider 'The President of the United States of America is always the Commander-in-Chief of the United States armed forces' or, for short, 'The F is always the G'. This unpacks into singular identity statements, such as 'The F on 7.12.41 was the G on 7.12.41'; but it will hardly serve as a proxy for the identity theory, because it equally allows us to pass from right to left, as in 'The G on 7.12.41 was the F on 7.12.41', whereas the identity theory does not allow us to pass from any neural state to a mental state. We might get nearer to a proxy for it by turning to the English peerage; this has one Earl Marshal and some thirty Dukes, the former always being one of the latter. We might abbreviate this to, 'The F is always a G'. This unpacks into statements each of which is a hybrid of an existential and a singular statement, such as: 'There is an x such that x is a G in 1953 and x is the F in 1953'.

We again get nearer to the mind-brain identity theory if we let the right-hand expression denote the composition of the thing referred to by the left-hand expression. Identity theorists often gave as the sort of example on which their hypothesis was based

statements of the form: 'For any x, if x is a flash of lightning then there is a y such that y is a movement of electric charges from one ionised layer of cloud to another, and $x = y$.[6] In this connection Place spoke of the 'is' of composition (1956, p. 44). Is the 'is' of composition the '=' of identity? Rather than pursue that question, we can fall back on the requirement that for identity to obtain there must be no property ϕ such that what the expression on the left of the 'is' refers to is ϕ and what the expression on the right refers to is $\sim\phi$. I will now present (with no claim to originality) five cases of a property ϕ such that something mental is ϕ and no brain-process is ϕ. These counter-examples to the identity theory will at the same time be instantiations of dualism.

(1) Frank Jackson's *knowledge argument* (1982, 1986) provides a clearcut case for such a ϕ. Its "Mary" has two distinguishing features: she knows, at least potentially, everything physical there is to know about the physical world; *but* she acquired her physical omniscience within the confines of a black-and-white room equipped with black-and-white television, and reading only black-and-white books. Let a denote the visual experiences of a normally sighted person viewing a ripe tomato in broad daylight, and let b denote this person's concurrent brain-processes. Mary was omniscient with respect to the properties of b. If $a = b$, then she also knew all the properties of a. But she subsequently comes to realise that she had not; for she is subsequently released from her black-and-white room into the colourful world outside where for the first time she observes, among other things, the *redness* of a ripe tomato. So a had a property ϕ, namely visual awareness of redness, that Mary had not known of previously, despite knowing all b's properties. Therefore $a \neq b$.

(2) Now to a ϕ for which Leibniz had a famous argument. He imagined an enormously magnified brain 'that one might go into as into a mill'; and he said that search it as one might one would not find any thoughts, feelings, or perceptions (*1714*, § 17). Churchland has challenged this: your failure to detect such items might be due to an inability to recognize them when you come across them (*1995*, pp. 191f). Well, let us modernize Leibniz's idea. Imagine two technological innovations. One is a brain-mon-

6. This example is adapted from Smart's *1963*, p. 92.

itoring device which can record every change, however minute, in a person's brain without disturbing it. The other innovation is *moving* holograms, or three-dimensional films which the spectator can get inside—'hologram-films' for short. Magnification can be varied, up or down, with no loss of definition, and the film can be speeded up or slowed down as desired. The suggestion was mooted some time ago that the Millennium Dome at Greenwich should house a model of the human brain in which visitors could walk about. Well, these two innovations together would allow it to be the theatre for a hugely magnified hologram-film of the inside of a living human brain.

To make it definite, suppose that, at a time when my brain is being monitored, I am woken in the night by the telephone ringing. As I reach out for the receiver I think: 'Something dreadful's happened'. Let 'a' now denote my experiences between t_0 when I was first aware of the ringing and t_1 when I picked up the receiver. Then the mind-brain identity theory says that there is an x such that x is a complex of processes in my brain between t_0 and t_1 and $x = a$. And Leibniz's thesis in this modernized version is that no observer who explored a vastly magnified hologram-film of my brain during this period would find my experiences. To obviate the objection that an amateur investigator might fail to recognize them we could invite Paul and Patricia Churchland to select a team of expert neuroscientists with instructions to look for just two straightforward items: my aural experience of the telephone ringing, and my thought that something dreadful had happened. They will be offered every technical assistance with respect to varying the magnification, homing in on a particular area, slowing the film down, putting it on "Hold", re-running it, and so on. Do we expect that they will eventually detect those two items? Of course not. This a has the property φ which no brain-process has of being in principle inaccessible to third-person observation.

(3) Next, a related φ to which Nagel famously drew attention (in § 4.2 above it was mentioned that there had been an anticipation of it in Darwin's Notebooks), namely that mental phenomena are essentially subjective in being tied to a single point of view, and hence are irreducible to physical phenomena, which are not so tied. (This has also been much emphasised by Searle.) Here is a thought-experiment in support of this thesis. It involves

a recurrent feature of my mental life: I may be contentedly potter-
ing in the garden on a sunny day when I suddenly have a vivid
recollection of an incident (such as my accidentally spilling red
wine over a lady's yellow dress) which still fills me with shame and
embarrassment; the incident happened long ago and nothing can
be done about it now; such "visitations", as I will call these
unwanted recollections, are entirely unprofitable. Now imagine
that an eminent neuroscientist says she can cure me. Over a
period my brain is again to be monitored very exactly and I will
carry a little device with which to register future "visitations". She
later reports a clear correlation between them and intensified
activity in a small and well-defined region of my brain. I submit to
tests, and each artificial stimulation of this area unfailingly brings
on a "visitation". I learn that this part of my brain serves no use-
ful function, and that modern techniques enable it to be neatly
excised with no ill effects. I agree to the operation. It is a success
and the "visitations" cease. I learn afterwards that she did not
throw out that bit of my brain but stored it in one of those brain-
vats. Later, she had another patient, call him Fred, with a com-
plaint similar to mine, and he too agreed to an operation. He
subsequently reported that his "visitations" had indeed ceased,
but something very unpleasant had taken their place: he now has
experiences in which, for example, he seems to remember spilling
red wine over a lady's yellow dress. In a spirit of scientific curiosity
our neuroscientist has implanted that bit of my brain in the vacant
place in Fred's brain.

Suppose that although they seemed veridical, my "visitations"
had in fact been hallucinatory, and that although Fred's matching
"visitations" resulted from that implant, they seemed veridical to
him. So the bit of my brain that is now in Fred's brain is function-
ing there as it had in mine. Does that mean that a bit of my mind
is now in Fred's mind? Of course not. My "visitations" were
about *me*, JW, doing something (whether real or imagined),
whereas his are about *him*, Fred, doing something. I could be a
donor with respect to parts of my brain but not of my mind.
Experiences have the property ϕ of being tied to one centre.

(4) Now to a ϕ that Schlick highlighted despite his adherence
to the identity theory. The latter requires what Feigl called a one-
to-one 'simultaneity-correspondence between the mental and the

physical';[7] and Schlick in effect pointed out that this does not obtain (*1925*, § 17). Neurobiologists teach us that a fifth of a second is a long time in the life of a brain.[8] For observers to be able to individuate neuronal events in that hologram-film of my brain during those few seconds, it would need to be shown in very slow motion; but if it were, they could be timed rather precisely. A neuronal event has a sharp beginning and a sharp ending. What about events in the mind? Well, experiences may have a sharp beginning, as when one hears a click, or takes the first sip of an ice-cold drink, or suffers a sudden stab of toothache. But they don't have a sharp ending; as William James put it, 'Objects fade out of consciousness slowly' (*1890*, i, p. 571).

Schlick's larger interest here was in the unity of consciousness. This has both a synchronic aspect with concurrent items blended into an undivided whole (when I was woken in the night, I knew who I was, where I was, where my hands and feet were. . . .) and a diachronic aspect, stressed by Kant in his doctrine of the synthetic unity of apperception. It is not clear to me whether consciousness with diachronic unity but without synchronic unity is conceivable; Strawson once postulated a purely auditory stream of consciousness (*1959*, chap. 2). Anyway, Schlick's point was that there could be no consciousness without diachronic unity. He was utterly opposed to Hume's psychological atomism, according to which an ego is nothing but a bundle of perceptions and all perceptions are distinct and distinguishable 'and may be conceiv'd as separately existent, and may exist separately'.[9] An oyster, Hume said, can be imagined to have just one perception; so God could, in principle, transfer each of the perceptions in the bundle that is my ego to a separate oyster; and if he did so then although *I* would no longer exist, no perception would have been lost. What's it like to be an oyster whose mental life consists of one perception? Schlick's answer was: no different from being an oyster with no mental life. And that would not change if God had despatched those perceptions, separately, one after another, to the same oyster; a chopped up "consciousness" would not be

7. As reported in Cornman, 1962, p. 73. Cornman gave no reference.
8. Eccles, *1970*, especially Ch V; among others he cited Libet, 1966.
9. *Treatise*, Appendix, p. 634.

consciousness.[10] For there to be a stream of consciousness there has to be 'a quite special kind of connection' between its successive components, an 'extending of each momentary content of consciousness beyond itself into the next moment', so that in listening to a tune, say, you experience temporally adjacent elements 'not merely as succeeding one another but also as being simultaneous.' In consciousness the present always has *duration* (*1925*, pp. 126–27). Schlick made an acknowledgement here to William James, who gave currency to the term 'specious present' (he referred to experiments by Wundt and others indicating that it stretches from about six to twelve seconds, *1890*, i, pp. 573f).

Schlick himself raised the question whether all this does not point to a mind-body dualism:

> Mental qualities have that special relationship which, as the interconnection of consciousness, has so often occupied us. And in this way they are distinguished from all other qualities Does this not represent a dualism as to the relation holding among the mental on the one hand and among the nonmental on the other, and does this not basically amount to . . . a dualism of being?

Alas, his answer infringed our fourth *Don't*; he called future science to his aid:

> science thus far does not possess quantitative concepts by which to designate the interconnection of these magnitudes in consciousness. But once these concepts are found, the unity of consciousness will be recognized as being only one of many interconnections and will be reduced to them. The problem of consciousness will then be solved. (p. 332)

(5) The ϕ that is perhaps the most acclaimed distinguishing mark of the mental is intentionality. Franz Brentano held it to be true of everything mental and of nothing physical that (i) it in some sense points or refers to something beyond itself, and (ii) that this something may be non-existent (*1874*). Thus when I was woken by the telephone, my thought that something dreadful had happened referred to something beyond itself and this

10. Schlick (ibid., p. 125n) quoted a remark to that effect by Wilhelm Wundt.

something was non-existent (the caller had the wrong number). Nowadays it is generally agreed that some mental phenomena, such as a vague feeling of anxiety or depression, may lack intentionality; and Humphrey's sharp distinction (*1992*, passim) between perceptions and pure sensations suggests that the latter lack intentionality. But beliefs, desires, hopes, fears, loves. and hates clearly possess intentionality in Brentano's sense. As to physical things: of course, we can sometimes *read* them as pointing to something beyond themselves; for instance, we can read a magnetic compass as pointing to the north, though it is in fact merely being aligned by whatever magnetic field it is in. And physical things can have intentionality impressed upon them, as when a bit of wood is shaped like an arrow; but it points only in virtue of the human intentionality impressed upon it. Physical things as such don't point or refer.

Anti-dualists have generally taken intentionality seriously as a potential stumbling block for their views. For instance, Armstrong wrote: 'If intentionality is to be reckoned an irreducible feature of mental processes there is a great gulf fixed between physical and mental properties' (*1968*, p. 48). And at about the same time Dennett wrote: 'the Intentionalist thesis . . . proclaims an unbridgeable gulf between the mental and the physical' (*1969*, p. 21). How have they sought to bridge this gulf? Armstrong claimed that physical analogues for intentionality are provided by a thing's relation to an unrealized potentiality of itself; for instance, a thing that is stretchable but unstretched "points" to the non-existent physical state of its being stretched (*1984*, p. 150). Well, this same object will almost certainly have lots of other unrealized potentialities: compressible but not compressed, flammable but never in flames. . . . Water in a bucket has the potential to turn to ice, or to be drunk, or to dowse a bonfire. If a physical object "points" to any of its unrealized potentialities it presumably "points" to all of them; but "pointing" all over the place is not *pointing*. The intentionality of mental states is not like that.

Armstrong also instanced a thermostat as "pointing" to a temperature level. Well, it can be read as doing that, rather as a homing device can be seen as seeking a target. We can adopt an intentional stance towards such artefacts. Which brings us to Dennett's way of bridging the gulf. The governing idea that runs

through his extensive writings on this subject is twofold.[11] (1) You are at liberty to adopt an intentional stance towards a computer you are playing chess with, to treat it as if it wants to beat you and will make the best moves it can; indeed, pragmatically speaking, you may be well-advised to adopt this stance, though adopting it does not of course mean that this artefact has intrinsic or original or real intentionality; it only has as-if intentionality. (2) *Precisely the same* applies to the human case (*1987*, pp. 293–94). (1) is uncontroversial, but he reports many people, including Fodor, Dretske, and Searle, quarrelling with (2). I will argue that they were right to do so.

A property P may be *intrinsic* or it may be *stance-dependent*. Gold's durability is an intrinsic property. President de Gaulle seems to have regarded its monetary value as likewise an intrinsic property, but if so he was wrong. This latter property is *stance-dependent*. As one learns in first-year economics courses, if gold were wanted only for industrial uses its value would be lower. Possession of a property P by x may be empirically undecidable for outside observers, leaving them free to adopt a positive or a negative stance on the question of x's possession of P. I will speak here of *stance-freedom*. Suppose that we could conclude that a certain tax change will increase social utility on the assumption that the individuals concerned all have the same utility functions. Lionel Robbins famously pointed out (*1932*, chap. 6) that interpersonal comparisons of utility are undecidable, though we are free to adopt the above assumption on moral grounds. The question of sentience in animals is another area of undecidability. Jeremy Bentham famously declared, 'the question is not, Can they *reason?* nor Can they *talk?* but, Can they *suffer?*'.[12] Because of the undecidability, very contrasting stances have been adopted here. Henry More told Descartes that he (Descartes) took a 'murderous view' in depriving animals of sensibility.[13]

There is no legitimate inference from stance-dependence to stance-freedom or from stance-freedom to stance-dependence.

11. Dennett *1968*, ch ii; *1979*, ch. 1; *1987*; *1991*, passim.

12. Collectors of famous footnotes may like to add this to the ones from Mach cited in § 4.3 above, and from Kant (*Religion*, p. 157n) cited in § 6.3 above. The reference is: *1789*, chap xvii, § i, para 4, footnote b.

13. Quoted in Williams, *1978*, p. 282.

The price of gold is both stance-dependent and empirically decidable; you can look it up in a newspaper. That stance-freedom has been exercised by Descartes, More, and others over the question of whether a mouse, say, has a capacity to suffer has no tendency to render a capacity for suffering stance-dependent; if the mouse has it, it has it as an intrinsic property.

There may also be freedom to adopt an *as-if* stance, proceeding as *x* is P though confident that in reality it is not. When Russell was told that he could know for sure that he was speaking truly if he addressed the statement 'You are hot' to a fellow philosopher in a Turkish Bath, he replied: 'But how am I to know that he is not a robot, wound up to say, "Your philosophy is altogether too egocentric"' (1944, p. 693). Or consider "reverse engineering". Paley wrote: 'It is always an agreeable discovery, when, having remarked in an animal an extraordinary structure, we come at length to find out an unexpected use for it' (*1802*, p. 218). One of his examples concerned nipples on the rump of certain birds. He explained their existence as follows: the nipples excrete the 'oil with which bird prune (*sic*) their feathers' (p. 211). Let P now be the property of having been skilfully designed. Then Paley believed that God's creatures possess P. A post-Darwinian successor engaging in "reverse engineering" proceeds as if they possess P. Again, this weaker kind of stance-freedom provides no support for stance-dependence. The wings of aircraft do, and the wings of birds do not, possess the intrinsic property of having been engineered. That's a fact; no amount of talk can alter it. And it is a fact that our beliefs, desires, hopes, fears, loves, and hates possess the intrinsic property, known as intentionality, of pointing or referring to something beyond themselves, and that this something may not exist. No amount of talk about stances can alter it.

So there are at least five cases of a f that is peculiar to mental phenomena. The identity theory stands refuted. Hilary Putnam was badly wrong when he wrote: 'The various issues and puzzles that make up the traditional mind-body problem are wholly linguistic and logical in character: whatever few empirical "facts" there may be in this area support one view as much as another' (*1975*, ii, p. 362).

Functionalism In the late 1960s the identity theory began to evolve into the functionalist philosophy of mind. In his 1967 Putnam had compared the mind/brain relation to the relation of an abstract Turing "machine" to its "multiple realizations"; however, he later withdrew these views. And the brand of functionalism to be considered here is that inaugurated, so far as I know, by David Lewis.

Back in the 1920s Frank Ramsey had shown how the theoretical stuffing can be taken out of scientific theories, while leaving their observational content intact, by constructing what came to be known as Ramsey-sentences for them.[14] Where the original theory might have spoken of an electro-magnetic field determining certain empirical regularities, its Ramsey-sentence will speak of an unspecified something or other determining those same regularities. Lewis (1970) developed Ramsey's idea; theoretical terms were now defined by their observational function. And in his (1972) he extended this treatment from the theoretical/observational divide to the mental/physical divide. He had expressed his basic idea here earlier, when he said that an experience is a "something or other" defined by its causal role (1966, p. 10). A particular mental state M was to be defined according to the causal role R it occupied. Where a type-type identity theory had said that all mental states of the same type (e.g. pains) have a physical property in common (e.g. stimulated C-fibres), functionalism says: yes, they do have something in common, but no, it's not a physical property, it's a causal role. Of course, functionalists did not speak with one voice. With Lewis, the old identity theory lingered on in the assumption that the very same causal role R is *also* occupied by some neural state N, so that M = N. Other functionalists insisted that there is a multiplicity of neural states any of which may have causal role R.

That functionalism defines "mental" items in terms of their causal role might suggest that it supports the present book's defence of the efficacy of the mental against, for example, Watson

14. To form a Ramsey-sentence of a theory, first recast it as a single sentence; then highlight its theoretical predicates, say P, R, . . . ; then replace P wherever it occurs by a predicate variable, say ϕ, and R by ψ . . . ; then put brackets round the whole string and preface it with those variables bound by the existential quantifier: $\exists \phi, \psi$. . . . For references see Watkins, 1975a, and especially p. 99n for the identity of the rediscoverer of Ramsey's idea, which lay around unnoticed for over 20 years.

who ridiculed those who say 'that consciousness is a real "force"—something that can do something, something that can start up a physiological process, or check, inhibit or down one already going' (Watson *1924/30*, p. 296, italics omitted). And we may begin by comparing functionalism with behaviourism. In § 4.6 above the latter's idea of behaviour as a succession of more or less immediate responses to stimuli was confronted with the fact that animals sometimes carry out quite long-term projects, as when wolves follow the spoor of the wounded moose for several days. But there is another objection to the S-R idea which is more relevant here. Sometimes a stimulus S suffices by itself to elicit a definite R (remember the birds reacting with disgust to the taste of the conspicuously coloured caterpillars). But S may be a new unit of situational information which does not suffice on its own to determine a behavioural response. A leopard emerges from the undergrowth and lo! it observes animals of a kind it preys on drinking at a water-hole. Its response? That depends on its preferences. If it has a full stomach but is thirsty, it may prefer a quiet drink to predatory exertions. To put it more generally: behaviourism postulated a mono-causal S-R pattern, whereas it typically happens that what response an input S stimulates will depend on internal factors of various kinds.

McGinn suggested that functionalism (which he opposes) set out to overcome this defect of behaviourism (*1991*, pp. 187f). Well, that may have been the intention, but it is hard to see how the brand of functionalism being considered here could have hoped to succeed. As he said, for functionalism, as for behaviourism, both input and output are to be understood in a physicalist way. True, functionalism allows a mental ontology of sorts. As Armstrong put it: 'If the essence of the mental is purely relational, purely a matter of what causal role is played, then the logical possibility remains that whatever in fact plays the causal role is not material' (*1984*, p. 157). But the "mental" so understood is completely constrained by its role within input-output sequences. Let *x* be a mental "something or other"; a functionalist definition of *x* requires a physical input S and a physical output R such that S is *apt* (Armstrong's term) for the production of *x* and *x* is apt for the production of R. It's really behaviourism again, with a certain *je ne sais quoi* interposed; the "mental" becomes 'the dash

between S and R in stimulus-response behaviourism'.[15] The S ∅ R pattern turns into an S ∅ *x* ∅ R pattern. It is still mono-causal.

For suppose that we try to allow a role to internal factors, such as current preferences. Let S be the above-mentioned scene of animals drinking at a water-hole, and *x* be our leopard's perception of it. As before we have S ∅ *x*. Let F be food preferred to drink and D be drink preferred to food, and let R_1 be going in pursuit of one of the animals and R_2 be drinking at the water-hole. We would now have something like this:

FIGURE E.5

The mental factor *x* would no longer be embedded in a one-track causal sequence; its contribution to the physical output would vary according to other mental factors for which Ramsey-substitutes have not been provided. If one tried to provide functionalist definitions of them a similar difficulty would arise.

Our lives do sometimes exhibit a mono-causal pattern; it can happen that a single mental item, such as experiencing a maddening itch, or being ravenous, or highly aroused sexually, temporarily gives an overriding utility to one particular outcome; and it may do so in a situation where behaviour R is the obvious way to securing that outcome; and cases of that kind may appear to exemplify the mono-causal pattern. But think of that mental item in an altered situation; for instance, imagine that same itch with your arms in plaster; you might invest considerable ingenuity in devising an alternative method R' of dealing with it. In the seemingly mono-causal case, R was actually the product, not of that one item alone but of it together with a situational appraisal of a situation that was so transparent and unproblematic that the appraisal was made unnoticingly.

15. Wilkes, *1978*, pp. 56-7. I apologise to her: I have slightly twisted her words.

The example of an *x* satisfying their S ∅ *x* ∅ R schema that functionalists endlessly present is *pain*: S might be your hitting your thumb with a hammer and R your emitting a cry of 'Ouch'. The present book cannot be accused of under-estimating the importance of pain, whose survival value was stressed in § 4.5 above. But there are other feelings: jealousy, exhilaration, moral outrage, joie de vivre. Functionalists keep quiet about these; they lie outside their schema, as do the colourful phenomena on the mental side of the psychophysical divide that fit in with "Conquer Fortune" as sketched in § 8.4 above: subversive jokes made under Communism, a PoW's dive into a ditch under the noses of his guards, a victim of the Great Purge making it his explanandum and seeking an estimate of its magnitude. In connection with these we might use the schema 'Prob _ *x* _ Sol', where '_' stands for a progression for which there is no causal guarantee nor any heuristic recipe. In such a case we cannot say that Prob is *apt* for the production of *x*; only inventiveness will get you there. Try to imagine a functionalist analysis of Hobbes's composition of the *Leviathan* as famously portrayed by John Aubrey:

> He walked much and contemplated, and he had in the head of his staffe a pen and ink-horne, carried always a note-booke in his pocket, and as soon as a thought darted, he presently entred it into his booke, or otherwise he might perhaps have lost it. He had drawne the designe of the booke into chapters, etc. so he knew whereabout it would come in. Thus that booke was made. (*Lives*, pp. 243–44)

Functionalism would be stumped by that.

Rylean "Behaviourism" I said (in § 4.7 above) of a champion billiard-player that it seems that there *is* a "ghost in the machine". Ryle would have said that this man is indeed mentally as well as bodily active; but to suppose that he is synchronously active in two ways is to fall into the Official Doctrine or Descartes's Myth.[16] (When Magee put it to Ryle that the idea of the "ghost

16. Descartes had spoken of 'the machine of the body', *Principles*, I, 71. Broad had previously spoken in this connection of an angel in a machine; see his *1952*, p. ix. Koestler turned Ryle's label into the title of his *1967*.

in the machine" was a pervasive one that had existed long before Descartes, Ryle agreed that it had been hanging around for donkey's years, but claimed that it was Descartes who turned it into a doctrine; see Magee *1971*, pp. 109–110.) Our billiard-player is no more doing two things than is a bird when flying south and migrating. He is engaged in one billiard-playing, activity. The overt intelligent performances in which active people engage are not clues to the working of their minds; they *are* those workings (*1949*, pp. 50–58). To suppose that a mind is something over and above intelligent behaviour is to commit a category mistake analogous to still wanting to see the University of Oxford after being shown all its colleges, libraries, museums . . .

It came to be generally agreed among materialists and their fellow-travellers that Ryle had done a fine job which, however, left 'raw feels' or *qualia* to be mopped up. Indeed, Ryle himself soon retreated from the seemingly full-blown anti-mentalism of his *1949*. For instance, in his 1951 he withdrew the claim that a tickle just is a thwarted impulse to scratch (p. 279); and in his 1956 he concluded that while verbs like 'see' and 'hear' are indeed "success"-words which report the achievement of a task, they also involve something reminiscent of the old idea of a sense-impression. My thesis will be that a nonchalant aside in his *1949* had already let in what the book purported to dispel, namely consciously pre-planned rational behaviour.

A main difference between Ryle's and earlier versions of behaviourism is that where they put behaviour he put *intelligent* behaviour. Let B and C be short for, respectively, 'intelligent behaviour' and 'consciously planned'. We may represent the "Official" Doctrine that he was attacking as affirming:

(A) 'All B is C'.

The contrary of A is:

(E) 'All B is ~C'.

We may complete this 'Square of Opposition' with

(O) 'Some B is ~C' and

(I) 'Some B is C'.

Before turning to Ryle's position, let us first locate dualist interactionism, as understood in this book, in relation to the above. Obviously it rejects E: our champion billiard-player's stroke was consciously planned. But what is its choice between A and O? Well, cases were discussed in § 4.7 above where a pianist, say, may be on auto-pilot as it were. Dualist interactionism can also allow that in a fast-moving situation one's body may need to respond to sensory inputs instinctively, without waiting for conscious instruction. (Some years ago I was driving down a nearly empty London street when a small boy darted out from between two parked cars. I thought: '*I'm bound to hit him*' but my body did better.) So dualist interactionism rejects A. To reject A and E is to endorse O and I.

Now let us locate Ryle's position in relation to the above. It obviously rejects A. But what is its choice between E and I? One might suppose that, if his intention was not just to tinker with "Descartes's Myth" but to scotch it altogether, Ryle would have gone for E. But he didn't. There are some intelligent performances that seem to fit the Cartesian pattern well enough, and he did not ride roughshod over these. For instance, he allowed that a chess-player 'may require some time in which to plan his moves before he makes them' (*1949*, p. 29). In high level chess a player may stare at the board for half an hour or more before making a move. Spectators at what came to be known as the "immortal game" (in 1851 between Anderssen, playing White, and Kieseritsky) must have rubbed their eyes around moves 17 and 18 when White, already a bishop down, allowed Black to snap up both his rooks. Suppose (correctly, as I believe) that he had already worked out the trap that was to materialize later when, after sacrificing his queen on move 22, White mated Black (all of whose major pieces were still on the board) on move 23. The dualism of conscious planning and bodily execution can be brought out by asking what would have been known of White's thinking around his 17th move if, after making it, he had suffered cardiac arrest? Posterity's judgement might well have been that this brilliant player's mind was already disturbed. Anyway, Ryle's version of behaviourism endorses I, as well as O; its emphasis may be different, but logically speaking its position is the same as dualist interactionism's.

It is worth mentioning that the time-lag between privately working something out and making it public is sometimes a matter of months rather than minutes. Iris Murdoch reported (in a television interview) that by the time she sat down to write a new novel she had it all worked out down to the last detail. Actually, it transpired from what she went on to say that her typewriting self was not just her authorial self's stenographer, but would introduce new jokes and minor twists. But Mozart, it seems, did sometimes copy out, very rapidly and with no corrections, a work that had existed only in his head.[17] One is tempted to say in such cases that the "ghost" composed the music and afterwards the "machine" wrote it down.

The invention of new ideas plays important roles in the present book. How does Ryle's thesis bear on that? The section in his *1949* that is given over to the making of theories is largely concerned with the valid point, referred to in § 7.3 above, that the sequence of propositions presented by a finished theory does not reflect the thinking that went into the building of the theory. As theory-builders he instanced Euclid, Newton, Adam Smith, and a housewife trying to find out whether a carpet will fit a floor (p. 288). The idea was that in all these cases there is 'a lot of soliloquy and colloquy, a lot of calculating and miscalculating . . ., a lot of interrogating, cross-examining, debating and experimental asseverating' (*1949*, p, 291). So it's a bustling, noisy process. But as we saw in Chapter 1, it often happens that in the course of a process of discovery there is a period of silence when the process seems to have ground to a halt. During this period (what Graham Wallas in *1926* called the "incubation" period) it is as if the "ghost" went underground for a while. The individual's behaviour is now quite dissociated from the inventive process.

So much by way of objections to attempts to escape the first horn of the dilemma (dualist interactionism is undeniable). Now for an argument that seems to me to make accepting that horn mandatory. It is an extension of the main argument for indeterminism in Chapter 3, which was based on the fact that some novel scientific ideas, such as Faraday's, have led to considerable

17. For instance, he wrote to his father concerning *Idomeneo*: '. . . everything is composed, just not copied out yet' (Hildesheimer, *1983*, p. 238).

physical disturbances around the earth's surface. When used as an argument for interactionism there is no longer a need for novelty in the scientific ideas. Hume, whose claim to have dissolved it we will be looking into shortly, depicted the mind-body problem rather melodramatically thus:

> Is there any principle in all nature more mysterious than the union of soul with body; by which a supposed spiritual substance acquires such an influence over a material one, that the most refined thought is able to actuate the grossest matter? Were we empowered, by a secret wish, to remove mountains, or control the planets in their orbit; this extensive authority would not be more extraordinary, nor more beyond our comprehension. (*Enquiries*, # 52)

Well, minds can now initiate processes that would bring about the removal of a mountain. But take the building of a power station, say. Let 'P-S' stand for the finished product and 'K' for all the knowledge that was relied on during its construction. Then P-S is a physical structure, while K consists of information; no doubt the information is largely incorporated in blue-prints, specifications, and so on, but it is the information they contain rather than the physical documents as such that make the construction possible. So the non-physical K has helped in the making of something physical. How did this come about?

I mentioned earlier that although he had it in his hands, Popper did not use the disturbing effect of scientific ideas as an argument for indeterminism; but he did use it in support of the reality of what he called World 3, and I will present my answer by way of a criticism of this argument of his. His World 3 is a suprapersonal "world" of abstract entities (problems, theories, numbers, . . .) that exist independently of whatever psychological processes generated them.[18] His argument may be put like this. Alfred Landé had said, with acknowledgements to Dr. Johnson, that *x* is real if *x* is kickable (*1965*, p. 17), to which Popper added, in effect, that if *y* can kick *x*, then *y* too is real. (His actual words were: 'We accept things as "real" if they can causally act upon, or interact with, ordinary real material things', *1977*, p. 10.) So anything that

18. See e.g. his *1972*, chaps. 3 and 4, and his *1994b*.

causally affects World 1, the physical world, is assuredly real; and this World, with its power stations, radio transmitters, jet aircraft . . . clearly exhibits the impress of World 3. Popper added that World 3 could not have brought about these technological modifications to World 1 by itself; it needed World 2, which consists of the thoughts etc. in individual minds, to serve as intermediary. But he tended to give the latter a subordinate role. Rather as he sometimes spoke of the species using the individual organism as a spearhead (*1994b*, p. 59), so he sometimes spoke almost as though he regarded World 3 as a Hegelian World-Spirit working through the minds of individual scientists, engineers, and others in World 2. On one occasion his way of speaking provoked a member of his audience to ask him whether World 3 ever *initiates* any process. I was relieved that he answered, 'I don't think so' (p. 44), though I would have preferred an emphatic, 'Certainly not'. I see World 3 on the analogy of archival deposits left by the thinking of once active individual people. I admit that this may not do justice to its partial transcendence, mentioned earlier, of that thinking; but any such transcendent content will remain inert unless detected and activated by individual people.

As to Popper's World 2. The suggestion in § 8.3 above that an individual may occupy a "world" was accompanied by the rider that such a "world" is proper to its occupant and can no more be shared than can a stream of consciousness. I won't attempt an ordinary language analysis of the word 'world' (there is an amusing one in Ryle *1960*, pp. 73f), but to my ears it sounds wrong to think of separate streams of consciousness making up *one* world. One can of course speak of the *set* of all subjective experiences, but *that* could no more act on World 1 than the set of all teaspoons could stir a cup of tea. In the present context, it is individual people guided by various ideas and instructions—chemical engineers, tractor drivers, and so on—who build power stations and suchlike. So let us put aside talk of Worlds acting on and being acted on by other Worlds in favour of talk in accordance with methodological individualism of technological changes which could not have come about through the unregulated interplay of natural forces being made possible by developments in human knowledge and being implemented by individual people. In these processes, it happens again and again that something physical is put in the right place as a result of some local mind-

body interaction. Consider the building of our power station P-S. A girder is being lowered slowly from a crane; the lowering stops. Why? The crane-driver adjusted a control. Why did he do that? He saw the foreman's arm go up. Why did that happen? The foreman saw the girder come level with a certain mark. Why had a mark been put there? Because someone measured it off from the architect's drawing. Why had the architect drawn it that way? . . . If one laboriously investigated the construction of P-S item-by-item and step-by-step, one would repeatedly come across loci at which a physical event was, quite unmistakably, the implementation of a mental judgement.

So much concerning the first horn of the dilemma, the undeniability of dualist interaction. Let us now turn to its second horn. Why has interaction been found incredible? To investigate this we need to go back for a moment to Descartes himself. For it was Descartes the natural philosopher who provided the main reason for rejecting Cartesian interactionism. But first a subsidiary matter. Descartes claimed that mental interventions as he understood them, namely as adjustments by the soul to the pineal gland, do not infringe the law of the conservation of motion (mass times velocity), the great conservation principle of his time, since they alter only the direction and not the quantity of motion. To which Leibniz rightly retorted that the velocity is vectorized, so that force is needed to redirect a mass's motion.[19] (Where he thought of a rider redirecting a horse we might think of a ship's captain redirecting a supertanker.) If I could address Leibniz I would have said to him that Descartes should have grasped this nettle: he should have said that if a reigning conservation law has the implication that physical processes can never be redirected by mental interventions then it cannot be right just as it stands, because we know that the building of cathedrals and the writing of books involves lots of little mental redirections of hands and fingers and could not have been done by undirected natural processes. Descartes should have stuck to his guns and asserted the existence of whatever degree of openness of the physical to the mental is required for the production of human artefacts.[20]

19. 1692, p. 649, 1695, p. 718, *1714*, § 80.
20. Popper said something more or less along these lines, *1977*, p. 542.

But the main reason for rejecting Cartesian interactionism that Descartes provided was of course his own theory that all physical change is some kind of motion and that extended bodies can be moved only by contact with other extended bodies, in other words by being pushed. His correspondence with Princess Elizabeth is revealing, here. It began with her asking him how the soul, a thinking substance, can determine bodily actions; in his first reply he drew an analogy between a body being moved by its soul and by its heaviness. When she pointed out that he had discarded heaviness as a falsely attributed property, he admitted that 'the analogy with heaviness was lame' and came near to imputing extension to the soul (*Letters*, pp. 136–144). Leibniz remarked somewhere that Descartes seemed from his writings to have given up the struggle over this problem.

A concept or theory of causation may be *universal* and *substantive* as Descartes's was, or substantive but *domain-specific*, or universal and *formal*. Domain-specific ones are typically associated with the dominant scientific theory for the domain in question. Whether either a domain-specific or a formal one could rule out mind-body interaction we will consider shortly. But it seems clear that a universal substantive one is more likely to do so. It will apply indifferently right across the board to billiard balls, and to chemical reactions, and to double stars, and to light, and to electro-magnetic phenomena, and to evolutionary strategies, and to embryological development, and to language acquisition, and to hypnosis, and to optical illusions, and to inflation . . ., and to (real or imagined) mind-body interactions. Of the above, Descartes's push-theory seems appropriate only for billiard balls (and even their elasticity presents a difficulty for it). Indeed, by Descartes's time there already existed a domain-specific concept of causation quite alien to his push-theory. William Gilbert's *1600* treated magnetic force in partial analogy and partial disanalogy with light. Descartes had got round the problem posed by light for his push-theory with his blind-man's-stick analogy; when you observe a star your retina is being affected by a ray of matter that is being vibrated along its length by vibrations at its source in the star. But there was no way he could have got around the disanalogy with light which Gilbert drew: 'But herein does the magnetic energy surpass light,—that it is not hindered by any dense or opaque body, but goes out freely and diffuses its force every whither'

(p. 124). Let *a* be a suitably powerful magnet and *b* be a suspended compass needle, with open space between them. Then *a* will act on *b*; and its action will not be affected by interposing a brick wall between them. As Gilbert put it, the action of magnetic energy is far more subtle than that of light (p. 123). Gilbert advertised the non-mechanical character of his domain-specific concept of magnetic causation by saying that in its effect on other bodies, magnetic force is rather like the human soul (pp. 308f).

So there was already a domain-specific counter-example to it when Descartes put forward his putative universal theory; and a grander counter-example arrived not long afterwards when Newton, having freed himself from the Cartesian metaphysics which he had imbibed in his youth, put forward a cosmology in which pull was no less fundamental than push. But although gravitational causation was conceived as applying throughout the material world Newton recognized (as we saw in Chapter 3) that magnetic and electric attractions are beyond its scope. It was domain-specific even though its domain was cosmic. Then came a theory to fill that large lacuna; but even when the latter's domain was much extended by Maxwell's equations bringing in light, it was still not all-embracing. And Einstein never achieved the unified field theory for which he was searching in his later years. Whether science will ever come up with a true "theory of everything" we do not know, and nor do we know what such a theory's implication would be for mind-body interaction.

Instead of infringing our fourth *Don't* by speculating about what the future will bring, let us now ask whether there could be a viable domain-specific concept of causation that rules out mind-body interaction. It would face a daunting task. There is a large body of experimental evidence, obtained under controlled conditions, which is highly relevant here, though contemporary philosophers of mind generally ignore it.[21] I refer to scientific investigations into hypnosis that have been carried out at Stanford University and other centres. The experiments are repeatable and, in some cases have been repeated several times with essentially the same results. (Remember the one with the beaker of fuming nitric

21. Though Ian Hacking (1999) rightly takes seriously the astonishing results of mesmerism reported in Alison Winter's *1998*.

acid which was mentioned when we looked briefly into some of this material in § 6.1 above, in connection with internal heteronomy.) Of course, there are wide variations in hypnotic suggestibility, and what follows is claimed only with regard to highly susceptible subjects. For present purposes it does not matter how hypnotic states are induced. Even if it were by a chemical injection or some other purely physical means, which it is not, the fact would remain that, a hypnotic state having somehow been induced, remarkable results are now brought about just by *words and meanings*. The experimenter's verbal suggestions may have a pseudo-factual character, for instance that the agent has no left arm; or they may invite the agent to try to imagine the arm being just a rubber hose with no sensitivity (Hilgard *1977*, pp. 171f). In either case the meaning-loaded words have an astonishing efficacy. Particularly intriguing are cases where analgesia is an indirect consequence of suggestions that say nothing about pain. For example, a subject is asked to

> hold up his forearm, the elbow resting on the arm of the chair or a table. Now the hypnotist proposes to move the hand and arm into the subject's lap, and the subject hallucinates the movement, although the hand remains suspended in the air. The subject now folds his other hand over the hallucinated hand in his lap, so that he feels comfortably sure that both hands are in his lap. *At this stage the hand suspended in the air will often prove to be anesthetic.* (Hilgard 1965, p. 126)

In the following example no false factual beliefs are induced in the subjects; it is not suggested to them that their left hand *is* immersed in icy water, for instance. Rather, they are asked to *imagine* some unusually cold condition for their left hand and some unusually warm condition for their right hand, knowing perfectly well that both hands are actually in the same, normal condition. In such cases, differences in the two hands' surface temperatures of as much as 7° C have been measured (Maslach et al. 1979, p. 653). The most hardened physicalist must admit that meanings are here having a strong physical effect; merely switching the words 'left' and 'right' would switch the effects from one hand to the other. If the laws of thermodynamics say it couldn't happen, they are wrong. Facts of this kind are not to my liking;

they do not exemplify any of the kinds of mind-body action celebrated in this book. But they do seem to constitute decisive counter-evidence to any neuroscientific or other theory that rules out the action of mind on body.

If no substantive theory of causation, whether universal or domain-specific, is available to establish the "incredibility" horn of the dilemma, the remaining question is whether a formal concept could do so. Such a concept may distinguish between different forms of causation; for instance, D. H. Mellor's *1995*, a recent addition to this genre, distinguishes between, among other things, deterministic and probabilistic causation and being the cause of an event and being the cause of a property. But a formal concept is, by definition, topic-neutral. A purportedly formal concept could rule out mind-body interaction only if some substantive content had been surreptitiously introduced into it.

The example of Hume is instructive here. His analysis of cause was, he claimed, entirely topic-neutral. It requires only regular succession. And he went on to apply this to the mind-body problem:

> Few have been able to withstand the seeming evidence of this argument [against any causal connection between thought and motion]; and yet nothing in the world is more easy than to refute it. We need only reflect on what has been proved at large, that we are never sensible of any connexion betwixt causes and effects, that 'tis only by our experience of their constant conjunction, we can arrive at any knowledge of this relation. . . . I have inferr'd from these principles, that to consider the matter *a priori*, any thing may produce any thing, and that we shall never discover a reason, why any object may or may not be the cause of any other, . . . however little the resemblance may be betwixt them. This evidently destroys the precedent reasoning . . . For tho' there appear no manner of connexion betwixt motion or thought, the case is the same with all other causes and effects. (*Treatise*, I, iv, 5)

Actually, Hume's original analysis of cause had not been entirely topic-neutral; as well as regular succession in time it required contiguity (I, iii, 2). But as he himself said, thoughts do not have location: a 'moral reflection cannot be plac'd on the right or on the left hand of a passion' (I, iv, 5). So a thought cannot be contiguous with a brain-movement. He now dropped this non-neutral requirement.

It is beginning to look as though the "incredibility" horn of the dilemma is made of papier mâché and has survived under the posthumous influence of that same discredited seventeenth-century idea of physical causation that led to Galileo's contemptuous dismissal of Kepler's lunar theory of the tides (*1632*, p. 462). In neither science nor philosophy is there an extant concept of cause adequate to the task of rightly excluding mind-body interaction. I am here echoing Schlick:

> even if the physical and the mental were in fact two different domains of the real, no difference in kind, however great, could constitute a serious obstacle to the existence of a causal relation between them. For we know of no law stating that things must be of the same kind in order to act on one another. On the contrary, experience everywhere shows that the most disparate things . . . interact with one another. (*1925*, p. 301)

Many years ago J. O. Wisdom presented electro-magnetic theory as a model for the mind-body relationship (1952). Its point, though he didn't put it this way, could be made as follows. Jim is a schoolboy who has done a little elementary science. On his birthday he is given a torch and a horse-shoe magnet. We ask him why the bulb lights up when he switches the torch on. He says that electricity stored in the battery is now flowing through a little wire inside the bulb which heats up and glows. With his magnet he now picks up a tea spoon. When we ask him to repeat the operation slowly, he duly observes that the spoon moves before the magnet has touched it. We ask him why the magnet acts across the small gap between it and the spoon. At school Jim has recently been shown patterns of iron filings induced by a magnet; and he answers that the magnet has a field of force round it. We now ask him whether electricity and magnetism could interact. If Jim were a rather donnish schoolboy he might reply: 'No. They belong to different domains. Where could the interaction occur?'.

I hear you ask: 'All the same, don't you still find it incredible that mind acts on body?' Well, I do indeed find it incredible that minds *push* brains about, however gently (recall Eccles, in § 4.7 above), but not that they interact in some more arcane way. Concerning this possibility, two suggestions have been put forward independently in recent years, as to what it might be like. I

bring them in here, not because I think they're likely to be true—that is a matter on which I prefer to keep an empty mind—but because they go some way to dispel the widely held conviction that it is incredible that mind and body interact. One suggestion is by Popper. So far as I know he first presented it, aged ninety, in an interview.[22] The other is by McGinn (*1991*, ch. 4). They tie in with and complement each other to some extent, Popper's being more a suggestion as to content, McGinn's as to structure. Popper's was that the electro-magnetic wave fields associated with the electricity of the brain's neuronal processes mediate between the latter and the mind's conscious experiences. (There may be a faint reverberation here from Wisdom's 1952.) McGinn's suggestion was that consciousness, like language, may have a deep structure beneath its surface layer and that this may mediate between overtly conscious experiences and brain processes. Searle commented on this idea that even if it were intelligible it 'gets us nowhere' (*1992*, p. 105). Well, that is said by someone who once showed rather plausibly how to get from an *is* to an *ought* by interposing mediating steps.[23] And McGinn claimed rather plausibly that his hypothesis does perhaps get us somewhere, with respect to blindsight. This is the phenomenon, discovered by Lawrence Weiskrantz (*1986*), in which subjects who have lost part of their visual field from damage to the visual cortex are asked questions by an experimenter about things in the occluded area; for instance, whether a grating is vertical or horizontal. When they impatiently exclaim that they can't know, they see nothing there, they are asked to guess; and their guesses are surprisingly good; it is as if they can "see" a lot more than we should expect (though a lot less than they could see before the damage; Humphrey *1992*, pp. 68f). Anything that helps with this seemingly baffling problem is welcome. McGinn's suggestion is that, in normal vision, properties of conscious experience at two levels, surface properties and deep properties, are co-operating,

22. Popper et al, 1993, p. 179. Popper's two interviewers discussed this idea of his in Lindahl & Arhem, 1994. The discussion continued in Libet, 1996, 1997; Beck, 1996; Lindahl & Arhem, 1996a, 1996b.

23. Searle, 1964; starting from the factual statement, 'Jones uttered the words "I hereby promise to pay you, Smith, five dollars"', he proceeded with the help of various subsidiary assumptions to the moral conclusion, 'Jones ought to pay Smith five dollars'.

whereas in cases of blindsight the deep properties are operating without the surface properties; hence the "seeing" blindly.

The three contemporary philosophers of mind to whose positions mine comes closest are Nagel, McGinn, and Searle, and I will conclude this Epilogue by looking into an issue over which the latter two disagree with each other and I disagree with them both. (Apart from a couple of skirmishes over peripheral matters I have no serious disagreements with Nagel.) I begin with Searle. First, a preliminary point over what is, I hope, only a terminological issue. Although he finds arguments for eliminative materialism 'breathtakingly bad' (*1992*, p. 46) and their conclusion 'crazy' (p. 48), he insists that he is not a dualist. He invariably speaks as though dualism postulates just *two* somethings where materialism postulates one. If, as I rather suspect, that is all there is to it, mutual consistency could be restored by us both dropping 'dualism' as a label for our positions in favour of the more accurate 'pluralism'. But he seems to go further, insisting that 'the *mental* state of consciousness is just an ordinary biological, that is, *physical*, feature of the brain' (p. 13) comparable with digestion or the secretion of bile (1995, p. 60). If his calling consciousness a biological feature meant only that consciousness is part of the animal's naturally evolved survival kit, there would be no disagreement. But for him to call it a *physical* feature puts me in mind of a shrewd comment by Nagel on Searle's remark, quoted earlier, about the prevailing 'terror of consciousness'. Nagel said that he was absolutely right, adding: 'indeed, I believe he himself is not immune to its effects' (1993, p. 39). Searle (*1992*, pp. 19–21) has frequently emphasised Nagel's point that mental states are essentially subjective, requiring an "I" and a first-person ontology. Is that just an ordinary physical feature, along with intentionality, inaccessibility to third-person observation, and the other features peculiar to consciousness? It seems a pity to stretch the word 'physical' to make it equivalent to what we would ordinarily understand by 'physical or mental'.

Now to the disagreement between him and McGinn. Searle is an optimistic naturalist who holds (1) that there is in the offing a true theory that explains how neurobiological processes in the brain cause consciousness, and (2) that this theory may well be discovered in the not too distant future. McGinn is a naturalist but not an optimistic one. He holds (1) but denies (2): we will

never find this theory.[24] It is not just that evolution has not adapted our brains to find it; rather, it has adapted them *not* to find it (*1991*, pp. 16f). I have a prejudice against doctrines involving truths that must forever remain hidden.[25] I agree that we will never find this theory but because there cannot be such a theory. I deny (1) above as well as (2).

The argument is straightforward and without profundity. It has to do with the special explanatory problems posed by emergent properties. Let C be a holistic property which supervenes upon an ensemble of b_i's, these being micro-entities. Suppose that C is not constructible from the non-relational properties of the individual b_i's. But perhaps we can explain how a large ensemble of b_i's gives rise to C when relational properties between the b_i's are taken into consideration. An H_2O molecule does not by itself possess anything like liquidity; but if we learn that there is a state in which the molecules can slide around each other, then we begin to understand the liquidity of water in analogy with that of a children's swimming "pool" consisting of a tankful of ping-pong balls. And when we learn that at a low temperature the molecules lose this mobility, while at a high temperature they start flying apart, then we can also begin to understand why water can turn to ice, or to steam. But if C is consciousness possessing all the above-mentioned ϕ's that physical things no physical things possess, then C is truly emergent and not open to an explanation in terms of the relations between the brain's micro-entities. A theory T that sought to explain or predict the emergence of consciousness in a newborn child would need to bring in a full-blown, independent, irreducible predicate for C. Let 'B' be short for a true description of the macro-level state of the baby's brain; then T could say, 'B \oslash C'. This would tell us that consciousness supervenes when conditions in the brain are right, but it would do nothing to explain why or how this happens. If the brain sciences make possible a far more detailed and richer description β of the micro-level state of the baby's brain, then the new T' could say, 'β \oslash C'; the description would go deeper but

24. See his 'Can We Solve the Mind-Body Problem?', *1991*, chap. 1, first published in *Mind*, July 1989. He reports that he and Nagel have been dubbed the "New Mysterians", after a defunct rock group, *1997*, p. 107.
25. See Watkins, 1974, p. 387.

no progress would have been made with respect to explaining why consciousness should emerge from entities beneath it.

Does this make consciousness uniquely anomalous? Although there is much to be said against Hume's analysis of causal law (and most of it is said in Armstrong's *1983*), I think that at bottom he was right. Let us say that a regular connection between events is "mysterious" (henceforth I'll drop the scare-quotes) if it is of a kind for which there is no current scientific explanation. Then Hume said, in effect, that *all* causal connections are mysterious, those between billiard ball movements no less than those between brain and mental events. You may say that with the progress of science, connections that had been mysterious get explained. Yes; but at the price of introducing mysterious new ones higher up. That billiard balls behave as they do will always depend on some unexplained regularity. The difference with consciousness is that the level of what's mysterious does not get shifted upwards but obstinately remains where it was in the days of the pre-Socratics.

But instead of lamenting that it exists *unaccountably* let us rejoice that consciousness unaccountably *exists*. True, it lends pain and suffering to the drama of human life; but without it there would be no love, no art, no music, no science—and no freedom.

References

Where, after the first entry, a reprint, translation, or later edition is listed, references in the text are to the latter.

Abbott, Thomas Kingsmill
 (1873) 'Memoir of Kant', in *Kant's Critique of Practical Reason and Other Work*, trans. T. K. Abbott, London: Longmans, Green, pp. xiii–lxiv.

Agassi, Joseph
 (*1975*) *Science in Flux*, Dordrecht: Reidel.
 (*1977*) *Towards a Rational Philosophical Anthropology*, The Hague: Martinus Nijhoff.
 (*1981*) *Science and Society*, Dordrecht: Reidel.

Albert, Hans
 (*1985*) *Treatise on Critical Reason*, trans. Mary Varney Rorty, Princeton: Princeton University Press.

Apter, Michael J.
 (*1970*) *The Computer Simulation of Behaviour*, London: Hutchinson.

Ardrey, Robert,
 (*1966*) *The Territorial Imperative*, New York: Atheneum.

Argyll, Duke of
 (1862) Review of Darwin's 'On the Various Contrivances by which British and Foreign Orchids are Fertilised by Insects', in *Edinburgh Review*, **116**, pp. 378–397.

Armstrong, D. M.
 (1965) 'The Nature of Mind', Inaugural Lecture, University of Sydney; in Borst (ed.), *1970*, pp. 67–79.
 (*1968*) *A Materialist Theory of the Mind*, London: Routledge and Kegan Paul.
 (*1983*) *What is a Law of Nature?*, Cambridge: Cambridge University Press.
 (*1984*) Contributions to Armstrong & Malcolm, *1984*, pp. 105–191 and 205–217.

Armstrong, D. M., and Malcolm, Norman
(*1984*) *Consciousness and Causality*, Oxford: Blackwell.

Attenborough, David
(*1979*) *Life on Earth*, London: Collins.

Aubrey, John
(*Lives*) *Brief Lives and Other Selected Writings*, ed. Anthony Powell,
London: Cresset Press, 1949.

Augustine, Saint
(*De Lib*) *De Libero Arbitrio Voluntatis*, trans. Anna S. Benjamin and L. H.
Hackstaff as *On Free Choice of the Will*, Indianapolis: Bobbs-Merrill, 1964.
(*Confessions*) Translated with an Introduction by R. S. Pine-Coffin,
Harmondsworth: Penguin, 1961.

Axelrod, Robert
(*1990*) *The Evolution of Co-operation*; with a Foreword by Richard Dawkins,
London: Penguin Books (first published in the USA by Basic Books).

Ayer, Alfred J.
(*1956*) *The Problem of Knowledge*, Harmondsworth: Penguin.

Bacon, Francis
(*NO*) *Novum Organum*, 1620; a reference such as 'i, 104', is to aphorism
104 in Part I.

Bacrac, Norman
(1991) 'Remarks on the Relation Between Brain and Consciousness', *The
Ethical Record*, **96**, October, pp. 7–12.

Bailey, Cyril
(*1928*) *The Greek Atomists and Epicurus*, Oxford: Clarendon.

Baldwin, J. M.
(1896) 'A New Factor in Evolution', *American Naturalist*, **30**, pp. 441-
451, 536–553.
(1898) Appendix to the English translation of Karl Groos, *The Play of
Animals: a Study of Animal Life and Instinct*, London: Chapman and Hall.
(*1902*) *Development and Evolution*, London: Macmillan.

Barrett, Paul H. (ed.)
(*1980*) *Metaphysics, Materialism, and the Evolution of Mind: Early Writings
of Charles Darwin*, with a commentary by Howard E. Gruber, Chicago:
University of Chicago Press. [Originally published as Book 2 of Gruber and
Barrett, *1974*.]

Beck, Friedrich
(1996) 'Mind-Brain Interaction: Comments on an Article by
B. I. B. Lindahl & P. Arhem', *The Journal of Theoretical Biology*, **180**,
pp. 87–89.

Beck, F., and Grodin, W.
(*1951*) *Russian Purge and the Extraction of Confession*, trans. E. Mosbacher
and D. Porter; New York: Viking.

Benn, Stanley I.
(*1988*) *A Theory of Freedom*, Cambridge: Cambridge University Press.

Benn, Stanley I., and Weinstein, W. L.
(1971) 'Being Free to Act, and Being a Free Man', *Mind*, **80**, pp. 194–211.

Bennett, Jonathan
(*1984*) *A Study of Spinoza's Ethics*, Cambridge: Cambridge University Press.

Bentham, Jeremy
(*1789*) *An Introduction to the Principles of Morals and Legislation*, in
Collected Works of Jeremy Bentham, ed. J. H. Burns and H. L. A. Hart,
London: Athlone Press, 1970.

Berkeley, George
(*Principles*) *A Treatise concerning the Principles of Human Knowledge*, 1710,
in Berkeley *Works*, vol. 2.
(*Dialogues*) *Three Dialogues Between Hylas and Philonous*, 1713, in Berkeley
Works, vol. 2.
(*1721*) *De Motu*, in Berkeley *Works*, vol. 2.
(*Works*) *The Works of George Berkeley, Bishop of Cloyne*, ed. A. A. Luce and T.
E. Jessop, 9 vols., 1948–57, London: Nelson.

Berlin, Isaiah
(*1958*) *Two Concepts of Liberty*, Oxford: Clarendon Press.
(1964) '"From Hope and Fear Set Free"', *Proceedings of the Aristotelian
Society*; reprinted in his *1978*, pp. 173–198.
(*1978*) *Concepts and Categories*, ed. Henry Hardy, intro. Bernard Williams,
London: Hogarth Press.

Binet, Alfred
(*1892*) *Les altérations de la personalité*; trans. Helen Green Baldwin as
Alterations of Personality, London: Chapman and Hall, 1896.

Black, Max
(1944) 'Russell's Philosophy of Language' in Schilpp (ed.), *1944*,
pp. 227–255.

Blake, Robert
(*1966*) *Disraeli*, London: Eyre and Spottiswoode; London: Methuen University Paperback, 1969.

Blakemore, Colin
(*1988*) *The Mind Machine*, London: B.B.C. Books.

Block, Ned (ed.)
(*1980*) *Readings in Philosophy of Psychology*, vol. 1, London : Methuen.

Block, Ned, Flanagan, Owen, and Güzeldere, Güven (eds.)
(*1997*) *The Nature of Consciousness*, Cambridge MA: MIT Press.

Bock, Walter
(1959) 'Preadaptation and multiple evolutionary pathways', *Evolution*, **13**, pp. 194–211.

Bone, Edith
(*1966*) *Seven Years Solitary*, Oxford: Cassirer.

Boden, Margaret A.
(*1990*) *The Creative Mind: Myths and Mechanisms*, London: Weidenfeld and Nicolson.

Born, Max
(*1951*) *The Restless Universe*, 2nd ed., New York: Dover.

Borst, C. V. (ed.)
(*1970*) *The Mind/Brain Identity Theory*, London: Macmillan.

Bossuet, Jacques Benigne
(*1681*) *Discours sur l'Histoire universelle*, in *Oeuvres de Bossuet*, Paris: Firmin-Didot, 1877, tome 1er, pp. 125–298.

Bradley, F. H.
(1894) 'On the Failure of Movement in Dream', in *1935*, vol. i, chapter 18.
(1895) 'On the Supposed Uselessness of the Soul', in *1935*, vol. i, chapter 20.
(*1935*) *Collected Essays*, Oxford: Clarendon Press.

Brandon, Ruth
(*1993*) *The Life and Many Deaths of Harry Houdini*, London: Secker and Warburg.

Brentano, Franz
(*1874*) *Psychology from an empirical standpoint*, trans. A. C. Rancurello, D. B. Terrell and Linda L. McAlister; London: Routledge and Kegan Paul, 1973.

Breuer, Josef
(*1895*) (With Sigmund Freud) *Studien Über Hysterie*; English translation in Freud, *Works*, vol. 2.

Bridgman, P. W.
(*1936*) *The Nature of Physical Theory*, Princeton: Princeton University Press, reprinted New York: Dover.

Broad, C. D.
(*1925*) *The Mind and its Place in Nature*, London: Kegan Paul, Trench, Trubner.
(*1952*) *Ethics and the History of Philosophy*, London: Routledge and Kegan Paul.
(1959) 'A Reply to my Critics', in Schilpp (ed.), *1959*, pp. 711–830.

Brown, Roger
(*1958*) *Words and Things*, New York: The Free Press.
(*1970*) *Psycholinguistics*, New York: The Free Press.

Brown, Roger & Fraser, C.
(1963) 'The Acquisition of Syntax', in Cofer, C. N., and Musgrave, Barbara S. (eds.), *Verbal Behavior and Learning*, New York: McGraw-Hill.

Buber, Martin
(*1952*) *Eclipse of God*, New York: Harper.

Buber-Neumann, Margarete
(*1949*) *Under Two Dictators*, trans. Edward Fitzgerald, London: Gollancz.

Bunge, Mario
(*1981*) *Scientific Materialism*, Dordrecht: Reidel.

Burnet, John
(*1930*) *Early Greek Philosophy*, fourth ed., London: Black.

Buss, David
(*1994*) *The Evolution of Desire: Human Mating Strategies*, New York: Basic Books.

Byrne, Richard, and Whiten, Andrew (eds.)
(*1988*) *Machiavellian Intelligence: social expertise and the evolution of intellect in monkeys, apes and humans*, Oxford: Oxford University Press.

Campbell, C. A.
(*1967*) *In Defence Of Free Will*, London: Allen and Unwin.

Campbell, Donald T.
(1974) '"Downward Causation" in Hierarchically Organised Biological Systems', in Ayala, F. J., and Dobzhansky, Th. (eds.), *Studies in the Philosophy of Biology*, London: Macmillan, pp. 179–186.

Campbell, Keith
(*1984*) *Body and Mind*, second ed. (first ed. 1970), Notre Dame: University of Notre Dame Press.

Carnap, Rudolf
(1963) 'Intellectual Autobiography', in Schilpp (ed.), *1963*, pp. 3–84.

Chalmers, David J.
(*1996*) *The Conscious Mind: in search of a fundamental theory*, New York: Oxford University Press.

Chaplin, Charles
(*1964*) *My Autobiography*, Bodley Head; reprinted Penguin Books, 1966.

Chomsky, Noam
(*1966*) *Cartesian Linguistics*, New York: Harper and Row.
(*1968*) *Language and Mind*, New York: Harcourt, Brace, and World.
(*1972*) *Problems of Knowledge and Freedom*, Fontana/Collins.

Churchill, Winston S.
(*1930*) *My Early Life*; reprinted Fontana Books, 1959.

Churchland, Patricia Smith
(*1986*) *Neurophilosophy: Toward a Unified Science of the Mind/Brain*, Cambridge, Mass.: MIT Press.

Churchland, Paul M.
(1981) 'Eliminative Materialism and the Propositional Attitudes', *The Journal of Philosophy*, **78**, 2, February, pp. 67–90.
(*1984*) *Matter and Consciousness*, Cambridge, Mass.: MIT Press.
(*1995*) *The Engine of Reason, the Seat of the Soul*, Cambridge, Mass.: MIT Press.

Clark, Peter
(1989) 'Determinism, Probability and Randomness in Classical Statistical Physics', in Gavroglu, K., Goudaroulis, Y., and Nicolapoulos P. (eds.), *Imre Lakatos and Theories of Scientific Change*, Dordrecht: Kluwer, pp. 95–110.
(1996) 'Popper on Determinism', in O'Hear (ed.), *1996*, pp. 149–162.

Clarke, Samuel
(1717) Papers in Leibniz and Clarke (*1717*).

Clifford, W. K.
(*1886*) *Lectures and Essays*, ed. Leslie Stephen and Frederick Pollock, London: Macmillan.

Cohen, David
(*1979*) *J. B. Watson: The Founder of Behaviourism*, London: Routledge and Kegan Paul.

Cohen, I. Bernard
(*1960*) *The Birth of a New Physics*, London: Heinemann.

Cole, Jonathan
(*1992*) *Pride and a Daily Marathon*, London: Duckworth.

Collingwood, R. G.
(*1938*) *The Principles of Art*, Oxford: Clarendon Press.
(*1946*) *The Idea of History*, ed. T. M. Knox, Oxford: Clarendon Press.

Compton, Arthur H.
(*1935*) *The Freedom of Man*, New Haven: Yale University Press.

Conquest, Robert
(*1968*) *The Great Terror: Stalin's Purge of the Thirties*, London: Macmillan.

Cornman, James W.
(1962) 'The Identity of Mind and Body', reprinted in Rosenthal (ed.), *1971*, pp. 73–79.

Cosmides, Leda
(1989) 'The Logic of Social Exchange: has natural selection shaped how humans reason? Studies with the Wason selection task', *Cognition*, **31**, pp. 187–276.

Crick, Francis
(*1981*) *Life Itself: Its Origin and Nature*, London: Macdonald.

Cronin, Helena
(*1991*) *The Ant and the Peacock*, Cambridge: Cambridge University Press.

Curley, Edwin
(*1985*) *The Collected Works of SPINOZA*, vol. i; translation with editorial prefaces, footnotes, glossaries, and indexes, Princeton: Princeton University Press.

Curtiss, S., Fromkin, V., Krashen, S., Rigler, D., and Rigler, M.
(1974) 'The Linguistic Development of Genie', *Language*, **50**, pp. 528–555.

D'Agostino, Fred
(*1986*) *Chomsky's System of Ideas*, Oxford: Clarendon Press.

D'Agostino, Fred, and Jarvie, Ian (eds.)
(*1989*) *Freedom and Rationality: Essays in Honor of John Watkins*, Dordrecht: Kluwer.

Dampier, William Cecil
(*1948*) *A History of Science and its relations with philosophy and religion*, Cambridge: Cambridge University Press.

Darwin, Charles
(*Auto*) *The Autobiography of Charles Darwin*, ed. Nora Barlow, London: Collins, 1958.
(*Beagle*) *The Voyage of the Beagle*, first ed. 1839; reprinted London: J. M. Dent, 1983.
(*Descent*) *The Descent of Man and Selection in Relation to Sex*, London: Murray; first ed. 1871, second ed. 1874.
(*Expression*) *The Expression of the Emotions in Man and Animals*, London: Murray, 1872; reprinted Chicago: University of Chicago Press, 1965.
(*Origin*) *The Origin of Species*, London: Murray, first ed. 1859; page references are to the sixth edition, London: Murray, 1872. If the passage referred to was not in the first edition, the edition in which it was introduced is indicated.
(1877) 'A Biographical Sketch of an Infant', Mind, **2**, pp. 285–294; reprinted in Barrett (ed.) *1980*, pp. 204–214.

Darwin, Francis (ed.)
(*1888*) *The Life and Letters of Charles Darwin*, 3 vols., London: Murray.

Darwin, Francis, and Seward, A. C. (eds.)
(*1903*) *More Letters of Charles Darwin*, 2 vols., London: Murray.

Davidson, Donald
(*1980*) *Essays on Actions and Events*, Oxford: Clarendon.

Dawkins, Richard
(*1976/89*) *The Selfish Gene*, Oxford: Oxford University Press; new enlarged edition 1989.
(*1982*) *The Extended Phenotype*, Oxford: Oxford University Press.
(*1986*) *The Blind Watchmaker*, Harlow: Longman.
(*1996*) *Climbing Mount Improbable*, Viking/Penguin.

De Beer, Gavin (ed.)
(*1958*) *Charles Darwin and Alfred Russel Wallace: Evolution by Natural Selection*, Cambridge: Cambridge University Press.

Delbrück, Max
(*1986*) *Mind From Matter? An Essay on Evolutionary Epistemology*, ed.
Gunther Stent, Ernest Fischer, Solomon Golomb, David Presti, Hansjakob
Seiler, Palo Alto: Blackwell Scientific Publications.

Dennett, Daniel C.
(*1969*) *Content and Consciousness*, London: Routledge and Kegan Paul.
(*1978*) *Brainstorms: Philosophical Essays on Mind and Psychology*, Sussex:
Harvester Press.
(*1984*) *Elbow Room*, Oxford: Clarendon.
(*1987*) *The Intentional Stance*, Cambridge, Mass: MIT Press.
(*1991*) *Consciousness Explained*, London: Allen Lane.
(*1995*) *Darwin's Dangerous Idea*, New York: Simon and Schuster.

Descartes, René
(*Discourse*) *Discours de la Méthode*, 1637; in *Works*, vol. I.
(*Letters*) *Descartes: Philosophical Letters*, ed. and trans. Anthony Kenny,
Oxford: Clarendon, 1970.
(*L'Homme*) French text with translation and commentary, in *Treatise of
Man*, ed. and trans. Thomas Steele Hall, Cambridge Mass.: Harvard
University Press, 1972; references, such as A-T 100, to page in Adam and
Tannery, *Oeuvres*, vol. 11.
(*Meditations*) *Meditationes de primá philosophiá*, 1641; 2nd ed 1642; French
translation, 1647; in Works, vol. I.
(*Replies*) Replies to Objections to the *Meditations*, in *Works*, vol. II.
(*Passions*) *Les Passions de l'Ame*, 1650; references to article-number.
(*Principles*) *Les Principes de la Philosophie*, 1644; a reference such as IV, 200
is to Part IV, principle 200.
(*Works*) *Philosophical Works of Descartes*, trans. E. S. Haldane and G. R. T.
Ross, Cambridge: Cambridge University Press, 1931.

Desmond, Adrian, and Moore, James
(*1991*) *Darwin*, London: Penguin.

Dewey, John
(*1910*) *The Influence of Darwin on Philosophy and Other Essays in
Contemporary Thought*, New York: Henry Holt.

Diels, Hermann
(*Diels*) *Die Fragmente der Vorsokratiker*, 5th ed., Berlin, 1935.

Dobzhansky, Theodosius
(*1962*) *Mankind Evolving: the Evolution of the Human Species*, New Haven:
Yale University Press.
(*1967*) *The Biology of Ultimate Concern*, New York: New American Library.

Dobzhansky, Th., and Montagu, M. F. Ashley
(1947) 'Natural Selection and the Mental Capacities of Mankind', *Science*, June 6.

Donagan, Alan
(1973) 'Spinoza's Proof of Immortality', in Grene (ed.), *1973*, pp. 164–181.

Duhem, Pierre
(*1906*) *La Théorie Physique: Son Objet, Sa Structure;* 2nd French Ed. 1914, trans. Philip P. Wiener as *The Aim and Structure of Physical Theory*, Princeton: Princeton University Press, 1954.

Earman, John
(1971) 'Laplacean Determinism, or Is This Any Way to Run a Universe?', *Journal of Philosophy*, **68**, pp. 729–744.
(*1986*) *A Primer on Determinism*, Dordrecht: Reidel.

Eccles, John C.
(*1970*) *Facing Reality*, Berlin: Springer-Verlag.
(*1977*) Part II and 'Dialogues', in Popper & Eccles *1977*.

Eccles, John C. (ed.)
(*1966*) *Brain and Conscious Experience*, Berlin: Springer-Verlag.

Eddington, Arthur
(*1928*) *The Nature of the Physical World*, Cambridge: Cambridge University Press.

Edelman, Gerald M.
(*1992*) *Bright Air, Brilliant Fire*, London: Allen Lane, Penguin Press.

Edwards, Paul
(1973) Introduction to Section V ('The Existence of God') in Edwards and Pap (eds.), *A Modern Introduction to Philosophy*, Third Edition, New York: The Free Press.

Einstein, Albert
(*1918/54*) *Relativity, the Special and General Theory: a Popular Exposition*, trans. R. W. Lawson, fifteenth ed., London: Methuen.
(1949) 'Autobiographical Notes', in Schilpp (ed.), *Albert Einstein: Philosopher-Scientist* (The Library of Living Philosophers); reprinted New York: Harper; pp. 2–95.
(*1954*) *Ideas and Opinions*, New York: Crown Publishers.

Einstein, Albert, and Infeld, Leopold
(*1938*) *The Evolution of Physics*, Cambridge: Cambridge University Press.

Engels, Frederick
(1890) Letter to Joseph Bloch, in *Karl Marx: Selected Works*, ed. C. P. Dutt,
London: Lawrence and Wishart, 1942, vol. 1, pp. 381–83.

Evans-Pritchard, Edward E.
(*1937*) *Witchcraft and Magic among the Azande*, Oxford: Clarendon Press.

Feigl, Herbert
(*1958/67*) *The "Mental" and the "Physical"*, Minneapolis: University of
Minnesota Press; 2nd ed. with a Postscript 1967.

Feuer, Lewis Samuel
(*1958*) *Spinoza and the Rise of Liberalism*, Boston: Beacon Press.

Feyerabend, Paul K.
(*1975*) *Against Method*, London: NLB.

Fisher, R. A.
(*1930*) *The Genetical Theory of Natural Selection*, Oxford: Clarendon Press.

Fodor, Jerry A.
(*1983*) *The Modularity of Mind*, Cambridge Mass: MIT Press.

Fox, Robin
(1971) 'The Cultural Animal', in Eisenberg, J. F. and Dillon, W. S. (eds.),
Man and Beast: Comparative Social Behavior, Washington, D.C.:
Smithsonian Institution Press, pp. 273–296.

Freeman, Derek
(*1983/96*) *Margaret Mead and the Heretic* (originally entitled *Margaret
Mead and Samoa*), Harmondsworth: Penguin.

Freud, Sigmund
(*1907*) *Delusions and Dreams in Jensen's* Gradiva, in *Works*, vol. ix, pp.
1–95.
(1908) 'Creative Writers and Day-Dreaming', in *Works*, vol. ix, pp.
141–153.
(*1910*) *Five Lectures on Psycho-Analysis*, in *Works*, vol. xi, pp. 7–56.
(1911) 'Formulations on the Two Principles of Mental Functioning', in
Works, vol. xii, pp. 215–226.
(*1917*) *Introductory Lectures on Psycho-Analysis*, in *Works*, vols. xv, xvi.
(1923) 'Josef Popper-Linkeus and the Theory of Dreams', in *Works*, vol.
xixi pp. 261–63.
(*1930*) *Civilization and its Discontents*, in *Works*, vol. xxi, pp. 57–145.
(*Works*) *The Standard Edition of the Complete Psychological Works of
Sigmund Freud*, James Strachey (ed.) 24 vols., 1966–74, London: Hogarth.

Friedenthal, Richard
(*1965*) *Goethe: His Life and Times*, London: Weidenfeld and Nicolson.

Friedman, Milton
(*1953*) *Essays in Positive Economics*, Chicago: University of Chicago Press.

Fromm, Erika, and Shor, Ronald E. (eds.)
(*1979*) *Hypnosis: Developments in Research and New Perspectives*, second ed., New York: Aldine.

Galileo, Galilei
(*1632*) *Dialogue Concerning the Two Chief Systems—Ptolemaic and Copernican*, trans. Stillman Drake, intro. Albert Einstein, Berkeley: University of California Press, 1953.

Galton, Francis
(*1869*) *Hereditary Genius: an Inquiry into its Laws and Consequences*, London: Macmillan; second ed. 1892.

Gellner, Ernest
(*1974a*) *The Devil in Modern Philosophy*, ed. I. C. Jarvie and Joseph Agassi, London: Routledge and Kegan Paul.
(*1974b*) *Legitimation of Belief*, Cambridge: Cambridge University Press.

Gilbert, William
(*1600*) *De Magnete*; trans. P. Fleury Mottelay, 1893; reprinted New York: Dover, 1958.

Gill, Merton M. & Brenman, Margaret
(*1959*) *Hypnosis and Related States*, New York: International Universities Press.

Gillies, Donald A.
(1992) 'Comments on "Scientific Discovery as Problem Solving" by Herbert A. Simon', *International Studies in the Philosophy of Science*, 6, pp. 29–31.

Ginzburg, Evgenia S.
(*1967*) *Into the Whirlwind*, trans. Paul Stevenson and Manya Harari, Harmondsworth: Penguin, 1968.

Globus, Gordon G., Maxwell, Grover, and Savodnik, Irwin (eds.)
(*1976*) *Consciousness and the Brain*, New York: Plenum Press.

Goldschmidt, Richard B.
(*1940*) *The Material Basis of Evolution*, New Haven: Yale University Press.

Gombrich, E. H.
(*1950/95*) *The Story of Art*, sixteenth edition; Oxford: Phaidon Press.
(*1960*) *Art and Illusion*, London: Phaidon Press.

Gould, Stephen Jay
(*1978*) *Ever Since Darwin*, Harmondsworth: Penguin Books, 1980.
(*1980*) *The Panda's Thumb*, Harmondsworth: Penguin Books, 1983.

Gould, Stephen Jay & Lewontin, R. C.
(1979) 'The Spandrels of San Marco and the Panglossian Paradigm: a Critique of the Adaptationist Programme', *Proceedings of the Royal Society of London*, vol. B 205, pp. 581–598.

Gregory, Richard L.
(*1986*) *Odd Perceptions*, London and New York: Routledge.

Grene, Marjorie (ed.)
(*1973*) *Spinoza: a Collection of Critical Essays*, New York: Doubleday/Anchor.

Gruber, Howard E. and Barrett, Paul H
(*1974*) *Darwin on Man*, Chicago: University of Chicago Press. [See Barrett *1980* and Gruber *1981*.]

Gruber, Howard E.
(1980) Comments on Darwin in Barrett *1980*, passim.
(*1981*) *Darwin on Man*, second ed., Chicago: University of Chicago Press.

Grünbaum, Adolf
(1972) 'Free Will and Laws of Human Behavior', in Feigl, H., Sellars, W. and Lehrer, K. (eds.), *New Readings in Philosophical Analysis*, New York: Appleton-Century-Crofts, pp. 605–627.
(1987) 'Psychoanalysis and Theism', *The Monist*, 70, April, pp. 152–192.
(1989) 'The Pseudo-Problem of Creation in Physical Cosmology', *Philosophy of Science*, 56, September, pp. 373–394.
(1995) 'The Poverty of Theistic Morality', in Gavroglu, K., Stachel, J. & Wartofsky, M. W. (eds.), *Science, Mind and Art* (Essays in honor of Robert S. Cohen), Dordrecht: Kluwer, pp. 203–242.

Hacking, Ian
(*1983*) *Representing and Intervening*, Cambridge: Cambridge University Press.
(1992) 'Experimentation and Instrumentation in Natural Science', in Newton-Smith, W. H. and Jiang, T. (eds.), *Popper in China*, London and New York: Routledge, pp. 21–36.
(1999) 'Mind Over Matter' (review of Winter, *1998*), *The New York Review of Books*, March 18, pp. 36–25.

Hadamard, Jacques
(*1945*) *The Psychology of Invention in the Mathematical Field*, Princeton: Princeton University Press; reprinted New York: Dover, 1954.

Haeckel, Ernst
(*1866*) *Generelle Morphologie der Organismen*, 2 vols., Berlin: Georg Reimer.
(*1899*) *The Riddle of the Universe*, trans. Joseph McCabe, London: Watts, 1904.

Hallett, H. F.
(*1957*) *Benedict de Spinoza*, London: Athlone Press.

Hampshire, Stuart
(*1951*) *Spinoza*, Harmondsworth: Penguin Books.
(1960) 'Spinoza and the Idea of Freedom', *Proceedings of the British Academy*, **46**, pp. 195–215.

Hardy, Alister
(1957) *Proceedings Linnean Society*, London, **168**, pp. 85–87.
(*1965*) *The Living Stream*, London: Collins.

Hardy, G. H.
(*1940*) *Ramanujan*, Cambridge: Cambridge University Press.
(*1940/67*) *A Mathematician's Apology*, Cambridge: Cambridge University Press; reprinted in 1967 with a Foreword by C. P. Snow.

Harris, Errol
(1975) 'Spinoza's Theory of Immortality', in Mandelbaum and Freeman (eds.), *1975*, pp. 245–262.

Hayek, F. A.
(*1967*) *Studies in Philosophy, Politics and Economics*, London: Routledge and Kegan Paul.

Hayes, K. J., and Hayes, C.
(1951) 'The Intellectual Development of a Home-Raised Chimpanzee', *Proc. Amer. Phil. Soc.*, **95**, pp. 105–109.

Heath, Thomas L.
(*1925*) *The Thirteen Books of Euclid's Elements*, second ed., Cambridge: Cambridge University Press; reprinted New York: Dover, 3 vols., 1956.

Heine, Heinrich
(*1835*) *Religion and Philosophy in Germany*, trans. John Snodgrass, Boston: Beacon Press, 1959.

Herman, L. M.
(1980) 'Cognitive Characteristics of Dolphins', in Herman, L. M. (ed.) *Cetacean Behavior: Mechanisms and Functions.*

Hildesheimer, Wolfgang
(*1983*) *Mozart*, trans. Marion Faber, London: Dent.

Hilgard, Ernest R.
(*1965*) *Hypnotic Susceptibility*, New York: Harcourt, Brace, and World.
(*1977*) *Divided Consciousness: Multiple Controls in Human Thought and Action*, New York: John Wiley. Expanded edition 1986.
(1979) 'Divided Consciousness in Hypnosis: the Implications of the Hidden Observer', in Fromm and Shor (eds.) *1979*, pp. 45-79.

Hinton, G. E., and Nowlan, S. J.
(1987) 'How Learning Can Guide Evolution', *Complex Systems*, 1, pp. 495–502.

Hobbes, Thomas
(*Leviathan*) *Hobbes's Leviathan*, Oxford: Clarendon Press, 1909; this gives the pagination of the first edition, to which references are made.
(*1655*) *De Corpore*, in *The English Works of Thomas Hobbes*, ed. Sir William Moresworth, London: John Bohn, vol. I.

Hobson, Alan
(1988) 'Psychoanalytic Dream Theory: A Critique Based upon Modern Neurophysiology', in Clark, P, and Wright, C. (eds.) *Mind, Psychoanalysis and Science*, Oxford: Blackwell.

Hofstadter, Douglas R.
(1982) 'Metamagical Themas', *Scientific American*, **247**, September.

Holmes, Richard
(*1989*) *Coleridge: Early Visions*, London: Hodder and Stoughton.

Holton, Gerald
(*1973*) *Thematic Origins of Scientific Thought: Kepler to Einstein*, Cambridge, Mass.: Harvard University Press.

Holton, Gerald, and Roller, Duane H. D.
(*1958*) *Foundations of Modern Physical Science*, Reading, Mass: Addison Wesley.

Honderich, Ted
(*1988*) *A Theory of Determinism: The Mind, Neuroscience, and Life-Hopes*, Oxford: Clarendon Press.

Howson, Colin
(1991) 'The Last Word on Induction?', *Erkenntnis* **34**, 73–82.

Hume, David
(*Treatise*) *A Treatise of Human Nature*, ed. Selby-Bigge, Oxford: Clarendon Press, 1888. A reference such as 'II, iii, 2' is to Book II, Part III, Section II.
(*Enquiries*) *Enquiries Concerning the Human Understanding and Concerning the Principles of Morals*, ed. Selby-Bigge, second ed., Oxford: Clarendon Press, 1902. References, such as # 44, are to marginal sections.

Humphrey, Nicholas
(*1986*) *The Inner Eye*, London: Faber and Faber.
(*1992*) *A History of the Mind*, London: Chatto and Windus.

Huxley, Leonard (ed.)
(*1903*) *Life and Letters of Thomas Henry Huxley*, 3 vols., London: Macmillan, second ed.

Huxley, T. H.
(*Essays*) *Collected Essays*, 9 vols., 1894–1903, London: Macmillan.
(1860) 'The Origin of Species', in *Essays*, vol. II, *Darwiniana*, pp. 22–79.
(1863) 'On the Relation of Man to the Lower Animals', in *1863*, pp. 77–156.
(*1863*) *Man's Place in Nature*, reprinted as vol. VII of his *Essays*.
(1868) 'On the Physical Basis of Life', in his *Essays*, vol. I, *Method and Results*, pp. 130–165.
(1871) 'Mr. Darwin's Critics', reprinted in his *Essays*, vol. II, *Darwiniana*, pp. 120–186.
(1874) 'On the Hypothesis that Animals are Automata, and its History', in his *Essays*, vol. I, *Method and Results*, pp. 199–250.
(1887) 'Science and Pseudo-Science', in his *Essays*, vol. V, *Science and Christian Tradition*, pp. 90–125.
(1889) 'Agnosticism', in his *Essays*, vol. V, *Science and Christian Tradition*, pp. 209–262.
(*1894*) *Hume*, in his *Essays*, vol. VI, pp. 1–240.

Ignotus, Paul
(*1959*) *Political Prisoner*, London: Routledge and Kegan Paul.

Jackson, Frank
(1982) 'Epiphenomenal Qualia', *The Philosophical Quarterly*, **32**, pp. 127–136.
(1986) 'What Mary Didn't Know', *Journal of Philosophy*, **83**, pp. 291–95; reprinted in Block *et al* (eds.), *1997*, pp. 567–570.

James, William
 (1879) 'Are We Automata?', *Mind*, **4**, January, pp. 1–22; reprinted in his *Essays in Psychology*, *Works*, 1983, pp. 38–61.
 (*1890*) *The Principles of Psychology*, reprinted in 3 volumes, collectively constituting vol. VIII of his *Works*.
 (*Works*) *The Works of William James*, ed. F. M. Burkhardt, F. Bowers, and I. Skrupskelis, Harvard: University Press, 1975-?.

Jeans, James
 (*1947*) *The Growth of Physical Science*, Cambridge: Cambridge University Press.

Jennings, H. S.
 (*1930*) *The Biological Basis of Human Nature*, New York: W. W. Norton.

Jerison, Harry J.
 (1985) 'Issues in Brain Evolution', in Dawkins, R. and Ridley, M. (eds.) *Oxford Surveys in Evolutionary Biology*, **2**, pp. 102–134.

Joachim, Harold H.
 (*1901*) *A Study of the Ethics of Spinoza*, Oxford: Clarendon Press.
 (*1940*) *Spinoza's Tractatus de Intellectus Emendatione*, Oxford: Clarendon Press.

Johanson, Donald C., and Edey, Maitland A.
 (*1981*) *Lucy: The Beginnings of Humankind*, Frogmore: Granada.

Jones, Ernest
 (*1953-57*) *Sigmund Freud: Life and Work*, 3 vols., London: Hogarth.

Jones, I. L., and Hunter, F. M.
 (1993) 'Mutual Sexual Selection in a Monogamous Seabird', *Nature*, **362**, pp. 430–442.

Kant, Immanuel
 (*CPR*) *Critique of Pure Reason*, first ed. 1781, second ed. 1787; trans. Norman Kemp Smith, London: Macmillan, 1953. A reference such as 'A 66 = B 91' is to p. 66 of the first German edition and to p. 91 of the second.
 (*CPrR*) *Critique of Practical Reason*, first ed. 1788; trans. T. K. Abbott, London: Longmans, Green, and Co, sixth edition, 1909; page references are to vol. VIII of the Rosenkranz & Schubert edition of Kant's works.
 (*CrJu*) *Critique of Judgement*, first ed. 1790; trans. J. C. Meredith, Oxford: Clarendon Press, 1928. Page references are to the numbers in the margins, from 167 to 485, corresponding to the those of the volume in the Prussian Academy of Sciences edition.

(*Foundations*) *Metaphysical Foundations of Natural Science*, 1786; trans. James Ellington, Bobbs-Merrill, 1970; page references are to the Berlin Academy edition.
(*Groundwork*) *Groundwork of the Metaphysic of Morals*, first ed. 1785, second ed. 1786; trans. H. J. Paton as *The Moral Law*, London: Hutchinson, 1948; page references are to the Berlin Academy edition; (also trans. T. K. Abbott and published with *CPrR*).
(*Prolegomena*) *Prolegomena to any future Metaphysics that will be able to present itself as a Science*, 1783; trans. Peter G. Lucas, Manchester: University Press, 1953.
(*Religion*) *Religion within the Limits of Reason Alone*, first ed. 1793, second ed. 1794; trans. T. M. Greene and H. H. Hudson, with an introduction by T. M. Greene, La Salle: Open Court, 1934; republished, with the addition of an introductory essay by John R. Silber, New York: Harper, 1960.
(1784) 'What Is Enlightenment?'; trans. Lewis White Beck *et al.* in *Kant on History*, New York: Bobbs-Merrill, 1963.
(*OP*) *Opus postumum*, ed. Eckart Förster, trans. E. Förster and M. Rosen; Cambridge: Cambridge University Press, 1993.

Kellock, Harold
(*1928*) *Houdini: His Life Story*, London: Heinemann.

Kennedy, J. S.
(*1992*) *The New Anthropomorphism*, Cambridge: Cambridge University Press.

Kenny, Anthony
(*1975*) *Will, Freedom, and Power*, Oxford: Blackwell.

Kerman, Joseph, and Tyson, Alan
(*1983*) *The New Grove Beethoven*, London: Macmillan.

Kim, Jaegwon
(*1998*) *Philosophy of Mind*, Boulder: Westview.

Kitcher, Philip
(*1985*) *Vaulting Ambition*, Cambridge, Mass.: MIT Press.

Kneale, Martha
(1973) 'Eternity and Sempiternity', in Grene (ed.), *1973*, pp. 227–240.

Kneale, William C.
(1955) 'The Idea of Invention', *Proceedings of the British Academy*, vol xli, pp. 85–108.
(1959) 'Broad on Mental Events and Epiphenomenalism', in Schilpp (ed.), *1959*, pp. 437–455.

Koestler, Arthur
(1952) Preface to Weissberg, *1952.*
(*1959*) *The Sleepwalkers*, London: Hutchinson.
(*1967*) *The Ghost in the Machine*, London: Hutchinson.

Köhler, Wolfgang
(*1927*) *The Mentality of Apes*, London: Methuen.

Kolakowski, Leszek
(1973) 'The Two Eyes of Spinoza', in Grene (ed.), *1973*, pp. 279–294.

Körner, Stephan
(*1966*) *Experience and Theory*, London: Routledge and Kegan Paul.

Koyré, Alexandre
(*1957*) *From the Closed World to the Infinite Universe*, Baltimore: The Johns Hopkins Press.

Kuhn, Thomas S.
(*1962*) *The Structure of Scientific Revolutions*, Chicago: University of Chicago Press.
(1970) 'Logic of Discovery or Psychology of Research?', in Lakatos and Musgrave (eds.), *1970*, pp. 1–23.

Lack, David
(*1947*) *Darwin's Finches*, Cambridge: Cambridge University Press.

Lakatos, Imre
(*1976*) *Proofs and Refutations: the Logic of Mathematical Discovery*, ed. John Worrall and Elie Zahar, Cambridge: Cambridge University Press.
(*1978*) *Philosophical Papers*, 2 vols., ed. John Worrall and Gregory Currie, Cambridge: Cambridge University Press.
(1978) 'A Renaissance of Empiricism in the Recent Philosophy of Mathematics?', in Lakatos *1978*, ii, pp. 24–42.

Lakatos, Imre, and Musgrave, Alan (eds.)
(*1968*) *Problems in the Philosophy of Science*, Amsterdam: North-Holland.
(*1970*) *Criticism and the Growth of Knowledge*, Cambridge: Cambridge University Press.

Landé, Alfred
(*1965*) *New Foundations of Quantum Mechanics*, Cambridge: Cambridge University Press.

Langley, P., Simon, H. A., Bradshaw, G. L., and Zytkow, J. M.
(*1987*) *Scientific Discovery: Computational Explorations of the Creative Process*, Cambridge, Mass.: MIT Press.

Laplace, Pierre S.
(*1812*) *Essai Philosophique sur les Probabilités*, trans. F. W. Truscott and F. L. Emory, New York: Dover, 1951.
(*Oeuvres*) *Oeuvres Complètes de Laplace*, Paris: Gauthier-Villars, 1878–1884.

Latsis, Spiro J.
(1972) 'Situational Determinism in Economics', *The British Journal for the Philosophy of Science*, **23**, pp. 207–245.

Leakey, Richard, and Lewin, Roger
(*1992*) *Origins Reconsidered: In Search of What Makes Us Human*, London: Abacus.

Leibniz, Gottfried Wilhelm
(1669) 'The Confession of Nature Against Atheists', in Loemker (ed.) *1956*, pp. 168–175.
(1692) 'Critical Thoughts on the General Part of the Principles of Descartes', in Loemker (ed.) *1956*, pp. 629–675.
(1695) 'Specimen Dynamicum', in Loemker (ed.) *1956*, pp. 711–738.
(1710) Letter to Des Bosses, in Loemker (ed.) *1956*, pp. 973–974.
(*1710*) *Essais de Théodicée sur la Bonté de Dieu, la Liberté de l'Homme et l'Origine du Mal*, trans. E. M. Huggard as *Theodicy*, London: Routledge and Kegan Paul, 1952.
(1714) 'The Principles of Nature and of Grace, Based on Reason', in Loemker (ed.) *1956*, pp. 1033–1043
(*1714*) *The Monadology*, trans. Robert Latta, London: Oxford University Press, 1898; references to numbered paragraphs.
(1715) Letter to Louis Bourguet, August 5, 1715, in Loemker (ed.) *1956*, pp. 1078–1081.
(1717) Papers in Leibniz & Clarke (*1717*).

Leibniz, Gottfried Wilhelm, and Clarke, Samuel
(*1717*) *A Collection of Papers Which Passed between the Late Learned Mr. Leibniz and Dr. Clarke, in the Years 1715 and 1716, Relating to the Principles of Natural Philosophy and Religion*, London. Reprinted in Loemker (ed.) *1956*, pp. 1095–1169.

Levey, Michael
(*1971*) *The Life and Death of Mozart*, republished 1988, London: Cardinal.

Lewis, David
(1966) 'An Argument for the Identity Theory'; reprinted in Lewis, *1983*, chap. 7.
(1970) 'How to Define Theoretical Terms'; reprinted in Lewis, *1983*, chap. 6.
(1972) 'Psychophysical and Theoretical Identifications'; reprinted in Block (ed.) *1980*, pp. 207–215.

(*1983*) *Philosophical Papers*, Volume I, New York: Oxford University Press.
(*1986*) *Philosophical Papers*, Volume II, New York: Oxford University Press.

Lewontin, R. C.
(*1974*) *The Genetic Basis of Evolutionary Change*, Columbia: Columbia University Press.
(*1982*) *Human Diversity*, New York: Scientific American Books.

Libet, B.
(1966) 'Brain stimulation and the threshold of conscious experience', in Eccles (ed.) *1966*, pp. 165–181.
(1996) 'Conscious Mind as a Field', *The Journal of Theoretical Biology*, **178**, pp. 223–124.
(1997) 'Conscious Mind as a Force Field: A Reply to Lindahl and Arhem', *The Journal of Theoretical Biology*, **185**, pp. 137–138.

Lindahl, B. I. B.
(1997) 'Consciousness and Biological Evolution', *The Journal of Theoretical Biology*, **187**, pp. 613–629.

Lindahl, B. I. B., and Arhem, P.
(1994) 'Mind as a Force Field: Comments on a New Interactionistic Hypothesis', *The Journal of Theoretical Biology*, **171**, pp. 111–122.
(1996a) 'The Mental Force Field Hypothesis: a Reply to Libet', *The Journal of Theoretical Biology*, **178**, pp. 225–226.
(1996b) 'The Relation Between the Conscious Mind and the Brain: a Reply to Beck', *The Journal of Theoretical Biology*, **181**, pp. 95–96.

Linden, Eugene
(*1975*) *Apes, Men and Language*, Harmondsworth: Pelican, 1976.

Locke, John
(*Essay*) *An Essay Concerning Human Understanding;* ed. A. S. Pringle-Pattison, Oxford: Clarendon Press, 1924; references to book, chapter, and section.

Loemker, Leroy E. (ed.)
(*1956*) *Gottfried Wilhelm Leibniz: Philosophical Papers and Letters*, 2 vols., Chicago: University Press.

Lorenz, Konrad Z.
(*1952*) *King Solomon's Ring;* trans. Marjorie Kerr Wilson; London: Methuen University Paperback, 1961.
(*1965*) *Evolution and Modification of Behavior*, Chicago: University of Chicago Press.
(*1970*) *Studies in Animal and Human Behaviour*, Volume I; trans. Robert Martin; London: Methuen.

Lowes, John Livingston
(*1927*) *The Road to Xanadu: A Study in the Ways of the Imagination*; 5th ed., 1951, London: Constable.

Lucretius
(*Rerum*) *De Rerum Natura*; trans. H. A. J. Munro as *On the Nature of Things*.

Lumsden, Charles J., and Wilson, Edward O.
(*1981*) *Genes, Mind, and Culture*, Cambridge, Mass.: Harvard University Press.
(*1983*) *Promethean Fire: Reflections on the Origin of Mind*, Cambridge, Mass.: Harvard University Press.

Mach, Ernst
(*1886/1906*) *The Analysis of Sensations*; trans. C. M. Williams and Sydney Waterlow of the fifth edition of *Beiträge zur Analyse der Empfindungenn*; New York: Dover, 1959.
(*1883/1933*) *Science of Mechanics*; trans. Thomas J. McCormack; 5th English ed., La Salle: Open Court, 1942.

MacKay, D. M.
(1960) 'On the Logical Indeterminacy of a Free Choice', *Mind*, **69**, pp. 31–40.
(*1967*) *Freedom of Action in a Mechanistic Universe* (Eddington Memorial Lecture), Cambridge: Cambridge University Press.
(1971) 'Scientific Beliefs about Oneself', in Vesey, G. N. A. (ed.) *The Proper Study*, Royal Institute of Philosophy Lectures, vol. 4, London: Macmillan.

Magarshack, David
(1953) Translator's Introduction to *The Devils* by Fyodor Dostoyevsky, London: Penguin Books.

Magee, Bryan
(*1971*) *Modern British Philosophy*, London: Secker and Warburg.
(*1983/97*) *The Philosophy of Schopenhauer*, first edition 1983, revised and enlarged edition 1997, Oxford: Clarendon Press.
(*1997*) *Confessions of a Philosopher*, London: Weidenfeld and Nicolson.

Mandelbaum, Maurice
(1958) 'Darwin's Religious Views', *Journal of the History of Ideas*, **19**, June, pp. 363–378.

Mandelbaum, Maurice & Freeman, Eugene (eds.)
(*1975*) *Spinoza, Essays in Interpretation*, La Salle: Open Court.

Maslach, C., Zimbardo, P., and Marshall, G.
(1979) 'Hypnosis as a Means of Studying Cognitive and Behavioral Control', in Fromm and Shor (eds.) *1979*, pp. 649–685.

Maxwell, Grover
(1968) 'Scientific Methodology and the Causal Theory of Perception', in Lakatos & Musgrave (eds.) *1968*, pp. 148–160.

Maynard Smith, John
(*1958*) *The Theory of Evolution*, second ed., Harmondsworth: Pelican Books, 1966.
(1974) 'The Theory of Games and the Evolution of Animal Conflicts', *Journal of Theoretical Biology*, **47**, pp. 209–221.
(*1982*) *Evolution and the Theory of Games*, Cambridge: Cambridge University Press.
(*1989*) *Did Darwin Get it Right? Essays on Games, Sex, and Evolution*, Chapman and Hall; Penguin Books, 1993.
(1990a) 'What Can't the Computer Do?'; review of Roger Penrose, *1989* in *The New York Review of Books*, March 15, pp. 21–25.
(1990b) An Exchange with John Searle, *The New York Review of Books*, June 14.

Mayr, Ernst
(*1976*) *Evolution and the Diversity of Life*, Cambridge MA: Harvard University Press.
(*1982*) *The Growth of Biological Thought*, Cambridge MA: Harvard University Press.

McDougall, William
(*1905*) *Physiological Psychology*, London: J. M. Dent.
(*1911*) *Body and Mind: A History and a Defense of Animism*, London, Methuen.

McGinn, Colin
(*1982*) *The Character of Mind*, Oxford: Oxford University Press.
(*1991*) *The Problem of Consciousness*, Oxford: Blackwell.
(*1997*) *Minds and Bodies*, Oxford: Oxford University Press.

McGuinness, Brian
(*1988*) *Wittgenstein A Life: Young Ludwig 1889–1921*, London: Duckworth.

McTaggart, John McTaggart Ellis
(*1906*) *Some Dogmas of Religion*, London: Edward Arnold.

Mellor, D. H.
(*1995*) *The Facts of Causation*, London: Routledge.

Mesnet, E.
(1874) 'De l'Automatisme de la Mémoire et du Souvenir, dans le Somnambulisme pathologique', *L'Union Médicale*, Juillet 21 et 23; quoted in extenso in Binet, *1892*.

Meyerson, Emile
(*1908*) *Identity and Reality*, trans. Kate Loewenberg, London: Allen and Unwin, 1930.

Mill, John Stuart
(*Works*) *Collected Works of John Stuart Mill*, ed. J. M. Robson, 33 vols., 1963–91, Toronto: University Press.
(*Logic*) *A System of Logic*, in *Works* vols. vii-viii.
(*Liberty*) *On Liberty*, in *Works* vol. xviii, pp. 213–310.

Miller, David
(*1994*) *Critical Rationalism: A Restatement and Defence*, Chicago: Open Court.

Miller, Geoffrey F.
(1997) 'Protean Primates: the evolution of adaptive unpredictability in competition and courtship', in Whiten, A. and Byrne, R. W. (eds.), *Machiavellian Intelligence II: Extensions and Evaluations*, Cambridge: Cambridge University Press, pp. 312–340.
(1998) 'How mate choice shaped human nature: A review of sexual selection and human evolution', in Crawford, Charles and Krebs, D (eds.), *Handbook of Evolutionary Psychology: ideas, issues, and applications*, pp. 87–129. Mahwah, New Jersey: Lawrence Erlbaum.
(in press) 'Mental traits as fitness indicators: Expanding evolutionary psychology's adaptationism', for *Annals of the New York Academy of Sciences*.

Mivart, St. George
(*1871*) *Genesis of Species*, London: Macmillan.

Monk, Ray
(*1990*) *Ludwig Wittgenstein: the Duty of Genius*, London: Jonathan Cape.

Monod, Jacques
(*1970*) *Chance and Necessity*, trans. Austryn Wainhouse, Alfred Knopf, 1971.

Montagu, Ashley
(*1965*) *The Human Revolution*, Cleveland: World Publishing Company.

Montague, Richard
(1962/74) 'Deterministic Theories', in Thomason (ed.), *1974*, pp. 303–359; first published in 1962.

Moore, G. E.
(1925) 'A Defence of Common Sense' (reprinted in his *1959*, pp. 32–59).
(*1959*) *Philosophical Papers*, London: Allen and Unwin.

Moore, James R.
(*1981*) *The Post-Darwinian Controversies: a study of the Protestant struggle to come to terms with Darwin in Great Britain and America 1870–1900*, Cambridge: Cambridge University Press.

Morgan, C. Lloyd
(1896) 'On Heredity and Variation', *Science*, **4**, pp. 733–740.
(*1900*) *Animal Behaviour*, London: Arnold.

Musgrave, Alan
(1989) 'Saving Science from Scepticism', in D'Agostino and Jarvie, *1989*, pp. 297–323.
(*1993*) *Common Sense, Science and Scepticism*, Cambridge: Cambridge University Press.

Nagel, Thomas
(1974) 'What is it like to be a bat?', *Philosophical Review*, **83**; reprinted in his *1979*, chapter 12.
(*1979*) *Mortal Questions*, Cambridge: Cambridge University Press.
(*1986*) *The View From Nowhere*, Oxford: Oxford University Press.
(1993) 'The Mind Wins!'; review of Searle, *1992*, in *The New York Review of Books*, March 4.

Neumann, John von, and Morgenstern, Oskar
(*1944*) *Theory of Games and Economic Behavior*, Princeton: Princeton University Press.

Neurath, Otto
(*1931*) *Empirische Soziologie*; trans. as 'Empirical Sociology', in Neurath *1973*, pp. 319–421.
(*1973*) *Otto Neurath: Empiricism and Sociology*, ed. Robert S. Cohen and Marie Neurath, Vienna Circle Collection, vol. 1, Dordrecht: Reidel.

Neurath, Otto *et al*
(1929) 'Wissenschaftliche Weltauffassung: der Wiener Kreis' (signed by Hans Hahn, Otto Neurath, Rudolf Carnap); translation in Neurath *1973*, pp. 299–318.

Newton, Isaac
(*Principia*) *Newton's Principia: Motte's translation revised*; Florian Cajori, Berkeley: University of California Press, 1934.
(*Opticks*) *Opticks: or a Treatise on the Reflections, Refractions, Inflections & Colours of Light*, based on the fourth edition, 1730; New York: Dover, 1952.

O'Connor, D. J.
(1948) 'Pragmatic Paradoxes', *Mind*, **57**, July, pp. 358–359.
(*1971*) *Free Will*, New York: Doubleday (Anchor Books).

Oddie, Graham
(1989) 'The Unity of Theories', in D'Agostino and Jarvie *1989*, pp. 343–368.

O'Hear, Anthony
(*1980*) *Karl Popper*, London: Routledge and Kegan Paul.
(1987) 'Has the Theory of Evolution any Relevance to Philosophy?', *Ratio*, **24**, June, pp. 16–35.
(*1997*) *Beyond Evolution*, Oxford: Clarendon Press.

O'Hear, Anthony (ed.)
(*1996*) *Karl Popper: Philosophy and Problems* (Royal Institute of Philosophy Supplement: 39), Cambridge: Cambridge University Press.

Orne, Martin T.
(1979) 'On the Simulating Subject as a Quasi-Control Group in Hypnosis Research: What, Why, and How', in Fromm and Shor (eds.), *1979*, pp. 519–565.

Paley, William
(*1802*) *Natural Theology; or Evidences of the Existence and Attributes of the Deity*, in *Paley's Works*, 1816–1821, Edinburgh/London, vol. iii.

Paloczi-Horvath, Gyorgy
(*1959*) *The Undefeated*, London: Secker and Warburg. Reprinted with an Afterword by Agi Argent, London: Eland, 1993.

Paton, H. J.
(*1947*) *The Categorical Imperative: a Study in Kant's Moral Philosophy*, London: Hutchinson.

Peirce, C. S.
(1892) 'The Doctrine of Necessity Examined', in *Papers*, 6.35–6.65.
(*Papers*) *The Collected Papers of Charles Saunders Peirce*, 8 vols. (1931-58), ed. C. Hartshorne, P. Weiss, & A. W. Burks, Cambridge MA: Harvard University Press. A reference such as 6.35 is to volume 6, para. 35.

Penfield, Wilder
(*1975*) *The Mystery of the Mind*, Princeton: Princeton University Press.

Penrose, Roger
(*1989*) *The Emperor's New Mind: Concerning Computers, Minds, and the*

Laws of Physics, Oxford: Oxford University Press.
(*1994*) *Shadows of the Mind: A Search for the Missing Science of Consciousness*, Oxford: Oxford University Press

Pinker, Steven
(*1994*) *The Language Instinct*, Morrow/Penguin Books.
(*1997*) *How the Mind Works*, Norton/Penguin Books.

Place, Ulam T.
(1956) 'Is Consciousness a Brain Process?', *The British Journal of Psychology*, **47**; reprinted in Borst (ed.) *1970*, pp. 42–51.
(1960) 'Materialism as a Scientific Hypothesis', *The Philosophical Review*, **69**; reprinted in Borst (ed.) *1970*, pp. 83–86.

Poincaré, Henri
(*1908*) *Science and Method*, trans. Francis Maitland, London: Nelson.

Pollock, Frederick
(*1880*) *Spinoza: His Life and Philosophy*, London: Kegan Paul.

Popper, Karl R.
(*1934*) *Logik der Forschung*, Vienna: Springer. English translation in Popper, *1959*.
(*1945/66*) *The Open Society and its Enemies*, 2 vols., London: Routledge and Kegan Paul, 5th ed.
(1950) 'Indeterminism in Quantum Physics and in Classical Physics', *The British Journal for the Philosophy of Science*, **1**, August, November, pp. 117–133, 173–195.
(1956) 'Three Views Concerning Human Knowledge', in H. D. Lewis (ed.), *Contemporary British Philosophy*, Third Series, London: Allen and Unwin, pp. 335–388; reprinted in his *1963*, Chapter 3.
(1957) 'The Propensity Interpretation of the Calculus of Probability, and the Quantum Theory', in S. Körner (ed.), *Observation and Interpretation in the Philosophy of Physics*, New York: Dover, pp. 65–70.
(*1957*) *The Poverty of Historicism*, London: Routledge and Kegan Paul.
(*1959*) *The Logic of Scientific Discovery*, London: Hutchinson; English translation of Popper, *1934*, with new preface, footnotes and appendices; 3rd ed. 1972.
(1962) 'Facts, Standards and Truth'; addendum to 4th ed. of Popper, *1945/66*, vol. ii, pp. 369–396.
(*1963*) *Conjectures and Refutations*, London: Routledge and Kegan Paul; 4th ed. 1972.
(*1966*) *Of Clouds and Clocks: An Approach to the Problem of the Rationality and the Freedom of Man*, St. Louis: Washington University Press; reprinted in his *1972*, Chapter 6.
(*1972*) *Objective Knowledge: An Evolutionary Approach*, Oxford: Clarendon

Press.

(1974) 'Autobiography of Karl Popper', in Schilpp (ed.), *1974*, pp. 3–181; reprinted in Popper, *1976*.

(1975) 'The rationality of scientific revolutions', in Rom Harré (ed.), *Problems of Scientific Revolution*, Oxford: Clarendon Press, 72-101.

(*1976*) *Unended Quest*, Glasgow: Fontana/Collins.

(*1977*) Part I and 'Dialogues', in Popper and Eccles *1977*.

(1978) 'Natural Selection and the Emergence of Mind', *Dialectica*, 32, 339–355.

(1982) 'The Place of Mind in Nature', in Richard Q. Elvee (ed.), *Mind in Nature*, San Francisco: Harper and Row, 31–59.

(*1982a*) *Realism and the Aim of Science*, ed. W. W. Bartley, London: Hutchinson.

(*1982b*) *The Open Universe*, ed. W. W. Bartley; London: Hutchinson.

(*1982c*) *Quantum Theory and the Schism in Physics*, ed. W. W. Bartley; London: Hutchinson.

(*1992*) *In Search of a Better World*, London and New York: Routledge.

(*1994a*) *The Myth of the Framework*, ed. M. A. Notturno; London and New York: Routledge.

(*1994b*) *Knowledge and the Body-Mind Problem*, ed. M. A. Notturno; London and New York: Routledge.

Popper, Karl R., and Eccles, John C.

(*1977*) *The Self and Its Brain*, Springer International.

Popper, K. R., Lindahl, B. I. B., and Arhem, P.

(1993) 'A Discussion of the Mind-Brain Problem', *Theoretical Medicine*, **14**, pp. 167–180.

Prince, Morton

(*1908*) *The Dissociation of a Personality*, second ed., New York: Longmans, Green.

Puccetti, Roland

(1975) 'Is Pain Necessary?', *Philosophy*, **50**, pp. 259–269.

Putnam, Hilary

(1967) 'Psychological Predicates', reprinted as 'The Nature of Mental States' in Putnam *1975*, ii, Chap. 21.

(*1975*) *Philosophical Papers*, 2 volumes, Cambridge: Cambridge University Press.

(*1988*) *Representation and Reality*, Cambridge, Mass.: MIT Press.

Quine, W. V. O.

(*1985*) *The Time of My Life: an Autobiography*, Cambridge Mass: MIT Press.

Raiffa, Howard
(*1970*) *Decision Analysis: Introductory Lectures on Choices under Uncertainty*, London: Addison-Wesley.

Ramsey, F. P.
(*1931*) *The Foundations of Mathematics*, ed. R. B. Braithwaite, intro. G. E. Moore; London: Routledge and Kegan Paul.

Rapoport, Anatol
(1966) *Two-Person Game Theory*, University of Michigan.

Rapoport, Anatol, and Budesco, D. V.
(1992) 'Generation of random series in two-person strictly competitive games', *Journal of Experimental Psychology*, **121**, pp. 352–363.

Redhead, Michael
(*1995*) *From Physics to Metaphysics*, Cambridge: Cambridge University Press.

Reed, John
(*1987*) *Schubert*, London: J. M. Dent.

Richards, Robert J.
(*1987*) *Darwin and the Emergence of Evolutionary Theories of Mind and Behavior*, Chicago: University of Chicago Press.

Richardson, Anthony
(*1950*) *Wingless Victory*, London: Odhams.

Ridley, Matt
(*1993*) *The Red Queen: Sex and the Evolution of Human Nature*, New York: Macmillan.

Robbins, Lionel
(*1932*) *An Essay on the Nature and Significance of Economic Science*, second ed. 1935; London: Macmillan

Robinson, Daniel N.
(*1978*) *The Mind Unfolded: Essays on Psychology's Historic Texts*, Washington: University Publications of America.

Rorty, Richard
(1965) 'Mind-Body Identity, Privacy and Categories', *The Review of Metaphysics*, **19**, pp. 24–54; reprinted in Rosenthal (ed.), *1971*, pp. 174–199.

Rosenthal, David M. (ed.)
(*1971*) *Materialism and the Mind-Body Problem*, Englewood Cliffs: Prentice Hall.

Roth, Leon
(*1954*) *Spinoza* (second impression), London: Allen and Unwin.

Rousseau, Jean-Jacques
(*Émile*) *Émile ou de l'education*, Amsterdam and Paris, 1762, trans. Barbara Foxley, London: Dent (Everyman), 1974.

Ruse, Michael
(*1979*) *The Darwinian Revolution*, Chicago: University of Chicago Press.
(*1995*) *Evolutionary Naturalism*, London: Routledge.

Russell, Bertrand
(1903) 'A Free Man's Worship', reprinted in Russell, *1917*, pp. 46–57.
(*1914*) *Our Knowledge of the External World*; revised edition 1926; London: Allen and Unwin.
(*1917*) *Mysticism and Logic*, London: Allen and Unwin.
(1944) 'Reply to Criticisms' in Schilpp (ed.), *1944*, pp. 681–741.
(*1948*) *Human Knowledge: its Scope and Limits*, London: Allen and Unwin.
(*Auto*) *The Autobiography of Bertrand Russell*, 3 vols., 1967–69, London: Allen and Unwin.
(*1959*) *My Philosophical Development*, London: Allen and Unwin.

Russell, E. S.
(*1945*) *The Directiveness of Organic Activities*, Cambridge: Cambridge University Press.

Ryle, Gilbert
(*1949*) *The Concept of Mind*, London: Hutchinson.
(1951) 'Feelings', in Ryle, *1971*, ii, pp. 272–286.
(*1960*) *Dilemmas*, Cambridge: Cambridge University Press.
(1968) 'The Thinking of Thoughts: What is "Le Penseur" Doing?', in Ryle, *1971*, ii, pp. 480–496.
(*1971*) *Collected Papers*, 2 vols., London: Hutchinson.
(*1979*) *On Thinking*, ed. K. Kolenda, Oxford: Blackwell.

Sacks, Oliver
(*1985*) *The Man Who Mistook His Wife For a Hat*, London: Duckworth.

Samuel, Arthur L.
(1960) 'Some Moral and Technical Consequences of Automation—A Refutation', *Science*, **132**, pp. 741–42.
(1963) 'Some studies in machine learning using the game of checkers', in Feigenbaum, E. A. and Feldman, J. (eds.), *Computers and Thought*, New York: McGraw-Hill.
(1967) 'Some studies in machine learning using the game of checkers. II. Recent progress' *IBM Journal of Research and Development*, **11**, pp. 601–617.

Saw, Ruth Lydia
(*1951*) *The Vindication of Metaphysics: A Study in the Philosophy of Spinoza*,
London: Macmillan.

Schelling, F. W. J.
(*1809*) *Philosopische Untersuchungen über das Wesen der menschlichen
Freiheit und die damit zusammenhängenden Gegenstände*; trans. James
Gutman as *Of Human Freedom*, Chicago: Open Court, 1936. References to
the pages of the original.

Schilpp, Paul Arthur (ed.)
(*1944*) *The Philosophy of Bertrand Russell* (The Library of Living
Philosophers), Evanston, Ill.
(*1959*) *The Philosophy of C. D. Broad* (The Library of Living Philosophers),
New York: Tudor.
(*1963*) *The Philosophy of Rudolf Carnap* (The Library of Living
Philosophers), La Salle: Open Court.
(*1974*) *The Philosophy of Karl Popper* (The Library of Living Philosophers),
La Salle: Open Court, 2 vols.

Schlagel, Richard H.
(*1986*) *Contextual Realism*, New York: Paragon House.

Schlick, Moritz
(*Papers*) *Philosophical Papers*, ed. Henk L. Mulder and Barbara van de
Velde, 2 vols., (Vienna Circle Collection, vol. 11), 1979, Dordrecht: Reidel.
(1909) 'The Fundamental Problem of Aesthetics Seen in an Evolutionary
Light', in Schlick, *Papers*, i, pp. 1–24.
(*1925*) *Allgemeine Erkenntnislehre* 2nd. ed. (1st ed. 1918); trans. Albert E.
Blumberg, as *General Theory of Knowledge* (intro. Albert Blumberg and
Herbert Feigl), New York: Springer-Verlag, 1974.
(1926) 'Experience, Cognition and Metaphysics', in Schlick, *Papers*, ii,
pp. 99–111.
(1934) 'Philosophy and Natural Science', in Schlick, *Papers*, ii,
pp. 139–153.
(1936) 'The Universe and the Human Mind', in Schlick, *Papers*, ii, pp.
499–513.

Schopenhauer, Arthur
(*1819/44*) *The World as Will and Representation*, trans. E. F. J. Payne, 2
vols., New York: Dover, 1966.
(*1836*) *On the Will in Nature*, trans. K. Hillebrandt (with *On the Fourfold
Root of the Principle of Sufficient Reason*), London: Bohn, 1889.
(*1841*) *Essay on the Freedom of the Will*; trans. Konstantin Kolenda,
Indianapolis: Bobbs-Merrill, 1960.

Schrödinger, Erwin
(*1958*) *Mind and Matter* (the 1956 Tarner Lectures), Cambridge: Cambridge University Press.
(*1964*) *My View of the World*, trans. Cecily Hastings, Cambridge: Cambridge University Press.

Scott, Captain Robert F.
(*1905*) *The Voyage of the "Discovery"*; new edition 1929, London: John Murray.

Scruton, Roger
(*1986*) *Spinoza;* Oxford: Oxford University Press.

Searle, John R.
(1964) 'How to Derive "Ought" from "Is"', *The Philosophical Review*, **73**, pp. 43–58.
(*1992*) *The Rediscovery of the Mind*, Cambridge Mass: MIT Press.
(1995) 'The Mystery of Consciousness—I', *The New York Review of Books*, November 2.
(1997) 'Consciousness and the Philosophers', review of Chalmers, *1996*, in *The New York Review of Books*, March 6.

Sherrington, Charles
(*1940*) *Man on his Nature*; Harmondsworth: Pelican Books, 1955.

Shimony, Abner
(*1993*) *Search for a Naturalistic World View*, 2 vols., Cambridge: Cambridge University Press.

Shor, R. E.
(1959) 'Hypnosis and the Concept of the Generalized Reality-orientation', *American Journal of Psychotherapy*, **13**, pp. 582–602.

Silber, John R.
(1960) 'The Ethical Significance of Kant's *Religion*'; introduction to Kant (*Religion*), pp. lxxix–cxxvii.

Simon, Herbert A.
(1976) 'From Substantive to Procedural Rationality', in Latsis, Spiro J. (ed.), *Method and Appraisal in Economics*, Cambridge: Cambridge University Press, pp. 129–148.
(1992) 'Scientific discovery as problem solving', *International Studies in the Philosophy of Science*, **6**, pp. 3–14.

Simpson, George Gaylord
(*1950*) *The Meaning of Evolution*, Oxford: University Press.
(1953) 'The Baldwin Effect', *Evolution*, 7, pp. 110–117.

Skinner, B. F.

(*1971*) *Beyond Freedom and Dignity*, reprinted with new Preface and Epilogue, Harmondswoth: Peregrine Books, 1988.

Sklar, Lawrence

(*1993*) *Physics and Chance; Philosophical issues in the foundations of statistical mechanics*, Cambridge: Cambridge University Press.

Smart, J. J. C.

(1959) 'Sensations and Brain Processes', *The Philosophical Review*, **68**; reprinted in Borst (ed.) *1970*, pp. 52–66.

(1961) 'Further Remarks on Sensations and Brain Processes', *The Philosophical Review*, **70**; reprinted in Borst (ed.) *1970*, pp. 93–94.

(*1963*) *Philosophy and Scientific Realism*, London: Routledge and Kegan Paul.

(*1989*) *Our Place in the Universe*, Oxford: Blackwell.

Snow, C. P.

(*1961*) *The Two Cultures and the Scientific Revolution*, Cambridge: Cambridge University Press.

(1967) 'Foreword' to Hardy (*1940/67*).

Sober, Elliott

(*1984*) *The Nature of Selection*, Cambridge Mass: MIT Press.

Sonneck, O. G. (ed.)

(*1926*) *Beethoven: Impressions by his Contemporaries*, New York: G. Schirmer (reprinted New York: Dover, 1967).

Spinoza, Benedict de

(*Corr*) *The Correspondence of Spinoza*; trans. A. Wolf, London: Allen and Unwin, 1928.

(*E*) *Ethics*, English trans. in *Works*, pp. 408–617. I follow, with minor variations, Curley's system for references, as follows: A = axiom; Ap = appendix; C = corollary; D (preceded by P) = demonstration; D (not preceded by P) = definition; P = proposition; S = scholium. Parts are indicated by roman numerals. Thus IP33S2 = Part One, proposition 33, scholium 2; IIP19D = Part Two, proposition 19, demonstration; ID8 = Part One, definition 8. A reference such as II/278 is to the volume and page number, which Curley provides, of Gebhardt's *Spinoza Opera*. I have not followed Curley's capitalizations of words like 'mind' and 'body'.

(*KV*) *Short Treatise on God, Man, and His Well-Being;* English trans. in *Works*, pp. 53–156. A reference such as 'II, xix, 13' is to Part II, chapter xix, section 13.

(*TdIE*) *Tractatus de Intellectus Emendatione* ; English trans. in *Works*, pp.

7–45. References are to section numbers.
(*TP*) *Tractatus Politicus*, trans. A. G. Wernham in *Benedict de Spinoza: The Political Works*, Oxford: Clarendon Press, 1958 (a reference such as 'ii, 8' is to chapter II, paragraph 8).
(*TPT*) *Tractatus Theologico-Politicus*, English trans. in R. H. M. Elwes in *The Chief Works of Benedict Spinoza*, 2 vols., London: George Bell, 1883, vol. 1, pp. 1–278.
(*Works*) *The Collected Works of SPINOZA*, ed. and trans. Edwin Curley, vol. i, 1985, Princeton: Princeton University Press.

Stich, Stephen
(1991) 'Do True Believers Exist?', *The Aristotelian Society*, supp. vol. lxv, pp. 229–244.

Strauss, Leo
(*1952*) *Persecution and the Art of Writing*, Glencoe: Free Press.

Strawson, Peter F.
(1958) 'On Justifying Induction', *Philosophical Studies*, **9**, pp. 20–21.
(*1959*) *Individuals: an essay in descriptive metaphysics*, London: Methuen.
(*1985*) *Skepticism and Naturalism: Some Varieties*, London: Methuen.

Stuckenberg, J. H. W.
(*1882*) *The Life of Immanuel Kant*, London: Macmillan.

Suppes, Patrick
(*1984*) *Probabilistic Metaphysics*, Oxford: Blackwell.

Swinburne, Richard
(*1986*) *The Evolution of the Soul*, Oxford: Clarendon Press.

Szasz, Bela Sandor
(*1971*) *Volunteers for the Gallows: anatomy of a show trial*, trans. Kathleen Szasz; London: Chatto & Windus.

Thomason, R. H. (ed.)
(*1974*) *Formal Philosophy, Selected Papers*, New Haven: Yale University Press.

Thorpe, W. H.
(*1956*) *Learning and Instinct in Animals*, London: Methuen.
(*1962*) *Biology and the Nature of Man*, Oxford: Oxford University Press.

Thurber, James
(*1963*) *Vintage Thurber*, 2 vols., London: Book Club Associates.

Tinbergen, N.
(*1953/65*) *Social Behaviour in Animals*, London: Methuen.

Torrance, E. P.
(1965) 'Scientific Views of Creativity and Factors Affecting its Growth', *Daedalus*, Summer, pp. 663–681.

Trivers, Robert
(1983) 'The Evolution of a Sense of Fairness', *Proceedings of the Eleventh International Conference on the Unity of the Sciences*, New York: International Cultural Foundation Press, vol. ii, pp. 1189–1208.

Troyat, Henri
(*1965*) *Tolstoy*, trans. Nancy Amphoux, London: Penguin Books, 1970.
(*1984*) *Chekhov*, trans. Michael Heim, New York: Fawcett Columbine, 1988.

Urbach, Peter
(1974) 'Progress and Degeneration in the "IQ Debate"', *The British Journal for the Philosophy of Science*, **25**, pp. 99–135 and 235–259.

Van Fraassen, Bas
(*1980*) *The Scientific Image*, Oxford: Clarendon Press.

Waismann, Friedrich
(*1968*) *How I See Philosophy*, ed. R. Harré, London: Macmillan.

Wallace, Alfred Russel
(1858) 'On the Tendency of Varieties to Depart Indefinitely from the Original Type'; reprinted in de Beer (ed.), *1958*, pp. 268–279.
(1869) Review-article (unsigned) of Lyell's *Principles of Geology* and *Elements of Geology*, in *The Quarterly Review*, **126**, pp. 359–394.
(*1889*) *Darwinism*; third edition, London: Macmillan, 1901.
(*1905*) *My Life: a record of events and opinions*, London: Chapman and Hall, 2 vols.

Wallach, M. A., and Kogan, N.
(1972) 'Creativity and Intelligence in Children', in Hunt, J. McV (ed.), *Human Intelligence*, New York: Transactions, pp. 165–180.

Wallas, Graham
(*1926*) *The Art of Thought*, London: Jonathan Cape.

Warnock, G. J.
(1979) Review of Popper and Eccles, *1977*, in *Brain*, **102**, pp. 225–228.

Watkins, John
(1958) 'Confirmable and Influential Metaphysics', *Mind*, **67**, July, pp.

344–365.
(1970) 'Imperfect Rationality', in Borger, R. and Cioffi, F. (eds.),
Explanation in the Behavioural Sciences, Cambridge: Cambridge University
Press, pp. 167–217.
(1971) 'Freedom and Predictability: an amendment to Mackay', *The British
Journal for the Philosophy of Science*, **22**, August, pp. 263–275.
(*1973*) *Hobbes's System of Ideas*, London: Hutchinson, second ed.
(Reprinted by Gower Publishing Co, 1989.)
(1974) 'The Unity of Popper's Thought', in Schilpp (ed.), *1974*, pp.
371–412.
(1975a) 'Metaphysics and the Advancement of Science', *The British Journal
for the Philosophy of Science*, **26**, pp. 91–121.
(1975b) 'Three Views Concerning Human Freedom', in R. S. Peters (ed.),
Nature and Conduct, London: Macmillan, pp. 200–228.
(1976) 'The Human Condition: Two Criticisms of Hobbes', in Cohen, R.
S., Feyerabend, P. K. and Wartofsky, M. W. (eds.), *Essays in Memory of Imre
Lakatos*, Dordrecht: Reidel, pp. 691–716.
(*1984*) *Science and Scepticism*, Princeton: Princeton University Press and
London: Hutchinson.
(1985) .'Second Thoughts on Landé's Blade', *Journal of Indian Council of
Philosophical Research*, **2**, Spring, pp. 13–19.
(1990) Review of Ted Honderich's *1988*, in *The Philosophical Quarterly*, **40**,
July, pp. 381–388.
(1991) 'Scientific Rationality and the Problem of Induction: Responses to
Criticisms', The *British Journal for the Philosophy of Science*, **42**, September,
pp. 343–68.
(1992) 'Has BACON Vindicated Kant?', *International Studies in the
Philosophy of Science*, **6**, pp. 65–67.
(1995a) 'Actions Against "Elbings", April 1944', *The Mariner's Mirror*, **81**,
May, pp. 195–206.
(1995b) 'How I Almost Solved the Problem of Induction', *Philosophy*, **70**,
July, pp. 429–435.
(1995c) 'Popper and Darwinism', in Anthony O'Hear (ed.), *Karl Popper:
Philosophy and Problems* (Royal Institute of Philosophy Supplement: 39),
Cambridge: Cambridge University Press, pp. 191–206.

Watson, John B.
(*1924/30*) *Behaviorism*, Chicago: University of Chicago Press, revised ed.

Weiskrantz, Lawrence
(*1986*) *Blindsight : a case study and implications*, Oxford: Clarendon.

Weissberg, Alex
(*1952*) *Conspiracy of Silence*; trans. Edward Fitzgerald, Preface by Arthur
Koestler, London: Hamish Hamilton.

Westfall, Richard S.
(*1980*) *Never at Rest: A Biography of Isaac Newton*, Cambridge: Cambridge
University Press.

Wheeler, John Archibald
(1977) 'Genesis and Observership', in Butts, R. E. and Hintikka, J. (eds.), *Foundational Problems in the Special Sciences*, Dordrecht: Reidel, pp. 3–33.

Whewell, William
(*1847*) *The Philosophy of the Inductive Sciences, Founded upon their History*, a new edition; 2 vols., London: Parker.

Whitehead, A. N.
(*1919*) *An Enquiry concerning the Principles of Natural Knowledge*, Cambridge: Cambridge University Press.

Wilberforce, Samuel
(1860) Review of *The Origin of Species*, *Quarterly Review*, **108**, pp. 225–264.

Wilkes, Kathleen V.
(*1978*) *Physicalism*, London: Routledge and Kegan Paul.
(1981) 'Multiple Personality and Personal Identity', *The British Journal for the Philosophy of Science*, **32**, pp. 331–348; modified version in Wilkes, *1988*, chapter 4.
(1984) 'Is Consciousness Important?', *The British Journal for the Philosophy of Science*, **35**, pp. 223–243; modified version in Wilkes, *1988*, chapter 6.
(*1988*) *Real People*, Oxford: Clarendon Press.

Williams, Bernard
(*1978*) *Descartes: The Project of Pure Enquiry*, Harmondsworth: Penguin.

Williams, George C.
(*1966*) *Adaptation and Natural Selection*, Princeton: Princeton University Press.

Williams, L. Pearce
(*1965*) *Michael Faraday: a Biography*, London: Chapman and Hall.

Williams, L. Pearce (ed.)
(*1971*) *The Selected Correspondence of Michael Faraday*, 2 volumes, Cambridge: Cambridge University Press.

Wilson, Edward O.
(1971) 'Competitive and Aggressive Behaviour', in Eisenberg, J. F. and Dillon, W. S. (eds.), *Man and Beast: Comparative Social Behavior*, Washington, D.C.: Smithsonian Institution Press, pp. 181–217.
(*1975*) *Sociobiology: The New Synthesis*, Cambridge MA: Harvard University Press.
(*1978*) *On Human Nature*, Cambridge MA: Harvard University Press (Penguin Books 1995).
And *see* Lumsden and Wilson.

Winter, Alison
(*1998*) *Mesmerized: Powers of Mind in Victorian Britain*, Chicago:
University of Chicago Press.

Wittgenstein, Ludwig
(*1922*) *Tractatus Logico-Philosophicus*, London: Routledge and Kegan Paul.
(*1967*) *Zettel* , ed. G. E. M. Anscombe and G. H. von Wright, Oxford:
Blackwell.

Wolf, A.
(1910) 'The Life of Spinoza', in *Spinoza's Short Treatise on God, Man, &*
His Well-Being, trans. A. Wolf; reissued in 1963, New York: Russell and
Russell.

Wolfson, Harry Austryn
(*1934*) *The Philosophy of Spinoza*, 2 vols.; Cambridge MA: Harvard
University Press.

Wooldridge, Dean E.
(*1968*) *Mechanical Man: The Physical Basis of Intelligent Life*, New York:
McGraw-Hill.

Wright, Sewall
(1964) 'Biology and the Philosophy of Science', *The Monist*, **48**, pp.
265–290.

Wynne-Edwards, V. C.
(*1962*) *Animal Dispersion in Relation to Social Behaviour*, Edinburgh:
Oliver and Boyd.

Yovel, Yirmiyahu
(*1989*) *Spinoza and Other Heretics*, 2 vols., Princeton: Princeton University
Press.

Zahar, Elie
(*1989*) *Einstein's Revolution: A Study in Heuristic*, La Salle: Open Court.

Index